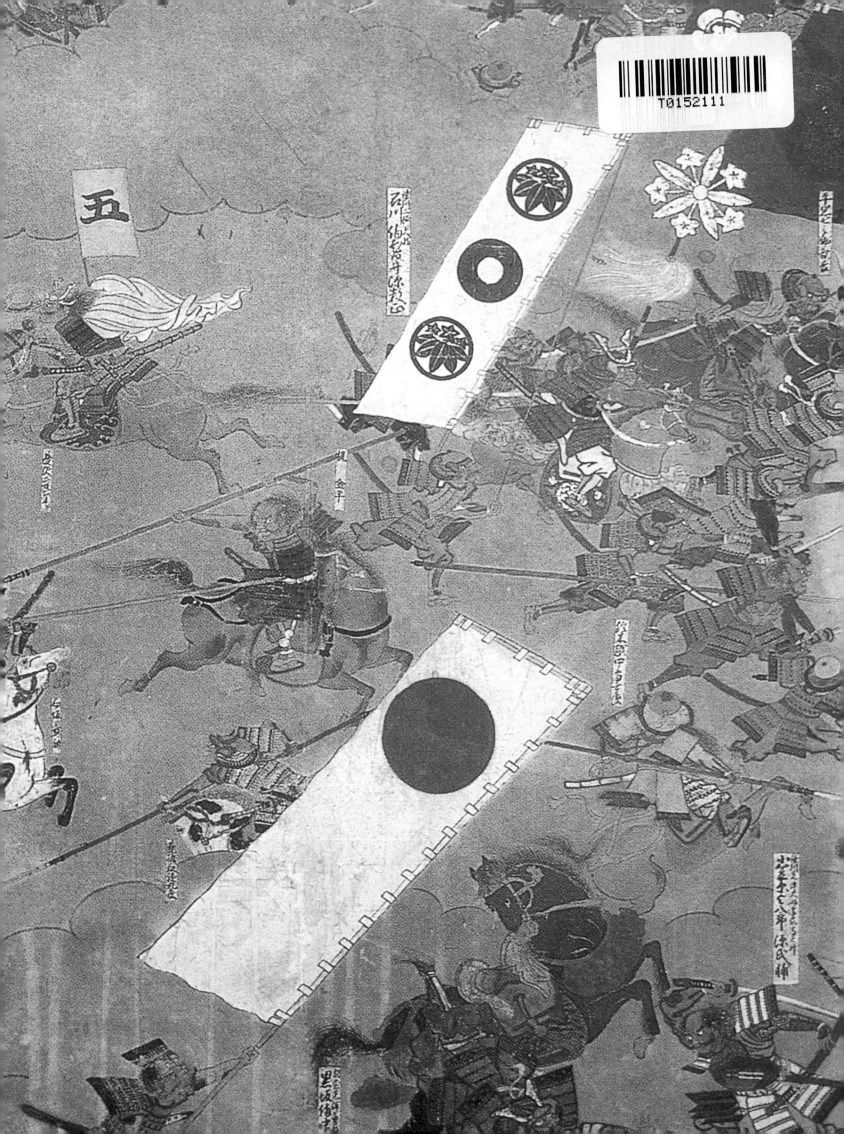

THE SAMURAI
SWORDSMAN

THE SAMURAI SWORDSMAN

MASTER OF WAR

STEPHEN TURNBULL

TUTTLE PUBLISHING

Tokyo · Rutland, Vermont · Singapore

This book is dedicated with grateful thanks to
Ian Bottomley, the Curator of Japanese Arms
and Armour at the Royal Armouries Museum,
who has taught me so much about the samurai
swordsman and his legendary weapon.

Published by Tuttle Publishing, an imprint of Periplus Editions (HK)
Ltd., with editorial offices at 364 Innovation Drive, North
Clarendon, Vermont 05759 U.S.A. and 61 Tai Seng Avenue #02-12,
Singapore 534167

Library of Congress Cataloging-in-Publication Data
Turnbull, Stephen R.
 The Samurai swordsman / master of war Stephen Turnbull.
 p. cm.
 ISBN 978-4-8053-0956-8 (hardcover)
1. Samurai. I. Title.
 DS827.S3T89 2008
 952'.02--DC22 2007021014
 ISBN-10: 4-8053-0956-3 ISBN-13: 978-4-8053-0956-8

Distributed by

North America & Latin America
Tuttle Publishing, 364 Innovation Drive
North Clarendon, VT 05759-9436 U.S.A.
Tel: 1 (802) 773-8930; Fax: 1 (802) 773-6993
info@tuttlepublishing.com www.tuttlepublishing.com

Europe, Middle East, S. Africa, New Zealand & Australia
Frontline Books, 47 Church Street
Barnsley, South Yorkshire, S70 2AS England
Tel: (44) 01226 734555; Fax: (44) 02116 734438
www.frontline-books.com

Japan
Tuttle Publishing, Yaekari Building, 3rd Floor
5-4-12 Osaki, Shinagawa-ku, Tokyo 141 0032
Tel: (81) 3 5437-0171; Fax: (81) 3 5437-0755
tuttle-sales@gol.com

Asia Pacific
Berkeley Books Pte. Ltd.
61 Tai Seng Avenue #02-12 Singapore 534167
Tel: (65) 6280-1330; Fax: (65) 6280-6290
inquiries@periplus.com.sg www.periplus.com

First edition
12 11 10 09 08 10 9 8 7 6 5 4 3 2
Printed in Singapore

TUTTLE PUBLISHING® is a registered trademark of Tuttle
Publishing, a division of Periplus Editions (HK) Ltd.

Front endpapers: **A painted screen depicting the 1570
Battle of the Anegawa. (Fukui Prefectural Museum)**

Page 1: **A fierce-looking member of the Forty-Seven Rōnin.**

Page 2: **Samurai engaging in swordplay.**

Right: **A street scene in an Edo-era Japanese town.**

Page 6: **The Forty-Seven Rōnin return from their mission.**

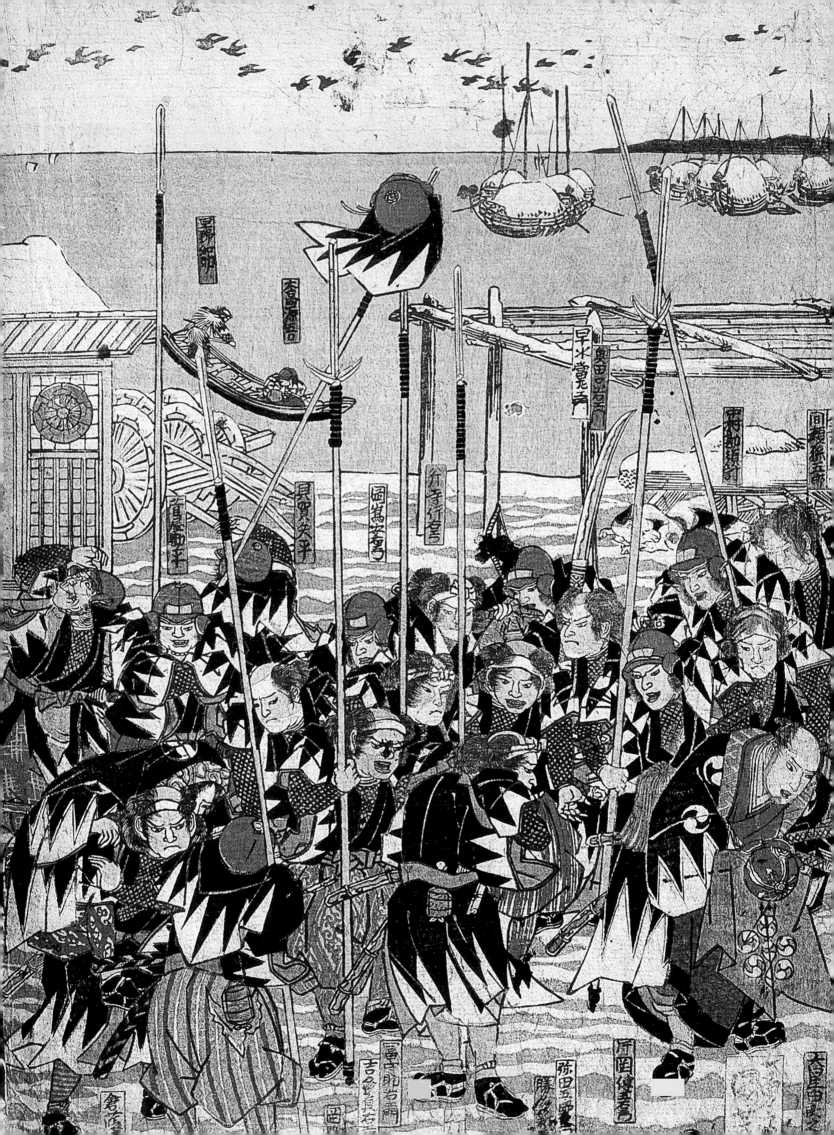

CONTENTS

PREFACE

The figure approaches from a distance, following the dusty road over the brow of a hill. As he gets closer, he is seen to be a man who is travel-stained and wild, with a sword at his side. He stops, and our eyes meet. Another man is nearby. He too is armed, and he is waiting. The opponents approach each other. There is the flash of a sword blade, and one falls dead.

This is the image projected almost daily in Japan by a million television screens, comics, and films. The wanderer is victorious, and he will wander again. He (and it is almost always "he," with notable exceptions, discussed in Chapter 8) is an expert in the martial arts, ruthless and deadly, and always ready for his next encounter. He is the samurai swordsman. The image of this legendary warrior is also fostered in the modern practice of the martial arts of Japan, whose devotees model themselves upon him, seeing themselves as heirs to a great tradition. The martial arts may have been refined and modified in response to changing conditions, but they still enshrine the more subtle and esoteric traditions of the brave samurai swordsman.

In addition to the samurai heritage, the other theme that we will follow throughout these pages is the development of the martial arts themselves. Although the fighting arts of the samurai sword will be emphasized, other tech-niques of single combat, using bow, spear, and dagger, will be studied to see how their prominence changes through history, and to examine closely how these weapons were actually used in the time when skill meant survival, and failure, death.

This work is a revised version of an earlier book of mine, *The Lone Samurai and the Martial Arts*, which has been out of print for many years. The text has been thor-oughly reworked and augmented by many new illustra-tions. Much new material has become available since the late 1980s, and a whole new generation of scholars has been producing excellent work from primary sources, which has raised questions about many established notions about samurai warfare. For example, the calling out of pedigrees and the issuing of personal challenges in the heat of battle, often regarded as the stock in trade of the samurai, has been called into question. I also acknowl-edge the high-quality research into the structure and design of Japanese armor undertaken at the Royal Armouries, Leeds, by Ian Bottomley. I also wish to acknowledge the cooperation of the Maniwa Nen-ryū dōjō and other martial arts institutions in Japan.

—Stephen Turnbull

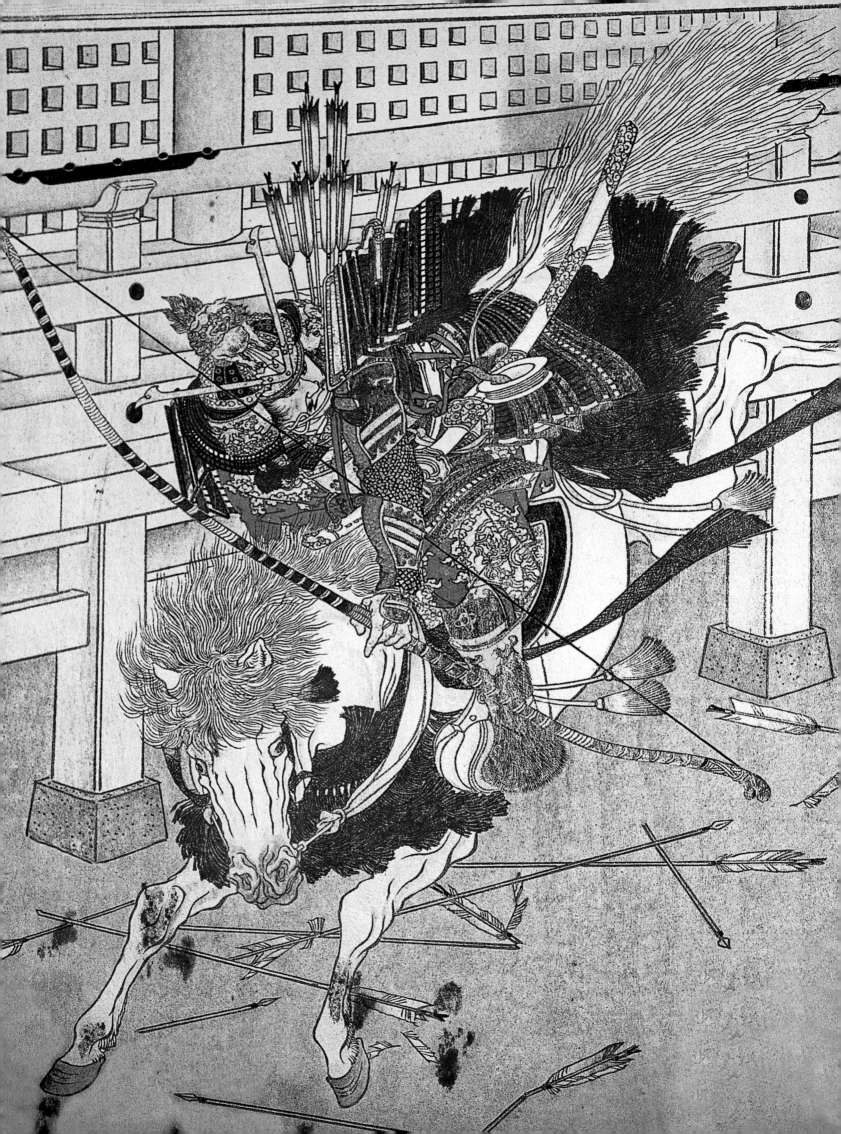

CHAPTER 1

SWORDS AND HEROES

The most enduring traditional image of the samurai is that of the lone wanderer, owing allegiance to none but himself, and relying for his continued survival on his skills with the sword. This is a powerful picture, and one that has tended to dominate the perception of the archetypal Japanese warrior. However, as the following pages will show, this image owes as much to the peaceful years of the Tokugawa period (1603–1867) as it does to the preceding years of war. It is also a far cry from the reality of the earliest samurai warriors, who were aristocratic mounted archers rather than swordsmen. These men relied far less on the sword than on the bow. Nor did they hold allegiance only to themselves. Instead, they were part of a vast web of dependent feudal links, with their ultimate loyalty being to the lords who led them into battle. Their fierce sense of pride and personal honor, and their individual prowess at the martial arts, were the only features they had in common with their later popular image. Yet their exploits with horse, bow, and sword set the standard by which future generations of samurai would be judged.

The Sword and the *Kami*

The first use of the word "samurai" dates back to the eighth century AD, but this was preceded by many centuries of myth, legend, and history. Japan's long military tradition, in fact, goes back over two millennia, and at the very beginning of time—according to the creation myths that explain the origins of the Japanese islands—we find the image of a weapon. This is the "Jewel-spear of Heaven" that Izanagi, the father of the *kami* (deities), plunges into the ocean, and from whose point drips water that coalesces into the land of Japan.[1] Later in the same work (the *Kojiki*, c. AD 712) we see a reference to the most enduring Japanese martial image of all, when Izanagi uses a sword to kill the fire god, whose birth has led to the death of his wife, Izanami.

Swords also played a part in the stories about the two surviving children of Izanagi: Susano-ō, the thunder god, and Amaterasu, the goddess of the sun. The *Kojiki* tells us how Susano-ō destroyed a monstrous serpent that was terrorizing the people. He began by getting it drunk on sake (rice wine) and then hewed off its heads and tail. But when he reached the tail, his blade struck something it could not penetrate, and Susano-ō discovered a sword hidden therein. As it was a very fine sword, he presented it to his sister, Amaterasu, and because the serpent's tail had been covered in black clouds, the sword was named *Ame no murakomo no tsurugi*, the Cloud Cluster Sword.[2] Amaterasu in turn gave the sword to her grandson, Ninigi, who was to descend from heaven and rule the earth. Ninigi eventually passed it on to his grandson Jimmu, identified as the first *tennō* (emperor) of Japan, whose traditional dates are 660–585 BC. Jimmu Tennō kept this sword as one of the "crown jewels" of the Japanese emperors.

The legendary Prince Yamato is the first of a long line of individual samurai swordsmen who meet a tragic death. In reality, Yamato is probably a composite character (*Yamato* is an early name for Japan), but the tales of his exploits give a fascinating insight into the attitudes of these early times.

Page 9: **Taira Shigehira, the classic samurai mounted archer.**

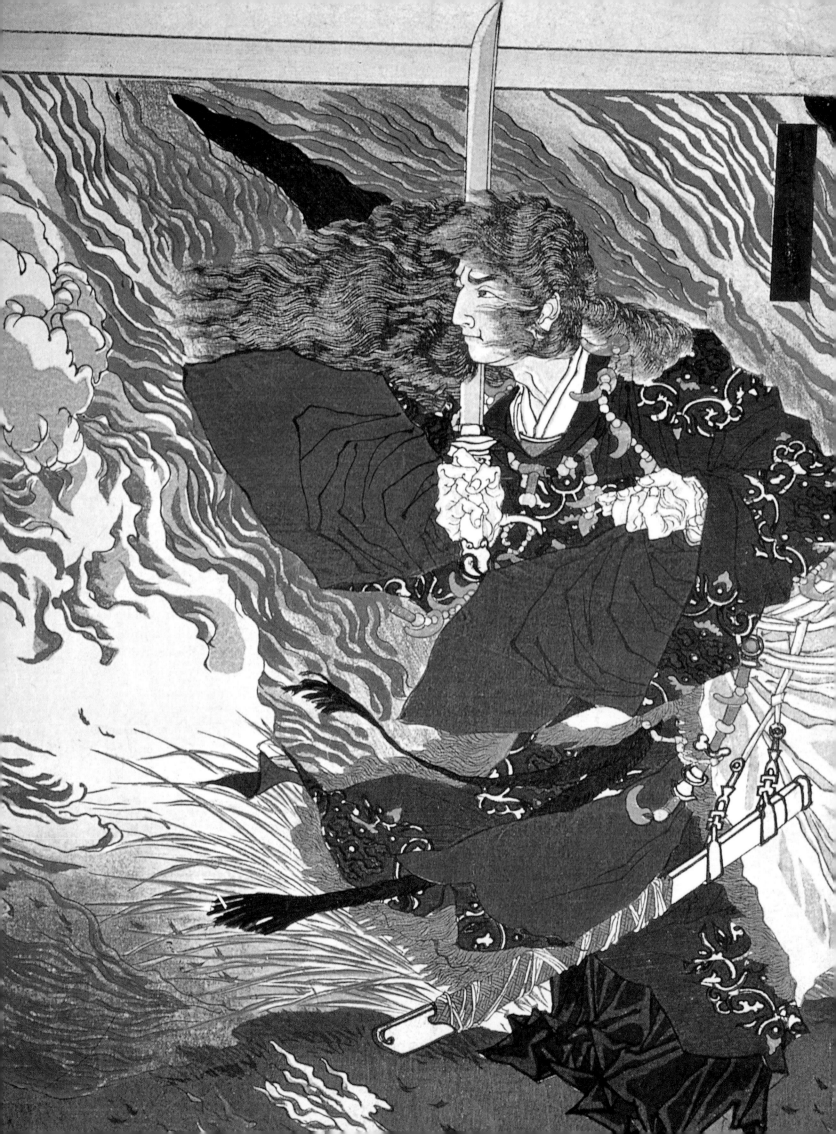

Historical figures blend with the characters of mythology in the other early chronicle, the *Nihon Shōki*, which gives us many details about the early emperors, including several individuals renowned for their prowess at the martial arts. But the character who can be regarded as the first of the long line of brave individual swordsmen is Prince Yamato. Yamatotakeru-no mikoto, to give him his full title, is probably a composite character (*Yamato* is an ancient name for the Japanese nation), because his heavenly exploits make a statement about the very earthly struggles that were then going on in Japan. The descendants of the "sun line" of emperors by no means ruled unopposed, and had to strive to assert the authority of their *uji* (clan) against challengers.

Prince Yamato was the third son of Emperor Keikō, and began his career inauspiciously when he murdered his elder brother. As a punishment, he was dispatched on a series of missions to quell rebels to the throne, thus bringing into the story some elements of the "wandering swordsman" image. Like the later stereotypes, Prince Yamato was forced to journey to a distant land where he could put his warrior skills to positive use by opposing the enemies to the imperial line. It is, however, fascinating to note that Yamato's first victory against a rebel chieftain was accomplished, not solely by the honorable use of a sword, but by employing skills that in later years would be considered techniques of *nin-jutsu*: the arts of stealth and invisibility. Yamato's trick consisted of disguising himself as a woman, with the Cloud Cluster Sword concealed beneath his robes. He joined in with the merrymaking at the rebel leader's banquet, and then at the right moment pounced on his victim.[3] Not long afterwards, another sword appears in a story, but once more it is involved in a trick. Prince Yamato fashioned an imitation sword out of wood, challenged his victim to a duel, and sportingly suggested that they should exchange swords for the fight. The outcome may be guessed at.[4]

So far, the legend of Prince Yamato also conforms to another alternative samurai stereotype: that of the warrior as a deceitful trickster—the genesis of the image of the ninja. However, the conclusion of the Yamato story places the hero in a much more acceptable light. Before setting off on his final campaign, Prince Yamato called in at the Great Shrine of Ise, where he was presented with the sword called Ame no murakumo: the Cloud Cluster Sword, which Susano-ō had wrested from the tail of the serpent. Armed with this miraculous weapon, the hero set about defeating the rebels.[5] The Cloud Cluster Sword also proved useful in an unconventional

Disguised as a woman, with the Cloud Cluster Sword concealed beneath his robes, Prince Yamato carried out an assassination. He joined in with the merrymaking at the rebel leader's banquet, and then at the right moment pounced on his victim.

way when Prince Yamato was invited to join in a stag hunt near Mount Fuji, and realized very quickly that he was to be the quarry. The hunters set fire to the long, dry grass, with the aim of either burning Yamato to death or driving him in confusion toward their ambush. The prince took the sword and cut his way through the burning grass to freedom, so that the Cloud Cluster Sword became known as Kusanagi, the "Grass-Mowing Sword." Here again is a powerful samurai image: that of the warrior slashing wildly about him with his sword. But a stranger enemy was lying in wait, in the shape of a huge serpent, which stung Yamato in the heel. This brought on a fever from which the prince died. The Yamato legend concludes with his death from the fever, after which he was transformed into a white bird.

It is interesting to follow the Yamato legend just a little further, because the sword Kusanagi was already revered as the sacred sword of Japan, and with a sacred mirror and a set of jewels was one of the three items of the imperial regalia. After Prince Yamato's adventures had finished, the Grass-Mowing Sword was placed in the Atsuta Shrine near modern Nagoya. In the appendix to the thirteenth-century epic the *Heike Monogatari*, known as *The Book of Swords*, the anonymous author recounts another legend associated with the sacred sword. It concerns an attempt to steal the sword, and brings in a further element of martial accomplishment, namely unarmed combat.

The thief was a Chinese priest called Dogyō, who came to worship at the Atsuta Shrine. He stayed for seven days, at the end of which he stole the sword, wrapping it in the folds of his *kesa*, the priest's wide, scarflike garment. But the Grass-Mowing Sword had a will of its own; it cut its way through the kesa and flew back to the shrine. Once more the priest took it, and wrapped it more securely, but again the sword made its escape. On his third attempt, Dogyō managed to wrap the sword in nine folds of cloth, which was apparently sufficient to prevent it from cutting its way through, and he got a considerable distance away from the shrine. At this point, the enraged spirit of Prince Yamato enters the story. He sent a fellow kami, Sumiyoshi Daimyōjin, to fight Dogyō for the sword. An interesting point about their subsequent combat is that the deity achieved victory by kicking the thief to death, an early example of *atemi*, the decisive striking techniques with fist or foot that have always been part of unarmed combat in Japan.[6]

The Rise of the Samurai

For Prince Yamato, or for the actual warriors whose exploits provide the basis for the Yamato legend, the word "samurai," which is often used to describe a Japanese fighting man at any period, did not in fact exist. Samurai means "one who serves," and although it first referred to domestic

servants, the word soon implied military service, provided for a powerful overlord or even the emperor of Japan. The very appearance of the word indicates the enormous change in the military and political life of Japan that had taken place since the days of the early emperors.

By the seventh century AD, the imperial system had evolved from a line of warrior chieftains, for whom martial prowess was a necessary fact of life, to a ruling house whose hegemony was largely accepted. The imperial lineage claimed to wield divine authority, through the emperor's descent from the sun goddess Amaterasu. At this time the greatest threat to the existence of the imperial line, and indeed of Japan itself, was perceived as being invasion from China. There was also the danger of the *emishi*, the tribes who lived in the north and east of Japan and were the last to accept the dominance of the Yamato line. To counter these threats, a conscript system was created. Theoretically, all adult males who were fit for military duty were liable for enlistment as *heishi* (soldiers). The resulting army, which spent much of its time on guard duty in remote areas of Japan, was heavily infantry-based, but backed up by mounted troops supplied by the wealthier landowners. These men were descended from the old provincial nobility, some of whom had once opposed the rise of the Yamato state. The creation of the conscript system shows both the resources possessed by the emperors and the authority they now wielded.

Military service was unpopular, but the arrangement sufficed for several decades until the threat from China began to fade during the eighth century. Security policies now had to concentrate on more mundane issues such as the capture of criminals and the suppression of bandits. The lengthy process of raising a conscript army was too cumbersome for dealing with such eventualities. What was needed was a rapid response force, primarily mounted, who could respond quickly when needed.

The gap was filled by hiring the forces of the old nobility, and this proved so successful that the use of conscripted troops rapidly diminished, and then was completely abandoned in AD 792.[7] The noble contribution had always been an elite force, the officer class in the conscript armies, largely privately funded and privately trained. The men who served in these elite forces were the first samurai, but it is important to realize that these samurai were still firmly under the control of the emperor, just as the conscripted peasants had been. The first samurai, who were virtually imperial mercenaries, may have constituted private armies, but they did not conduct private warfare.[8]

However, several factors would make their mark over the next three centuries to produce the spectacle of samurai fighting samurai in wars of their own, or in wars carried out only nominally in the name of the emperor. First, there

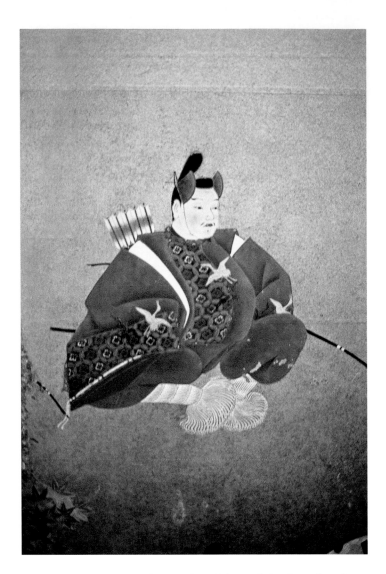

Prince Genji dressed in the fashion of the Heian period and carrying a bow.

was a succession of younger imperial princes leaving the capital and heading off for the "new frontiers" of Japan to serve their family's name and open up new territories. This may have widened the emperor's authority, but it also had the potential to weaken it by dispersal. Second, there was the domination of the imperial family by the Fujiwara clan, who supplied a seemingly endless line of imperial consorts, causing great jealousy among other powerful families, who felt squeezed out. Two in particular greatly resented the Fujiwara domination, the clans of Taira and Minamoto. Both these families had imperial blood in their veins, through intermarriage with some of the above-mentioned distant princes, and both had built up spheres of influence far from the capital. The Taira were based in the west, on the shores of the Inland Sea, and the Minamoto to the east and north.

The emperors had the occasional rebels against the throne to deal with, and the frontiers of the civilized imperial state were constantly being pushed out. Both these tasks were performed eagerly by the samurai of the Taira and

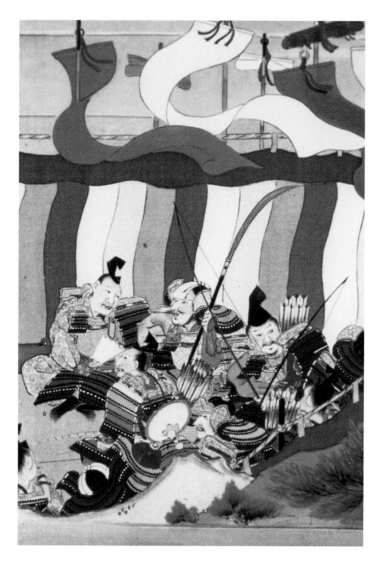

The *maku* (curtains) from which the term *bakufu* derives.

Taira Shigehira, the classic samurai mounted archer.

Minamoto, who grew rich on rewards for this service. They grew closer to the imperial court until, by a process of imperial matchmaking, Taira Kiyomori (1118–1181) held great influence at court by virtue of being the emperor's grandfather. So the center held, and the "sun line" survived, as it has to this day, as the oldest established ruling house in the world. In fact, it is somewhat surprising that the samurai clans did not assert themselves politically earlier than they did, but the bonds of imperial loyalty and the generosity of the rewards that the emperor bestowed were both considerable.[9]

But there was one other factor: the tendency that developed during the tenth century AD for an emperor to abdicate while still young and active, in favor of a child relative, thus freeing himself from the huge religious and ritual responsibility of kingship. The child emperor thus created was still honored, but was also extremely vulnerable to manipulation. No rebel in Japan would ever have sought to overthrow the emperor. Such a course of action was unthinkable, and was also totally unnecessary—the important thing was to control the emperor. It is the

attempts by the Taira and the Minamoto to control emperors, or at least to control their nominees for the post, that form the background to the civil wars that exploded during the twelfth century. Two skirmishes, the Hōgen and Heiji "disturbances," named for the years when they were fought (1156 and 1160 respectively), were the curtain raisers to a major war that lasted from 1180 to 1185. It was called the Gempei War, from the Chinese reading of the names of the warring clans, the Minamoto (Genji) and Taira (Heike).

The Hōgen Rebellion, however, was fought in 1156 by two coalitions of warrior houses that included Taira and Minamoto warriors on each side. The subsequent 1160 troubles saw the first direct Minamoto/Taira clash, and the brutal way by which Taira Kiyomori, who had supplanted the Fujiwara in imperial favor, did away with his Minamoto rivals sowed the seeds of the major war that began in 1180. After some initial success by the Taira, their samurai were swept aside in a series of brilliant battles fought by the general Minamoto Yoshitsune, whose victories at Ichinotani (1184), Yashima (1184), and Dannoura (1185) enabled his

elder brother Yoritomo to become military dictator.

Yoritomo took a title that is almost as familiar as samurai when he became Japan's first shogun. The government of Japan thus passed from the system of abdicated emperors and imperial grandfathers to the newly created *bakufu*, or shogunate, which was based far from imperial Kyoto, in Kamakura. The term *bakufu* proclaimed its military origins, because it meant government from "behind the curtain" of the *maku*, the heavy ornamental curtains that marked a commander's post on the battlefield. This set a pattern whereby Japan was to be dominated by the rule of the samurai for eight hundred years, although there was a brief early attempt at imperial restoration in 1221. Accounts of the fighting in this rebellion, the Shōkyū War, are included in the extracts that follow.

Before studying written accounts of samurai combat in this period, let us first examine the context in which such encounters were fought. The first point to note is that these contests were fought between men who were members of an elite: a status that depended as much on their ancestry as on their martial prowess. Martial skills, however, could sometimes compensate for being comparatively lowly born, as indicated by a story in the twelfth-century *Konjaku Monogatari*, which grudgingly praises a certain warrior in the following terms:

This Noble Yasumasa was not a warrior inheriting the tradition of a military house. He was the son of a man called Munetada. However, he was not in the slightest degree inferior to such a warrior. He was bold in spirit, skilled with his hands and great in strength.[10]

The elite nature of the samurai is an important factor to remember when considering the historical sources for the period. Some, like the important *Azuma Kagami*, are in the form of diaries or official chronicles, but others are more like heroic epics, written for an aristocratic public who wished to read of the deeds of their own class, and preferably their own family's ancestors. So, for example, the hundreds of foot soldiers who accompanied the samurai into battle are almost totally ignored. For this reason, these *gunkimono* (war tales) have to be treated with considerable caution as historical records. They are, however, invaluable for the light they shed on samurai values and beliefs, and in particular the ideals the samurai cherished about how they should behave in action.[11] Much of the description is concerned with the samurai acting as an individual and aristocratic lone warrior, whose brave deeds in single combat contribute to the overall victory. As will be explained below, this is a misleading construction, but it can provide very valuable information about the practice of the martial arts because the mode of combat and the use of various weapons are described within a framework of sound knowledge of the technical limitations of the arms and armor of the period.

Several of the most important gunkimono have been translated fully or partially into English. The earliest of the genre, the *Shōmonki*, which deals with the rebellion of Taira Masakado, was written about the year AD 954, and contains valuable early descriptions of combat.[12] The *Konjaku Monogatari*, which also includes Taira Masakado among its wide-ranging subject matter, has several sections of great interest, some of which are used here.[13] *Hōgen Monogatari* contains vivid descriptions of the brief fighting of the 1156 rebellion.[14] The later gunkimono, such as the well-known *Heike Monogatari*, are much less reliable in their descriptions of combat, and can indeed be very misleading. Karl Friday, in particular, has drawn attention to the deficiencies in *Heike Monogatari*, which is a work of polemics that achieved its present form as late as 1371. Among its stereotypes is an entirely fictitious contrast between the Minamoto as rough and ready warriors from the east, and the Taira as refined imperial courtiers.[15]

Samurai Arms and Armor

The samurai were fully armored and went into battle mounted on horses. By the twelfth century, the samurai wore armor of a characteristic design that was to have an

important influence on the martial arts. It was made from small scales tied together and lacquered, then combined into armor plates by binding them together with silk or leather cords. A suit of armor made entirely from iron scales would have been prohibitively heavy, so a mixture of iron and leather scales was used, with iron predominating to protect the most vulnerable areas of the samurai's body. This classic "samurai armor" was therefore of lamellar construction (armor made from small plates fastened together), the traditional defensive armor of Asia, rather than the plate and mail of European knights.[16]

The standard suit of armor of the classical samurai of the Gempei War was known as the *yoroi*. The body of the armor, the *dō*, was divided into four parts, giving the yoroi a characteristic boxlike appearance. Two large shoulder plates, the *sode*, were fastened at the rear of the armor by a large ornamental bow called the *agemaki*. The agemaki allowed the arms fairly free movement, while keeping the body always covered, because the samurai did not use shields. Two guards were attached to the shoulder straps to prevent the tying cords from being cut, and a sheet of ornamented leather was fastened across the front to stop the bowstring from catching on any projection.

The iron helmet bowl was commonly of eight to twelve plates, fastened together with large projecting conical rivets, and the neck was protected with a heavy, five-piece *shikoro*, or neck guard, which hung from the bowl. The top four plates were folded back at the front to form the *fukigayeshi*, which stopped downward cuts aimed at the horizontal lacing of the shikoro. The samurai's pigtail of hair was allowed to pass through the *tehen*, the hole in the center of the helmet's crown, where the plates met, either with or without a hat to cover it, which would give some extra protection. No armor was worn on the right arm, to leave the arm free for drawing the bow, but a *kote*, a simple baglike sleeve with sewn-on plates, was worn on the left. This completed the costume of the samurai which had one overriding purpose: to provide the maximum protection for a man who was a mounted archer. This role was so important that the samurai referred to their calling as *kyūba no michi*, or "the way of horse and bow."

The design of the traditional Japanese bow that the samurai wielded from his horse is still used today in the martial art of *kyūdō*. The bow was a longbow constructed from laminations of wood and bound with rattan. The arrow was loosed from about a third of the way up the length of the bow. A high level of accuracy resulted from hours of practice on ranges where the arrows were discharged at small wooden targets, from the back of a galloping horse. This became the traditional art of *yabusame*, which is still performed at festivals, notably in the city of Kamakura and the Tōshōgu Shrine in Nikkō. The archer, dressed nowadays in traditional hunting gear, discharges the bow at right angles to his direction of movement.

The Way of Horse and Bow

In ancient times, horses had been known only as beasts of burden, and the Japanese first came across war-horses during one of their early expeditions in Korea. During the first five centuries of the Christian era, Korea was ruled by the three rival kingdoms of Koguryo, Silla, and Paekche. Kinship ties with Paekche meant that this was a conflict in which Japan

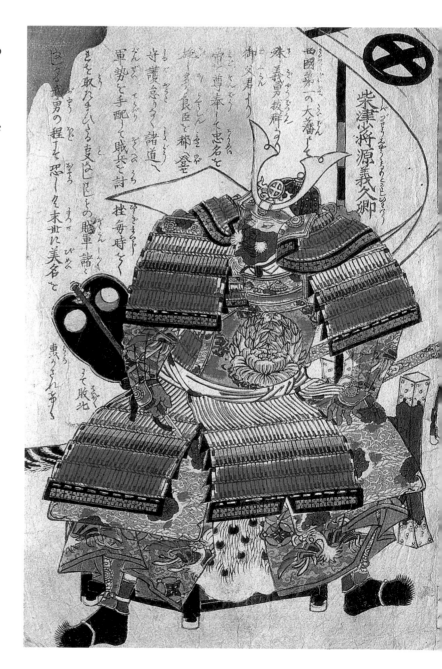

Opposite: **An excavated *tanko*, the early style of plate armor worn during the Nara Period.**

Right: **Shimazu Yoshihisa of Satsuma (1533–1611), dressed in full armor.**

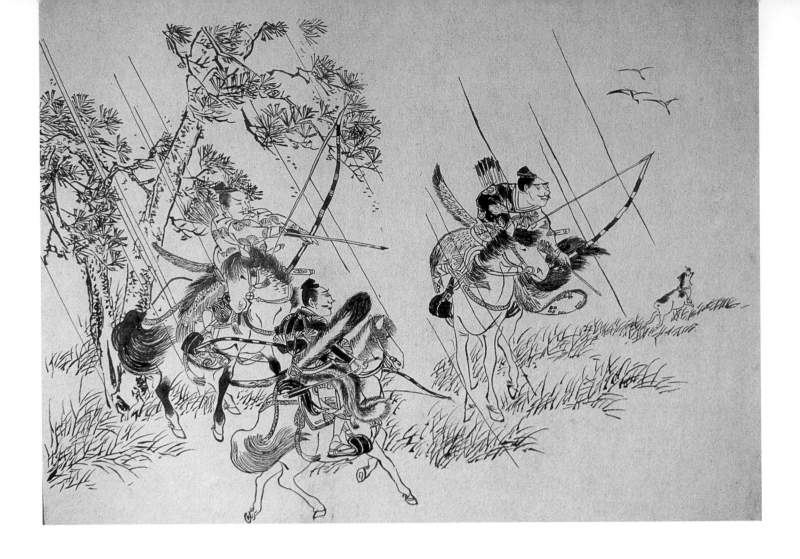

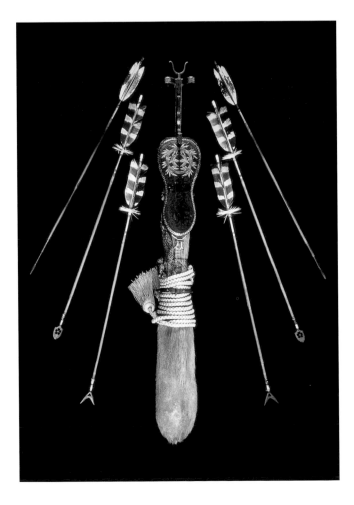

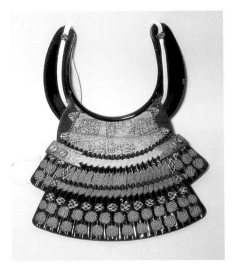

Above: A hunting party, one of the best ways of training a mounted archer.

Far Left: A fur covered quiver and a selection of arrows.

Left: A face mask, complete with moustache.

Below Left: A *nodowa*, giving protection of the throat.

Right: One of the most celebrated demonstrations of skill given by a mounted archer occurred at the Battle of Yashima in 1184. The Taira fastened a fan to the mast of one of their ships and challenged the Minamoto to bring it down. This drawing by Hokusai shows the young Nasu no Yoichi earning great glory for himself by hitting the fan with his first arrow, which greatly enhanced the morale of the Minamoto.

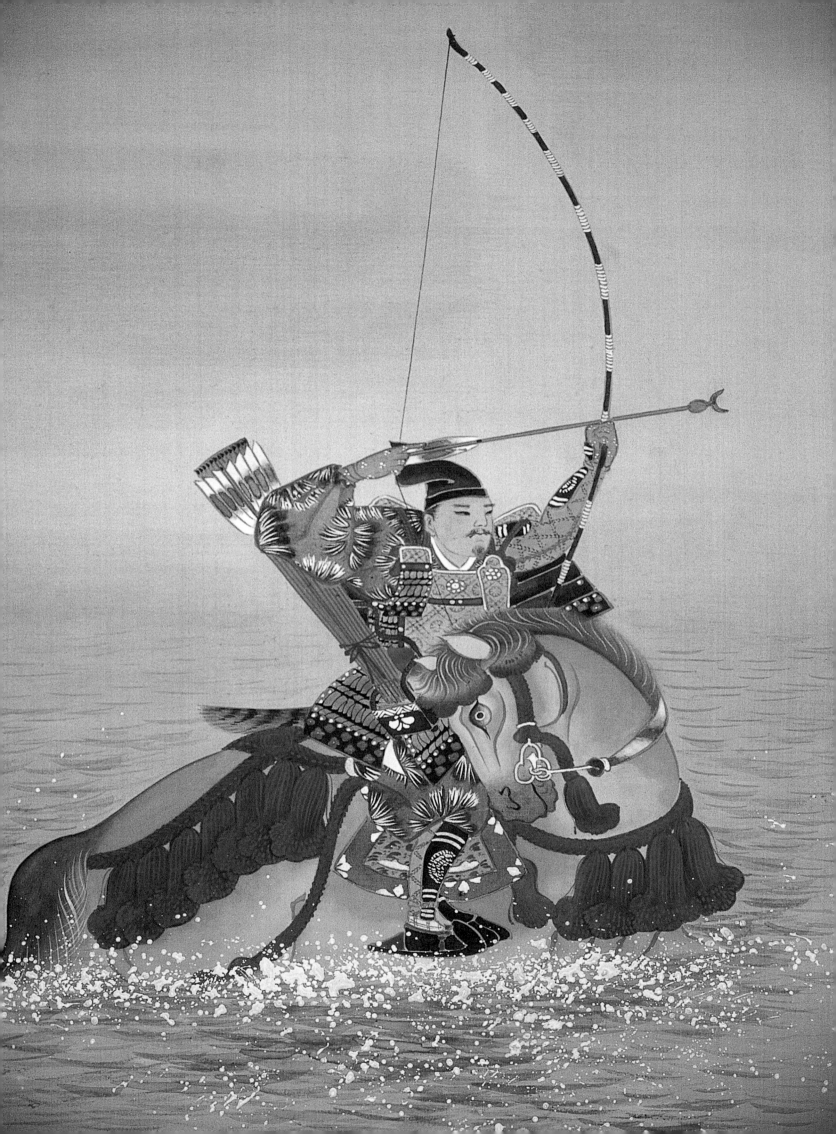

inevitably became involved, and in about AD 400 a Japanese army, sent to support Paekche and composed entirely of foot soldiers, was heavily defeated in battle by a Koguryo army riding horses. This battle was Japan's first encounter with cavalry, and there is archaeological evidence that horses were being ridden in Japan within a century of this event. The plains of eastern Japan proved to be ideal ground for horse breeding and pasturing, and as riding skills developed, so did the notion of cavalry warfare, with mounted archery coming to be the preferred technique. In 553, Paekche once again sought Japanese help, and this time asked specifically for a large supply of bows and horses, thus indicating that the combination of horsemanship and archery was now firmly established in Japan. There are further references to the deployment of mounted archers in AD 672, when the brother of the late Emperor Tenchi asserted his claim to the throne in a bold revolt against his usurping nephew, and used the powerful striking force of a squad of mounted archers.

Samurai mounted combat, single or in the form of a pitched battle, began with the bow, and usually ended with it. Accounts of sword fighting between samurai, or

even hand-to-hand grappling with dagger or bare hands, are quite clearly descriptions of what happened at the end of an encounter if, and only if, the mounted samurai had lost the use of his bow, or horse, or both. Otherwise, a fight between mounted samurai would be decided by bow and arrow. The following account from *Konjaku Monogatari* is probably the best of the genre:

> Then fitting arrows with forked heads to their bows, they urged their horses toward each other, and each let off his first arrow at the other. Intending that his next arrow would hit his rival without fail, each drew his bow and released the arrow as he galloped past. Then they drew up their horses and turned; again drawing their bows they galloped by but did not shoot off their arrows. When they had both passed again, they pulled up, turned, drew their bows and aimed.[17]

This example is somewhat unusual in that it took the form of a personal duel between two opponents, but it nevertheless illustrates the technique of one-to-one mounted archery—a skill so highly prized that it could be applauded in an enemy. There is an interesting account in this vein in *Heike Monogatari* of what happened during the Battle of Yashima in 1184. The Taira fought from a rear defensive line of ships anchored in Yashima Bay. Towards evening, when the fighting was at a lull, they hung a fan from the mast of one of their ships and invited the Minamoto to shoot it down, hoping thereby to persuade one of their finest archers to waste precious arrows, along with being disgraced by his failure. But young Nasu no Yoichi hit the fan with his first arrow, even though he was on horseback in the water, and the boat he was aiming at was bobbing up and down. This achievement was an excellent morale booster for the Minamoto, but it is also interesting to note what happened immediately afterwards. As men who valued good archery, the Taira samurai appreciated the feat, and one of them started dancing on the boat in his enthusiasm. At the urging of one of his superiors, Nasu no Yoichi took another arrow and shot the celebrant dead. This act was not at all approved of by the Taira, who regarded it as both cruel and unnecessary.[18]

The gunkimono relate many incidents of skill with the bow and arrow during actual fighting. A notable example is the archer Minamoto Tametomo, who fought during the

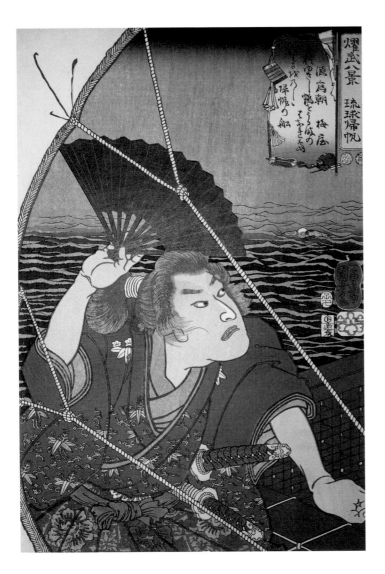

Left: **Minamoto Tametomo, the great archer, is exiled following his defeat in battle.**

Right: **The archer Minamoto Tametomo, who fought during the attack on the Shirakawa Palace in the Hōgen Incident of 1156, was renowned both for his skill and for his immense strength. In this print, we see him on his island of exile, but his bow is still ready for action.**

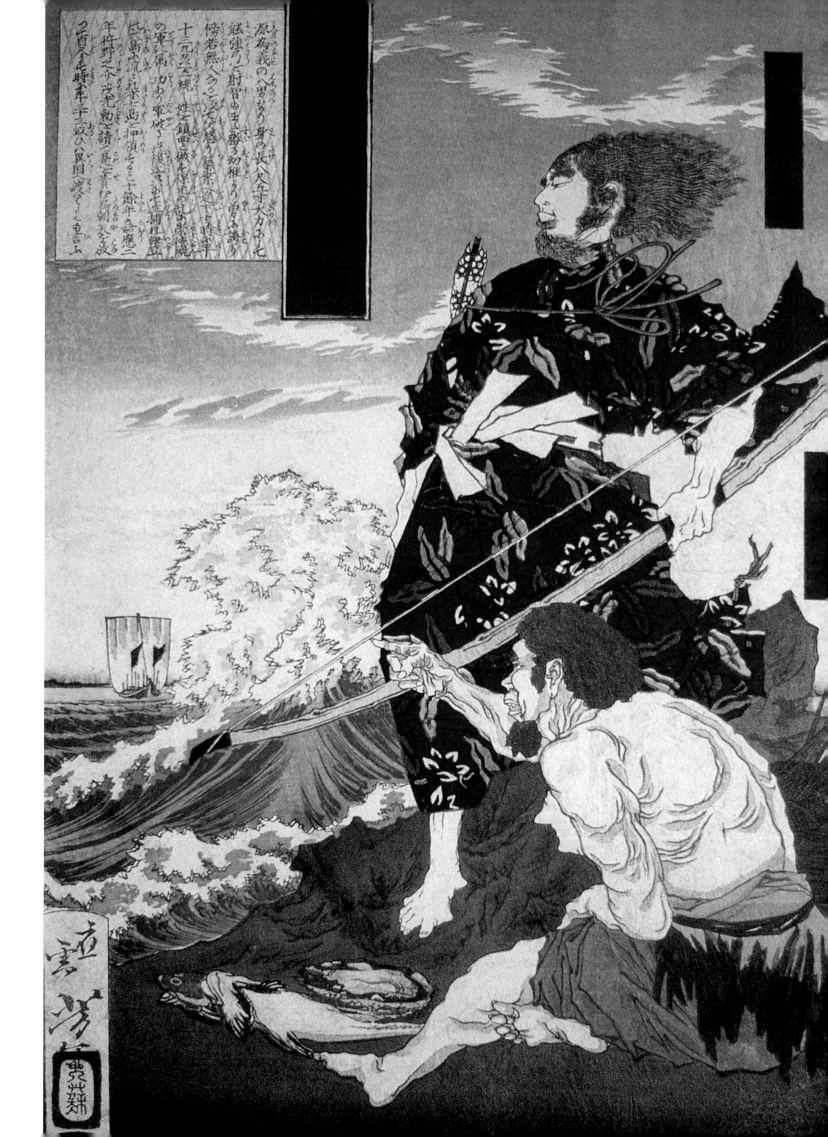

attack on the Shirakawa Palace in the Hōgen Rebellion of 1156. He was renowned both for his skill and for his immense strength, and shot many arrows clean through saddles, horses, and his opponents, as the *Hōgen Monogatari* tells us:

> Pausing a moment, he let it off whistling. Piercing unchecked the breastplate of Itō Roku who was in the lead, the arrow passed on the other side through the left sleeve of Itō Go and stuck in the lining of his armour. Rokurō fell dead on the spot.[19]

Later in the same action:

> His first arrow having missed, Koreyuki was fitting the second to his string when Tametomo drew his bow to the full and fired with a whiz. The shot went through from the front bow of Yamada Kosaburō's saddle, passing through the armour skirts and hitting the rear bow, and the point stuck out more than three inches on the other side. For a moment he seemed to be staying in the saddle, held up by the arrow. Then when he fell headlong to the left, the arrowhead remained in the saddle, and the horse galloped towards the riverbed.[20]

Minamoto Tametomo is also credited with using a bow and arrow to sink a ship full of Taira samurai, as a gesture of defiance, immediately before he committed suicide. The massive arrowhead struck the overloaded boat just above the waterline and split the planking![21]

The Samurai Battle

A samurai battle would traditionally begin by the firing of signal arrows high into the air over the enemy lines. Each signal arrow had a large, bulblike, perforated wooden head that whistled as it flew through the air. The sound was a call to the kami, to draw their attention to the great deeds of bravery that were about to be performed by rival warriors. The two armies would then clash, and it is concerning this phase of a battle that the gunkimono can be most misleading. *Heike Monogatari* gives the impression that what followed was a series of almost exclusively individual combats between worthy opponents, who sought each other out by issuing a verbal challenge that involved reciting one's exploits and pedigree. The challenge would be answered from within the opposing army, providing a recognized mechanism whereby only worthy opponents would meet in combat. This process, the stock in trade of the traditional samurai image, has recently been discussed critically and convincingly by Karl Friday.[22] Leaving aside the obvious difficulties of being able to conduct verbal negotiations among the din of battle, there are in fact very few examples in the gunkimono where elaborate declarations are recorded. Instead, a more likely scenario is that samurai, when entering a battle situation, shouted out their names as war cries. Also, as Friday cleverly points out, "in any given pairing of warriors, one of the challengers would always have been a worthwhile adversary for the other," and would be most unlikely to let the occasion pass if the other disdained his challenge! He concludes by suggesting that name calling and pedigree recitations were general, rather than specific challenges.[23]

The recital of pedigrees is only one aspect of samurai combat that had a ritualized form, which again has led to the misunderstanding that battles themselves were largely ritualistic affairs: mock battles where honor could be satisfied without actually killing anyone. In fact there is only one encounter in *Heike Monogatari* that can be regarded as a ritualized battle, and this is the archery duel, and the series of challenges that followed it, at the Battle of Kurikara (also

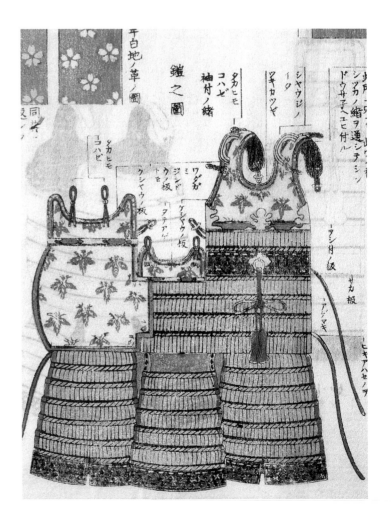

Right: **A suit of armor opened out flat, from a military manual.**

Far Right: **Taira Tomomori, defeated at the battle of Dannoura in 1185, prepares to drown himself, tied to a massive anchor.**

known as the Battle of Tonamiyama) in 1183, but on this occasion the madness had method in it. Minamoto Yoshinaka planned to divide his forces and surround the Taira army, but how was he to cover these movements and hold the Taira in position? His solution was to conceal his maneuvers by fighting a battle, but a battle so formal and so stylized that there would be no risk of his side being defeated. Nor would there be any opportunity for the Taira to realize that the whole purpose was to confine them to this small area until night fell. The trick worked, and the Taira samurai gave it their full concentration, hoping thereby to earn a name for themselves in the epic poetry that would be written about the event in the future. As *Heike Monogatari* relates, the Minamoto "purposely avoided a decision."[24]

The cruel reality of samurai warfare could not have been further from the notion of battle as a ritualized set piece. Yoshinaka's illustrious predecessor Minamoto Tametomo believed that surprise was essential to victory, particularly when fire was involved:

Whether to break strong positions though surrounded by the enemy, or to destroy the enemy when attacking a

fortified place, in any case there is nothing equal to night attack to achieve victory. Therefore if we bear down on the Takamatsu Palace immediately, set fire to it on three sides and hold them in check on the fourth side, those who escape fire cannot escape arrows, and those who escape arrows cannot escape fire.[25]

Konjaku Monogatari shows one encounter beginning with clear enthusiasm for the element of surprise that the situation offered:

As he advanced Yogo had a man sent ahead with orders to search out carefully where Sawamata was and report back. The scout came running back and said, "They are in a meadow with a marsh on the south face of that hill over there. They've been eating and drinking sake; some are lying down, and some seem to be sick." Yogo was delighted to hear this and he commanded his men, "Just hit them fast."[26]

In the *Azuma Kagami*, the sequence of events in a battle may be traced in all its savagery and confusion, from the use of deception at the start:

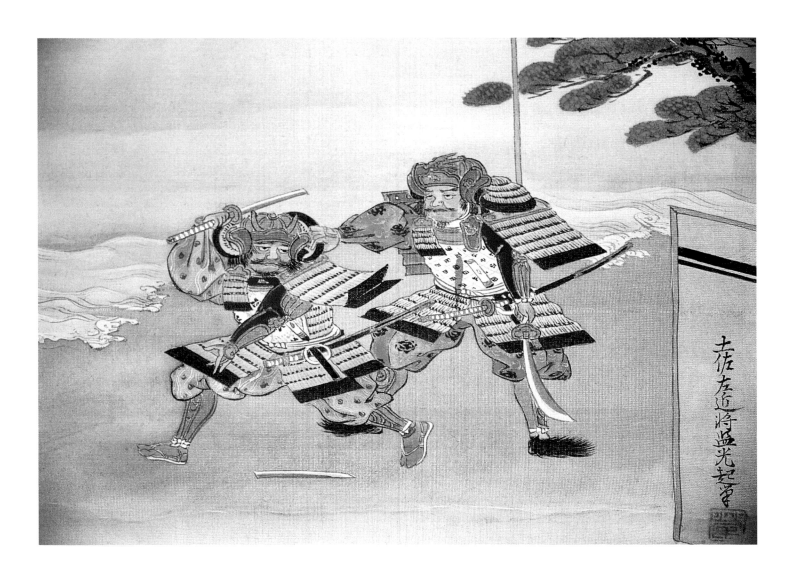

Tomomasa's men, who had climbed the trees at Todorokizawa and at Jigokutani, emitted battle cries according to a prearranged plan. The cries reverberated through the ravine, giving the impression of a huge force. In his astonishment and confusion Yoshihiro was attacked by Tomomasa's followers. . . . At the time strong winds blowing from the southeast raised a cloud of dust from the burning fields and obscured the vision of men and horses, causing many to break ranks and lose their footing.[27]

The Sword in Combat

If a samurai had run out of arrows, or had otherwise lost the use of his bow, he would have to use cutting weapons, the best known of which, of course, was the famous "samurai sword." The word usually used for the long sword carried by samurai in this early period is *tachi*. This was the samurai's principal side arm. The other edged weapon that the samurai would carry was a sword with a much shorter blade, and the meticulous research of Karl Friday has shown that the names given to this weapon vary through history.[28] What we see being worn on picture scrolls such as *Heiji Monogatari Emaki* are the tachi, which is slung from a separate sword belt with the cutting edge downwards, and the shorter weapon, which is stuck through the wide sashlike belt around the waist of the armor. Although it is frequently referred to as a *tantō* (dagger), Friday points out that this word is of much later origin. In translations of *Heike Monogatari* such as those quoted below, the shorter edged weapon usually appears as "dagger"—a convention I have retained for clarity. Contemporary names for this second weapon include *katana*—the word used later in history for the standard fighting sword—and *koshigatana*, the prefix *koshi-* meaning "the hips." The tachi would be used for sword fighting, and when its use is described in the chronicles and the gunkimono, we note the use of verbs such as "cut" and "strike," while the katana is used to "stab" and "thrust."

There was, however, another type of sword coming into use, called an *uchi-gatana*. This was like a short tachi or a very long katana, and it was carried in the same way as the katana: that is, thrust through the belt. Originally used by warriors too poor to afford a tachi, it was eventually to supplant the tachi as the weapon of choice, as its size and position enabled the wearer to make a devastating stroke straight from the scabbard. With its name shortened to katana, it became the most familiar form of samurai sword. Some uchi-katana were in fact shortened tachi.[29]

However, as was implied by the phrase *kyūba no michi*, a samurai's worth was measured in terms of his prowess with the bow, rather than the sword. Now, to the modern mind, the ideas of a samurai and of a sword are almost inseparable. The sword has acquired a quasi-religious, almost mystical, symbolism, and is wielded in a way that often appears to be a combination of superhuman skill and technical perfection. But between the tenth and twelfth centuries, all the traditions to be associated with the Japanese sword lay in the future, including that of the invincible swordsman. One incident in particular, described in *Heike Monogatari*, in fact describes the complete antithesis to the "super-swordsman." Mionoya Jūrō of Musashi has had his horse shot from under him during the Battle of Yashima in 1184:

The rider at once threw his left leg over the animal and vaulted down to the right, drawing his sword to continue the fight, but when he saw the warrior behind the shield

Left: **The complete antithesis to the "super-swordsman" is Mionoya Jūrō of Musashi. He had his horse shot from under him during the Battle of Yashima in 1184. He was attacked by a samurai with a *naginata*, who grabbed him by the neckpiece of his helmet. When the lacing tore apart, Mionoya escaped.**

Right: **Two competing samurai could really only engage in swordplay when they had dismounted. Here, one samurai appears to have been unhorsed by a *kumade* (a rakelike polearm), which now is broken.**

come to meet him flourishing a huge halberd, he knew that his own small sword would be useless, and blew on a conch and retreated.[30]

The story then diverges even further from the traditional samurai image:

The other immediately followed him, and it looked as though he would cut him down with his halberd, but instead of doing so, gripping the halberd under his left arm, he tried to seize Mionoya no Jūrō by the neckpiece of his helmet with his right. Three times Mionoya eluded his grasp, but at the fourth attempt his opponent held on. For a moment he could do nothing, but then, giving a sudden violent wrench, the neckpiece parted where it joined the helmet, and Mionoya escaped and hid behind his four companions to recover his breath.[31]

The "halberd" in the above account refers to a weapon known as a *naginata*, which had a long shaft, oval in cross section, and a curved blade. This gave a samurai a longer reach than a sword, but whatever the quality of his cutting weapons, the skill he showed with a bow was unquestion-ably the samurai's most prized accomplishment. At the Battle of Yashima in 1184, the Minamoto commander, Yoshitsune, accidentally dropped his bow into the sea, and put himself at some personal risk in his efforts to retrieve it. When his older retainers reproached him, he replied:

It was not that I grudged the bow . . . and if the bow were one that required two or three men to bend it, like that of my uncle Tametomo, they would be quite welcome to it, but I should not like a weak one like mine to fall into the hands of the enemy for them to laugh at it.[32]

Yoshitsune clearly felt that his reputation as an archer, and therefore as a samurai, would be undermined if his enemies realized that he lacked the physical strength to draw a large bow. But this feeling that the sword was as nothing compared to the bow was not confined to the battlefield, and a passage in *Konjaku Monogatari* provides the most surprising anecdote for anyone brought up with the tradition of the invincible samurai swordsman. One night, robbers attacked a certain Tachibana Norimitsu while he was on his way to visit a female acquaintance. He was armed only with a sword:

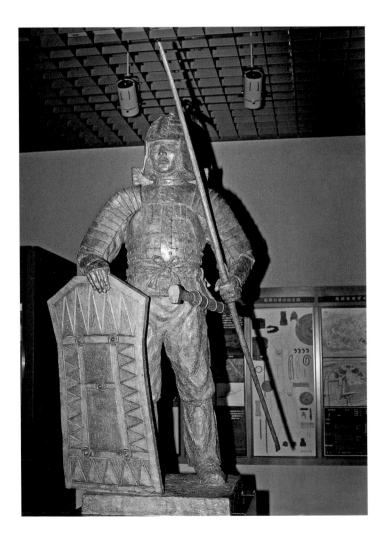

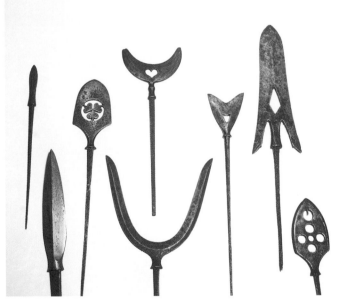

Left: A statue of a warrior dressed in a *tanko* armor of about AD 700.

Above: A selection of arrowheads.

Top right: The two monk heroes of the Battle of Uji in 1180. They are fighting with sword and *naginata* across the broken beams of the bridge.

Far right: Sato Tsuginobu, one of the loyal followers of Minamoto Yoshitsune, fighting in the snow with a drawn sword.

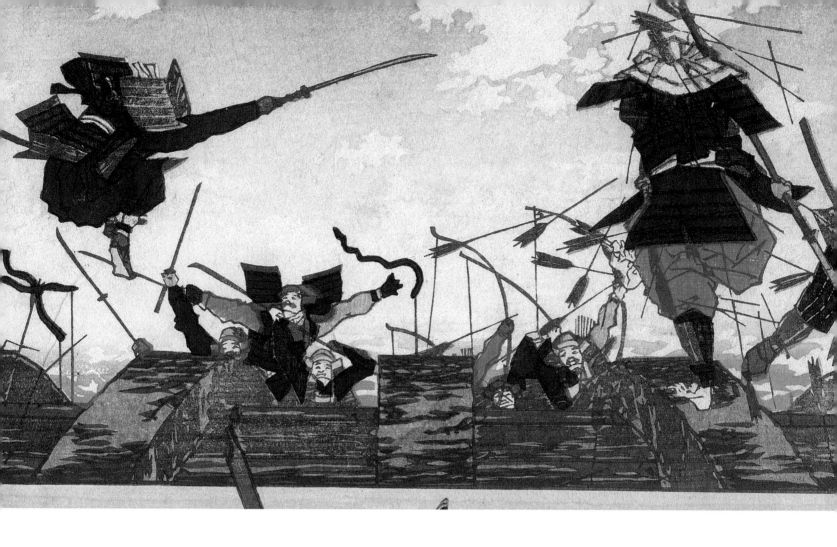

Norimitsu crouched down and looked around, but as he could not see any sign of a bow, but only a great glittering sword, he thought with relief, "It's not a bow at any rate."[33]

He did in fact vanquish the robbers, but his evident relief that he was not up against anyone armed with a bow is very telling. Common sense, after all, states that a bow gave a skilled archer (as all samurai were trained to be) a considerable advantage over a swordsman, who could be shot or incapacitated long before he came within striking distance.

In addition to the absence of a sword mystique in the gunkimono, there is also an apparent absence of sword technique, with a shortage of references to anything resembling proper swordplay, either from the saddle or on foot. There is in fact only one incident in *Heike Monogatari* that suggests mounted sword combat, when two comrades support each other as they lead an assault on the Taira fortress of Ichinotani in 1184:

Kumagai and Hirayama both bore themselves most valiantly, one charging forward when the other gave back, and neither yielding to the other in strength and boldness, hewing at the foe with loud shouts while the sparks flew from their weapons.[34]

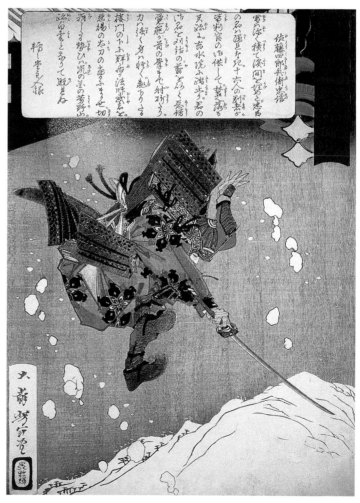

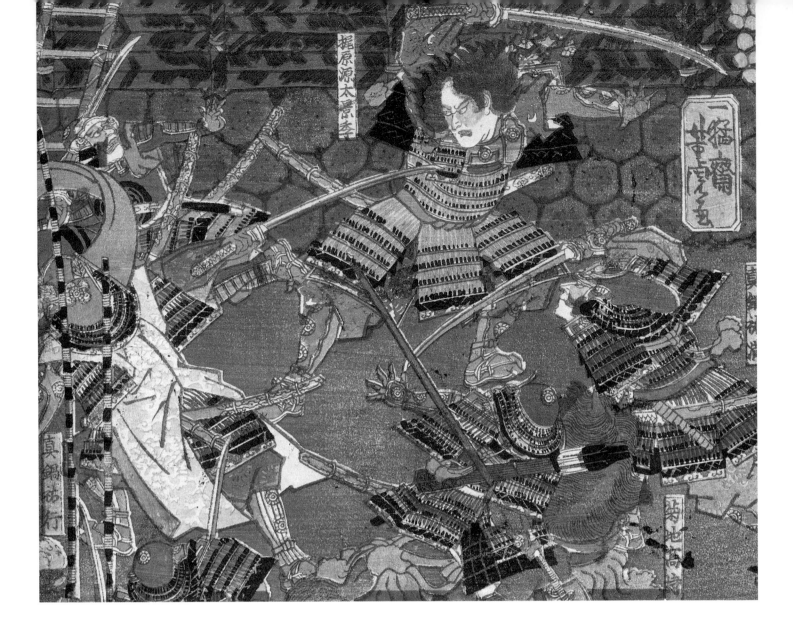

This passage is very ambiguous, however, because the account goes on to say that Kumagai's horse had been shot in the belly. He dismounted and stood leaning on his bow, which would have been an unusual thing to do if he had discarded his bow for a swordfight. He then began to pull arrows out of his armor, indicating that arrowheads caused the "sparks" that flew off the two opponents, not sword blades. A samurai who had lost his horse would still prefer to use his bow, as long as he had arrows left. Only when he had no more arrows would he move on to using his sword. At the Battle of Shinohara in 1183:

Arikuni, having penetrated very deeply into the ranks of the foe, had his horse shot from under him, and then while he was fighting on foot, his helmet was struck from his head, so that he looked like a youth fighting with his long hair streaming in all directions. By this time his arrows were exhausted, so he drew his sword and laid about him mightily, until, pierced by seven or eight shafts, he met his death still on his feet and glaring at his enemies.[35]

The unusual situation of a battle fought completely dismounted is illustrated by the Battle of Mizushima (1183), which was fought from on board ship, and again we see a preference for the bow. The Taira had tied their ships together and created a flat surface using planking, but even though their horses had been left on land, the battle began with bows, which continued "until they came to close quarters, when they drew their swords and engaged each other hand to hand."[36] A samurai was therefore most unlikely to voluntarily abandon his bow for a sword, particularly when his enemy still had the use of a bow, as is perfectly illustrated in *Azuma Kagami*. In 1180 the Minamoto under Yoritomo were fighting Oba Kagechika:

When they encountered Kagehisa at Hashida Mountain, they turned their horses and attacked him. Caught without

Above: **When not mounted on his horse, the samurai could wield his sword more freely, though he was still encumbered somewhat by the design of the *yoroi* armor. In this illustration to *Heike Monogatari*, we see Kajiwara Genda, whose horse has been shot from under him, fighting on foot with his helmet struck from his head and his long hair flying in the wind.**

bowstrings and forced to use their long swords, Kagehisa and his men could not defend themselves adequately against the arrows and the stones, and many of them were struck. Although Yasuda's men could not escape the enemy swords entirely, nevertheless, Kagehisa pocketed his pride and quietly took flight.[37]

On rare occasions, a brave samurai might approach an opponent with sword drawn, hoping, no doubt, that the demands of samurai honor would cause his enemy to hesitate to put an arrow into him. An example of this appears in *Azuma Kagami*:

Then Takatsuna moved up to the edge of the courtyard and released an arrow. This was the moment of the beginning of the Minamoto war against the Taira. A bright moon above made the night as bright as midday. Nobutō's followers, seeing Takatsuna's challenge, shot their arrows at him, while Nobutō, his long sword in hand, went forth round toward the southwest to confront Takatsuna. The latter discarded his bow, grasped his long sword, and facing his adversary to the northeast, engaged him in combat. Both excelled in bravery, but Takatsuna was struck by an arrow.[38]

So Takatsuna respects Nobutō's unusual approach, but his more conventional comrades do not, with fatal results. The most famous example of a warrior armed with a cutting weapon taking on bows and arrows occurs in the *Heike Monogatari* account of the Battle of Uji in 1180. The retreating Minamoto army, accompanied by their monk allies, had torn up the planking on the bridge over the Uji River to delay pursuit by the Taira, and had taken their stand on the far bank of the river. One group of mounted Taira samurai charged out of the morning mist and went straight through the hole on the bridge, but then the fight began with a series of arrow duels and individual combats across the broken beams. Tajima, who was a *sōhei* (warrior monk) from the temple of Miidera, was one of those who mounted the bridge. He used his naginata (the sōhei's traditional weapon) in a very unusual way:

Then Gochin-no-Tajima, throwing away the sheath of his long naginata, strode forth alone on to the bridge, whereupon the Heike straightaway shot at him fast and furious. Tajima, not at all perturbed, ducking to avoid the higher ones and leaping up over those that flew low, cut through those that flew straight with his whirring naginata, so that even the enemy looked on in admiration. Thus it was that he was dubbed "Tajima the arrow-cutter."[39]

We may assume that the whirling of the naginata was designed to put the Taira archers off their concentration, rather than represent any serious attempt to deflect arrows. (An illustration of a monk whirling a naginata to this purpose appears on the picture scroll called the *Ishiyamadera emaki*). We may also reasonably assume that by the time Tajima mounted the bridge to perform his strange feat, he had exhausted his own supply of arrows, because he was followed onto the broken structure by his comrade Tsutsui Jōmyō Meishū, who ran through the whole repertoire of samurai weaponry before retiring:

And loosing off his twenty-four arrows like lightning flashes he slew twelve of the Heike soldiers and wounded eleven more. One arrow yet remained in his quiver, but flinging away his bow, he stripped off his quiver and threw that after it, cast off his foot gear, and springing barefoot on to the beams of the bridge, he strode across. . . . With his naginata he mows down five of the enemy, but with the sixth the halberd snaps asunder in the midst and flinging it away he draws his tachi, and wielding it in the zig-zag style, the interlacing, cross, reverse dragonfly, waterwheel and eight sides at once styles of fencing, and cutting down eight men; but as he brought down the ninth with an exceeding mighty blow on the helmet the blade snapped at the hilt and fell splash into the water beneath. Then seizing the dagger which was his only weapon left he plied it as one in the death fury.[41]

When Jōmyō finally rested after his exertions, he counted sixty-three arrows or arrow wounds in his armor or his body. This fascinating account also confirms the existence, by the mid-fourteenth century at least, of several recognized styles of *ken-jutsu* (sword-fighting techniques). However, little technique is recognizable when a sword is used for a swift opportunistic stroke against a samurai who has just spared the swordsman's life, as at the Battle of Shinohara (1183) in *Heike Monogatari*:

Then Takahashi got off his horse to recover his breath and wait to see if any of his retainers would come up, and Nyūzen also dismounted, but, still thinking what a feat it would be to kill such a famous leader, even though he had just spared his life, he cast about to see how he could take him unawares. Takahashi, never dreaming of such treachery, was talking to him quite without reserve, when Nūzen, who was famous for the rapidity of his movements, catching him off guard, suddenly drew his sword and aimed a lightning thrust under his helmet.[42]

Hand-to-Hand Fighting

If archery did not produce a direct hit or a mortal wound, the two competing samurai would try to grapple with one another, using the techniques later given the name *yoroi-gumi* (armor grappling). This would result in the unhorsing of one or both, at which point the short katana (rendered into English as "dagger" in the accounts that follow) was the weapon most favored for close-quarters fighting. This directly contradicts the usually accepted theory that the tachi developed as a fairly long, curved bladed weapon that could more easily be wielded from the saddle. One may perhaps hypothesize that the reason for the yoroi-gumi style of combat was largely the samurai's primary role as a mounted archer. While mounted and wearing a suit of armor built like a rigid box, he was effectively a mobile "gun platform." When unable to wield his bow, he was ungainly and unwieldy, able only to grapple in the most clumsy fashion. His defensive costume, although not unduly heavy, was not designed to allow him to take the fight to the enemy, and was certainly not helpful in allowing a sword to be used from the saddle. The tachi was also a two-handed weapon, so to draw it, the samurai would have to discard his bow, which required his opponent to be already helpless. In the *Shōkyūki*, which deals with ex-emperor Go-Toba's rebellion of 1221, a "grapnel" (probably a *kumade*, a polearm with several hooks at the end) is used to hold an enemy out of range while the sword is drawn: ". . . he rushed up and hooked his grapnel into the crown of Satsuma's helmet, pulled him close, and struck off his head."[43]

Several examples of similar practices are recorded in *Heike Monogatari*, such as the account of a fight that eventually led to the death of Taira Tadanori at the Battle of Ichinotani in 1184:

> But Satsuma-no-kami, who had been brought up at Kumano, was famous for his strength, and was extremely active and agile besides, so clutching Tadazumi he pulled him from his horse, dealing him two stabs with his dagger while he was yet in the saddle, and following them with another as he was falling. The first two blows fell on his armour and failed to pierce it, while the third wounded him in the face but was not mortal. . . .[44]

At the same battle, the single combat between Etchū Zenji Moritoshi and Inomata Noritsuna began without an archery exchange.

> Rushing upon each other, they grappled fiercely so that both fell from their horses . . . he gripped his adversary and pinned him down so that he could not rise. Thus

Right: **Two bows mounted on a bow stand with a quiver.**

Far right: **A fine suit of armor laced throughout with white silk.**

Opposite page, left: **A suit of armor of *nuinobe-do* style, typical of the sixteenth century.**

Opposite page, right: **Armor with a distinctive checkerboard pattern woven into the breastplate.**

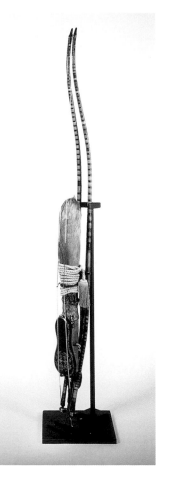

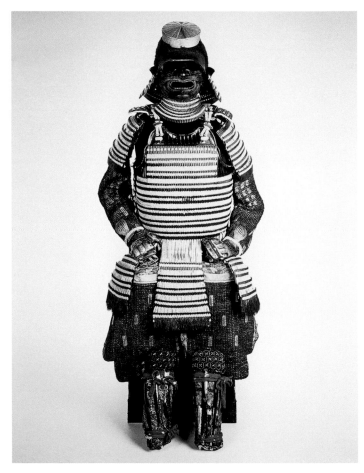

prostrate beneath his foe, try how he would to shift him or draw his sword, he could not so much as stir a finger to the hilt, and even when he strove to speak, so great was the pressure that no word would come forth.[45]

The intervention of a third party caused a pause in the combat, but soon they returned to the fray:

He suddenly sprang up from the ground and dealt Moritoshi a heavy blow on the breastplate with his closed fist. Losing his balance at this unexpected attack, Moritoshi fell over backwards, when Inomata immediately leapt upon him, snatched his dagger from his side, and pulling up the skirt of his armour, stabbed him so deeply thrice that the hilt and fist went in after the blade. Having thus despatched him he cut off his head.[46]

In *Shōkyūki* we have a full account of a vivid encounter that begins with an archery duel and is concluded by a yoroi-gumi fight using tantō:

Pulling an outer arrow from his quiver and fitting it to his rattan-striped bow, he drew the shaft to its full length and let fly. The arrow pierced the breast plate of Takeda

Rokurō's chief retainer, who was standing at the left side of his lord, and shot through to the clover-leaf bow (the *agemaki*) at the armour's back, toppling the retainer instantly from his horse. Saburō shot again, and his second arrow passed completely through the neck bone of one of Takeda Rokurō's pages. Then Rokurō and Saburō grappled together and fell from their horses. As they tumbled back and forth, Saburō drew his dagger and pulled the crown of Rokurō's helmet down as far as the shoulder straps of his armour. Rokurō looked to be in danger, but just at that moment Takeda Hachirō came upon the scene, and pushing Rokurō aside, cut off his assailant's head.[47]

That was the reality of samurai warfare during the "golden age." A samurai was primarily an archer, with the sword as a secondary weapon. Yet all had to be skilled at wrestling also. This is very different from the popular image of the samurai, but it was to change dramatically over the next few centuries, as we will see.

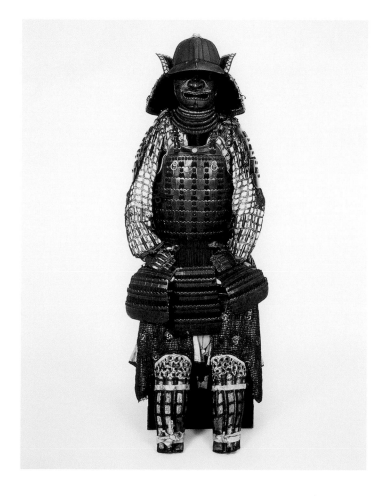

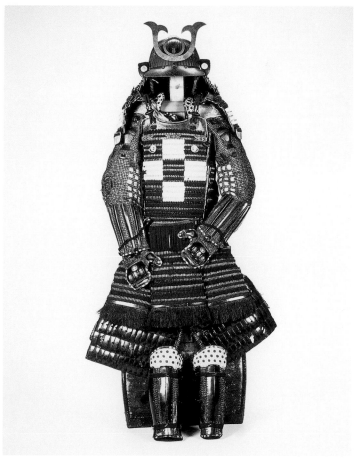

SWORDS IN SERVICE

Following the conclusion of the Gempei and Shōkyū Wars, the Japanese sword began to acquire a new role and a new significance. Although in domestic conflicts the emphasis was still on the mounted archer, knowledge both of the samurai sword and of the swordsmen who wielded it spread abroad to other countries. The result was that the sword itself and the art of the samurai swordsman became exportable items. The process began with some very harsh lessons concerning the sword's strength and efficiency, and developed into a situation where swords were for sale and the ideal of the samurai as primarily a mounted archer slowly began to fade.

This development could hardly have been guessed at in 1192, when the samurai of the Minamoto family had achieved the establishment of a native military dictatorship by means of their superior Way of Horse and Bow. The Minamoto, however, whose personal supremacy seemed as well assured as that of the institution of the bakufu itself, did not have long to enjoy their power, for within three generations they were supplanted by the Hōjō family. The Hōjō, nevertheless, showed a surprising respect for the institution of the shogunate and ruled Japan until 1333 in the capacity of regents. It was therefore under the Hōjō *shikken* (regency) that the samurai swordsman began to export his wares.

The Dwarf Robbers

The first foreign country to suffer from the Japanese sword was Korea, and the means was provided by the *wakō*, the pirates of Japan.[1] This word consists of two characters. The first, *wa*, can mean dwarf, and was also an ancient Chinese appellation for Japan. *Kō* means robber or brigand, making the compound that appears in Korean as *waegu* and in Chinese as *wokou*.

The long and disgraceful career of the wakō began during the early thirteenth century. From 1218 onwards, the Koreans had been resisting attacks from the advancing Mongols in the north of their country, a long conflict that had denuded the southern coastal area of soldiers.[2] Korea therefore lay open to pillage from the seas, and the wakō took full advantage of the situation, although drought and disastrous harvests in the area of Japan that produced the pirates have also been suggested as motives for their actions. The wakō heartlands were certainly poor, and this forced their inhabitants to seek sustenance from the sea, legitimately or otherwise.[3] Mounted archery would have been impossible in seaborne raids, so the wakō, even those wealthy enough to afford horses, fought on foot. Bows and arrows would still have been seen in plenty, but swords and naginata were the weapons of choice in the circumstances of a raid.

In 1223, two years after the Shōkyū War had ended, gangs of Japanese pirates launched their first attacks on Korea's southern coast from locations on the northern coast of Kyūshū and the islands of Iki and Tsushima, which lie in the straits between the two countries. Further raids followed in 1225, 1226, and 1227, and are well documented in both Japanese and Korean sources. A Japanese

The use of the samurai sword is demonstrated by Tominori Suke'emon Masakata, his sword raised with both hands, as a brazier and charcoal are thrown at him.

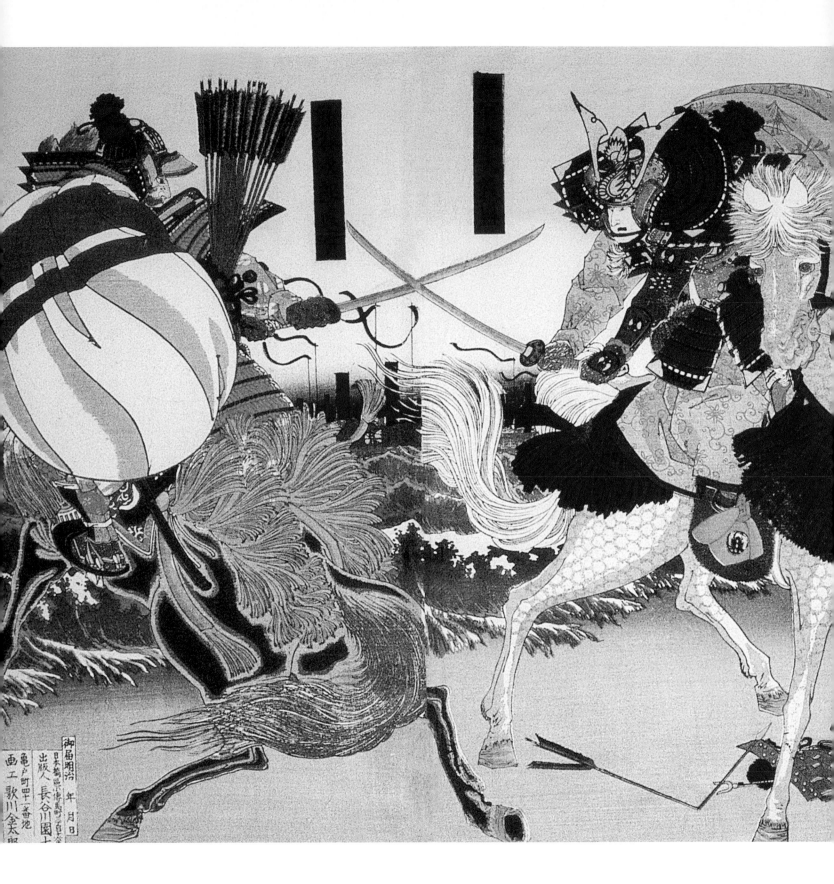

description of the 1226 raid identifies the culprits as being from the "Matsuura gang" *(Matsuura-tō),* who were located in Hizen Province. This raid was a much larger attack than the raid by two ships noted for 1225, because "several tens of ships" were involved. Pirates from Tsushima acted as guides, and there was apparently some participation by unemployed samurai from elsewhere in Japan, the end of the

Shōkyū War having left them without work. Nevertheless, so fierce was the Korean resistance that half of the raiders were killed, while the rest returned with valuables, having burned and plundered villages. In the 1227 raid, the Korean island of Koje was targeted. This time most of the pirates escaped during the night, without meeting resistance, but two of them were captured and beheaded.[4] The two attacks of 1227

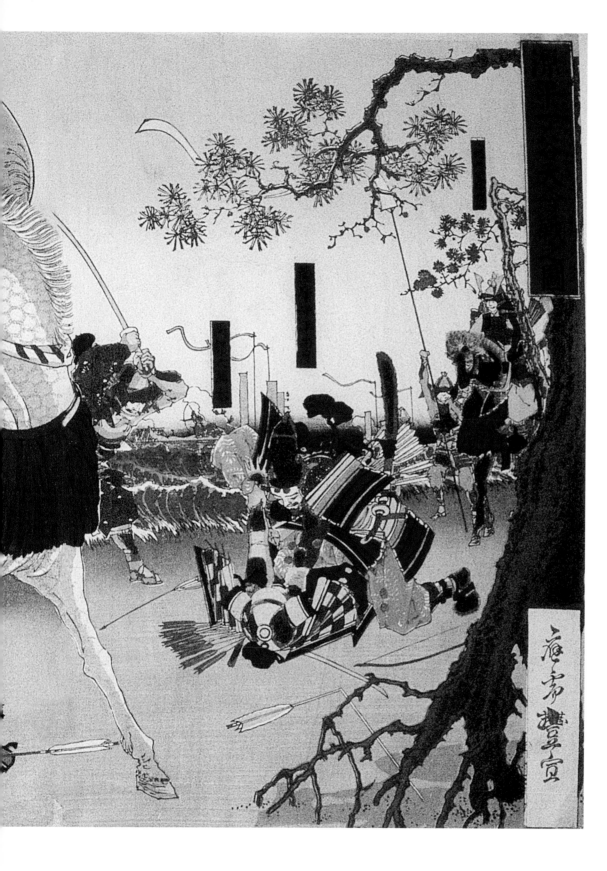

Mounted combat between two samurai armed with swords. Each is wearing a horō, the ornamental cloak supposedly used as an arrow-catcher, which distinguished an important samurai, such as a messenger between allied commanders.

led to a protest from Korea, to which the authorities on Kyūshū responded positively by executing ninety pirates in the presence of Korean envoys.[5]

These executions brought the raids to a halt for over thirty years. In 1259 the wakō returned to Korea, and again in 1263 and 1266, but by then the political situation in Korea had changed dramatically. By 1259, after a succession

of Mongol invasions and the flight of the Korean court, the Mongol control of Korea was virtually complete. Korea's fate was finally to be sealed in 1273 by a dynastic marriage between the Korean crown prince and a daughter of Khubilai Khan, but by then the considerable naval resources of Korea were already at the disposal of the first Yuan (Mongol) Emperor of China, as Khubilai Khan became in

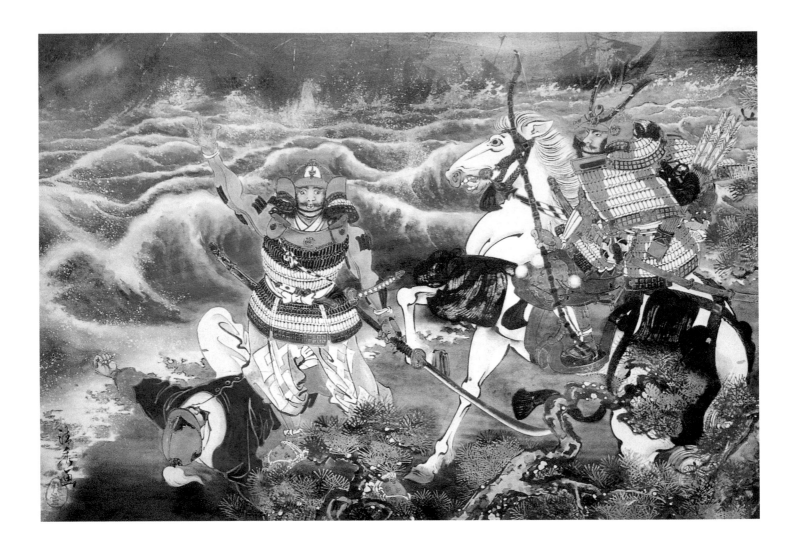

1271. It was not long before these invaders turned their attentions towards Japan, and the pirate families of Kyūshū soon found themselves wielding their swords in self-defense.

Khubilai Khan's first approaches to Japan were diplomatic ones. In 1266 he sent two envoys on a goodwill mission. The two men passed through Korea, where they were strongly urged to abandon any plans to visit Japan, and to return to China lest they risk their lives.[6] This was a reaction that may well have puzzled the Chinese, because their traditional view of the Japanese had always been a positive one. From Japan had come many an earnest seeker after truth, such as the monk Saichō (767–822), who had introduced Tendai Buddhism to Japan. In 719 the arrival of a group of envoys from Japan had occasioned the comment that Japan was a "country of gentlemen."[7]

Following the failure of the 1266 embassy, a further mission was dispatched in 1269. After a year the envoy reported back to Khubilai Khan that, in his opinion, the Japanese were "cruel and bloodthirsty" and lived in "a country of thugs."[8] Japan was certainly projecting a very different image from that of the peaceful Nara period! The Japanese had, after all, experienced a century of warfare and the establishment of a warrior class, and this negative view may well have been one

factor behind Khubilai Khan's decision to subdue this unruly island empire and bring it under his sway. In addition to passing on his comments about the Japanese, the envoy had delivered Khubilai Khan's demand for tribute from Japan, which had provoked a harsh reaction. The Japanese, who fully appreciated the threat of invasion conveyed by the demand, were placed very much on their guard, and they did not have long to wait for the outcome. Khubilai Khan gave orders to Korea to supply nine hundred ships and an army of five thousand men. The fleet that finally set sail in 1274 included fifteen thousand Yuan (Mongol) soldiers and eight thousand Koreans, together with a very large number of crewmen.[9]

The First Mongol Invasion

The Mongol invasions of Japan (Khubilai Khan's army returned in 1281) provided the only occasion in over six hundred years when the samurai were fighting enemies other than themselves. The first Mongol attempt at invasion was a short-lived affair, fitting the usual Mongol pattern of sending out a reconnaissance in force prior to a major cam-

Above: Two samurai fight the Mongols on the beach on Tsushima Island. (from a votive painting in the shrine on the site of the Battle of Kowada)

paign. Much of their time was taken up in crossing from Korea and devastating the islands of Tsushima and Iki, the two islands that have always provided the easiest means of crossing the straits. The first landfall on Japanese territory was made on Tsushima, which lies much nearer to Korea than it does to Japan. Tsushima consists of two islands, and most of the invading force came ashore on the complex and ragged coastline between the two islands, where many safe anchorages could be found. A particularly fierce battle took place at Kowada, where a Shintō shrine now commemorates the battle.[10]

In charge of Tsushima's defense was Sō Sukekuni (1207–74), the deputy *shugo* (governor). He appears to have risen to the occasion splendidly, although in the subsequent fierce fighting the pace was first set by the Mongols, leaving the Japanese defenders confused by the invaders' unfamiliar tactics. The most noticeable divergence from the Japanese tradition was the way in which the Mongols advanced in large dense groups, controlled by drums and to the accompaniment of much noise. In the lively, epic words of Yamada's retelling of the story, they:

. . . advanced in phalanx, which was also a novelty to the Japanese, protecting themselves most effectually with their shields. . . . The Mongolian shafts harassed them terribly; still all the Japanese soldiers fought according to their own etiquette of battle. A humming arrow, the sign of commencing the combat, was shot. The Mongols greeted it with a shout of derision. Then some of the best fighters among the Japanese advanced in their usual dignified, leisurely manner and formulated their traditional challenge. But the Mongol phalanx, instead of sending out a single warrior to answer the defiance, opened their ranks, enclosed each challenger, and cut him to pieces. The invaders moved in unchanging formation, obeying signals from their commanding officers.[11]

Yamada is, of course, making the assumption that the issuing of challenges and the seeking out of a worthy opponent were the norm in the warfare of the time—an assumption that was questioned in the previous chapter. But even if that had been the expected way to fight, surely no samurai would have been so stupid as to think that the Mongols spoke Japanese! The essential dichotomy between Japanese and Mongol tactics was that the samurai preferred to fight as individuals targeting other individuals, while the Mongols fought in dense groups. An anonymous work of the fourteenth century, called *Hachiman Gudōkun*, sets out precisely the problems that faced the samurai: "Calling our names to one another, as in Japanese warfare, we expected fame or ignominy to be found in contesting against individuals, but

in this battle the hosts closed as one."[12]

The extant accounts of the actual fighting that took place on Tsushima, and afterwards on Iki island and the mainland of Kyūshū, show that the samurai were far from being stunned into inaction by the novelties of Mongol warfare. Language difficulties, of course, precluded the conventional name-shouting for any audience other than the samurai's own comrades, but in terms of making a name for oneself, that audience was vital. It was also not impossible to figure out who were the officers among the dense Mongol phalanx, so the likely "worthy opponents" could indeed be targeted. And if the goal was simply to take the largest number of heads, the Mongol armies provided numerous targets for the mounted samurai archers. The clouds of Mongol arrows, some of which may have been poisoned, that were loosed in return from within the invading squads must have caused problems, but once the fight developed into hand-to-hand combat, there was no opportunity for such haphazard archery. It was then that the samurai sword came into its own. The long, curved, and razor-sharp blades cut deeply into the brigandine-like coats of the Mongol invaders, whose short swords were much inferior.

One outstanding example of a Tsushima samurai dealing successfully with the Mongol tactics appears in Yamada's account, and tells of a samurai called Sukesada (his surname is not given, but he was probably of the Sō family) who killed twenty-four men on the Mongol army's flank, probably with his bow. A grove of trees had conveniently broken up the Mongol phalanx, and at least one senior Mongol officer became Sukesada's victim. But the enthusiastic Sukesada became isolated from his comrades, and a shower of arrows hit him, three of which pierced his chest.[13]

From a devastated Tsushima, the Mongol army moved on to Iki. Iki is a much smaller place than Tsushima, and in 1274 was under the governorship of Taira Kagetaka. Kagetaka received intelligence of the Mongols' attack on Tsushima and immediately sent a request for reinforcements to Dazaifu, the regional center of government on Kyūshū. Unlike the samurai of Tsushima, however, the Japanese defenders of Iki were quickly driven back from the beaches and sought refuge inside Kagetaka's castle—which was probably little more than a wooden stockade. Here the Japanese defenders held out, hoping for relief. When none came, Taira Kagetaka prepared to lead his men out in a final charge, but as they approached the gates with their bows drawn, they were confronted by a human shield consisting of scores of their fellow countrymen, who had been chained together. Abandoning their bows and arrows, the samurai drew their swords and plunged into the Mongol host. They were soon overwhelmed, and, in the face of certain defeat, Kagetaka withdrew to his castle to commit sui-

cide along with his family. With resistance at an end, Iki was overrun, and among the cruel punishments inflicted upon the population, their prisoners had their hands pierced and were strung in a line along the Mongol ships that then proceeded to Kyūshū.

The Mongol "reconnaissance in force" was completed by a landing on the beaches of Hakata Bay. More details are known of this part of the operation than of the Tsushima and Iki raids because of the existence of a remarkable set of scroll paintings called the *Mōko Shūrai Ekotoba*.[14] The scrolls are among the most important primary sources for the appearance and behavior of samurai of the thirteenth century, but were never intended to be a historical document for posterity. They were instead created purely and simply to press the claim for reward being put forward by a certain Takezaki Suenaga. It is his achievements that are recorded there, the first scroll covering the 1274 invasion, and the second dealing with the 1281 action.[15] As a *gokenin* (houseman or retainer) of the ruling Hōjō shikken, Suenaga had rushed to defend Japan against the Mongols, but his motives were clearly more than simple patriotism. At the conclusion of hostilities, Suenaga felt that he had been denied the rewards that were properly his, so he took his complaints directly to the Hōjō's capital of Kamakura. His efforts to obtain a reward were every bit as insistent as his efforts against the Mongols, and of much longer duration! The journey to Kamakura from his home province of Higo took five months each way, and the interview lasted the better part of a whole day. Suenaga eventually got his reward, even though his achievements were not quite as impressive as he seems to have thought. During the first invasion, he did not kill a single Mongol. His sole achievement was apparently

leading a suicidal charge with only four companions, as the Mongols were retreating. His horse was killed under him, and Suenaga would almost certainly have been killed had another Japanese detachment not managed to rescue him.

Suenaga's attitude towards fighting the Mongols in 1274 was one that conformed rigidly to samurai tradition. He still fought as a mounted archer, and the demands of personal glory were as dominant as ever. But by 1281 even Suenaga had changed, and his military record became more impressive when he took part in one of the famous "little ship" raids against the Mongol fleet, described in the next section. Using only his sword and his quick wits, Suenaga cut off enemy heads, showing that when the situation was appropriate, the sword could be wielded every bit as skillfully as the bow.

The most interesting section of the *Mōko Shūrai Ekotoba* shows Suenaga's horse being shot from under him, while immediately in front there is an explosion from the Mongols' "secret weapon." The samurai had to contend not only with the unfamiliar formations adopted by the Mongols, but with exploding iron bombs thrown by

Above: **A conch shell signalling trumpet.**

Right: **A war drum, which would be carried by two men.**

Opposite: **One of the "little ship" raids on the Mongol fleet, where the samurai sword came into its own.**

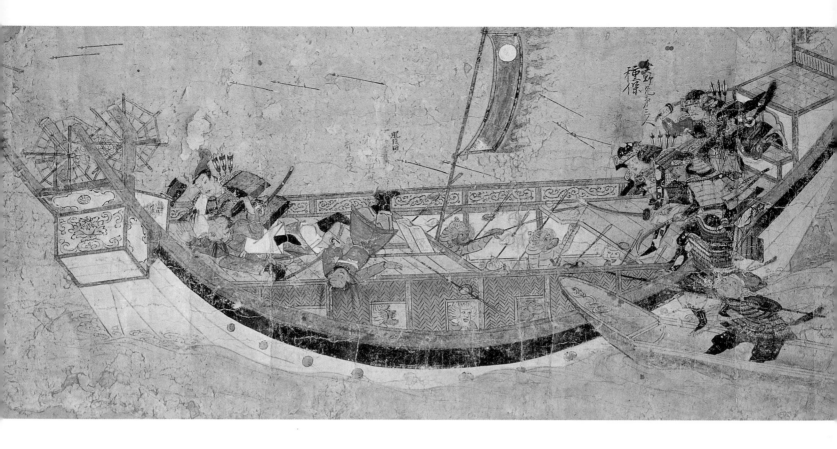

catapult, as well.[16] This was the first experience that the Japanese had of gunpowder weapons, which had been in use in China for over a century. They operated on a time fuse, and exploded as they passed into the Japanese ranks, shooting out iron fragments from inside the bombs, together with jagged pieces of the casing, in a deadly form of shrapnel.[17] The *Hachiman Gudōkun* account says:

> Whenever the Mongol soldiers took to flight, they sent iron bomb shells flying against us, which made our side dizzy and confused. Our soldiers were frightened out of their wits by the thundering explosions, their eyes were blinded, their ears deafened, so that they could hardly distinguish east from west.[18]

Until recently, no one was exactly sure what these bombs were. Earlier scholars suggested cannonballs, and put them forward as evidence that the Mongols used gunpowder as a propellant in the later thirteenth century. This has since been disproved, first of all by Needham, who made the link between the Chinese exploding bombs and those used in Japan.[19] The invention of these bombs is credited to the Jin dynasty, and their first recorded use in war dates from the siege by the Jin of the Southern Song city of Qizhou in 1221. The fragments produced when the bombs exploded at Qizhou caused great personal injury, and one Southern Song officer was blinded in an explosion that wounded half a dozen other men.

Underwater archaeology over the past thirty years has added greatly to our knowledge of the Mongol invasions in general and the exploding bombs in particular, although physical evidence of the latter has taken years to acquire.[20] In 1994 archaeologists discovered three wood and stone anchors at Kozaki harbor, a small cove on the southern coast of the island of Takashima. The largest anchor was still stuck into the seabed with its rope cable stretching toward the shore, and provided a tantalizing clue that a wreck lay nearby. In the 1994–1995 season, a diving team recovered 135 artifacts near the shoreline, then slowly traced the finds back into deeper water through the 2001 season. In October of that year, the patient fieldwork paid off with the discovery of the ship's remains. The main portion of the wreck site lies in forty-five feet of water and was buried beneath four feet of thick, viscous mud. It was completely excavated by the end of 2002.

The objects found ranged from personal effects, such as a small bowl on which was painted the name of its owner (a commander called Weng) to provision vessels and the implements of war. The vessels include a large number of storage jars in various sizes, all of them hastily and crudely made, which hints at the rapid, if not rushed, pace of the Khan's mobilization for the invasion. So, too, do the anchor stones. Chinese anchor stones of the period are usually large, well-carved, single stones that were set into the body of the stock to weight the anchor. Examples may be found on display in the Hakozaki Shrine in Fukuoka and at Setaura on Iki.

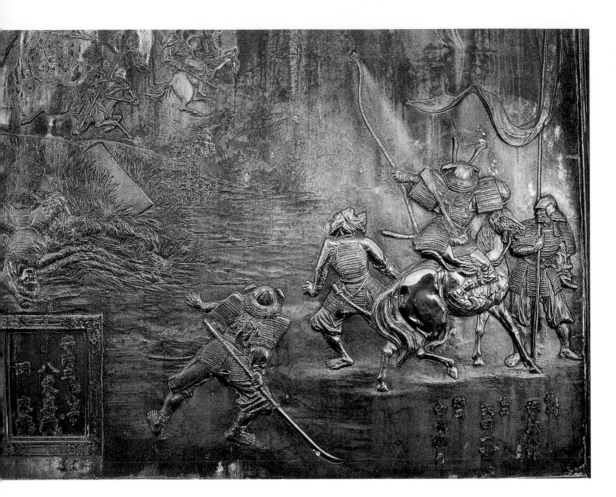

As the advancing Mongols came within bowshot, Shōni Kagesuke suddenly turned in his saddle and sent a well-aimed arrow into the Mongol leader. This scene is depicted on the side of the memorial to the heroes of the Mongol Invasions, in Hakata.

Those found at Takashima are only roughly finished and made of two stones. More easily and quickly completed than their longer, more finished counterparts, they are not as strong as the single-stone anchors. It may be that these hastily fabricated anchors contributed to the fleet's demise in the famous storm that dashed Khubilai's hopes for the conquest of Japan (see the following section).

The weapons recovered from the site included bundles of iron arrow-tips or crossbow bolts, spearheads, and more than eighty swords. But the most exciting finds were the ceramic projectile bombs, of which six were recovered from the wreck. Some are filled with gunpowder, others with iron shards also, just as we would expect from the Chinese sources.[21]

The Second Mongol Invasion

The Mongol invaders returned to Japan in 1281, and this time they were determined both to conquer and occupy the country, as evidenced by the inclusion of farm implements on board the invasion fleet.[22] The vanguard of the force attacked Tsushima and Iki and then attempted to land in Hakata Bay. As before, the ferocity of the Japanese defense forced them back, but the Mongols established themselves on two islands in the bay, one of which, Shiga, was connected to the mainland by a narrow spit of land.

From these islands they launched attacks against the Japanese for about a week.

The Japanese responded with night raids against the Mongol ships. The small boats, holding between ten and fifteen samurai, would close with a Mongol ship under cover of darkness, and lower their own masts to make bridges for boarding. The samurai would then engage in hand-to-hand fighting with their swords. On one occasion, thirty samurai swam out to a Mongol ship, decapitated the entire crew, and then swam back. Two renowned heroes of these raids hailed from local families who were firmly associated with pirate activities: Kusano Jirō led a raid in broad daylight and set fire to a ship even though his left arm was cut off, while Kōno Michiari also led a daytime raid with two boats. Thinking the Japanese were coming to surrender, the Mongols allowed them to come close, at which point they were boarded and a high-ranking general was captured. Attempts were also made to dislodge the Mongols from Shiga island.

The Mongol response to the raids was to stretch chains between their ships and throw stones with catapults to sink the Japanese vessels. But at the end of this phase of the invasion, the bravery of the samurai, unaided by any storm, led the Mongol fleet to withdraw to Iki Island, there to await the arrival of the southern Chinese

contingent, which made up the second phase of the invasion. By the early part of the following month, this huge armada had begun arriving at various parts of the Japanese coast, from the Gotō islands around to the west to Hakata. They eventually made rendezvous to the south of Iki, near the island of Takashima, where the Japanese launched a bold raid that deserves the title of the Battle of Takashima. The fighting lasted a full day and night, but the Japanese were eventually driven off by sheer weight of numbers. A massive attack on Hakata Bay now looked inevitable, but it never happened.

Within days of the Japanese attack at Takashima, a typhoon blew up, and was devastating in its effects. Korean casualties were 7,592 out of 26,989 men, nearly 30 percent, but the Mongol and Chinese figures were much higher, between 60 and 90 percent. Forced by the Japanese raids to stay in their ships, and unable to drop anchor in protected harbor waters, the Mongol fleet was obliterated. Tens of thousands of men were left behind with the wreckage as the remains of the fleet headed home, and most of these were killed in Japanese attacks over the following few days. The typhoon became known as the *kamikaze* (divine wind), sent by the sun goddess to aid her people.[23] It was this term, kamikaze, that the suicide pilots of World War II adopted as their title, thus identifying themselves with the successful destruction of an invader.

Decisive though the typhoon was, it would have been minimal in its effectiveness if the determination and fighting qualities of the samurai had not forced the entire fleet to lie at anchor with all their armies on board, unable to establish a beachhead. The kamikaze has tended to overshadow such achievements, but there are many recorded examples of superlative samurai archery and swordsmanship defeating Mongol forces.

Swordsmanship is most evident in the "little ship" raids at Takashima, but on land, traditional samurai horseback archery was still much preferred. A good example of the latter is provided by the action fought by three generations of the Shōni family on Kyūshū and Iki. Shōni Kakuie was the governor of Dazaifu, and was in charge of a combined operation during the second invasion of 1281. The Japanese aim was to push the Mongol fleet further out into the bay by seaborne attack, while a mounted army speedily reinforced the coastal area, where a detachment of the Mongol army was expected to attempt its next landing. The arrival of the Shōni force put great heart into the defenders, who rallied to the attack, but there was a grave danger of the Japanese army being surrounded by the vastly larger Mongol force, who poured their customary showers of arrows down upon

them. At this point Kakuie's nineteen-year-old grandson, Suketoki, with supreme confidence, rode up to the Mongol lines where he had spotted a person who was obviously of very senior rank. Suketoki shouted out his name, put an arrow to his bow, and, without waiting for a reply, shot the Mongol general clean through the chest.

This triumph provided just the inspiration the Japanese had been looking for, and proud grandfather Shōni Kakuie led the samurai in a charge into the midst of the Mongols, whereupon fierce hand-to-hand fighting took place. The battle continued until nearly dark, when Kakuie withdrew his troops to the safety of the Japanese fortified lines. One by one the stragglers withdrew, until only the contingent commanded by Kakuie's son Kagesuke was left, and they were being pursued vigorously by a number of Mongol horsemen led by another general. As they came within bowshot, Shōni Kagesuke suddenly turned in his saddle and sent a well-aimed arrow into the Mongol leader.[24]

The next battle took place as the Mongols regrouped on the island of Iki, where the grandson, Shōni Suketoki, had his domain. A fierce fight with the retreating Mongols took place at Setanoura on the eastern coat of the island. Here Shōni Suketoki fought bravely to the last, and is commemorated on Iki as the island's other great hero of the resistance against the Mongols. Like Taira Kagetaka, Suketoki has a shrine dedicated to him, and his fine equestrian statue stands in front of one of Iki's main harbors.

The experience of defeating the Mongols was one never to be forgotten, and the exploits of the Kyūshū warriors joined those of their ancestors in the amalgam of myth and tradition that was to carry their memory through another six centuries. But we look in vain to discern any real changes in the techniques of combat as a direct result of the experience. Even though the samurai had been faced in 1274 with an alien enemy with alien ways, the traditional ways of fighting as horseback archers had been found to be sufficient in most circumstances. Evidence for this is provided by the design of the stone wall around Hakata Bay, erected in anticipation of the Mongols' return. The wall sloped down gradually at its rear so that horses could be ridden up it.

There may, however, have been a fresh realization that different styles of fighting and behavior might have to be adopted at times. For example, the "little ship" raids of the 1281 invasion used fighting techniques profoundly different from those developed for a force of mounted archers. The ship-to-ship fighting required good swordsmanship, and it may perhaps have been Japan's good fortune that the men who bore the brunt of the

Mongol incursions were the same impoverished warriors of Kyūshū who had so recently exported their sword-fighting skills to the Asiatic mainland. As noted earlier, the names that appear most prominently in the "little ship" raids are from the established pirate families of Kyūshū, who were to be joined so enthusiastically by such grandees as Takezaki Suenaga.

The Pirates Return

When Zheng Sixiao, a Chinese scholar who was committed to the restoration of the Song Dynasty, heard of the defeat of the ruling Yuan emperor by the Japanese, he was ecstatic, and composed a poem to celebrate the victory. But he was also very wary of the Japanese, writing that they were "fierce and do not fear death," and that ten Japanese soldiers would fight an enemy unit of one hundred men. He also made a particular reference to Japanese swords, writing that "their swords were extremely sharp."[25] Similar comments were recorded in a later description of the wakō made to the king of Korea. This account states that the pirates were a distinct subgroup of Japanese. They took their families on their boats with them when they went on raids. Their dark skin, sun-bleached clothing, accessories, and language all differed from those of other Japanese. They were skilled at using bows and swords, and adept at diving under water and boring holes in the bottom of enemy boats.[26] Later descriptions are expressed in a very similar vein, as for example the *Riben kao* of Ye Xianggao:

> It is their habit to be fond of looting. They disdain life and are bloodthirsty. . . . The blades of the Japanese swords are sharp. Chinese swords are inferior. The men go hatless and their hair is dishevelled. They have branded faces and tattooed bodies.[27]

Bu Datong added in his *Bei Wo tuji* that the Japanese "make their homes on islands and use boats instead of horses. They are adept with swords and spears, and use them on their raids."[28]

Zheng Sixiao's wish for the end of the Yuan Dynasty came true in 1368 when Zhu Yuanzhang (1328–1398), who had overthrown the Mongols in the previous year, became China's first emperor of the Ming dynasty. As was customary, the new emperor dispatched missions to neighboring countries, including Japan, to inform them of this momentous development. As was also customary, he encouraged the recipients to send tribute to the new Son of Heaven. By this time the Japanese had clearly returned to piracy, because the message he sent to Japan in 1369 included the words, "Japanese pirates repeatedly plunder

areas along the coast, separating men forever from their wives and children and destroying property and lives." He went on to demand that Japan should either send tribute and declare itself a vassal state of China, or ensure by military means that its least attractive exports stayed at home. In fact the wakō were now raiding further than ever, taking in the Chinese provinces of Shandong, Jiangsu, Zhejiang, and Fujian.[29]

The Ming embassy was received at Hakata by Prince Kanenaga, who had been sent to Kyūshū by the "Southern Court." This is the name given to one of the two warring imperial factions whose rivalries dominated Japanese politics and warfare during much of the fourteenth century. The wars between them are known as the Nambokuchō Wars (the wars between the Southern and Northern Courts). The continued unrest meant that Prince Kanenaga lacked both the authority and the means either to consent to vassal status or to suppress the pirates. The embassy was therefore a resounding failure, a disaster compounded by the imprisonment of the unfortunate ambassador and the execution of some of his colleagues.

In 1370 another envoy was sent to confront Prince Kanenaga over his failure to control his subjects. At first the threats seemed to be effective, and the necessary guarantees were given. It was only when the Chinese discovered that the prince was no more than a provincial military commander that they realized that his new promises of tribute and pirate curtailment were worthless. The Ming emperor was greatly displeased, and wrote that the Japanese were petty thieves with shorn hair and mottled clothes, who spoke a language that sounded like croaking frogs.[30] Numerous other Ming documents add descriptions of the cruelties of the Japanese pirates on their raids: When they attacked a community, they burned government offices and private houses to the ground, desecrated graves, and stole valuables. Murder and rape were commonplace. In 1439 in Zhejiang, children were tortured with boiling water, and pregnant women cut open by the blades of the Japanese swords.[31]

Korea also suffered anew. During the ten years between 1376 and 1385, there were 174 recorded wakō raids on Korea. Some of these expeditions amounted to miniature Japanese invasions of Korea, with as many as three thousand wakō penetrating far from the coast, ravaging Kaesong, the Koryo dynasty's capital, and even pillaging as far north as P'yongyang. Ships carrying tax rice (taxes paid in rice) were seized, and when the Koreans decided to transport the rice by land, the wakō followed them inland and sacked the granaries. In addition to looting property, the wakō became slave traders, taking the well-established Korean tradition of slave owning to its

Images of the Japanese, from the Ming dynasty *Xuefu quanbian*. The picture on the lower right shows a *wakō* with a drawn sword.

logical conclusion by shipping their captives back to Japan. In 1429, Pak So-saeng, sent on a diplomatic mission to Japan, was to report on how conditions had improved since the "bad old days":

> Previously, the Wa pirates would invade our country, seize people, and make slaves of them. . . . Wherever we went and whenever our ships put into port in Japan, slaves would struggle against each other in their efforts to flee to us, but they were unable to do so because of the chains that their masters had put on them.[32]

Matters improved for Korea under the guidance of Yi Song-gye, who was later to found the Yi, or Choson, dynasty. He believed in hitting back at the wakō. In 1380, over five hundred Japanese ships were set ablaze at the

mouth of the Kum river after being blasted by Korean cannon; three years later, Admiral Chong Chi, in command of forty-seven ships, chased away more than one hundred Japanese ships with gunfire. In 1389, a successful raid was carried out against the pirates based on the Japanese island of Tsushima. Three hundred Japanese ships were burned and more than one hundred Korean prisoners were repatriated.

But the most important influence against the wakō was political, because in 1392, the same year in which the Choson dynasty was founded, Japan acquired a new shogun. His name was Ashikaga Yoshimitsu, and in addition to the achievements for which he is best known—the reconciliation between the rival Southern and Northern Courts and the building of the Kinkakuji, or Golden Pavilion, in Kyoto—Yoshimitsu accepted from the Ming emperor the nominal title of "King of Japan." Ashikaga Yoshimitsu thereby formally assumed the status of subject of the Ming, and restored a situation that the Chinese considered to have existed from the Han dynasty until it was grievously sundered by acts of piracy and war. The benefit to Yoshimitsu and to Japan was trade. Henceforth, trade would be carried on under the tally system, which legitimated voyages that—in the eyes of the Ming, at any rate—brought "tribute" to the court of the Son of Heaven.[33]

The newly licensed trade agreements with the Ming provided the stability that both governments needed to deal with piracy. That the Japanese did take measures to control the pirates is evident from 1405, when an envoy to China from the shogun Ashikaga Yoshimitsu arrived with twenty captive pirates from Iki and Tsushima. The Ming emperor was delighted, and handed the pirates back to the envoy to be disposed of as he thought fit. Their fate was to be taken to Ningbo and boiled to death in a cauldron.[34]

Following this dramatic demonstration of goodwill, trade flourished legitimately, and Japanese daimyō (feudal lords) returned captives for profitable gifts. The Koreans conducted business through the Sō family of Tsushima, whom they held personally responsible for the good behavior of the Japanese. Raids declined greatly, but when there were new incursions in 1419, the Korean government quickly took drastic measures in retaliation. Seven hundred and thirty-seven lawful Japanese traders were executed as a reprisal, and another punitive expedition was launched against Tsushima at a time when it was known that a wakō fleet from Tsushima was out at sea. Under the orders of King T'aejong, two hundred ships and seventeen thousand Korean soldiers set out to destroy the pirates' bases before they had time to return.[35] Sō

Sadamori (1385–1452) bore the brunt of the attack, which is celebrated in the annals of Tsushima as the Oei Invasion. Sadamori appears to have been as successful at diplomacy as he was at fighting, because he entered into successful negotiations with the Koreans. He promised to quell the wakō, but it was his warning of the approaching typhoon season, which would have stirred some very acute folk memories among the invaders, that finally persuaded them to withdraw.[36]

In that same year of 1419, the Chinese also hit back against pirate raiding. A large wakō fleet was ambushed off the Liaodong Peninsula, and perhaps a thousand Japanese pirates were relieved of their heads. At the same time, diplomatic discussions took place between the Choson court and the Ashikaga shogun on ways to curb the wakō by more peaceful means. One result was a report from the Korean ambassador Pak So-saeng in 1429, recommending a direct approach to the particular Japanese daimyō who controlled the territories where the pirates lurked. After all, as another ambassador reported in 1444, these people lived in a barren land that constantly threatened them with starvation, so piracy was only natural to them. It was a generous memorandum, but one that merely echoed comments that had been made earlier.

Swords in Action

Perhaps because of tales taken home by the survivors of the Mongol invasions, or more likely because of the destructive effects of Japanese pirates, the inhabitants of continental Asia had acquired a healthy respect for the qualities of the Japanese sword by the beginning of the fifteenth century. Thus, when, under the influence of the shogun Ashikaga Yoshimitsu, Japan began to trade with Ming China, swords were among the objects most in demand. Initially, they were needed for use against the pirates, but as Yoshimitsu had taken pains to demonstrate his determination to curtail this aspect of his countrymen's activity by boiling a few of them alive, this need disappeared. The largest quantity of swords shipped in one consignment totalled thirty thousand, which led to a major disagreement over the price.[37]

What is interesting from the point of view of samurai fighting arts is that, although the Japanese sword is commonly regarded as a very precious and symbolic individual weapon, here we have evidence of mass production. We also read of blades breaking or becoming stuck in the bodies of victims. The

Left: Onchi Sakon, a follower of the great loyalist Kusunoki Masashige, fights bravely. His helmet crest is in the form of a *tengu*.

Japanese sword was sometimes not all that its reputation would have led one to expect.[38]

Nor was it always used for the noble purposes of honorable combat. One menial task for which the short katana sword was very frequently used was the decapitation of defeated enemies. This practice, known as *buntori* (literally, "taking one's share"), was no mere finishing stroke to make sure that the man was dead. The head was taken as a trophy, the best evidence of duty done, because it proved the samurai's competence in combat. Nothing was more acceptable or more certain to win recognition from a samurai's lord than the presentation of the enemy's head. A major victory would always end with the piling up of dozens, even hundreds, of severed heads in the commander's headquarters.

An intense ritual attended this bizarre but critical practice, which went from mere proof of a job well done, to a practice that developed its own mystique. Although its origins are obscure, the persistence of the tradition of head collection spans the entire period of samurai warfare and dates back at least to the system of assessing battlefield merit for the ancient conscript armies.[39] As early as 1062, we read of Minamoto Yoshiie riding into Kyoto carrying the head of the rebel Abe Sadato as proof that he had fulfilled the government's commission. A few years later, he was to throw the heads of vanquished rebels into a ditch when the government refused to reward the quelling of a rebellion undertaken without the correct requisition. Two centuries on, the chronicle *Azuma Kagami* records that the insurrection of Wada Yoshimori in 1213 yielded 234 heads of defeated warriors, which were duly displayed along the banks of the Katasegawa River.

Head collection was never a casual practice. There was a hierarchy of value based on the rank or prestige of the victim and the circumstances under which the victor had killed him. Great rivalry attended the choice of a potential victim, and there are records of heads being stolen before presentation. Someone who had taken a particularly eminent head would want it to be noted immediately. Brandishing a fresh head on the point of a spear or a sword was not unknown, and the effects on morale could be profound. The *Azuma Kagami* tells us how Minamoto Yoritomo exhibited the heads of nineteen enemy samurai after the Battle of Azukashiyama in 1189, while a thirteenth-century warrior called Obusuma Saburō liked to maintain a steady supply of fresh heads hanging on the fence surrounding the riding field of his home.[40] Given the importance of the custom, it is not surprising that a little deception was sometimes practiced, but to have five different heads displayed,

each with the name of the same man, was to invite considerable ridicule:

> Suda and Takahashi galloped through the capital gathering up the heads of the wounded and dead men from ditches here and there, and hung them up in rows at the Rokujō river bed, eight hundred and seventy-three of them. Yet not so many of the enemy had been struck down. Some were merely heads brought forth by Rokuhara warriors who had not joined in the fighting, but sought to gain honour for themselves, heads of commoners from the capital and other places, labelled with various names. Among them were five heads labelled, "The lay monk Akamatsu Enshin" which were all hung up in the same way, since all of them were heads of unknown men. Seeing them, the urchins of the capital laughed.[41]

The main focus of head collection, however, came after a battle, when most of the ritual surrounding a victory celebration concerned the formal inspection of the heads by the victorious general. He would sit in state, and one by one the heads would be brought before him for comment. These ceremonies appear to have been quite informal affairs until the fourteenth century. The *Mōko Shūrai Ekotoba* shows head inspection taking place during the Mongol invasions. The heads, from which blood is still seeping, have been casually placed on the ground.[42] The ceremony later grew into one of considerable formality, to which the victorious commander would give his full attention—a matter that proved to be the undoing of Imagawa Yoshimoto in 1560. He was so engrossed in head viewing that he suffered a surprise attack, and a few hours later it was his own head that was being viewed by someone else!

The press of battle often left little opportunity for anything other than simple head identification. The formalities had to wait until later, and during the Age of Warring States it became most undesirable for a daimyō to be presented with an untidy trophy. Prior to his inspection, the heads would be washed, the hair combed, and the resulting trophy made presentable with cosmetics, tasks traditionally done by women. The heads would then be mounted on a spiked wooden board with red labels for identification. This act of cleaning the heads was in part a sign of respect for fallen warriors. It also represented a tribute to the victors' pride as men who could defeat heroic enemies.

An obsessive concentration on head collection could, of course, be detrimental to the course of a battle. If one's finest warriors were expected to quit the field with their trophies or spend time in collection, then the army's progress would be unnecessarily slowed. One samurai was felled by an arrow while taking a head.[43] We therefore read of prohibitions on head taking, and the substitution of written reports on battlefield glory. Heads might therefore be cut off, recorded, and then discarded. One warrior even contented himself with a piece of his enemy's armor as a trophy because the fighting was so fierce.[44] Time was far better spent in following the general's plan of victory than in furthering one's own reputation.

Yet in spite of the evident quality of Japanese swords the style of samurai warfare during the fourteenth and early fifteenth century remained very similar to that employed in previous conflicts. Thomas Conlan's fascinating study of the Nambokuchō Wars shows that the bow remained the dominant weapon, because arrows caused on average 73 percent of all wounds. These wounds, however, were not necessarily lethal, a conclusion that is supported by the image of the monk Jomyō at the Battle of Uji in 1180 counting sixty-three arrows or arrow wounds in his armor or his body. In Conlan's fourteenth-century example, one Imagawa Yorikuni required twenty arrows to finish him off.[45] Wounds could, however, be cumulative in their effects, so that Wada Takanori was unable to see properly because his wounds had not healed from a previous battle. Takeda Gorō was unable to hold a sword because of his damaged fingers, but went into battle regardless.[46]

Swords were still primarily a weapon for use while dismounted. Many of the battles of the Nambokuchō Wars were fought in wooded and mountainous terrain, where horses were not appropriate, making swords the weapon of choice. Also, the sight of a naked tachi blade being swung close to a horse's head might cause the mount to buck and throw off its rider, so it was sometimes better to dismount first. Just as in the case of the "little ships" raids against the Mongols, the choice of weaponry depended upon circumstances, and the samurai had to be willing to adapt. Horsemen could still easily overcome infantry when out in the open, and one account notes that "the strongest soldiers cannot withstand the bite of arrows, nor can the fastest of men outrun a horse."[47] Mounted archers naturally preferred open ground on which to operate, and one reason for the frequent reference to arson in the chronicles was the need to create such an open space artificially. A horseman could then ride around, picking off foot soldiers at will.

Yet at this point in history came the greatest challenge so far to traditional samurai cavalry tactics. Generals realized that one way to use the numerous foot soldiers in their armies was to take away their edged weapons and give them bows to pour volleys of arrows

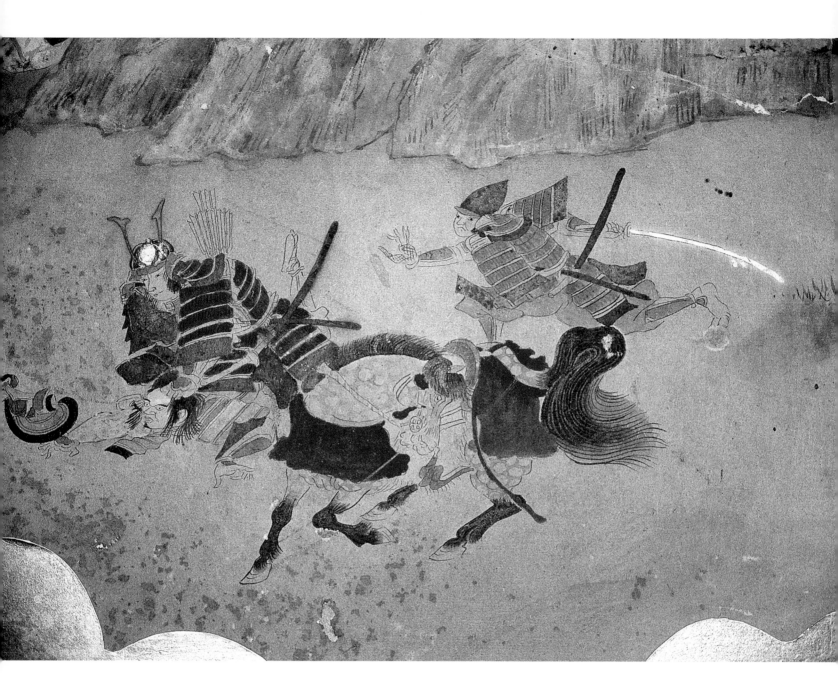

into the enemy, much as the Mongol archers had done. This was the complete antithesis of the notion of the elite mounted archer delivering one arrow with great precision—and, of course, enemy mounted archers provided excellent targets for this new technique. The practice also implies a better organization of foot soldiers and an increase in discipline. If these factors could be achieved, then a general would possess an ordered infantry corps for the first time since the days of the conscript armies. A samurai galloping forward and loosing a few arrows into a mass of disciplined foot archers was unlikely to discourage them, and they would reply with scores of arrows of their own. The *Taiheiki* refers to these lower-class archers as *shashu no ashigaru* ("light foot shooters"), the first use in Japanese history of the term *ashigaru*, a word that was later to be adopted to describe all infantry troops. Out of two thousand men who fought for the Sasaki at the battle of Shijo Nawate in 1348, eight hundred were these "light archers."[48] Such mass firing of arrows is implied in the following account that describes what happened when some samurai horsemen of the Hosokawa were trapped on the edge of Lake Biwa and came under fire from men in boats:

They could not pass to the north because they had not finished burning the dwellings of Otsu. A deep lake to the east was likewise impassable, forcing the Hosokawa army to advance in single file along a narrow road. The enemy rowed parallel to the Hosokawa and shot them from the side, killing five hundred in all.[49]

Above: **The taking of a victim's head, from a painted scroll of the Battle of Ichinotani in the Watanabe Museum, Tottori.**

CHAPTER 3

SWORD AND SPEAR

So far in this book, the samurai swordsman has proved to be a somewhat elusive character who greatly prefers his role as a mounted archer and delivers death from a distance, rather than close at hand. When forced by circumstances both to dismount and to discard his bow, he wields the world's finest edged weapon and is very proficient in its use, but accounts of its employment are tantalizingly few. Even the Mongol invasions provide no overall change to this pattern. Sword use against the invaders is decisive and dramatic, but the employment of swords rather than bows is dictated totally by circumstances and runs contrary to the prevailing mood. For a major change in weaponry to occur, we must wait for a social change, and the first stirrings of one are discernible during the fifteenth century.

We noted earlier how the greatest of the Ashikaga shoguns, Ashikaga Yoshimitsu (1358–1408), had ended the Nambokuchō Wars and restored relations with Ming China, but his descendants were not to enjoy such glory, and the last century of the Ashikaga dynasty witnessed the total collapse of their authority. The Ashikaga shoguns had followed a policy of decentralization, so that military governors, or shugo, ruled the provinces of Japan on their behalf. Many shugo were samurai aristocrats who had ruled their provinces for centuries and had submitted to the Ashikaga. The system worked well until the mid-fifteenth century, when a dispute over the succession to the shogunate led to a number of prominent shugo taking opposing sides and resorting to violence. The incumbent shogun was powerless to control them, and suffered the indignity of witnessing fighting in the streets of Kyoto, Japan's capital. The disturbances in Kyoto proved to be the beginning of a civil war known as the Onin War, which lasted from 1467 to 1477. Kyoto was devastated and the fighting spread to the provinces.

The Age of Warring States

The tragic Onin War ushered in a century and a half of conflict that is known as the *Sengoku Jidai*—the Age of Warring States, by analogy with the most warlike period in ancient Chinese history. As the shogunate had been exposed as a powerless entity, erstwhile shugo took the opportunity to create petty kingdoms for themselves in the provinces they had formerly administered. These men were the daimyō (feudal lords), a title with the literal meaning "great name." Their ancestors were as likely to have been farmers or umbrella makers as glorious samurai, and the present head of a family might well have risen to that height by murdering his former master. Alliances between daimyō were regularly made and as easily broken. New family names were created by opportunistic warriors, while old established ones disappeared forever.

A good example is provided by one of the most successful daimyō dynasties of the Age of Warring States: the Hōjō family of Odawara. Their founder, a samurai who bore the Buddhist name of Sōun and was formerly known as Ise Nagauji, was skilled in war but of modest background; he appropriated his new surname from the long-extinct samurai lineage of the Hōjō because it sounded impressive. Another new warlord called Uesugi Kenshin (1530–1578) saved his

Suzuki the sharpshooter. Suzuki Shigehide was a follower of the Ikkō-ikki, and tried unsuccessfully to shoot Oda Nobunaga.

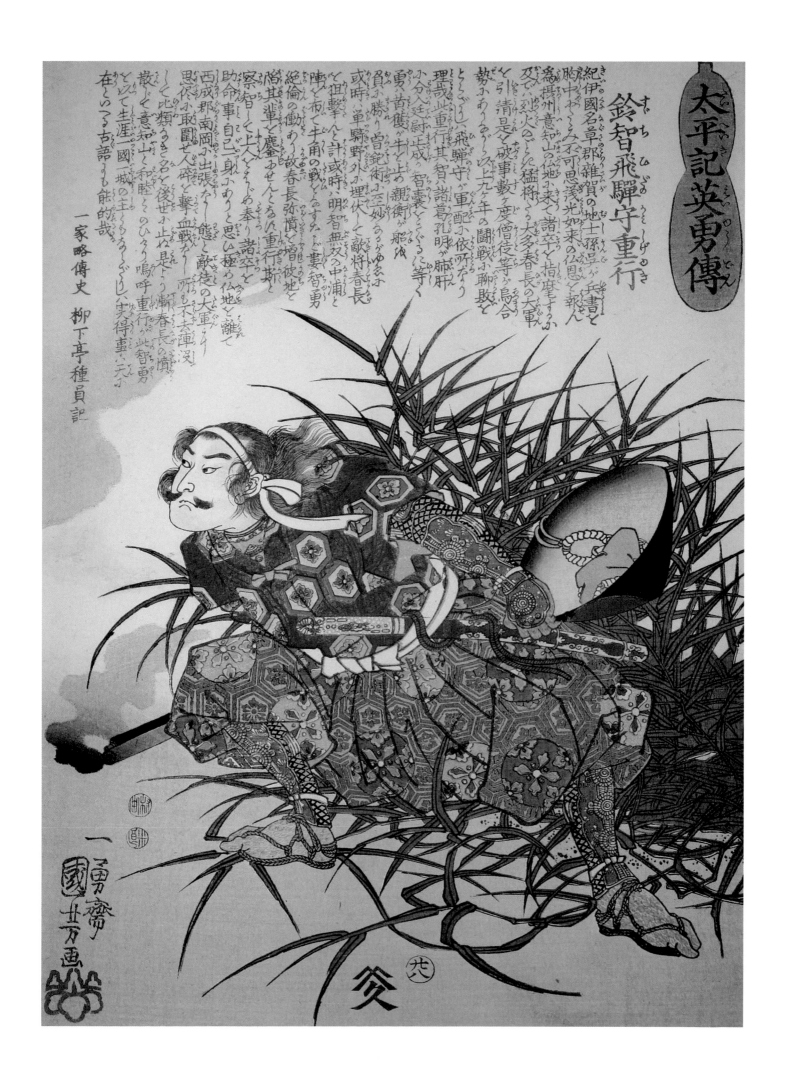

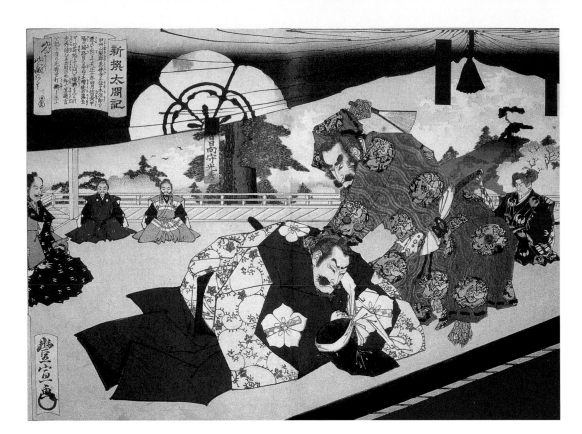

former daimyō's life, on condition that the daimyō adopt him as his heir and give him the glorious name of Uesugi. From about 1530 onwards, the Hōjō and Uesugi were engaged in sporadic armed rivalry with each other and with their neighbors, the Takeda and Imagawa, to name but two opponents. Scores of smaller samurai families were alternately crushed, courted, and absorbed by these growing giants. The southern Japanese island of Kyūshū witnessed a similar rivalry among the samurai who fought under the flags of Shimazu, Itō, Otomo, and Ryūzōji, while the Mōri family steadily increased its influence along the Inland Sea at the expense of the Amako. The Age of Warring States was a time of large-scale strategy, huge battles, and tremendous developments in weaponry and tactics. From the mid-1540s onwards, we read of firearms being used for the first time in Japanese history, although their full potential was not to be realized for three decades.

This situation of chaos persisted until a succession of "super-daimyō" managed to reunify the country. The first important name is that of Oda Nobunaga (1534–1582). Nobunaga inherited a comparatively minor territory from his father and appeared to be heading for quick extinction when his lands were invaded by the hosts of Imagawa Yoshimoto in 1560. Nobunaga, however, took advantage of a lull in Yoshimoto's advance while the latter was enjoying the traditional head-viewing ceremony in a narrow gorge called Okehazama. A fortuitous thunderstorm cloaked Nobunaga's final movements and allowed him to take the Imagawa samurai completely by surprise. The victory at Okehazama thrust Nobunaga to the forefront of Japanese politics and samurai glory. Using a combination of superb generalship, utter ruthlessness, and a willingness to embrace new military technology such as European firearms, Nobunaga began the process of reunification of Japan.

Oda Nobunaga was killed when Akechi Mitsuhide, one of his subordinate generals, launched a surprise night attack on him in the temple of Honnōji, in Kyoto, in 1582. Mitsuhide had taken advantage of the absence from the scene of nearly all his fellow generals—but one of them, Toyotomi Hideyoshi (1536–1598), hurried back from a distant campaign to vanquish Mitsuhide at the battle of Yamazaki. Basking in the honor of being the loyal avenger of his dead master, Hideyoshi hurried to establish himself in the power vacuum that Nobunaga's death had created. In a series of brilliant campaigns, Hideyoshi either eliminated or thoroughly neutralized any potential rivals, including Nobunaga's surviving sons and brothers. Over the next five years, Hideyoshi conducted campaigns that gave him the islands of Shikoku and Kyūshū, and when the daimyō of northern Japan pledged allegiance to him in 1591, Japan was finally reunified.

Unfortunately for Hideyoshi, his ambitions did not stop at Japan, and in 1592 he sent tens of thousands of samurai across the sea in an invasion of Korea. This was to be the first stage of a process that would make Hideyoshi Emperor of China, but the expedition was a disaster. A

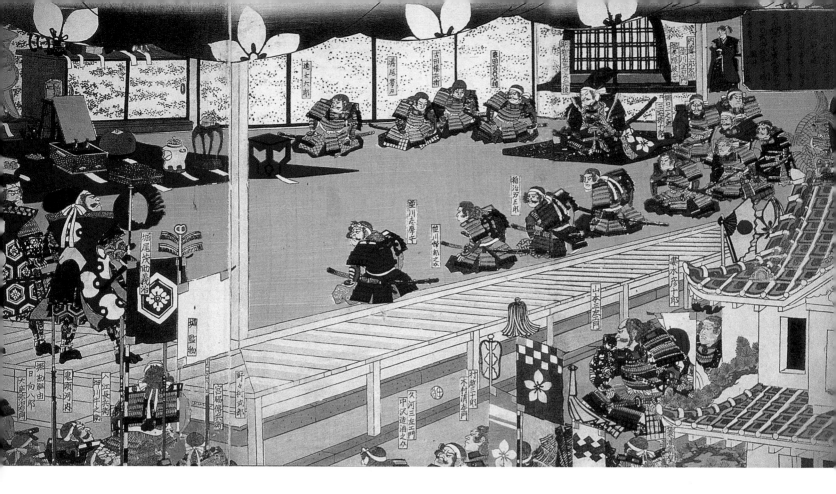

second attempt was made in 1597, but when Hideyoshi died in 1598 the samurai were recalled, and Japan looked as though it was going to slip back into the chaos from which Hideyoshi had rescued it. His son and heir, Hideyori, was only five years old, but when war broke out the matter was quickly resolved at the decisive battle of Sekigahara in 1600. The victor, Tokugawa Ieyasu (1542–1616), could trace his ancestry back to the Minamoto, and was therefore proclaimed shogun in 1603. The final remnants of the supporters of Toyotomi Hideyori were defeated at the siege of Osaka Castle in 1614–1615. Apart from the short-lived Shimabara Rebellion of 1637–1638, the Age of Warring States was over. The triumph of the Tokugawa family finally provided a period of stability. They ruled Japan with a rod of iron until the mid-nineteenth century, when the arrival of foreign voyagers and traders forced Japan to enter the modern world.

Changes in Warfare

Although the structure of a daimyō's army changed greatly over time, there was always a basic distinction between the samurai and the foot soldier. At the time of the Onin War, the samurai were still the elite troops, the officer corps, the aristocracy, while the foot soldiers were lower-class warriors recruited from the daimyō's estate workers. Over the years, the lawlessness of the times led to another source of supply for foot soldiers, and a daimyō's loyal and long-standing infantry found themselves fighting beside, and

often outnumbered by, freelance fighters who were casually recruited into an army, enticed by the prospect of loot. These were the ashigaru ("light feet"). They could fight well when the occasion demanded, but they were also notorious for deserting from an army. The successful daimyo were the ones who recognized that ashigaru needed discipline and training to produce modern infantry squads, and soon the term *ashigaru* began to be applied to any nonsamurai soldier who fought on foot.

By about 1530, we see ashigaru used regularly as missile troops, armed with bows, while the mounted samurai fight with spears rather than bows. From the 1550s onwards, the ashigaru bows were augmented by firearms, but for these to be effective the ashigaru had to be placed at the front of an army, the position traditionally occupied by the most loyal and glorious samurai. There was much honor attached to being the first to come to grips with an enemy. To place the lowest-ranking troops in such a position was a challenge to samurai pride, even if the overall tactical plan envisaged the ashigaru's fire merely breaking down enemy ranks to prepare for a spirited charge by samurai, at which point the samurai spear and sword would dominate the fighting. By the 1590s, however, arrangements that placed the ashigaru at the front of an army had become commonplace, showing a profound difference in military attitude. Not everyone approved, and a scornful and snobbish comment in a later chronicle laments that "instead of ten or twenty horsemen riding

out together from an army's ranks, there is now only this thing called ashigaru warfare."

This "thing called ashigaru warfare" was of course nothing less than the emergence of large-scale infantry tactics in an exact parallel to similar developments in sixteenth-century Europe. However, although infantry warfare became increasingly common, it never completely replaced mounted warfare, largely because successful generals had to use a combination of both to their best advantage. But one other more subtle factor was at work: throughout Japanese history, most generals had cherished the notion that samurai were innately superior to foot soldiers, and samurai had traditionally been seen as primarily mounted men. As noted earlier, the popular notion of the samurai swordsman, so beloved of the movie industry, owes more to the time when wars had ceased than to the reality of the battlefield. The major change in the history of horseback fighting was therefore not its overall decline, but a radical difference in how, and with what, mounted warfare was carried out. This was the remarkable development, so often glossed over in historical accounts, whereby the mounted samurai archer of earlier centuries was transformed into the mounted samurai spearman—part of the long struggle for superiority between the cavalry and the infantry.

The Mounted Spearman

The stimulus for the development of mounted spearmen was the practice, noted earlier, of using foot solders as missile troops, and the additional growing trend towards large armies—resulting in the most important change in cavalry tactics in the whole of samurai history. Somehow the samurai horseman had to hit back at the enemy's missile troops, using his mobility and striking power to provide the shock of a charge against the ashigaru. The problem was that a samurai traditionally carried a bow, which was an encumbrance in hand-to-hand fighting, and even if the bow was given to an attendant, swords were of limited use from the saddle. So, in a dramatic change to established practice, the bow was abandoned in favor of the spear, and the mounted archer gave way to the mounted spearman. Some mounted archers were still retained, operating

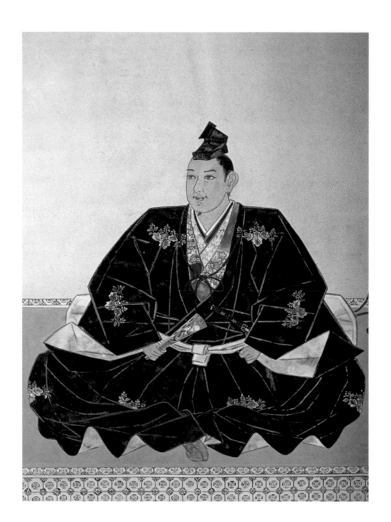

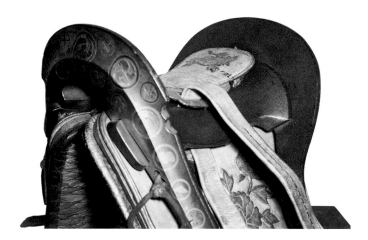

Top: **Ukita Hideie, who was supreme commander following the invasion of Korea in 1592.**

Center: **A samurai saddle.**

Right: **A pair of iron stirrups.**

Opposite: **A samurai defends himself with his sword against a dismounted samurai armed with a spear. This was a dangerous position for a horseman to be in, because the spearman on foot could keep him at a distance.**

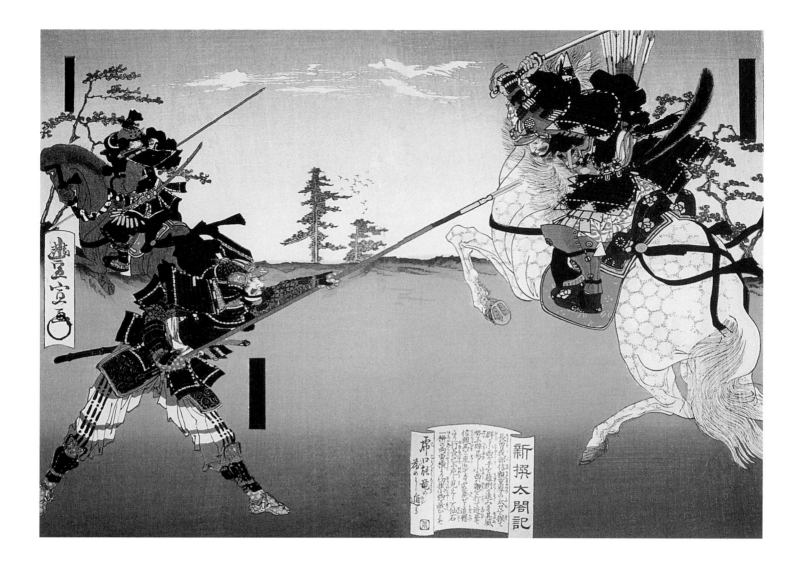

as mobile sharpshooters, but the majority of samurai now carried *yari* (spears), fitted with blades that were every bit as sharp as their swords. *Yari* is sometimes translated as "pike," but the European pike was never carried by cavalrymen, and even the large squads of ashigaru spearmen wielded their *nagaeyari* (long-shafted spears) far more freely than did their European counterparts.

The spear's blade was protected from the weather when not in use by a lacquered wooden scabbard. Some samurai preferred short spear blades, while others liked long ones. Blade lengths varied enormously, from about 10 centimeters (4 inches) to 1.5 meters (5 feet). A fine, if much damaged, specimen of a samurai's spear is preserved in the Sainenji, a Jodō temple in Tokyo. The spear was presented to Hattori Hanzō (1541–1596) by Tokugawa Ieyasu, and was then donated to the temple as a votive offering. The weapon suffered damage during the firebombing of Tokyo in 1945, losing 30 centimeters (12 inches) from its blade and 150 centimeters (59 inches) from its shaft. Having examined the spear, I have been able to calculate its original dimensions: a shaft length of

3.1 meters (10 feet), on which was mounted a straight blade that was 5 centimeters (2 inches) wide and 127 centimeters (50 inches) long. The total length of the weapon was therefore 4.38 meters ($14^1/_3$ feet), of which the blade made up just over a quarter. The weight of the remaining parts is 7.5 kilograms ($16^1/_2$ pounds), indicating that the original weight was about 12 kilograms ($26^1/_2$ pounds). The size and weight of the Hanzō spear probably indicates an upper limit to the size of a long-bladed spear that could be wielded from a saddle.

Long-shafted spears often had much shorter blades, and several specimens exist that have been fitted with cross-blades to pull an opponent from his saddle, an example being Katō Kiyomasa's spear preserved in the Hommyōji temple in Kumamoto. At the siege of the Hōjō's castle of Takiyama, Takeda Shingen's son and heir, Katsuyori, made a name for himself while using a *kama-yari* (a spear with an additional cross-blade like a sickle), a weapon traditionally said to be invented by the monk Inei of the Hōzō-In Temple.[1] The *yari* thus gave its bearer the advantage of a weapon as useful on foot as on horseback,

so the range of options for samurai was extended from that of elite missile troops to a role of considerable versatility. Spear techniques were therefore developed to enable the samurai to use this weapon in any situation: from horseback, in a charge on foot, or defending castle walls. The painted screens and scrolls of the period show the use of spears from horseback. Ashigaru are run through, while rival horsemen are transfixed through the neck and lifted off their saddles. Spears are also very much used in the siege situation, and several Japanese prints show spears being thrust through loopholes in castle walls. Prior to the Battle of Tennōji, which brought to an end the siege of Osaka in 1615, the Tokugawa commanders ordered their samurai to leave their horses at the rear and to go in on foot with spears.[2]

The yari, therefore, permitted the samurai to defend himself and take the fight to his enemies, in a way that the exclusive use of a bow had never allowed. Spear techniques from the saddle also meant that, for the first time in Japanese history, a samurai army could deliver something recognizable as a cavalry charge. Such techniques from horseback must have been practiced alongside yabusame, but there is a dearth of references as to how this was actually done. The nearest form of martial art to equestrian yari-jutsu (spear fighting) would appear to be dakyū. This was the Japanese equivalent of polo, and is said to have the same roots as polo, in Central Asia. Dakyū was played between two teams of five riders each. There was only one goal post, on which either red or white flags were raised when a team scored a goal. The game concluded when twelve balls had been played. Although popular in the Nara period, dakyū went into a decline until being revived by the shogun Tokugawa Yoshimune (1677–1751), who was an enthusiast of the martial arts. Dakyū riders wielded a long pole with a net at the end, making the action more like mounted lacrosse than Western polo, but the benefits for training a mounted samurai are obvious.

Above: **A sketch by Hokusai showing *yabusame* and *dakyū*, two Japanese versions of polo.**

Opposite: **A painted scroll depicting Honda Tadakatsu (1548–1610), showing how a samurai in armor could be armed with two swords and a dagger.**

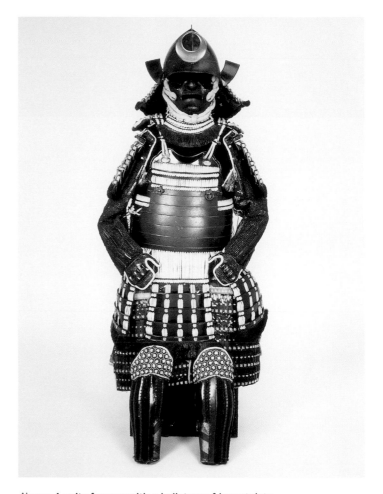

Above: **A suit of armor with a bullet-proof breastplate.**

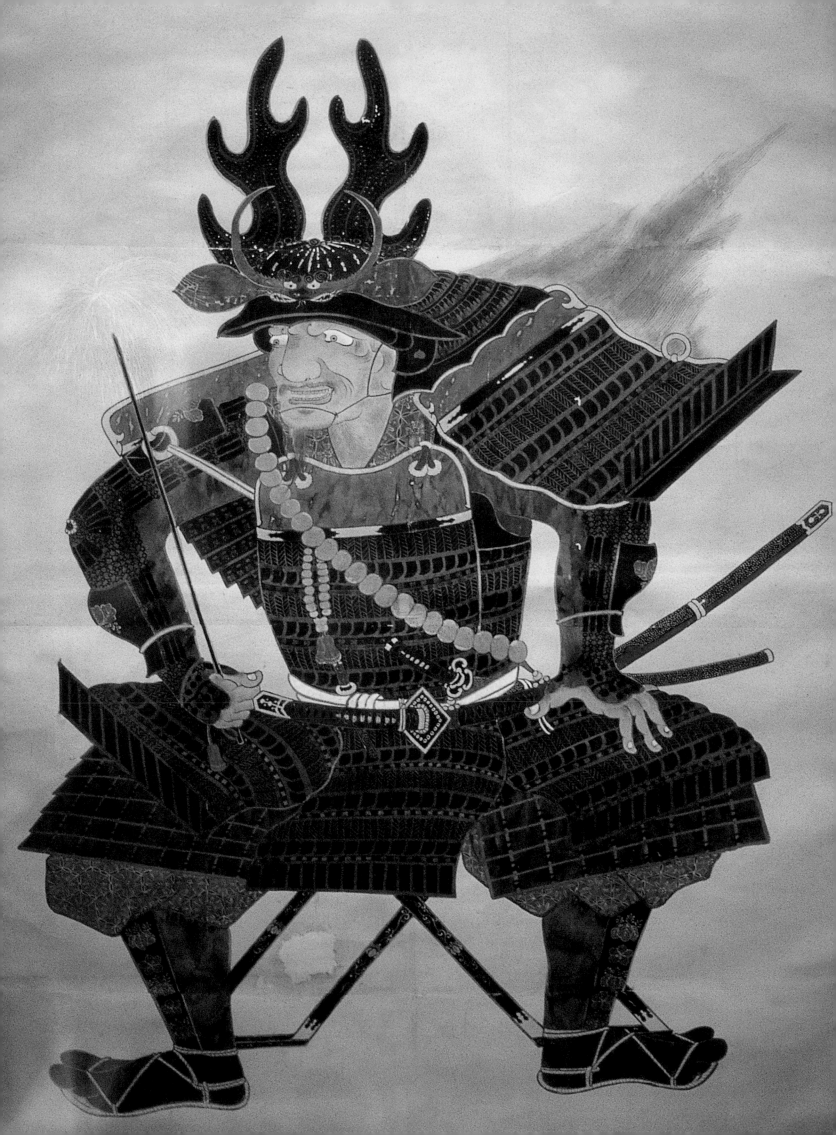

The Sword in Battle

A samurai in civilian dress—that is, when not wearing a suit of armor—would rarely have been seen without the traditional two swords thrust through his belt. The longer one was the katana, which had evolved from the earlier tachi and uchi-gatana. The shorter of the pair was the wakizashi. The two would almost invariably have been mounted and decorated similarly to make a pair (daishō), and were the distinguishing badge of the warrior class. Contrary to popular belief, the two swords were often worn when the samurai was in armor. The lower-ranking ashigaru would wear both swords thrust through the belt underneath their simple armor, with the hanging cords of the skirt armor draped over the scabbards. The more elaborate armor worn by a samurai may have precluded having the swords thrust through either the under-belt or the over-belt, but his katana could alternatively be slung from an extra sword belt, like the older tachi. The wakizashi could accompany it in the same sword carrier, or be thrust through the over-belt. However, we also encounter tantō (daggers) being worn, as in the contemporary illustration on page 55 of Honda Tadakatsu, who is armed with these three edged weapons.

Sword fighting from a horse had never been easy, because the normally two-handed katana had to be used in one hand, but this disadvantage was somewhat overcome by the samurai's position above a foot soldier, and the momentum of his horse. The process was helped by the curvature of the sword's blade, which allowed the very hard and very sharp cutting edge to slice into an opponent along a small area that would widen as the momentum of the swing continued to cut through to the bone. Sixteenth-century designs for armor also made swordplay from a horse much easier than it was when wearing the boxlike yoroi. Some very long swords existed, and these allowed the horseman to reach down at his victim. These ōdachi or nōdachi (long swords) were sometimes only partially sharpened, with the lower half of the blade being left blunt and used more like a mace.[3]

As for inflicting casualties, in the press of battle the swinging of a sword was greatly restricted, and Japanese armor gave good protection, so it was rare for a man to be killed with one sweep of a sword blade, unless the blow was so powerful that it split an opponent's helmet in two. It was boasted of the samurai Maehara Chikuzen-no-kami that he could "smash a sixty-two-plate helmet."[4] The armor of the sixteenth century was also stronger than a yoroi, thus giving better protection, as well as being better designed. The weight was more evenly distributed around the body rather than concentrated on the shoulder straps. The okegawa-dō, for example, was virtually a solid-plate

Above: **Maeda Toshiie (1538–1599) of Oda Nobunaga's Red Horō Unit, shown wearing a _horō_, the cloak stretched across a frame that was the mark of a distinguished samurai.**

Opposite: **A samurai on horseback uses his sword to overcome an enemy. He has cut him so violently that his victim's sword has flown out of his hands.**

cuirass, similar to contemporary European armor. Clearly recognizable too, was a reduction in the number of cords that tied the armor plates together. Instead of the _kebiki-odoshi_ style of numerous closely woven cords, _sugake-odoshi,_ spaced out braiding, meant less weight, and a savings in time for busy makers of armor. A face mask was also introduced, which as well as protecting the face, served as an anchor point for the cords of the helmet. Smaller _sode_ (shoulder guards) also served the samurai's role as a mounted spearman without taking away from his role as a mounted archer. Those who still liked to discharge arrows at a gallop would have found the new styles of armor much more convenient. All in all, the armor of the Sengoku was a solid and practical battledress, giving the maximum protection and allowing the freest movement

that current technology could provide.

Thus, when spears replace bows we do not see a shift to swords as a primary weapon. Instead, swords are now secondary to spears, and most references to sword fighting are still concerned with fighting on foot. In the chapters that follow, we will see many stories of swordsmen, but nearly all take place off the battlefield. On the battlefield, there was much fighting, but often little in the way of artistic sword technique. Nor was there much scope for the brave lone samurai. At this period, the lone warrior was less prized as an individual fighter than at any time in Japanese history. The great "individuals" of the Age of Warring States were men who commanded others and set an example by the excellence of their fighting in the press of battle, rather than samurai renowned for selfish feats of individual glory. It was therefore the age of samurai armies, rather than of samurai, but now and again the individual spirit did assert itself, as a surprising number of examples show—some of which we will examine in this chapter. We will also note the genuine, and perhaps slightly nostalgic, pride that commanders took in their followers when this occurred (provided, of course, that it did not interfere with the overall aim of the army), as in this description from the *Iranki*:

> An inhabitant of Koga, Mochizuki Chōtarō, was a soldier big and strong, and a hot-blooded warrior. He had a large sword 4 *shaku* 5 *sun* (about five feet) long, which he brandished crosswise as he fought. He furiously mowed down opponents as he went around with this sword. One person who had fled, an inhabitant of Shimotomoda called Yamauchi Zae'mon-dono, seeing this, unsheathed his sword and advanced to meet Chōtarō to cross swords with him. Chōtarō accepted the challenge, and advanced to kill him. He parried the sword stroke, and then suddenly struck at him and broke both his legs. He killed him without hesitation. He was a splendid master of the Way of the Sword, the model and example of all the samurai in the province.[5]

Swords, however, were just one item in the samurai's toolbox, and just as a hammer will not do the job of a screwdriver, so a variety of weapons were needed for a variety of circumstances. Confirmation that this attitude was common during the Age of Warring States comes from no less a person than Miyamoto Musashi, the swordsman par excellence. In his *Gorinshō (The Book of Five Rings)*, Musashi writes:

> There is a time and place for the use of weapons. The best use of a companion sword is in a confined space, or when you are engaged closely with an opponent. The long

sword can be used effectively in all situations. The halberd is inferior to the spear on the battlefield. With the spear you can take the initiative; the naginata is defensive. . . . The bow is tactically strong at the commencement of a battle, especially battles on a moor, as it is possible to shoot quickly from among the spearmen. . . . From inside fortifications the gun has no equal among weapons. It is the supreme weapon on the field before the ranks clash, but once swords are crossed the gun becomes useless. . . . You should not have a favourite weapon. To become over-familiar with one weapon is as much a fault as not knowing it sufficiently well.[6]

These sentiments are echoed in *Heihō Okugishō*, one of the earliest treatises on the Japanese martial arts. It is attributed to Yamamoto Kansuke, who was one of Takeda Shingen's "Twenty Four Generals." He was killed at the Fourth Battle of Kawanakajima in 1561. Kansuke states:

> There are all kinds of weapons, both short and long, which I have studied and learned how to use. However, knowing when and how to use them in battle was difficult to learn because small details were different in each battle. When fighting was done at a considerable distance, bows and arrows and guns were effective. When fighting was somewhat closer, spears and long-handled weapons were effective. When fighting was close enough for hand-to-hand fighting, the short swords were effective.[7]

Heihō Okugishō includes practical advice on how to wield sword, spear, bow, and gun from the point of view of the individual warrior, rather than for a troop of ashigaru. Much of it is very matter-of-fact:

> When attacking a castle, keep the wall of the castle on your right side because if you were in the middle of a crowd you would find it hard to move. There are four good reasons for leaving the wall on your right side. One, it is easier to move along the wall; two, it is easier to use your weapon; three, you are safer against arrows when you are not standing in the centre; four, you will find it easier to get into the castle and distinguish yourself.[8]

Kamiizumi Nobutsuna—the Master Swordsman

We conclude this chapter with a handful of examples that record individual prowess, particularly with a sword, in the midst of a battle. We begin with the great swordsman Kamiizumi Ise-no-kami Nobutsuna (1508–1577), whose

Right: **The death of Takeda Nobushige, the brother of the famous Shingen, from gunfire at the Fourth Battle of Kawanakajima, in 1561.**

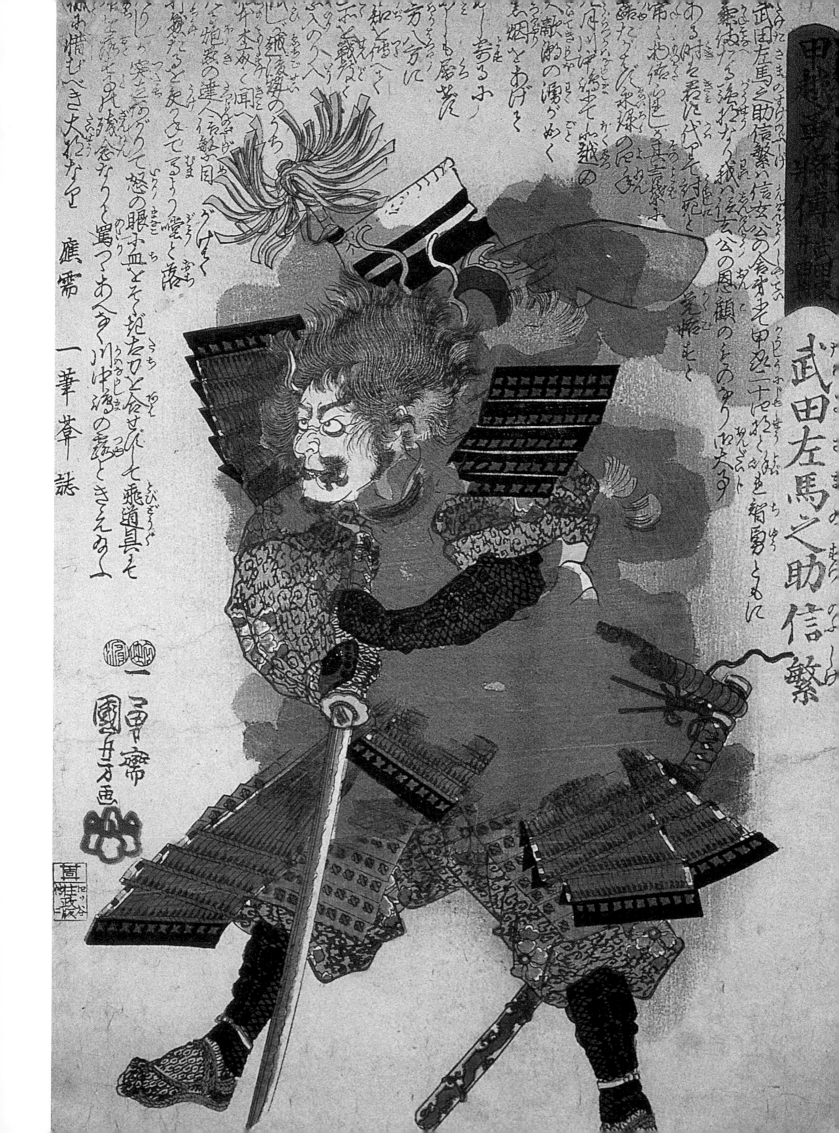

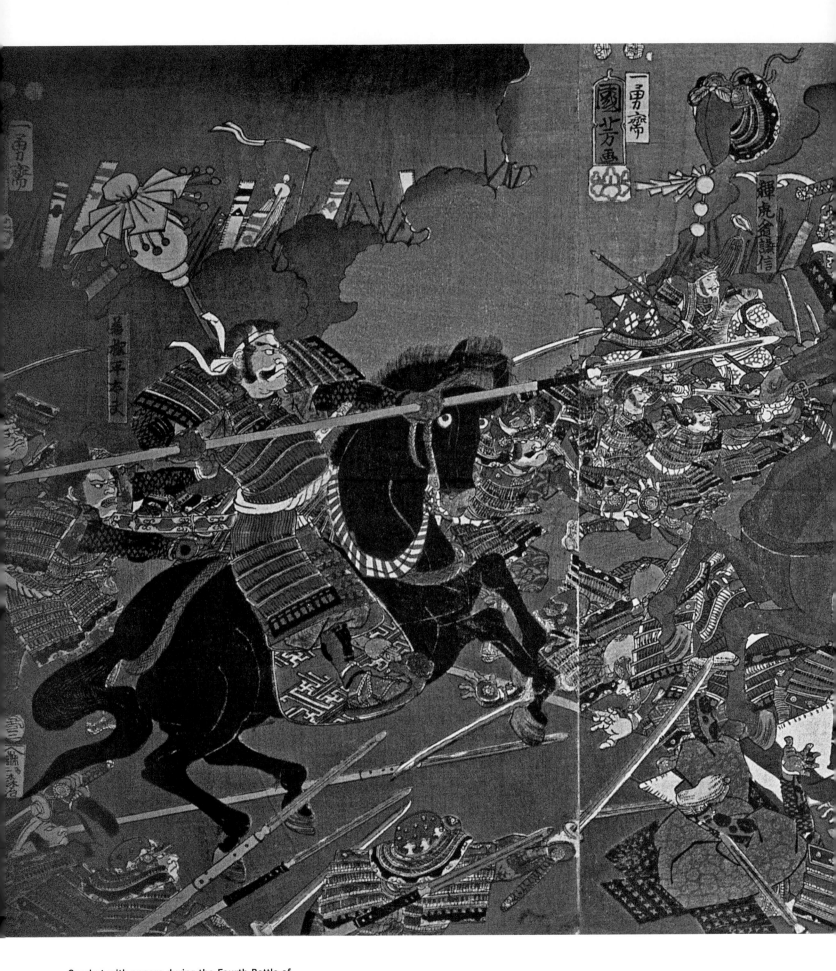

Combat with spears during the Fourth Battle of
Kawanakajima, in 1561.

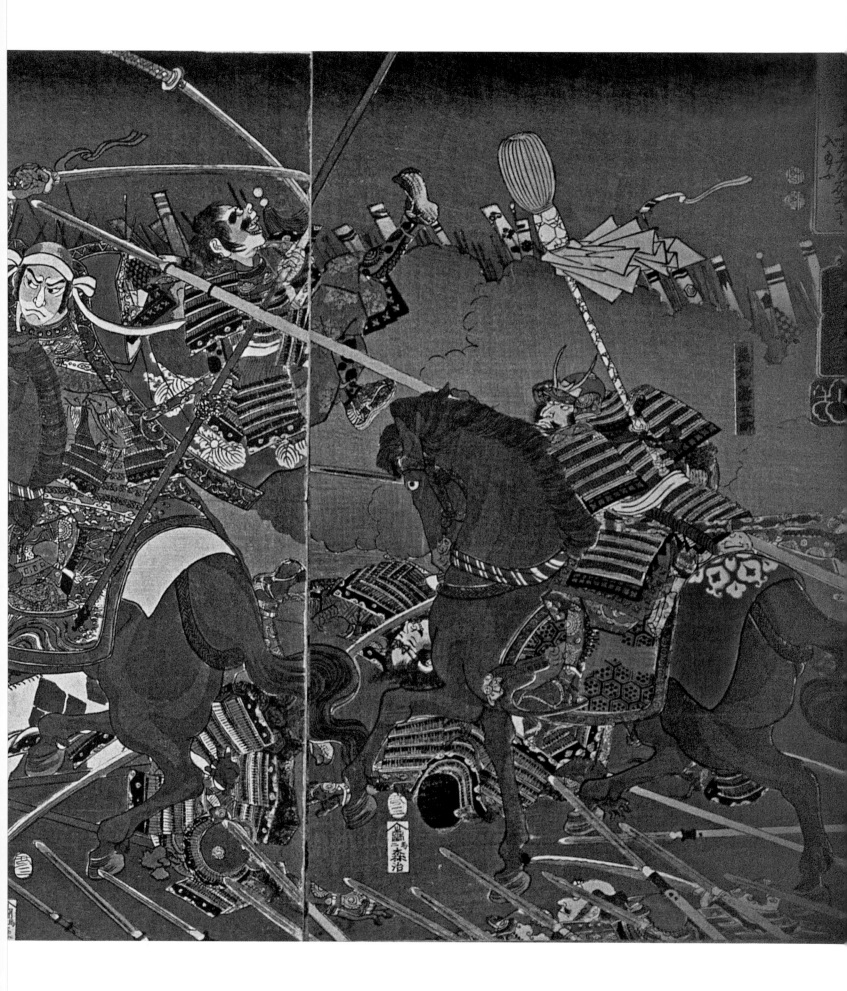

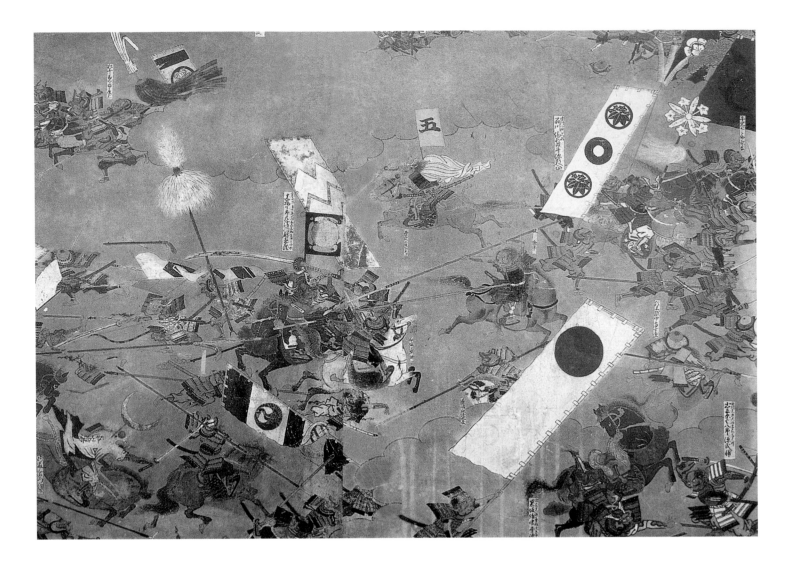

the other, was almost entirely a hand-to-hand affair that produced a remarkable number of single combats. Among them was a series of actions that were fought not for individual glory but to cover a fighting retreat, thus placing these individual combats firmly in the mode of an action done for the greater good of an army. Much of the fighting at the Anegawa was conducted in the river itself, which was sluggish and about three feet deep. We read of samurai fighting furiously, the sweat pouring off them and mingling with the waters of the river, which soon were stained with red.

The most celebrated encounter happened when Honda Tadakatsu launched a flank attack, which was so successful that Asakura Kagetake, the commander in chief, was completely surrounded in the furious melee. It was essential that the Asakura army withdraw to the northern bank, and a certain samurai called Makara Jurōzaemon Naotaka, a retainer of the Asakura family, volunteered to cover their retreat. Makara Jurōzaemon was apparently a giant of a man, who carried a nōdachi sword with a blade over five feet long. Like the samurai of old, whose stories he would have been told as a child,

Makara bellowed out his name. His challenge was first accepted by a vassal of the Tokugawa called Ogasawara Nagatada, whom Makara killed. He was then joined by his eldest son Makara Jurōsaburō Naomoto, and together father and son faced repeated attacks by Tokugawa samurai, as the Asakura withdrew, until both were killed. But their sacrifice was not in vain, because their rearguard action allowed the army to rally, even though they were then pursued for a considerable distance. That put paid to the Asakura, but farther upstream, the Asai soldiers had reversed the positions, and another single combat took place. A samurai of the

Above: **During the Battle of the Anegawa, in 1570, Makara Jurōzaemon deliberately engaged the opposing army in a series of individual combats, in order to give his own side the chance to regroup. He fought from horseback, and wielded a** *nōdachi*, **an extra-long variety of sword. He is shown in action here on a painted screen depicting the Battle of the Anegawa. (Fukui Prefectural Museum)**

Opposite: **A dismounted spearman has at his mercy a samurai who has fallen from his horse. The spearman is ready to deliver the killing thrust. The spear enabled the samurai to fight in a wider range of situations: from horseback, on foot, or defending castle walls.**

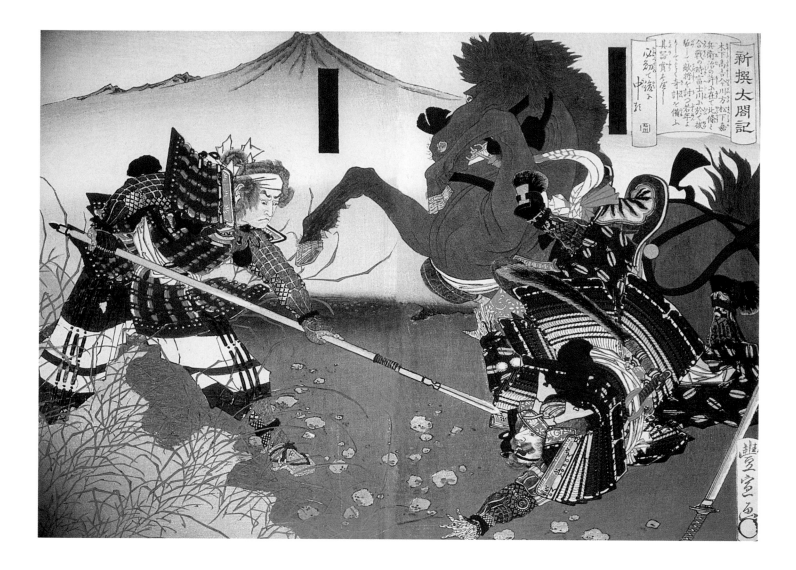

Asai called Endō Kizaemon had resolved to take Nobunaga's head, and had fought his way by hand-to-hand sword fighting into the headquarters post. He was only cut down when he was quite close to his target.

The Seven Spears

The best evidence that the generals of the Warring States period still valued individual fighting skills, and did not regard their samurai as a mass of anonymous cannon fodder, is the tradition of naming the seven most valiant warriors in a battle the *shichi hon yari,* or the "seven spears." Thus we have the Seven Spears of Azukizaka, and best known of all, the Seven Spears of Shizugatake.

Shizugatake was a frontier fortress that belonged to Toyotomi Hideyoshi and was besieged by Sakuma Morimasa in 1583. Sakuma Morimasa led fifteen thousand troops, and ten hours before attacking Shizugatake, he had achieved a considerable success by capturing the fort on the neighboring summit of Oiwayama. But the orders of his commander, Shibata Katsuie, had been to attack only Oiwayama, and to withdraw inside it. Sakuma chose instead to disobey Shibata's orders and concentrate

on capturing one further prize. Shizugatake would be his before night fell, and he dismissed out of hand any suggestion that Hideyoshi could come to its relief. Six times Shibata Katsuie sent the order, and six times Sakuma refused to comply.

By now a messenger had galloped the thirty-two miles to Ogaki with the intelligence for Hideyoshi that Oiwa and Iwasaki had fallen, and that Shizugatake was likely to follow. Very early in the morning of April 20, 1583, Hideyoshi made ready to rush back to Kinomoto. The only way he could achieve surprise was by taking an entirely mounted army with him, while the infantry and supplies marched along far behind. It was an enormous risk to separate the different units of his army in this way, but it was a chance that Hideyoshi had to take. Burning pine torches lit their way as Hideyoshi's army of one thousand mounted samurai hurried along the familiar and well-trodden road. The first that Sakuma Morimasa knew of their arrival was the sudden appearance of a thousand burning pine torches down in the valley. Then, following a signal from a conch shell trumpet, blown, it is said, by Hideyoshi himself, his eager and impatient

men poured up the mountain paths towards Shizugatake and Sakuma's siege lines.

Battles fought on the tops of mountains are not a common occurrence in military history. Even in Japan, where mountains are plentiful and many have castles or the remains of them on their summits, mountaintop conflicts tended to be either sieges or actions fought in the valleys below, with the hilltops being used solely as vantage points. This is what makes Shizugatake almost unique. It was not a siege, but a field engagement—except that the "field" lay on the tops and along the

ridges of a wooded mountain chain. The first armed contact was made as dawn was breaking. Numerous small group and individual combats took place all along the mountain paths, and in among the trees, with Hideyoshi's mounted vanguard playing a leading role. Spears, swords, and daggers decided the outcome of Shizugatake, not blocks of ashigaru spearmen, and the heroes of the hour were the valiant Seven Spears of Shizugatake, who were all members of Hideyoshi's own mounted bodyguard.

Leading Hideyoshi's vanguard was a young warrior

called Katō Kiyomasa, eager to take part in his first major encounter. Wielding a cross-bladed spear, Kiyomasa confronted one of Sakuma's most experienced generals. Abandoning their spears for bare hands, the two grappled, and the agile young Kiyomasa employed some yoroi-gumi techniques that turned the older man's strength against himself. The two samurai fell off the edge of a cliff, and Kiyomasa, who survived, cut off the older man's head. Another young samurai, one year senior to Kiyomasa, who also distinguished himself at Shizugatake, was Fukushima Masanori. He attacked a prominent samurai called Haigō Gozaemon and ran him through with his spear, the spear point entering Haigō's armpit and penetrating through to his stomach. Five more samurai earned great honor for themselves at the Battle of Shizugatake, and together with Katō Kiyomasa and Fukushima Masanori became known as the Seven Spears of Shizugatake.

Above: **Mounted mayhem during the Battle of Shizugatake, in 1583.**

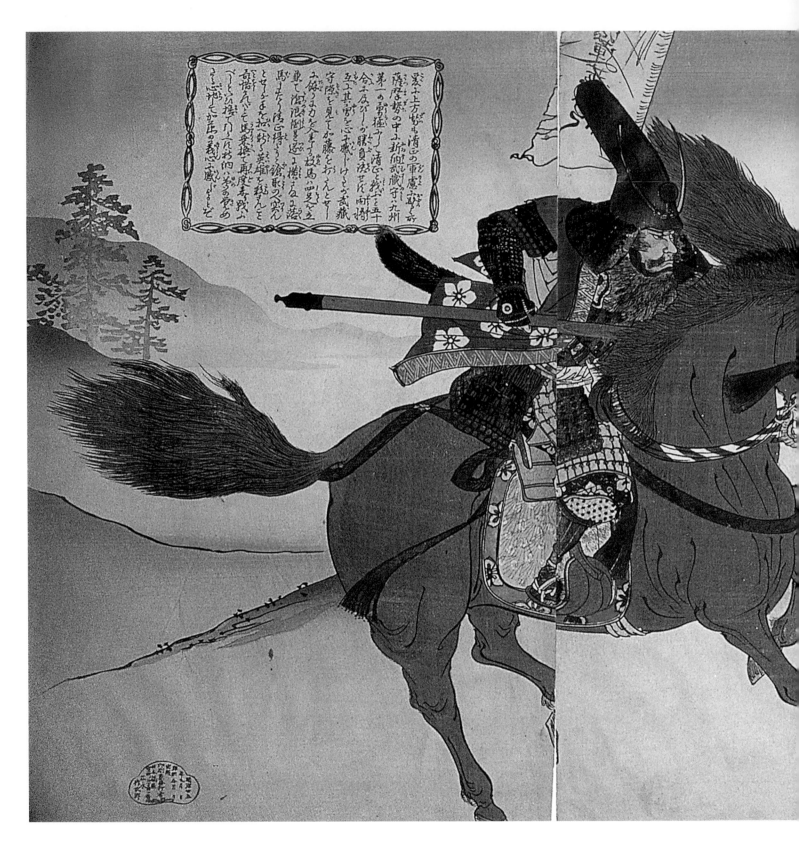

衆十方勢も清正の軍慮六郎と有
薩摩陣の中み新納武蔵守・九州
第一の勇猛守て清正に我に五十
合え以か一つ勝負致たしと町挿
弓て其前を応そ蔵トけるとの武蔵
守陣を見て清正郎藤をおろと十
之海うる力を盡す藤をおろと十
馬なくして候を逃す遊る遊て
事て淘酒御を近く橋寺る四見之立
馬飞又た堀っ得よう橋久安へ
とせうまた堀るっ街蔵を殺んと
と身英雄を殺んと
高橋ろえつて再鶴寿残へ
べ亭六撮り月々作内弟子堂め
う亭御六とか戻の裁心て感がとぞ

The Sword in Korea

Toyotomi Hideyoshi's invasions of Korea in 1592 and 1597 provided the opportunity for Japanese swords to be compared with their mainland Asiatic counterparts. At the Battle of Pyokje-yek in 1593, it was noted that Japanese swords cut deeply into the armored coats of the Ming soldiers, and when the Japanese captured Namwon, Korea, in 1597, some fierce swordplay took place. The Japanese assault party under Okochi Hidemoto was faced with a counterattack from mounted men, yet even in all this confusion and danger, the personal credit for taking a head was all-important:

Okochi cut at the right groin of the enemy on horseback and he tumbled down. As his groin was excruciatingly painful from this one assault the enemy fell off on the left-hand side. There were some samurai standing nearby and

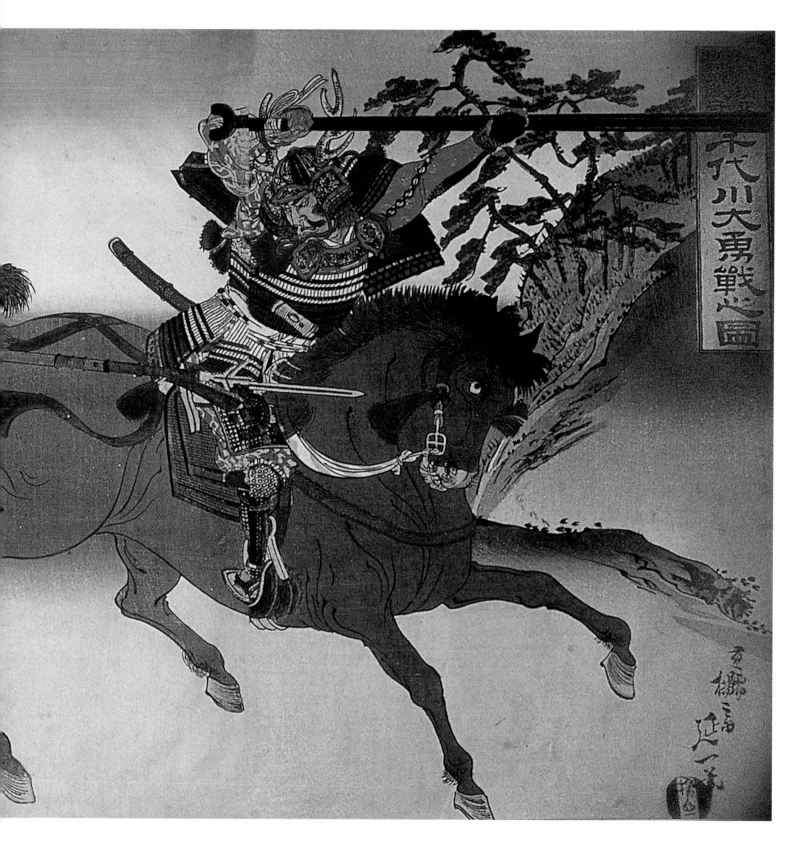

three of them struck at the mounted enemy to take his head. Four men had now cut him down, but as his plan of attack had been that the abdominal cut would make him fall off on the left, Okochi came running round so that he would not be deprived of the head.[11]

Soon Okochi Hidemoto himself became a casualty. He was attacked by a group of Koreans and was knocked to

the ground. As he was getting up, several sword cuts were made to his chest, leaving him crouching and gasping for breath. His comrade Koike Shinhachiro came to his aid, while Hidemoto parried five sword strokes with the edge of his blade. A sixth slash struck home, severing the mid-

Above: **A mounted fight between Katō Kiyomasa and his opponent.**

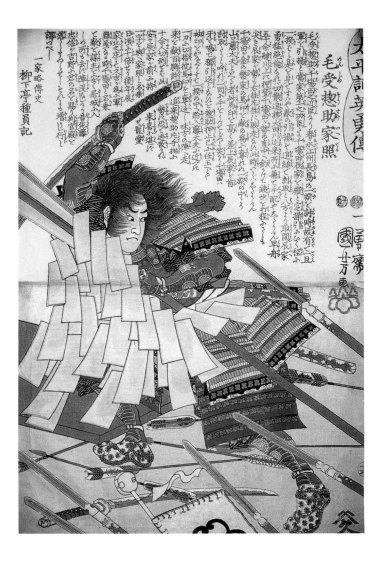

dle finger of his bow hand, but he still managed to rise to his feet, and quickly decapitated his assailant. Advancing more deeply into Namwon's alleys, Hidemoto encountered another strong man dressed magnificently in a fine suit of armor over a dark blue brocade coat. Hidemoto "was cut in four places on his sleeve armour, and received two arrow shafts that were fired deeply into his bow arm in two places," but in spite of these wounds, he managed to overcome the man and take his head.

The Unwelcome Combat

We conclude this chapter with an account of another swordsman who had the opportunity to display his skills on the battlefield. Like Kamiizumi Nobutsuna, Ono Tadaaki was a great *sensei* (teacher), who inherited the leadership of the Ittō-ryū. Tadaaki served the Tokugawa family as a ken-jutsu instructor, and when war came, he fought alongside his companions in the army. He belonged to the army of Tokugawa Ieyasu's son Hidetada, a contingent that missed the Battle of Sekigahara because they were delayed along the Nakasendō Road by laying siege to Ueda Castle, in 1600. The castle of Ueda

was defended by the Sanada family, who realized the opportunity they had of splitting the Tokugawa army, and therefore allowing their ally Ishida Mitsunari time to destroy the main body. Consequently, Ueda was defended more stubbornly than at any similar siege, and in fact is regarded as one of the three classic sieges of Japanese history where the defenders were ultimately successful.

Ono Tadaaki held the title of *karita bugyō,* or "commissioner for harvested rice-fields," a position whose primary purpose was to ensure that crops were not looted. As there were other disciplinary functions, the post did not make the holder the most popular warrior in the army. It was a responsibility akin to being in charge of the military police. One day during the siege of Ueda, as Tadaaki was making his regular tour of inspection, he saw a samurai approaching from the besieged castle, waving a spear and shouting what appeared to be a challenge. For a challenge to be shouted against a fortified line in the year 1600, when a hundred arquebusiers had their weapons trained on any encounter, was an unusual event—and perhaps just one further example of the clever Sanada's delaying tactics. However, the curious Tadaaki responded to the shout by heading over the line towards the challenger, closely followed by another samurai called Tsuji Tarōnosuke. As the two samurai approached him, the challenger thought better of his impetuosity, turned on his heels, and fled, but as Tadaaki and his companion reached "no-man's land," they discovered two other enemy soldiers who were obviously on a reconnaissance mission. The way they couched their weapons when they saw Tadaaki also convinced him that the two were good swordsmen. Sensing the opportunity of a rare occasion to display his skill, Tadaaki drew his sword.

Two individual combats therefore began. Tadaaki skillfully parried the spear strokes of his opponent, and felled him with the fourth blow of his sword. Had the man not been heavily armored, one might have expected the first blow to be fatal. Tadaaki's comrade in arms cut through the spear of his own adversary, whose nerve then cracked. He turned and fled, so the frustrated Tarōnosuke contented himself with delivering a bad-tempered stroke to the already prostrate body of Tadaaki's foe, who, it was to be revealed, was a high-ranking retainer of the Sanada, called Yoda Hyōbu. Tadaaki and Tarōnosuke withdrew to the lines under a barrage of arquebus fire from the castle, leaving the Sanada samurai to take away the body.

There followed a most unusual episode. Tadaaki reported the deed to his superior officer, only to find that Tsuji Tarōnosuke had already reported that he himself had killed the man. So vigorously did each samurai argue

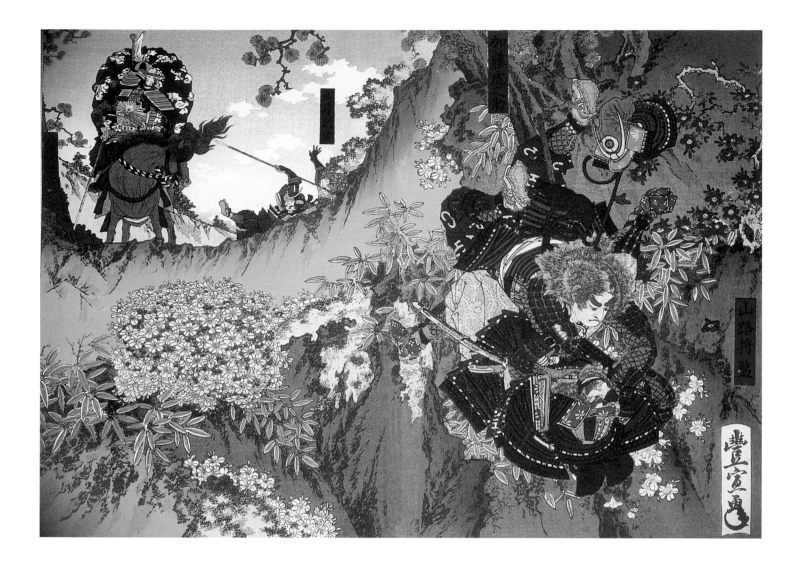

his case that an inquiry was set up, and the claim seemed to hinge on identification, and on whether or not the victim, who had worn red lacquered armor, was also wearing a face mask at the time. Tadaaki claimed that he was not; Tarōnosuke said that he was. To settle the matter, the Tokugawa hierarchy went so far as to send spies into Ueda to discover the truth about the dead man, and when they reported that he had not been wearing a face mask, Tadaaki's story was vindicated.

But the unusual episode was not quite over, because Tadaaki, in pursuing the challenge, had broken ranks without permission for a private battle, and had therefore committed a breach of military law—quite a contrast to the days of the Gempei War! Tadaaki was found guilty and sentenced to a year's probation. This was a strange end to an individual combat, but what is more remarkable is that none of Tadaaki's comrades spoke up on his behalf. Perhaps there was some resentment of Tadaaki because of his position as karita bugyō, but there may also have been a feeling that to seek for individual combat was now counterproductive behavior for a samurai, and that Tadaaki's action, far from being admirable, was

one to be condemned even by his fellow samurai—a clear reversal of the popular perception of single combat.[12]

So what are we to make of the samurai swordsman of the Age of Warring States? In spite of the large-scale use of ashigaru missile troops, and the ordering of bodies of mounted spearmen, there was still some scope for the skilled individual to demonstrate his talents, but it was a drastically reduced scope. However, the references above to the existence of schools and teachers, and particularly the desire of swordsmen to decline further service in battle in order to travel the country and improve their skills, suggest another world, where the arts of the samurai swordsman could flourish unhindered. This is the topic to which we will now turn.

Above: **Katō Kiyomasa, one of the Seven Spears of Shizugatake, used grappling techniques against an enemy samurai until both fell off the side of a cliff, and Kiyomasa cut off the other's head.**

Opposite: **Menju Ietora plunges into the thick of the fighting to rescue the** gohei **standard of his master, Shibata Katsuie. A** gohei **is an implement used for blessings in Shinto.**

CHAPTER 4

SWORD AND SAMURAI

There is no more popular image of the lone samurai than that of the wandering swordsman, traveling from place to place, fighting duels, and then wandering once more. For many people, this wandering figure *is* "the samurai," with the figure of the mounted archer or the swordsman on the battlefield as a dimly perceived shadow of reality.

This character has been personified most memorably for my generation by the great actor Toshiro Mifune in such films as *Sanjurō* and *Yōjimbō*. Most of the wandering characters that Toshiro Mifune has portrayed are *rōnin*, literally "men of the waves": samurai who have no master, owing to the destruction of their clan in battle, the disgrace of their master, or personal dismissal. The "seven samurai" in the famous film of the same name, which is set in the year 1587, are all rōnin, and the long wars of the Age of Warring States meant that there was no shortage of dispossessed samurai seeking work for their swords. The background to *Seven Samurai* is therefore an accurate one, although most actual rōnin did not wander for long. Daimyō competed with each other for high-quality men to defend and expand their territories.

Of course, Toshiro Mifune's roles are fictional characters whose exploits and personal skills are often greatly exaggerated. The real "wandering swordsmen" of history were often not rōnin with swords for hire, but kengō (master swordsmen) like Kamiizumi Nobutsuna, who chose not to serve a particular master. They were seeking to challenge worthy opponents and thereby achieve two goals: to develop their skills as swordsmen

and to elevate their practice of swordsmanship on to a spiritual level.[1]

The Samurai Sword

As this chapter will concentrate for the first time on the sword as the primary weapon of the samurai, let us begin by examining that famous object. The Age of Warring States was accompanied by a peak of achievement in the manufacture of the weapons the samurai were to employ, notably in the field of sword making. Compare any museum's rusty specimens of medieval European knights' swords with their gleaming Japanese contemporaries, and it is easy to see how the weapon acquired a legendary life of its own. Even its making is shrouded in mystery, because none of the great swordsmiths ever wrote down their secrets. Everything was passed on from master to favored pupil, based entirely on practical experience gained over centuries, and without the guidance of any modern metallurgical or other scientific principles.

The making of a Japanese sword consisted of a series of complex activities. First of all came the production of a workable quantity of steel from iron ore, which was then worked into a composite blade. There was a hardening process, and a final shaping and polishing. The first stage was a very laborious one, at the end of which the swordsmith possessed a bar of tool steel that could then be subjected to a remarkable, but well-authenticated, process of hammering, notching, and folding. By this method, the single plate was beaten out, then deeply notched, folded over, and again hot-forged

元亀二年三月十一日享年☖

塚原卜傳入道

此本景師志熊寺子院瑞峯精含藏也本祖昌清真逆
塚原公業長坡騰寓八藏於巖中有年頃日廣島
松岡君末防說次及此因不顧批酒秋寬八贈之

嘉永二年
酉四月・栗原信充

so that the surfaces welded tightly together. This process was repeated, sometimes as many as thirty times, producing numerous laminations in the steel structure. This gave the blade a tremendous strength, and the capacity to be ground to a very sharp edge.

No smith, however, was satisfied to produce a sword from just one piece of tool steel. For all but the simplest daggers, the sword blade was of composite construction, combining an extreme hardness—and therefore potential sharpness—of its cutting edge and a resilient cushion for a body. To achieve this, an envelope of tool steel was wrapped around a core of very hard, low-carbon laminated steel. A certain few swordsmiths used an even more complicated arrangement of three or four types of steel bound together. The crude sword blade was then shaped until it was almost at its final form, leaving very little metal to be removed in sharpening and polishing. It was then prepared for heating and selective quench-hardening, which involved plunging the hot blade into cool water. To make sure that the back of the blade, which would take the shock waves of a cut, was not itself hardened, the whole blade was

encased in a stiff paste of clay and water, which was scraped away almost completely from the cutting edge. The blade was next brought to the desired temperature (monitored solely by color—one of the most vital trade secrets of all), then placed horizontally into a trough of water, again kept at a critical and secret temperature. One of the many legends about the old swordsmiths tells of a greedy apprentice who attempted to discover the secret of the correct temperature by dipping his fingers in the trough—and was punished by having his hand instantly cut off by a sword stroke from the furious master.

The resulting blade then received its final shaping and polishing to bring out its full and terrible beauty, of which the most noticeable feature was the wavy line that ran from one end of the blade to the other. It indicated where the super-hard cutting edge met the body of the sword, its edge

Above: **A scene from the film *Sanjuro* showing the lone samurai (portrayed by Toshiro Mifune) taking on several opponents at once.**

Opposite: **A samurai drawing his sword, portrayed by an actor.**

pattern following the boundary of the insulating clay.[2]

This method served the swordsmiths well throughout the centuries of their craft. Of swordsmiths known to us by name, the numbers grew from about 450 in the Heian period to 1,550 in the Kamakura period. As the fourteenth century gave way to the fifteenth, the numbers jumped to around 3,550.[3] Many of the greatest names were active at this time, and of the outstanding craftsmen, none was more celebrated than Masamune, who was alive around the time of the Mongol invasions.

The Warrior Pilgrimage

These peerless swords were the weapons carried through the belts of the great swordsmen of Japan, whose wandering in search of physical and spiritual self-improvement often took the form of a *musha shūgyō* (warrior pilgrimage). This practice was much akin to the common Japanese practice of making long religious pilgrimages to distant parts, thereby obtaining spiritual enlightenment through endeavor and personal discomfort.

The typical "sword pilgrim" was likely to have had some service to a daimyō and some battle experience behind him before setting off. His wandering could last for several years, and might include temporary spells of military service and some teaching. Austerity and abstinence were the hallmark of the pilgrim warrior, whose travels would invariably involve duels, each of which taught the swordsman a little more about himself. In many cases, the wanderer would develop a technique that was uniquely his own. This he would attempt to pass on to a chosen pupil, or he might even found an entirely new ryūha (style) of sword fighting—an important development that will be covered in the following chapter.

Popular Japanese movies often give the impression that the musha shugyō, far from being a spiritual journey, was nothing more than a series of killings, a wasteful exercise in terms of the numbers of fine swordsmen who were killed. But the truth is that the vast majority of challenges that arose on the musha shūgyō never went to the death. In most cases, the contestants did not use real swords and spears, replacing them with the wooden *bokutō* used by students of martial arts. The encounters were nevertheless deadly serious. A warrior on a musha shūgyō might arrive at a town or village, take lodgings, and then announce that he was seeking a contest with local swordsmen. He might even erect a notice board to that effect. If his challenge was accepted, and it usually was, then both participants would agree upon a time and a place for the duel to take place. Actual dōjō (practice halls) were rare in the Warring States period, so a contest would be more likely to take place at a crossroads, or even in the courtyard of a daimyō's mansion.

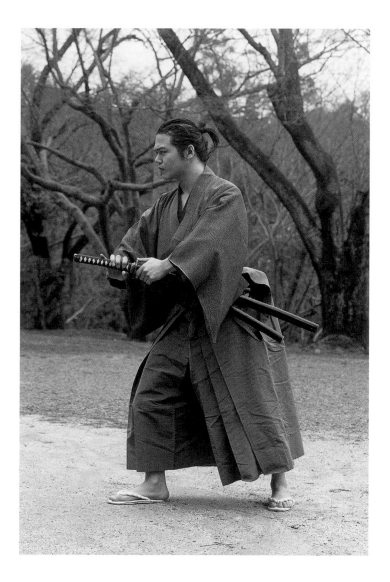

In these encounters, the shouting of a pedigree and the selection of a worthy opponent—largely mythical on the battlefield—were very real events, recorded in history and often witnessed by hundreds of people. The resulting duel could take many forms, because there were no rules except those that the participants had agreed upon, and that they were quite likely to break, as several of the following examples will illustrate.[4]

Not all samurai, however, approved of the idea of the musha shūgyō, and they had various reasons for their disdain. An early writer on military matters, Kōsaka Danjō, maintained that one could not learn anything useful off the battlefield. Only in the conditions of warfare could previously learned martial techniques be perfected. A similar skepticism about the musha shūgyō comes from a later work, the *Buke Giri Monogatari* of 1688, by Ihara Saikaku. His grounds for questioning its worth are, however, very different:

The present age has brought about a drastic change in the behavior and the attitude of samurai. In bygone

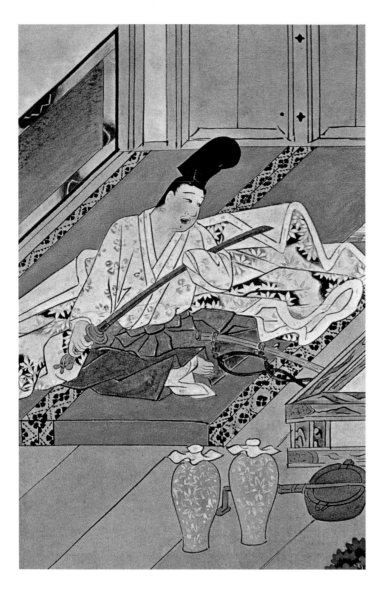

Above: **The connoisseur of swords. An admiring samurai examines the details on his fine blade.**

While on a pilgrimage, of course, the master swordsman had no lord but himself, and far from failing to be impressed, daimyō would compete among themselves to invite the wanderers into their service, often as teachers.

Tsukahara Bokuden

Probably the earliest recorded musha shūgyō was performed by a certain Haneo Unno, who lived between 1509 and 1579, but perhaps the most famous samurai from the early sixteenth century to become a wandering swordsman was the celebrated Tsukahara Bokuden, the first of the great kengō. There are few written accounts of his life, but a lively oral tradition tells us that he was born in 1490 in Kashima, in Hitachi Province. His father combined the professions of samurai and Shintō priest, the latter vocation being based at the Kashima Shrine, where was enshrined the spirit of a kami of the martial arts. Kashima is quite close to the Katori Shrine, which also enshrined a martial arts deity and was the cradle of the school of sword fighting known as the Shintō-ryū. It is therefore not surprising that the young Bokuden was trained from an early age in sword-fighting skills. His talent brought him to the notice of a swordsman of the Shintō-ryū, who adopted the young man and continued his training in the Shintō-ryū style.[6] At the early age of seventeen, Bokuden was allowed by his adoptive father to set out on a musha shūgyō pilgrimage. It was very successful, and among those whom Bokuden defeated was a renowned swordsman called Ochiai. Bokuden spared his life, but it was such a disgrace to Ochiai to have been defeated by this young upstart that he lay in wait to murder him, and on their second encounter he was killed by a rapid stroke of Bokuden's sword.

The area of Japan in which Bokuden lived suffered greatly from the interminable civil wars, and following his initial musha shūgyō, Bokuden had to take his place in the armies of his lord, as did most of his contemporaries. We have no record of the locations of Bokuden's involvement on the battlefield, other than a note that he fought in thirty-seven separate engagements and took twenty-one heads. He fought nineteen duels with real swords.[7]

By the age of thirty-seven, he had formed his own unique style of sword fighting, which he named the Shintō-ryū. It was an interesting choice of name, because it was a homophone of the name of the style of fighting in which he had been trained. But the *kanji* (ideograms) for this version of "Shintō" were different from those of the existing Shintō-ryū, and meant "new strike." Many pupils flocked to his side, but there were still those who

days, proving one's mettle was the paramount consideration and life was held cheap. If the sword sheaths of two men accidentally clashed together, they would rail at each other, and then begin a profitless duel which would result either in both their deaths or else the emergence of a victor who would stride away from his slain opponent. This type of behavior was praised for it was said to reflect the true samurai spirit. In fact, however, this kind of bravado is completely contrary to the way a samurai should live. In order to be prepared for the worst eventuality, a lord bestows on each of his retainers a considerable stipend. Any man who ignores the obligations thus incurred and casts his life away over a selfish, personal quarrel is a villain, deaf to righteousness. Consequently, no matter how outstanding a samurai's achievements may be in his private battles, his lord will understandably fail to be impressed by such exploits.[5]

sought to challenge him. Among them, the biggest threat was a man called Kajiwara Nagatonosuke, who was renowned for his wielding of the naginata. This was unusual for the Warring States period, as straight spears were the commonly accepted samurai polearm, but Nagatonosuke had trained for years with this fierce weapon. The one advantage possessed by a skilled naginata fighter over a swordsman was that his long polearm enabled him to attack the swordsman at a distance that the sword could not cover. Bokuden began the duel by concentrating on the blade of the naginata as if it were a sword held by a man closer to him than was the case. Judging his distance carefully, Bokuden struck a rapid blow from the scabbard at the naginata, as if he were cutting at this invisible opponent, and with this first stroke he sliced the shaft in half, leaving Nagatonosuke defenseless. It was a significant victory.

Bokuden called this decisive stroke, delivered straight from the scabbard, the *hitotsu tachi* ("one sword," implying "one stroke"), and it became the hallmark of his Shintō-ryū. As the Shintō-ryū was not destined to survive in the form established by Bokuden, we have no way of knowing exactly how this devastating stroke was performed, but it served him well in building up a tremendous reputation.

While on his second musha shūgyō, Tsukuhara Bokuden was invited to Kyoto to teach ken-jutsu to the shogun Ashikaga Yoshiteru, as great a commission as a kengō could receive. The ill-fated family of Ashikaga ruled Japan as shoguns from 1333 until 1573, but its later members have often been represented as mere pawns in a power game, unable to stand up against the new daimyō who ruled petty kingdoms of their own, heedless of shogunal authority. At the level of politics, this is probably true, but the Ashikaga family produced at least one skilled swordsman in the person of Yoshiteru, the thirteenth shogun. Tsukahara Bokuden became his tutor in 1552, when Yoshiteru was seventeen years old. Yoshiteru was a promising pupil, and his skills were put to their ultimate test in 1565, when Matsunaga Hisahide and Miyoshi Chōkei—who were responsible for forcing Yoshiteru to rule as a "puppet shogun"—determined to get rid of him.

Yoshiteru was in his palace on Muromachi Avenue, in Kyoto, when the palace was raided in the middle of the night under the direction of the above two conspirators. The guards proved useless. Most were in the pay of Miyoshi and Matsunaga anyway, and soon Yoshiteru found himself surrounded on all sides. Guns were discharged into the room as Yoshiteru drew his sword and prepared to put into operation the skills that Bokuden

Above: **The great *kengo* Tsukuhara Bokuden, carrying the wooden pot lid with which he is supposed to have defended himself against Miyamoto Musashi.**

Below: **The standard fighting sword was the *katana*, which was slightly shorter than the old *tachi*, and designed to be carried thrust through the belt, so that a blow could be delivered straight from the scabbard. This example is mounted with a *wakizashi* to make a pair of swords, or *daisho*. (Courtesy of Sotheby and Co.)**

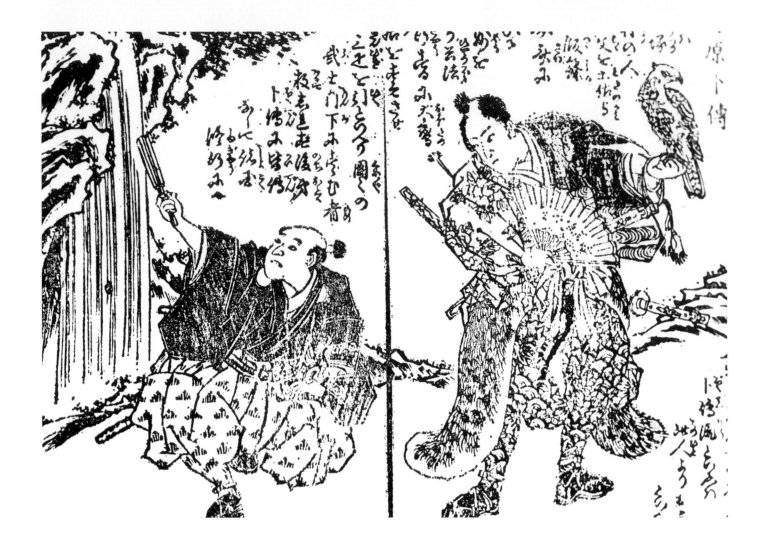

had taught him. His enemies appeared first only as dark shadows on the panels of the *shōji* that divided room from room. Sweeping the shōji to one side to reveal his adversaries, Yoshiteru laid about him with the sword, using the hitotsu tachi strokes of the Shintō-ryū, but a spearman thrust at his legs and brought him to the ground. Mortally wounded by sword strokes, Yoshiteru crawled into another room and committed *seppuku*—a further noble gesture giving the lie to the commonly held view of the weak and effeminate shoguns.

By the time Tsukuhara Bokuden went on his third musha shūgyō, his reputation had grown so much that he was attended by eighty followers and took along three spare horses. At the head of the procession, he flew three large hawks, and he looked as proud as any daimyō. His retinue was indeed very splendid, but there was less of an air of ostentation about Bokuden himself, for he realized, as did all great swordsmen, that no matter how good he was, he needed to pass on his skills to one trusted follower if his style of fighting was to survive. The warlike nature of the times made this very difficult, however. It is believed that the essential secrets of the hitotsu tachi were passed on to Bokuden's trusted pupil Kitabatake Tomonori, the daimyō of Ise Province,

whom he charged with preserving the traditions and secrets and initiating Bokuden's son into them when the boy was old enough. Tomonori did in fact pass them on to Bokuden's youngest son, whom his father had named as his heir, but when Bokuden died in 1571 at the age of eighty-one, his successors became the victims of forces far beyond the control of an individual swordsman. The Kitabatake family suffered from the expansion into Ise Province of Oda Nobunaga, and Tomonori died defending his province. It is not clear whether he was killed on the battlefield or murdered by treacherous retainers, as accounts differ. Nor is anything known of the fate of Bokuden's son, apart from a few fascinating legends about him joining the ninja groups of Iga.

In spite of the lack of historical continuity, Tsukahara Bokuden remains a very important figure in the early history of the master swordsmen, and there are many stories told about him, of which the best is undoubtedly his amusing but telling encounter with a boasting samurai on a ferryboat. The man in question, who had managed to terrify the passengers with his bragging about his prowess at sword fighting, picked on the silent Bokuden, who alone had remained unintimidated, and challenged him to a fight. Bokuden politely

declined, saying that he never wielded his sword in such circumstances. The furious samurai poured scorn upon what he took to be cowardice, and asked Bokuden to name his school of sword fighting, to which Bokuden replied, "the *Munekatsu-ryū*," or "the style that wins without a sword." This reply made the samurai all the more angry, and he ordered the boatman to stop at a nearby island so that he could teach the stranger a lesson. As they reached the island's beach, the samurai leapt ashore, and took up a guard position with his sword, screaming for Bokuden to disembark and fight him. At that moment, Bokuden took the ferryman's pole and drove the boat away from the shore, leaving the samurai stranded. To the samurai's yells of protest, Bokuden shouted back to him, "See, this is what I meant by the Munekatsu-ryū! After all, I have just defeated you without a sword, haven't I?"[8]

The Wanderings of Kamiizumi Nobutsuna

In the previous chapter, we described how Kamiizumi Nobutsuna was honored by Takeda Shingen but chose the wandering life instead of continued service to any daimyō. He set off on the musha shūgyō sometime subsequent to 1561, and was accompanied on his travels by two companions, each of whom was a renowned swordsman: his nephew Hikita Bungorō, and Jingo Muneharu. Nobutsuna's skills soon reached a wide audience, and in 1571 he was invited to demonstrate his skills before Emperor Ogimachi (1521–1573), who apparently loved ken-jutsu, and the emperor was so impressed by Nobutsuna's performance that he granted him noble rank.

One incident that occurred on his travels has become very famous, since Akira Kurosawa incorporated the story, with some modification, as a scene in the film *Seven Samurai*. On approaching a certain village, Nobutsuna was told that a criminal was holding a child hostage in a house. No one knew what to do, and the parents were desperate. Nobutsuna formulated a bold

Above: **The death of the Shōgun Ashikaga Yoshiteru. Tsukahara Bokuden was his tutor, and his illustrious pupil put his lessons to good effect when he was attacked by samurai of the conspirators Miyoshi and Matsunaga. The sword techniques were not sufficient to save his life against enormous odds, however, and he committed** *seppuku*.

Opposite: **Tsukahara Bokuden made three celebrated** *musha shūgyō*, **the warrior pilgrimages carried out by a swordsman to test and improve his skills by challenging worthy opponents. On his third journey, he was accompanied by a large entourage, including followers flying hawks, as in this illustration from** *Musha Shūgyō Jun Rokuden*.

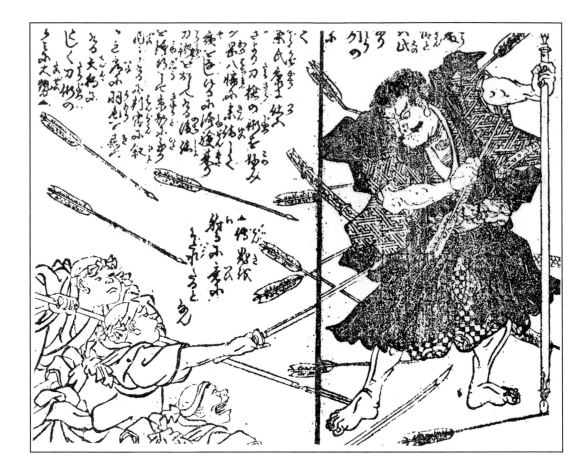

Left: **Saito Denkibō, from the** *Musha Shūgyō Jun Rokuden.* **He was a pupil of Tsukahara Bokuden's Shintō-ryū, but exhibited none of the restraint associated with his teacher. In revenge for Denkibō's killing of his son in a duel, the father ambushed him in a temple with ten soldiers, and Denkibō was shot down in a hail of arrows.**

Opposite: **The famous swordsman Miyamoto Musashi in the guard position, ready to face attack from any direction.**

plan. He called over a priest, and asked if he could borrow his robe. Then, out of sight of the cottage where the child was being held, he had his head shaved. In this disguise, Nobutsuna approached the cottage with two balls of rice in his hand. He explained to the criminal that he was a priest who had brought food for the child, and threw one of the rice balls through the doorway. He took the second rice ball, and, offering it to the criminal, rolled it along the floor towards him. The criminal grabbed at the rice ball, letting his guard down just for a second. At that moment, Nobutsuna seized him in a jū-jutsu hold and pinned him to the floor. In the film, the supposed priest kills the man with the man's own sword, but in the original version, Nobutsuna tackled the swordsman and left him, quite unharmed, to the far from tender mercies of the villagers. Kamiizumi Nobutsuna went on to found the Kage-ryū, the second of the three most influential styles of swordsmanship in the Age of Warring States.[9]

Death of a Swordsman

The scenario of a musha shūgyō that ended with the unnecessary deaths of two fine swordsmen is provided by the sad tale of one of Tsukuhara Bokuden's later pupils: Saito Denkibō, who was born in 1550. When he was twenty years old, he went on a musha shūgyō, and meditated in Kamakura at the great shrine of Hachiman, the kami of war, where he had a dream of founding his own fighting style. Eventually he went to the capital, where he settled in 1587 and founded the Tendō-ryū, and his reputation ensured that many novices were attracted to his teaching. He was a strangely flamboyant character, and wore clothes interwoven with feathers, so that people said he looked like a *tengu*, a goblin of the forests. Tengu were half man and half crow, and according to legend, they had taught sword fighting to Minamoto Yoshitsune.

Denkibō apparently had an ego to match his appearance, and displayed an arrogant attitude that alienated many of the established kengō. Among them was Shinkabe Ujimoto, the sensei of a well-established sword-fighting school in Kyoto. Ujimoto regarded Denkibō's conduct as scandalous, and totally out of keeping with the developing traditions of the kengō. He may also have resented Denkibō's arrival from nowhere. Ujimoto, however, held back from issuing a challenge to Denkibō. He frowned upon such behavior in his pupils, and also clearly thought that such an action would be beneath his dignity. But Ujimoto had a favorite pupil called Sakurai Kasuminosuke, who possessed considerable talent. Those of his colleagues who resented Saitō Denkibō saw this young man as a potential champion, and tried to persuade him to challenge Denkibō, all of

which the naive young man drank in. All this soon reached Denkibō's ears and made him angry, so he challenged young Kasuminosuke to a decisive swordfight.

Kasuminosuke was in a dilemma. He agreed to the duel, but fearing that he would be punished by the sensei Ujimoto for accepting a challenge, he kept quiet about it, and arranged to fight Denkibō in secret. There turned out to be a considerable difference between the talents of the two men, and Kasuminosuke was cut down with the single hitotsu tachi stroke that was the speciality of the Bokuden Shintō-ryū. It was totally unnecessary for Denkibō to have killed the boy. Kasuminosuke's father was furious when he heard of his son's death, and challenged Denkibō to meet him for revenge. Denkibō accepted, and was as scornful at the prospect of meeting the father as he had been about the son. But the grief-stricken father had not come alone and prepared only for a swordfight; he had brought ten soldiers with him. As Denkibō entered the courtyard, he was met with a volley of arrows. With his spear he knocked aside the first three arrows that were loosed at him, but the odds were against him, and he was eventually felled by ten fatal arrows. Few contests between swordsmen had outcomes as tragic as this.[10]

Miyamoto Musashi

The life of the famous Miyamoto Musashi, the greatest wandering swordsman of all, has been so obscured by legend and fiction that it is difficult to disentangle the real man from the myth. He comes across as a strange character, solitary and obsessive, whose skills with the sword were unquestioned and greatly admired, but at the same time made him feared and disliked.[11]

Miyamoto Musashi was probably born in 1584, and led a life so full and eventful that he deserves a book to himself.[12] To sum up the salient features of his life is difficult, but we do know that his appearance was marred by very bad eczema, and he also seemed to have an aversion to personal cleanliness. He seldom changed clothes and almost never took a bath. Unlike almost every other kengō, he never founded a fighting style of his own. By the age of thirteen, he had become quite an accomplished swordsman, and at this age took part in his first duel. Musashi was responding to a general challenge issued by a certain Arima Kibei, a swordsman of the Shintō-ryū. Musashi turned up for the duel armed with a wakizashi, the shorter of the two swords worn by samurai when out of armor, and a bō, the long wooden staff. It was the bō that he wielded against Arima's sword, and knocked Arima cleanly to the ground with it.

In 1605, Musashi set off on a musha shūgyō, and he

fought some sixty authenticated duels over the following eight years. In Kyoto he defeated, in two successive duels, two brothers of the Yoshioka family, having first used a little psychological warfare by arriving late for each contest and thereby unnerving his opponents. He fought the elder with a bokutō and knocked him unconscious, breaking his right arm. The younger took up the challenge with a nōdachi, and Musashi killed him with his own normal katana. Disgraced by this reverse, the surviving Yoshioka brother issued a further challenge,

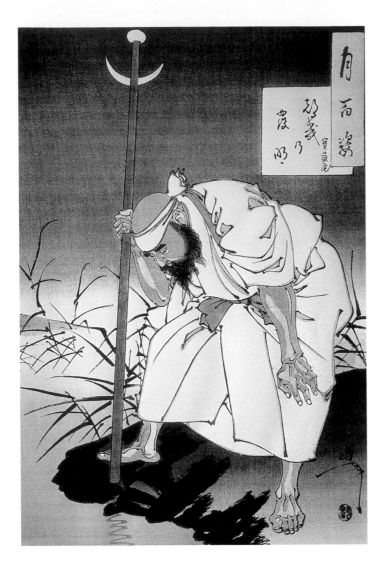

but he was planning an ambush, not a swordfight. The scheme was that as soon as Musashi was engrossed in the duel, the other Yoshioka followers would attack him en masse, and avenge their previous defeats. But their tongues wagged a little too freely, and Musashi got to hear of the plot. So when he arrived at Ichijōji, in northern Kyoto, the venue that had been selected, he was prepared for the sudden rush of swordsmen that descended upon him. The attackers were put off by his unexpected composure, and their careful plan went to pieces. One by one they fell beneath Musashi's sword.

Other opponents on his journey included a talented pupil of Inei the chief priest of the Hōzō-In, a subtemple of the Kōfukuji Temple at Nara. Inei was a martial arts enthusiast, and it was said that he was never without a spear in his right hand. Late one night he was exercising with his spear, practicing his moves by thrusting the

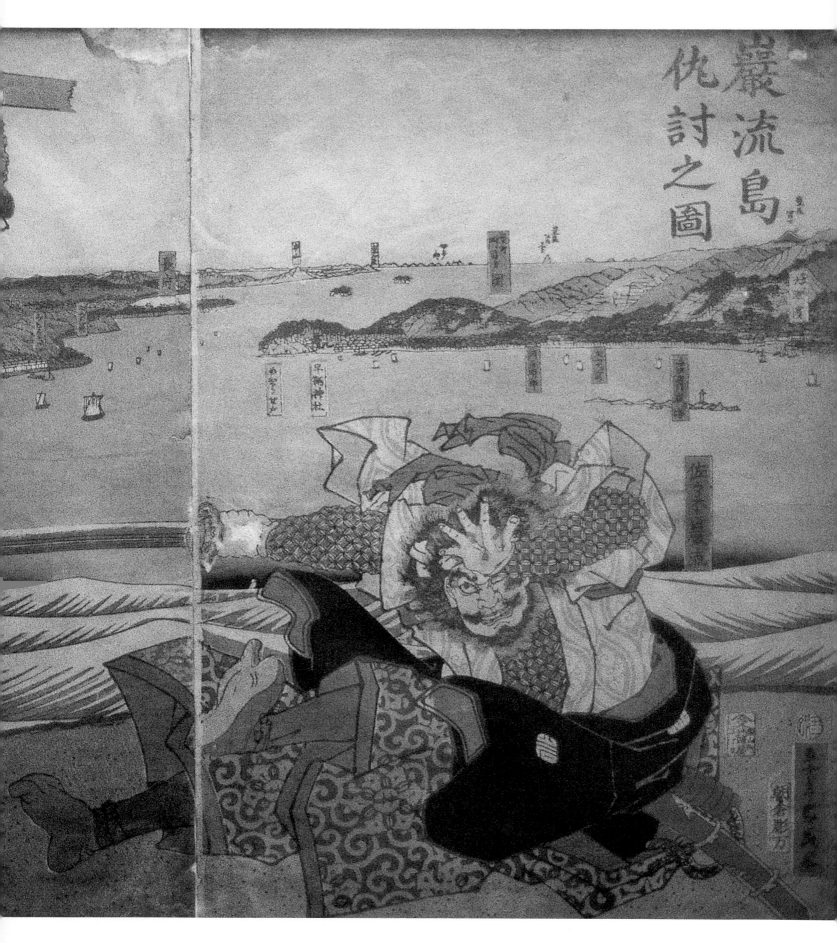

嚴流島仇討之圖

Top Left: **Inei of the Hōzō-In.** Inei was the chief priest of the Hōzō-In, a subtemple of the Kōfukuji at Nara. He is carrying a *kamayari*, the style of spear that he is said to have invented when he was cutting with a straight spear at the reflection of the crescent moon in a pond.

Above: **A scene from the fight between Miyamoto Musashi and Sasaki Ganryū.**

A statue of the swordsman Sasaki Ganryū beside the hill of Iwakuni Castle.

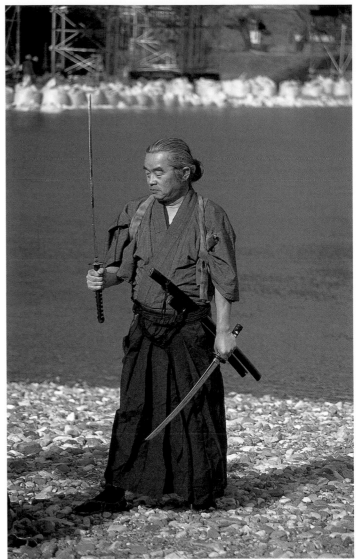

Miyamoto Musashi as played by an actor.

spear at the new moon reflected in the waters of the Sarusawa Pond. The neck of the spearhead, where it joined the shaft, mingled with the crescent moon and took on the shape of a sickle. This gave him an idea to improve the design of a spear, so he fitted a blade of a crescent-moon design onto the neck of the spearhead. This weapon became known as the kamayari of the Hōzō-In-ryū. The fame of the Hōzō-In monks spread widely, and the monk Shōji, who was one of Inei's best pupils, challenged Miyamoto Musashi to a contest. After some difficulty, Musashi overcame the kamayari, but he emerged from the encounter with a heightened respect for these fighting monks. A more serious contest was with a certain Shisidō Baiken, who was adept with the kusarigama, a weapon that consisted of a sharp sickle with a long weighted chain attached to the base of the handle. Musashi defeated him by throwing a small dart

called a shūriken. This stopped the whirling of the chain, and then Musashi finished him off with his sword.

Musashi's most famous duel happened in 1612, when his wanderings took him to the southern island of Kyūshū. The foremost swordsman in northern Kyūshū was a man called Sasaki Ganryū, who served the Hosokawa family. Musashi's challenge to him was eagerly accepted, and they chose as the venue the island of Funajima, just off the mainland, which was later to become known as Ganryūjima. Ganryū, a handsome and popular young man, made a great contrast to the disreputable-looking Musashi. Their choice of weapons, too, differed widely. Ganryū had his fine katana, Musashi just a rough wooden sword, which he had whittled into shape from a boatman's oar. The duel, which was watched by hundreds of spectators, was a sensation. Both men appeared to land blows at the same moment, but it was Ganryū, not

Miyamoto Musashi with two swords, a technique he made especially his own.

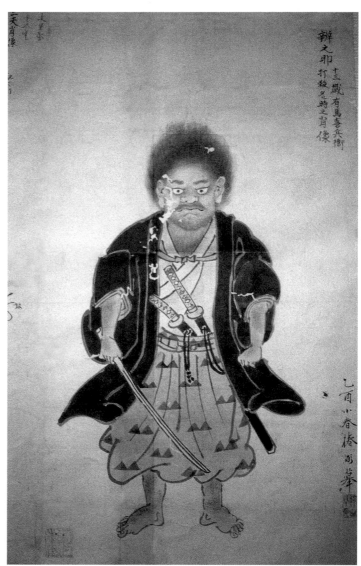

Miyamoto Musashi: A rather crude painting of the illustrious and greatly feared swordsman. This simple caricature of him sums up the forbidding aspect he presented to many of his contemporaries.

Musashi, who staggered from the force. He recovered, and slicing upward with his sword, aimed a blow at Musashi, but Ganryū received another furious blow from the wooden sword, and fell dying. Without a word, Musashi turned and walked back to his boat.

With the defeat of Ganryū, Musashi's first period of wandering ceased, and he opened a fencing school in Kyoto. This lasted until he became involved in the Osaka Campaign of 1614–1615, where he served on the battlefield. From this time on, his life became a series of wanderings, short periods of service to various daimyō, numerous duels, and an increasingly deep philosophical insight into swordsmanship, taking its final form in the famous *Gorinshō (The Book of Five Rings),* which he completed shortly before his death in 1645.[13]

In this, Miyamoto Musashi made an outstanding contribution to the literature based around sword fighting, and by

and large the musha shūgyō continued to have a very significant spiritual dimension to its practice. There were, however, occasions when the challenge matches that arose out of encounters on a musha shūgyō were no more than excuses for personal gain and intimidation. Such unscrupulous swordsmen would haunt a local dōjō, hoping to pick on some unsuspecting pupil. This practice, sometimes called *dōjō yaburi* (an expression otherwise used for contests between schools), was particularly common in the years between the campaigns of Sekigahara (1600) and Osaka (1614), when a surplus of unscrupulous rōnin were traveling the roads of Japan. They sought very little in the way of spiritual inspiration, and instead coerced others into fights, and made contests for bets, taking sake or cash as prize money. The kengō, by contrast, set the example that others were to follow and emulate, a task carried out through their other great role: that of the *sensei* (teacher).

CHAPTER 5

SWORD AND SENSEI

As has already been noted, the nature of warfare during the Age of Warring States did not usually provide the conditions whereby fine swordplay could be seen on the field of battle. But even though spear techniques from the saddle may have been more useful in the battlefield situation, good sword fighting was both vital and very highly valued. The best evidence for this is threefold: the large number of swordsmiths who were active at the time, the prestige of kengō such as Tsukuhara Bokuden, and the creation of "schools" of swordsmanship—ryūha—a development that experienced its most rapid growth at the time when its battlefield expression was least evident. The term *ryūha* (shortened to *-ryū* when used as a suffix) is best understood in the sense of a continuing tradition—as in the "school of Rembrandt"—rather than any actual building, which would be called a *dōjō* (practice hall) in martial arts terms. Seven hundred and forty-five ryūha have been identified, but most of these are derivations from only three originals, dating from the Age of Warring States.[1]

The First Schools

One of the first ryūha that can be dated with some accuracy is the Shintō-ryū in which Tsukuhara Bokuden was trained, otherwise known by its full title of the Tenshin Shōden Shintō-ryū. *Tenshin Shōden* means "the divine, true and correct tradition," and *Shintō* is the same word as the title of Japan's indigenous religion, which is usually translated as "The Way of the Gods." The founder of Shintō-ryū was Iizasa Chōisai Ienao, who was probably born in 1387, in a village called Iizasa in Shimōsa Province, to the east of present-day Tokyo. Near to Iizasa was a very

important Shintō shrine called the Katori *jingu* (shrine), where was enshrined one of the most important deities associated with martial arts: Futsunushi no kami. During his youth, Iizasa served the shogun Ashikaga Yoshimasa, then returned to his home province, and after many spiritual experiences in the Katori Shrine, he founded the school that still exists to this day—hence the other name by which it is known, the Katori Shintō-ryū. As Iizasa was also associated with the Kashima Shrine and its own martial arts kami, his ryūha was twice blessed. The date of the school's foundation may be placed at the very beginning of the Age of Warring States, because Iizasa died in 1487 or 1488.[2]

The second important school of sword fighting is the Kage-ryū (Shadow School) and its various offshoots. It is associated particularly with Kamiizumi Nobutsuna, although he is not recognized as its actual founder. The original Kage-ryū is customarily traced back to Aisu Ikō (1452–1538), who had an unusual background as a pirate. He operated from the Kumano area, and his travels took him as far as China.[3] Kamiizumi Nobutsuna called his version of the Kage-ryū the Shinkage-ryū (New Shadow School). From the Shinkage-ryū derives the Hōzō-In-ryū, the Taisha-ryū, and the Yagyū Shinkage-ryū, which became the most influential school of swordsmanship in Tokugawa, Japan.[4]

The founding of the Ittō-ryū (One Sword School), the third of the early schools, may well have occurred prior to the time of Iizasa's Shintō-ryū, but its early history is not

Two samurai swordsmen on the road.

clear, nor is there any definite account of the life of its traditional founder, Chūjō Nagahide, who is supposed to have served the shogun Ashikaga Yoshimitsu. He called his school the Chūjō-ryū, but just as in the case of the Kage-ryū, a later swordsman was most influential in the school's development. In this case, the crucial figure is Itō Ittōsai, who was born sometime around 1550 or 1560. It was he who gave the school its final name, which expresses a philosophical concept about "one-ness."

Ittōsai's life is more shrouded in mystery than many of his contemporaries'. According to which accounts one reads, he came from any one of three locations and supposedly lived into his nineties. He exhibited the precocity of youth recorded for every great kengō, and received training in the Chūjō-ryū under the direction of Kanemaki Jissai. Kanemaki was a former pupil of Toda Seigen, whose inspired use of a piece of firewood will be seen in the next section. Sasaki Ganryū, defeated by Miyamoto Musashi, had also been Kanemaki Jissai's pupil, so this was a school to be reckoned with. After a period of time with Jissai, Ittōsai left to found his own Ittō-ryū, based on the Chūjō-ryū. His skills were very highly regarded, and he had the unusual compliment paid to him, albeit posthumously, of having a book published about him by the grandson of one of his pupils, Kofujita Kageyu. The book, published in 1653 under the title *Ittōsai Sensei Kemposhō*, is a seminal work on swordsmanship and the more practical side of the values later to be known as *bushidō* (the "way of the warrior").[5]

Sensei and Students

By the beginning of the sixteenth century, these three schools and their offshoots were very active in teaching the families and the retainers of powerful daimyō the niceties of swordplay, a skill they had to master in the time of almost constant warfare that engulfed Japan after the Onin War. To be a sensei (teacher) in one of these schools meant a busy life, but also a great honor, because it implied not only the quintessence of skill, but an almost unchallengeable status, making the sensei the ultimate kengō. The great sensei thus became the most influential people in the development of the martial arts of Japan. All had their own individual characteristics and personality, and their own distinctive styles and philosophies, but by the very nature of the respect their position engendered, they all had two things in common: an aura of mystique and a tremendous authority. Some acquired a hereditary position with particular daimyō, while others maintained their own independent ryūha, and enjoyed the spectacle of swordsmen who were skilled in their own right begging to be allowed to be taken on as pupils. Such masters could therefore afford to be very selective about the people they chose to join them, and had very subtle ways of weeding out whomever they wanted.

Sensei such as Iizasa Ienao were the first masters of a long tradition of education in sword technique, but they were of course hampered by the almost inescapable fact that realistic practice with such a sharp and deadly weapon was almost impossible. The slightest mistake by one of a pair of sparring students would have led to a death, so various teaching methods were developed to get around this problem. One was the practice of *suburi*, a drilling method whereby the sword was swung repeatedly, in a form of "shadowboxing." Alternatively, the student could practice *kata*, a series of standard forms (rehearsed movements). When kata were practiced with a partner, each knew precisely what the other's next move would be. Both suburi and kata were repetitious and boring, and required great dedication from the student.

Another form of practice was to substitute dummy weapons for real ones, to allow a certain amount of contact between opponents. For yari-jutsu (spear techniques), they used a *tampo yari*, a practice spear with a round padded end, and for sword fighting they used the wooden bokutō that we noted earlier in duels. The word consists of the two characters for "wood" and for "sword," as that is

what bokutō were—wooden swords made with the overall shape of a real sword and with a real sword's approximate weight. To compensate for the higher density of steel, the blade was made about an inch thick. They were practically identical to the modern bokutō, also called *bokken*, that are used in present-day aikidō. Unlike the armored practitioners of the later sport of kendo, the bokutō fighters fought with unmasked faces and unprotected sleeves, so that even if mortal wounds and disablement were avoided, very savage blows could still be sustained, leading to severe bruising and the occasional broken limb.

Bokutō were also used for duels between rivals, and it was accepted practice that before two men began such a fight they exchanged documents that said that neither cared about mortal wounds. In some contests, the fighters would use a method of pulling their punches before the opponent was actually struck, thus giving one a victory "on points." This technique, also used in sword practice, was called *tsumeru*, and was brought to perfection by Miyamoto Musashi, who, according to one of the many stories told about him, could so control the blow from a real sword that he could sever a grain of rice placed on a man's fore-

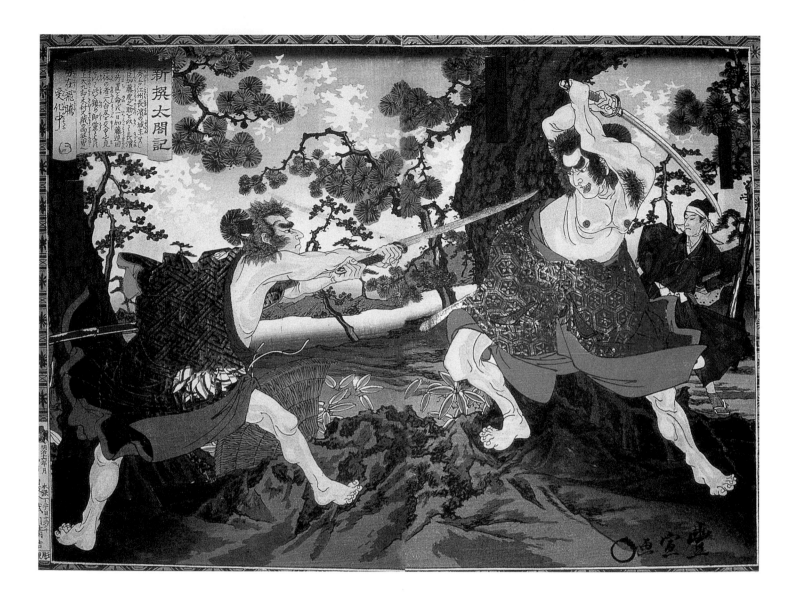

Above: A swordfight between two opponents armed with real swords.

Left: The title of this print by Yoshitoshi tells us that it depicts the aged Bokuden teaching sword fighting to the young Miyamoto Musashi. Musashi was in fact born twelve years after Bokuden's death, so such an incident can never actually have taken place. It would appear that the artist has mistaken Tsukahara for Kasahara, a swordsman believed to have been Musashi's teacher. There are several prints by other artists that name Kasahara correctly. Musashi is shown with a long and a short *bokutō*, and Kasahara is receiving the blows on the wooden lid of a rice-pot. (Photograph courtesy of the Oranda-jin Gallery, Netherlands)

Opposite: A samurai reenactor waits with his sword in the guard position.

Kamiizumi Nobutsuna was a swordsman whose career spanned the whole range from soldier fighting anonymously in battle to master of *ken-jutsu*. A superb swordfighter in his own right, he is best remembered for being the founder of the Yagyū Shinkage-ryū, one of the foremost schools of sword fighting in Japan.

Toda Seigen (from the *Bukei Hyakunen Isshu*). Toda Seigen was a swordsman of the Chūjō-ryū, and a retainer of the Saitō family of Gifu. He is famous for a duel he fought against a rival, whom he defeated using a piece of firewood instead of a *bokuto*.

head without drawing blood. To be praised for one's tsumeru, especially in the heat of a contest, was one of the greatest compliments a swordsman could receive. This was, however, always difficult to achieve (compare modern karate!), and victory was just as difficult to judge. This is very well illustrated in a famous scene in the film *Seven Samurai*. The duel is based on an incident that is supposed to have occurred in the career of the swordsman Yagyū Mitsuyoshi, when the loser in a fight with dummy swords is so convinced he has won that he makes his opponent fight with real swords, and is killed in the process.

Even in the Sengoku period, tsumeru did lead to rather odd-looking and unsatisfying contests. Some sensei selected only those pupils who were good at tsumeru, perhaps because of the damage unrestrained practice could produce, but this was not perhaps the most appropriate criterion to apply in a situation where wars were liable to break out at any time. Towards the end of the sixteenth century, *shinai* were developed for "friendly" encounters. The shinai, the weapon used in modern kendō, consists of a number of light bamboo blades tied together in a cloth bag. It enables

what one might term "full-contact ken-jutsu" to be practiced, thus making the simulation of actual combat that much more realistic. It was introduced by Kamiizumi Nobutsuna, and first used by him in his epic meeting with Yagyū Muneyoshi. In about 1711–1714, the Jikishinkage-ryū began to use protection for the face and forearms for practicing martial arts, but these were always abandoned for serious contests, and bokutō used instead.

An early example of a serious encounter using bokutō is the contest between Toda Seigen and a man called Umezubō, during the 1560s. Toda Seigen was a famous kengō of the Ittō-ryū, and was a retainer of the Saitō daimyō. One day Toda Seigen visited his family at Gifu, the Saitō headquarters. This was at the time when Saitō Yoshitatsu was keeper of Gifu Castle, and just before he lost it to Oda Nobunaga. Seigen's Chūjō-ryū was not the only prominent school in those parts. Another of the Saitō retainers, a man called Umezubō, was a kengō of Bokuden's Shintō-ryū, of which fact he was very proud. In his opinion, Ittō-ryū practitioners had a style of swordsmanship that was much inferior to his own, and if challenged

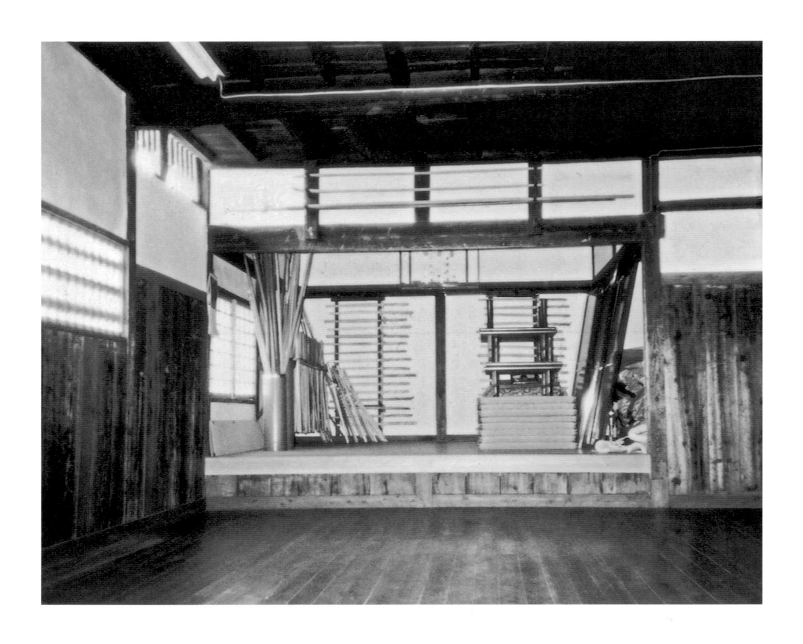

Above: The interior of the Maniwa Nen-ryū *dōjō*. The floor of the *dōjō* is of highly polished natural wood. Most of the old *dōjō*, the scenes of many *dōjō-yaburi*, would have looked like this.

Left: Equipment for *ken-jutsu*. This *bokutō* and the protective gauntlets are at the Maniwa Nen-ryū *dōjō*.

Above: **Yagyū Muneyoshi was the first member of the Yagyū Shinkage-ryū, the most illustrious school of swordsmanship in Japan. The Yagyū became tutors to the ruling shōgunal family of Tokugawa. This is a wooden statue of Yagyū Muneyoshi in Yagyū village.**

Opposite: **The *dōjō* of the Yagyū Shinkage-ryū in Yagyū village.**

would be unlikely to win. A master of the Ittō-ryū had now turned up on his own doorstep, so Umezubō challenged Toda Seigen to a contest to determine which was superior.

The daimyō Saitō Yoshitatsu was in two minds over the matter. Could he afford to let two of his retainers fight among themselves, when there were powerful enemies outside who threatened the entire family's position? On the other hand, Umezubō's destructive arrogance needed to be somewhat curtailed, and the best way to accomplish that was for him to be beaten in a contest without serious injury. But Saitō Yoshitatsu eventually decided that the needs of the whole domain were paramount, so he entreated with Umezubō to withdraw the challenge. This only made Umezubō worse, however, and he accused Saitō

Yoshitatsu of being frightened of the contest. That settled the matter. Lord Saitō's own pride was now involved, so he allowed the challenge to go ahead.

On the appointed day, the angry Umezubō turned up with a real sword, while Toda Seigen had only a bokutō. Nothing daunted, Toda Seigen invited Umezubō to use the real sword against him, claiming that his bokutō would be quite sufficient. Such a confident gesture unnerved Umezubō, who put his real sword to one side and took up a bokutō of his own. At this, Seigen used a further psychological ploy and abandoned his bokutō in favor of a tree branch from a pile of firewood that was at hand!

So the strange contest began. Using the tree branch, Toda Seigen guided Umezubō's bokutō out of the way as Umezubō brought it down in a wide sweep aimed at Seigen's forehead. As the bokutō continued to the floor, Seigen stamped his foot down on it and broke it completely in half. Umezubō unsheathed his wakizashi, which, according to the custom of the times, he had not abandoned along with his katana, and struck at Seigen, but Seigen dodged, and hit him with the tree branch, knocking him down. The one-sided contest was over, and Umezubō was thoroughly defeated and disgraced, but as this had been achieved without bloodshed, the cohesion of the Saitō domain remained undisturbed.[6]

Ryūha and Rivalry

The contest described above demonstrates that a rivalry existed between schools that was every bit as intense as the rivalry between individual swordsmen. No ryūha could expect to have a constant and unchallenged monopoly of service, and duels were occasionally used to decide the choice of the best school for a daimyō's retainers. One example is provided by the Taisha-ryū of Satsuma Province in Kyūshū, founded by Marume Kurandō. The reputation of the Taisha-ryū suffered badly from Hideyoshi's defeat of the Shimazu clan in 1587. Among the disillusioned Shimazu men was Tōgō Shigekata, who considered that the Shimazu had been defeated by following the teachings of the Taisha-ryū, and that a new school was needed.

In 1588, in order to display his new loyalty to Hideyoshi, Shimazu Yoshihisa went up to Kyoto. Shigekata was ordered to be his attendant, and he took the opportunity to be taught fencing by the priest Zankitsu of the Jigen-ryū, a school that emphasized the need for Zen meditation. Shigekata was eager to prove the worth of the new ryūha, and yearned to return to Satsuma. This finally happened in 1601, when Iehisa became daimyō of the Shimazu. Iehisa was the sole Shimazu family member who had favored the Jigen-ryū, and in 1604 he ordered a *taryū jiai*, a contest between the two schools. Shigekata was to

fight for the Jigen-ryū, and the Shimazu family's current sensei, Tō Shinnojō, for the Taisha-ryū. Shinnojū was the son of a former sensei of the Taisha-ryū, under whom Shigekata had originally studied. It was a deeply emotional occasion for Shigekata, but his trouble and hard work bore fruit, and he was victorious. The Jigen-ryū then became the official school of the Shimazu daimyō.[7]

Sensei and Shogun

We noted in the previous chapter how Tsukahara Bokuden became tutor to the ill-fated shogun Ashikaga Yoshiteru. The great honor of being the teachers of swordsmanship to the Tokugawa shoguns was shared between the Ittō-ryū and the Yagyū Shinkage-ryū, a derivative of Kamiizumi Nobutsuna's Shinkage-ryū. The Yagyū were a minor daimyō family with lands in the vicinity of Nara, and in the mid–fifteenth century they were embroiled in the struggles for territory and power that were as common in this part of Japan as elsewhere. Yagyū Muneyoshi studied sword fighting under the Chūjō-ryū, which was to become the Ittō-ryū, and participated in his first battle at the age of

sixteen. It was fought against Tsutsui Junshō, an ally of Miyoshi Chōkei, the man who was eventually to murder the shogun Yoshiteru. The Yagyū were defeated in the struggle and made to fight for the victor from then on, until Miyoshi's ally Matsunaga launched an attack on Tsutsui, and the Yagyū joined Matsunaga's side. Matsunaga was victorious, and the Yagyū subsequently fought for him. Their battles included one against warrior monks, during which Yagyū Muneyoshi received an arrow through his hand, but this does not seem to have affected his sword-fighting prowess.

A few years later, he fought a famous duel that was to prove to be the beginning of the Yagyū Shinkage-ryū. The wandering Kamiizumi Nobutsuna and his companions had been given a letter of introduction to the monk Inei, chief priest of the Hōzō-In Temple at Nara. Inei was related to Yagyū Muneyoshi. Knowing the reputation of both men, he decided to bring them together, and a contest was arranged to take place at the Hōzō-In. Nobutsuna was then fifty-five years old, while Muneyoshi was twenty years younger. Imagine Muneyoshi's disappointment, then, when

he learned that his opponent was not to be Nobutsuna himself, but his nephew, Hikita Bungorō. A further surprise awaited Muneyoshi when he arrived, because Bungorō was not carrying a bokutō, but what appeared to be a bundle of bamboo sticks bound together—the prototype shinai.

Muneyoshi faced his rival holding his bokutō. Each watched the other, waiting for an unguarded moment. Then suddenly Bungorō struck, and Muneyoshi had the unfamiliar experience of feeling a wooden sword blade actually strike him across the forehead. Being used to tsumeru techniques, he ignored the blow, and continued the duel, only to be struck by the shinai again. At this point, Muneyoshi realized that he had come across a style of sword fighting superior to his own, and was about to acknowledge this, when the master Kamiizumi Nobutsuna took the shinai from Hikida Bungorō and challenged Muneyoshi to a further duel. Muneyoshi took his guard, but the mere gesture of the challenge had beaten him. He threw his bokutō to the ground and knelt before Nobutsuna, begging to be taken on as his pupil. Nobutsuna consented, and the result of his teaching was to be the Yagyū Shinkage-ryū, one of the greatest schools of swordsmanship that Japan was ever to see.

The next most important event in the life of Yagyū Muneyoshi occurred in 1594, when the future shogun Tokugawa Ieyasu invited him to his mansion in Kyoto. Muneyoshi was accompanied by his son Munenori, and they gave such a fine display of swordsmanship that the enthusiastic Ieyasu took a wooden sword to try his skill against Muneyoshi. He brought the bokutō down against Muneyoshi's forehead, but before he knew what had happened, Muneyoshi had dodged, deflected the blow, and grabbed the sword by the hilt in a move similar to a modern aikidō kata. He held Ieyasu by the left hand and made a symbolic punch to his chest. The sword had gone spinning across the room. This was Muneyoshi's demonstration of the technique he called *mutō* (literally "no sword"). Following this encounter, Ieyasu asked the Yagyū to become the Tokugawa's sword instructors. Muneyoshi excused himself, on the grounds of his age, but suggested that his son Munenori would make an excellent sensei, an offer that Ieyasu gladly accepted. Muneyoshi then retired from swordsmanship, and eventually died in 1606, by which time Tokugawa Ieyasu had become shogun.

Tokugawa Ieyasu was very interested in swords, swordsmanship, and *bugei* (martial arts) in general. He swam regularly in the moats of Edo castle until he was in his seventies, and was a good shot with bow and gun, both of which he practiced daily. Ieyasu was also very strong, as he once demonstrated by shooting a crane off one of the towers of Hamamatsu Castle using the heavy form of

arquebus known as a "wall-gun," without the extra support normally needed for its weight. At the Battle of the Anegawa in 1570, Ieyasu commented favorably upon the sword-fighting skills of Okudaira Nobumasa, and added that good ken-jutsu was a question of skill and not strength. He once interviewed the kengō Hikita Bungorō, Kamiizumi Nobutsuna's nephew, whom he criticized for failing to understand that not everyone needed sword-fighting skills. For a daimyō, according to Ieyasu (who may have had his tongue firmly in his cheek when he spoke), the important thing was to know how to choose men who would do the fighting for him. A daimyō should not take risks.

Yagyū Munenori continued serving the Tokugawa to the third-generation shogun Iemitsu, but on the death of Muneyoshi, the ryūha split into two. His elder son, Munenori's brother, had been severely wounded in battle in 1571 and crippled so badly that he was unable to wield a sword, but his was the senior line, and his son Toshiyoshi was the official heir of the Owari Yagyū Shinkage-ryū, which was to serve the junior branch of the Tokugawa,

based in Nagoya. The school of Munenori, sensei to the shoguns and based in Edo (later Tokyo), became the Edo Yagyū Shinkage-ryū, which Munenori eventually passed on to his son Yagyū Jūbei Mitsuyoshi. There was much rivalry between the Edo and Owari schools over the years to come.

Yagyū Jūbei Mitsuyoshi is a character almost as mysterious as Miyamoto Musashi, and his adventures, which allegedly included spying and ninja-like activities, have spawned many historical novels and films. Most of the legends and inventions revolve around a "lost" twelve years in his life, when he was abruptly dismissed by the shogun, and later reinstated. He was supposedly fired for drunkenness, but the lack of evidence, and the complete mystery surrounding his subsequent movements, have led many story writers to the conclusion that his dismissal was merely a front. In this scenario, Mitsuyoshi continued to serve the Tokugawa as a ninja, obtaining information for them as he went from province to province on a musha shūgyō, trying to wipe out his disgrace by worthy challenges. The best-known story about his wanderings was

mentioned in a previous chapter. This is the incident with dummy swords reenacted in *Seven Samurai*, in which Yagyū Jūbei had to kill his opponent to convince him that he had already won the contest using tsumeru techniques.

Passing on the Tradition

The history of the Yagyū family and their ryūha is an excellent illustration of the procedure and beliefs involved in passing on the secrets of a school, granting the right to teach, and choosing a successor. The transmission of the leadership of the ryūha was, of course, a very serious matter. Ideally, the recipient would be a son, but if there was no child, it could be given to another—usually the finest pupil. If a child was born subsequently, however, leadership of the ryūha would be returned to the family, as in the case of Tsukahara Bokuden.

Above: **A page from a training manual of the Yagyū Shinkage-ryū.**

Opposite: **Hikida Bungorō, from the *Musha Shūgyō Jun Rokuden*. He is carrying the prototype *shinai*, with which he defeated Yagyū Muneyoshi.**

The various schools of swordsmanship always claimed to possess their own specific and secret traditions. These secrets—the *menkyō kaiden* (secrets of the art)—were known only to very few people in any ryūha, who maintained the monopoly of this secret knowledge. Yagyū Munenori, Muneyoshi's heir, expressed it in the following way in his preface to *Heihō Kaidenshō*:

> The contents of those three volumes must not be released outside this family; however, this does not mean that our Way has to be completely concealed. To withhold the prescribed skills and theories in our ryū means to preserve the purity of our tradition, and to transmit them to students who are truly qualified. If these are never transmitted to others, then it is as if I had never written.[8]

In this treatise, Yagyū Munenori uses the words *ie* ("family" or "household") and *ryū* almost interchangeably, in a way that implies that he saw his students as his own children. In this extended family system, the eldest son did not necessarily have precedence in inheritance. Although Munenori had inherited the Edo Yagyū Shinkage-ryū from his father, Muneyoshi, he still pointed out that the successor as head of the school was required to be the best-qualified student:

> The first volume of this book was called *Shinrikyo,* and outlined the entire contents which were directly transmitted to my deceased father from its founder Kamiizumi Nobutsuna. Nobutsuna's swordsmanship was compiled into one volume to preserve his knowledge by transmitting it to the student who strove to reach the highest.[9]

Just as Nobutsuna had given one to Muneyoshi, Muneyoshi gave Munenori a certificate in the form of a scroll, formally transmitting the secrets of the craft. But not all knowledge was so esoteric. There were in fact three grades of secret: the *kirikami,* the *mokuroku,* and the *menkyō kaiden.* Broadly speaking, they are analogous to the *dan,* or teaching grades, in modern *budō,* but at a much higher level. Kirikami dealt with the fundamentals of posture and the preparation of the mind, which were the basis of their techniques. A more mature person who had studied more deeply would receive the mokuroku, which indicated a certain insight on the pupil's part. Last of all, and the highest, was the menkyō kaiden.

To form one's own ryūha was the final stage of the three stages, which some sensei identified as being the normal path

of instruction, expressed by three characters pronounced in Chinese. The first was *shu* ("to keep, observe, or obey"), which had as its goal to copy perfectly the techniques taught by the sensei. The second was *ha* ("to break"), indicating that the student was now ready to apply these techniques, adjusting them if necessary, and thereby developing his own style. The final stage was *ri* ("to depart") whereby a student finds new techniques, and ultimately creates an entirely new style of his own. This was, however, a very rare event in the Sengoku period. One example is Marume Kurando, a pupil of Kamiizumi Nobutsuna, who had originally disgraced himself during Nobutsuna's absence by ignoring his sensei's rule banning contests. Kurando had a spear fight with a man called Otaki Shigoroemon, whose nose he cut off. Kurando was punished for this, but from that time on, he worked hard at his training and eventually became one of Nobutsuna's star pupils. In 1567, Kurando asked Nobutsuna for the menkyō kaiden of the Shinkage-ryū, which was presented to him as a scroll, which still exists. Part of the text reads as follows:

> Having instructed so many in the virtues of strategy in many provinces, since you are first in the ability of strategy . . . you will be initiated into the secrets. The mystery of the two swords has not been taught except to one person in the whole country. This must be kept absolutely secret. In consequence I give this letter my seal.

As Kurando could not be Nobutsuna's heir, he went back to his native Kyūshū and founded the Taisha-ryū, which became for many years the official ken-jutsu school for the Shimazu family of Satsuma. He died in 1627 at the end of a full and long life.[10]

If one's pupil happened to be the shogun, he might be granted a sort of "honorary menkyō kaiden" for appearances' sake. For instance, the Yagyū gave the following document to the third Tokugawa shogun, Iemitsu:

> You have received everything, including the weak points of our style, originated by Kamiizumi Nobutsuna, the secret techniques, and the secrets of preparation of mind and body, all the techniques you have learnt from a young age, and our style covering all the weak points. May the various gods and Buddhas punish you if you reveal it.

Needless to say, the shogun had not actually been given any great secrets, but Iemitsu was certainly a keen and a dedicated swordsman, and summoned fighters from all over the country for regular tournaments. On receiving the document, Iemitsu then gave a promise called a *kishōmon* to the master, Yagyū Munenori, promising to the kami

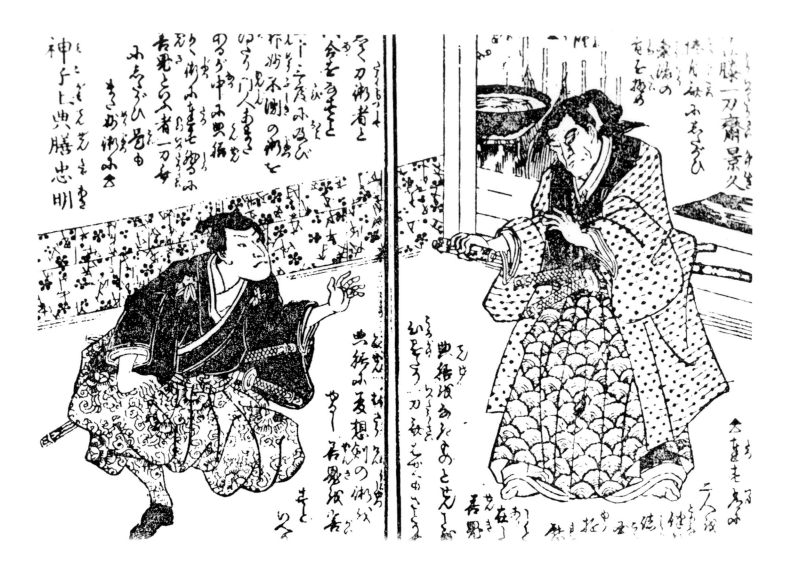

not to pass on anything to anyone unauthorized to receive it. This was a formality used when any techniques were passed on to a pupil, either verbally or in writing. The pupil in receipt of a menkyō kaiden would then customarily express his gratitude in the form of a gift.

Several of these so-called secret documents have survived, but little enlightenment can be gleaned from them nowadays for modern kendō enthusiasts seeking to improve their technique. In essence, they were only outlines or summaries of important things that had been passed on verbally. Some do contain drawings of fighting positions, but even these are difficult to interpret. The documents acted in effect as an aide-mémoire to the techniques that had already been learned, and of course, in the case of passing on an inheritance, the mere possession of the documents indicated the legality of succession, whatever they actually said. This was to have an important bearing on the bizarre way in which the succession was passed on in the Ittō-ryū.

The Fight for Succession

There can be no greater contrast to the orderly transfer of inheritance within the Yagyū Shinkage-ryū than the extra-

ordinary affair within the Ittō-ryū, the other school of swordsmanship to become tutors to the Tokugawa family. Their sensei was Ono Tadaaki, the contemporary and rival of Yagyū Munenori.

Ono Tadaaki's military service was mentioned in a previous chapter in connection with the disciplinary action brought against him when he broke ranks to pursue a challenge during the siege of Ueda castle in 1600. The whole of Ono Tadaaki's career, and indeed that of his master, Itō Ittōsai, has this wild aspect to it, a trait that is more akin to the strange lone figure of Miyamoto Musashi than to a man who is ken-jutsu instructor to the shogun. Apparently, Ono Tadaaki literally never pulled punches with his bokutō, even when practicing with future shogun Tokugawa Hidetada, leaving the heir to the bakufu with many painful bruises. It is hardly surprising that once Hidetada succeeded as the second Tokugawa shogun, he

Itō Ittōsai and Ono Tadaaki. This illustration shows the *sensei* Itō Ittōsai passing on to his successor, Tenzen (Ono Tadaaki), the secret scrolls that indicated his inheritance of the Ittō-ryū. Tenzen won the right of succession by fighting a duel with a rival pupil.

tended to favor the more diplomatic Yagyū Shinkage-ryū over the brusque Ittō-ryū.

Much of Ono Tadaaki's attitude stemmed from his sensei, Itō Ittōsai, who was a hard taskmaster. But the major difference between Itō Ittōsai and the other legendary kengō, such as Tsukahara Bokuden and Miyamoto Musashi, is that every other master swordsman sought at some time in his career to discover a deep religious, philosophical, or moral element in the practice of swordsmanship. Miyamoto Musashi wrote his famous *Gorinshō* (*The Book of Five Rings*). The Yagyū family produced treatises on sword fighting, presenting the wielding of a sword as a way of preserving and enhancing life, rather than merely destroying it. But Itō Ittōsai was different. He devoted himself totally to swordsmanship as the simple art of wielding a sword. To him, there was no inner meaning, no philosophical link with Zen Buddhism or Confucianism, just the single-minded goal of perfection in the art of fighting. The cynical would call him an inhuman butcher. Others, perhaps, who see Ittōsai's career in the context of the turbulent Sengoku Period, might call him a realist.

Itō Ittōsai is best remembered, however, for the quite extraordinary way in which he chose his successor. In contrast to the solemn passing on of tradition and secrets from Kamiizumi Nobutsuna to Yagyū Muneyoshi, or the careful entrusting to a third party of Bokuden's hitotsu tachi secrets, Itō Ittōsai made two of his disciples fight a duel to decide which of them should inherit. The pupils were a man called Zenki, who had formerly worked as a ferryman, and Tenzen, whom Ittōsai had once defeated in a bokutō duel. The fight between Zenki and Tenzen took place early one morning in 1588. As his pupils, armed with real swords, prepared to take up their positions, Ittōsai placed on the ground the official scrolls containing the menkyō kaiden of the school, possession of which would confirm the new master. The pupils drew their swords and waited, each so thoroughly aware of the other's techniques, and so keenly sensitive to each other's body language, that for a long period of time they stood like statues.

Then Zenki moved, but not to the attack. Instead he dashed over, picked up the scrolls, and proclaimed himself as the successor! Tenzen chased after him, as Zenki fled with the documents that would be accepted as proof of his succession by every swordsman in Japan. He caught him at the edge of a grove of trees and brought his sword down on Zenki's shoulder with a violent blow that almost cut him in two. That was the violent way in which Tenzen, afterwards known as Ono Tadaaki, inherited the leadership of the Ittō-ryū.[11]

The Dying Sensei

There are many other stories concerning the transfer of power within a ryūha, from tales of squabbles between sons to the devising of tests to decide the best swordsman. Tsukahara Bokuden, according to legend, tested his three sons by balancing a piece of wood on top of a door so that it would fall on them when they entered. One son caught the wood in mid-air. Another cut clean through it with his sword in a hitotsu tachi stroke. But the succession went to the son who refused to enter by the door until he had checked if there was a piece of wood ready to fall on him! No sensei other than Itō Ittōsai specified anything so dramatic as a fight to the death. One, however, got one almost by default, when his inheritance was finally settled by a duel on a bridge between his natural successor and one who disputed it.

In the latter half of the Sengoku period, in present-day Edosaki in Ibaraki Prefecture, there was a sensei called Morooka Ippa. Ippa may have been a pupil of either the Tenshin Shōden Shintō-ryū, or of Bokuden's Shintō-ryū, but whatever his origins, he was a fine swordsman and a devoted teacher. But there was one black cloud on Ippa's horizon: his health was very delicate. Ippa was in fact suffering from leprosy, a disease for which contemporary medicine could offer no cure. As his sword-fighting skills diminished with the decline of his physical health, so the numbers of his pupils dwindled. Finally he had only three senior pupils left: Negishi Tokaku, Iwama Koguma, and Hijiko Doronosuke.[12]

The three men pledged their best efforts to attend to their master's troubles, and to preserve his teachings. However, that same night, Negishi Tokaku fled, unwilling to restrict his own prowess by service to a dying master. By contrast, Koguma and Doronosuke were determined not to abandon their master in his serious illness. Such a course of action was unthinkable to faithful samurai who had received so much from their master's deep kindness. This principle of responding to a lord's benevolence by loyalty was to become a cornerstone of bushidō. Koguma and Doronosuke went without meals and suffered poverty in order to be able to supply medicines for their master. At one time, they even pawned their swords. But after three years of rudimentary medical skills and devoted nursing, the great master Morooka died, to be followed shortly by one of his two devoted pupils, Hijiko Doronosuke.

At this stage, the other senior pupil, Tokaku, reenters the story. He had gone to the city of Odawara, where he had made a name for himself as a swordsman, associating himself with another sensei called Tenka Musō, a strange character who, in addition to being a swords-

man, was also a *yamabushi*, a member of the mystical Buddhist sect of Shugendō who went on austere mountain pilgrimages. There were many legends about him, such as that he performed magic, or that he was really a tengu. Tokaku was supposed to have been initiated into the secret arts by Musō. On hearing of his former sensei's death, Tokaku proclaimed himself as the heir to the ryūha by virtue of being the most accomplished swordsman, a claim that scandalized the faithful Koguma. Only a duel between the two of them could settle the inheritance, and hearing that Tokaku had made his temporary base in Edo, Koguma resolved that the decisive contest should be carried out there.

It was now 1593. Koguma fixed a notice board in front of the Ote gate of Edo Castle, and wrote on it the following public notice: "For persons who aspire to the military arts, victory or defeat will alone decide the inheritance between master and pupil. Iwama Koguma." Koguma intended this to be a provocation to Tokaku. If Tokaku heard of this notice board, he would certainly

guess the meaning behind the strange wording, which implied a recognition by Koguma of the principle that the most skilled swordsman should inherit a school. Very soon the challenge was taken up, and the site of the contest was to be the bridge in front of the Ote gate where Koguma had pasted his notice. Both parties would use bokutō for the fight.

By this time, Koguma's physical appearance was dreadful. His enforced poverty had made him thin and wasted, and his clothes were very poor. By contrast, the tall Tokaku cut a dashing figure, and judging by his appearance alone, the numerous sightseers expected to see him win a quick victory. He wore a satin robe, *hakama* (divided-skirt-like trousers) of white cloth, black leggings, and straw sandals. He carried a very long and unusual bokutō, hexagonal in cross section and reinforced with iron, while Koguma had only an ordinary one.

Koguma strode on to the Ote bridge from the west, while the confident Tokaku virtually danced from the east, swinging his large bokutō. The despised Koguma

held his weapon in the high position known as *jōdan*. Koguma was an intelligent swordsman, and was looking for that brief instant when Tokaku might drop his guard. As he sensed the moment, he took the opportunity and lowered his bokutō slowly to *gedan,* the low posture, which looked deceptively unguarded.

From this point onwards, accounts of what happened during the next few seconds of this unusual contest become very confusing, and there are several theories to explain why it was that, without landing one blow on Koguma, the haughty Tokaku found himself falling from the parapet of the bridge into the river. The idea has been suggested that Tokaku tried to land a blow, but that Koguma sidestepped it, allowing the momentum of the heavy bokutō to break Tokaku's balance, whereupon Koguma pushed him to the side of the bridge and lifted him below his hips so that he fell upside down into the river. An alternative theory is that Koguma was pushed by Tokaku against the railings of the bridge, but suddenly took hold of Tokaku's leg, to off-balance him, then pulled him down and over into the river, using a throw similar to the *tomoe nage* throw of modern jūdō.

Whatever the theories say, they agree that Koguma avoided Tokaku's blow and pushed his opponent over the railings, so there was no longer any doubt as to who should follow Morooka Ippa as sensei. Tokaku had behaved recklessly, and to be thrown into the river, with his own sword neutralized, was a symbolic end for him. Koguma had appreciated his own limitations, and had thought how to turn his opponent's strength and greater skill against him. He had learned and read much during his master's serious illness, and as well as being the one who had remained loyal to his master, he had in fact benefited from the experience. From this time, the name of Tokaku virtually disappears from history. It is believed that he changed his name and eventually took service with Kuroda Magamasa, the lord of a province far from the scene of his disgrace.

Sensei and Survival

The Nen-ryū provided a later addition to the trio of schools already discussed, and is the last of the four schools regarded as the classic sword-fighting ryūha of the Age of Warring States. It is now called the Maniwa Nen-ryū, the name Maniwa referring to a place in Kōzuke Province where it had its base in the late sixteenth century.

The founder of the Maniwa Nen-ryū, Higuchi Matashichirō, was descended from a follower of Kiso Yoshinaka, one of the leading samurai in the Gempei War. The Higuchi family, a country samurai family of modest means, moved to Maniwa in 1500, where they remain to this day. The tradition of the Nen-ryū, however, predated the move to Maniwa, and is commonly traced back to a certain Soma Yoshimoto, who lived about the end of the twelfth century If true, this would make it much older than the Shintō-ryū. According to legend, when Yoshimoto was five years old, his father was murdered, and Yoshimoto was taken by his wet nurse to a place of safety to be brought up as a monk. Yoshimoto swore to avenge his father, and learned secret methods of sword fighting from a priest of Kamakura. When he turned eighteen, he returned to his home town and fulfilled his vow of vengeance, and after that he entered the Zen sect. On founding his own temple, he changed his name to Nen Oshō, which is the origin of the name Nen-ryū.

One of Nen Oshō's finest pupils was a member of the Higuchi family. However, the tradition was not followed continuously within the main line of the family, there being a break about four generations before the seventeenth generation, Matashichirō, in the 1590s. The Shintō-ryū had been adopted as the Higuchi family's new tradition, with the Nen-ryū tradition having been almost completely forgotten. Matashichirū, who ran a dōjō in Maniwa, was a skilled swordsman, and wanted to learn the truth about the fundamentals of the Nen-ryū, which he could only glean from writings of the family, because he thought it had died out. Young Matashichirū was very disappointed at the lack of continuity of what had once been a family tradition.

Then one day a distant relative called Konishi Kyobei appeared. Kyobei had a fairly good sword technique learned from the Shintō-ryū, although he had never been as good as Matashichirō. The unfortunate Kyobei had recently developed an eye disease, and had been without sight for two months. In spite of his handicap, Kyobei could not resist challenging his relative to a fight. Of course Matashichirō accepted, and to his surprise he was defeated by the blind man. They fought again, but the result was the same. Kyobei had a strange power that Matashichirō had never seen before. Kyobei attributed it to an eye doctor whom he had consulted, called Tomomatsu Gian, who was also a skilled swordfighter and had taught him the innovative methods. On further questioning, Matashichirō learned that this Gian was the seventh-generation master who had received the Nen-ryū tradition directly. Matashichirō's heart leapt. This was his opportunity to reestablish the family link with the Nen-ryū. He immediately went to be a pupil of Gian, leaving his dōjō under the care of his younger brother. He traveled through many provinces on a musha shūgyō

with Tomomatsu Gian, carrying the master's medicine chest on his back and training with him as he traveled. In 1590 he returned to the Maniwa dōjō. In 1595 he received the menkyō kaiden of the Nen-ryū, and in 1598 became the eighth master of the Nen-ryū. This was the origin of the Maniwa Nen-ryū.

At that time, in the nearby castle town of Takasaki, there was a person called Murakami Tenryū, who had inherited Saitō Denkinbō's school, called the Tendō-ryū. He was said to have been born in Kashima, and in a mere three years about a hundred pupils had passed through his hands. He had a proud nature and was a man of great strength and ability, but he had a reckless personality similar to that of his late master, Saitō Denkibō, whose untimely death was recounted in a previous chapter. As ill luck would have it, the village that contained the Maniwa

Nen-ryū dōjō was not far away. A new ryūha to rival the Tendo-ryū had been founded, and it was one run by a mere local village samurai!

Tenryū made a written challenge to the Maniwa dōjō, but Matashichirō had made it a rule that such contests were banned, and politely refused. For a second time, Tenryū issued the written challenge, and received the same reply. Of course the Tenryū side denounced Matashichirō as a coward, and began to ridicule the talents of the Nen-ryō. The pupils of the Maniwa side managed to keep silent, but finally they could no longer let the situation stand, and Matashichirō was forced to accept. It was a contest he had to win. A defeat would destroy both his life and the meaning of the Nen-ryū. So he visited the Yamana Hachiman Shrine in a nearby village, and vowed to defend the honor of the Maniwa Nen-ryū. There is a

stone (the "sword vow stone") commemorating the fulfilment of his vow in the same shrine to this day.

Thus, in March 1600, on the banks of the Karasu River in Kōzuke Province, a duel was fought that risked the future of two schools of martial arts. The fight began at the hour of the dragon (8:00 A.M.). The surface of the river was covered in mist, and the sound of the running water was very clear. An intense and expectant atmosphere hung over the scene. The rivals fought within a bamboo fence, outside of which were the pupils from the two schools and also crowds of people from the castle town, samurai, and townspeople and farmers from the nearby villages who had left their work to see the fight. Everyone was agog with anticipation as the two men arrived. Matashichirō had a bokutō carved from loquat wood. They were of equal height, and both were imposing figures.

The contest began from the moment when both men entered within the barrier, and it was decided within seconds. Seeing Matashichirō apparently totally relaxed and calm, Tenryū charged forward quickly, shouting, "I have won!" and waved his sword rather than lowering it in a defensive guard position. As he rushed headlong, Matashichirō's loquat bokutō smashed against the upper half of his face. Tenryū fell on his back with his mouth open, gurgling forth clots of blood. As he tried to get up, he dropped his sword, and received a blow on top of the head from Matashichirō's weapon. This one blow decided the future of one of the greatest sensei of the Sengoku period, and also the future of the Maniwa Nen-ryū, which is today one of the few authentic schools of traditional martial arts left in Japan.[13]

CHAPTER 6

SWORDS IN SOCIETY

It is not often recognized how much the popular image of the samurai owes to members of the nonsamurai classes, which included, it must be said, the criminal element of old Japan. To some extent, the same is also true of the image of the martial arts, which are commonly regarded as purely samurai arts: the exclusive and esoteric preserve of the aristocratic military class, never taught to the lower orders. However, many of the techniques that nowadays come under the category of samurai martial arts owe much of their development to the need for what one might call "anti-samurai martial arts." Townsmen and farmers, deprived of the right to carry weapons, had to develop techniques involving simple weapons and bare hands to defend themselves against any abuse of power by their betters.

Some well-respected writers go even further in their analysis. Yamada's study of ken-jutsu suggests that the elevation of swordsmanship to a quasi-religious and aesthetic status did not originate with the samurai class, who had neither the time nor the inclination to practice fine technique, let alone raise it to an art form. To the battle-hardened warrior, sword fighting was a savage and anonymous business of hacking at one's opponent, from which only a genius such as Kamiizumi Nobutsuna could lift himself. According to Yamada, the greatest prowess in swordsmanship arose instead from people who had been forced to make up for their deficiency in physical strength and battle experience by learning to handle the sword in a manner that was technically expert. Practice in this, which could only be conducted away from the battlefield, inevitably led to swordsmanship being seen more as an art than as a series of techniques.[1]

In contrast to this idea, we have the words attributed to someone who actually fought during the Age of Warring States: Kōsaka Danjō, the author of *Kōyō Gunkan*, the epic chronicle of the Takeda family.[2] As noted earlier, Kōsaka Danjō maintained that swordsmanship could only be learned on a battlefield. As the *Kōyō Gunkan* was published in twenty editions between 1600 and 1750, his words were undoubtedly influential, but its author did not live to see the debilitating effects on the samurai class as the "Age of War" gave way to the two and a half centuries of the "Age of Peace," as represented by the ascendancy of the Tokugawa family.[3]

Studies of samurai behavior during the two centuries when there were no battles to fight provide ample evidence that the mainstream martial skills of sword, spear, and bow suffered something of a decline, even among the close retainers of the shogun. There is little indication of their development into an "art," and not much more of their elevation onto a spiritual plane. Kōsaka Danjō's claim that the battlefield was the only place to learn true martial skills seemed to be coming truer with every peaceful year that passed. In his book *Taiheisaku*, Ogyū Sorai (1666–1728) denounced what he saw as the bad behavior of his class, both on duty and off:

A group of ignoble people who hide themselves behind the name of *bushi* do not attempt to expand their intellectual capacity through study, or to govern the nation with

A fierce swordfight in the shadow of Mount Fuji.

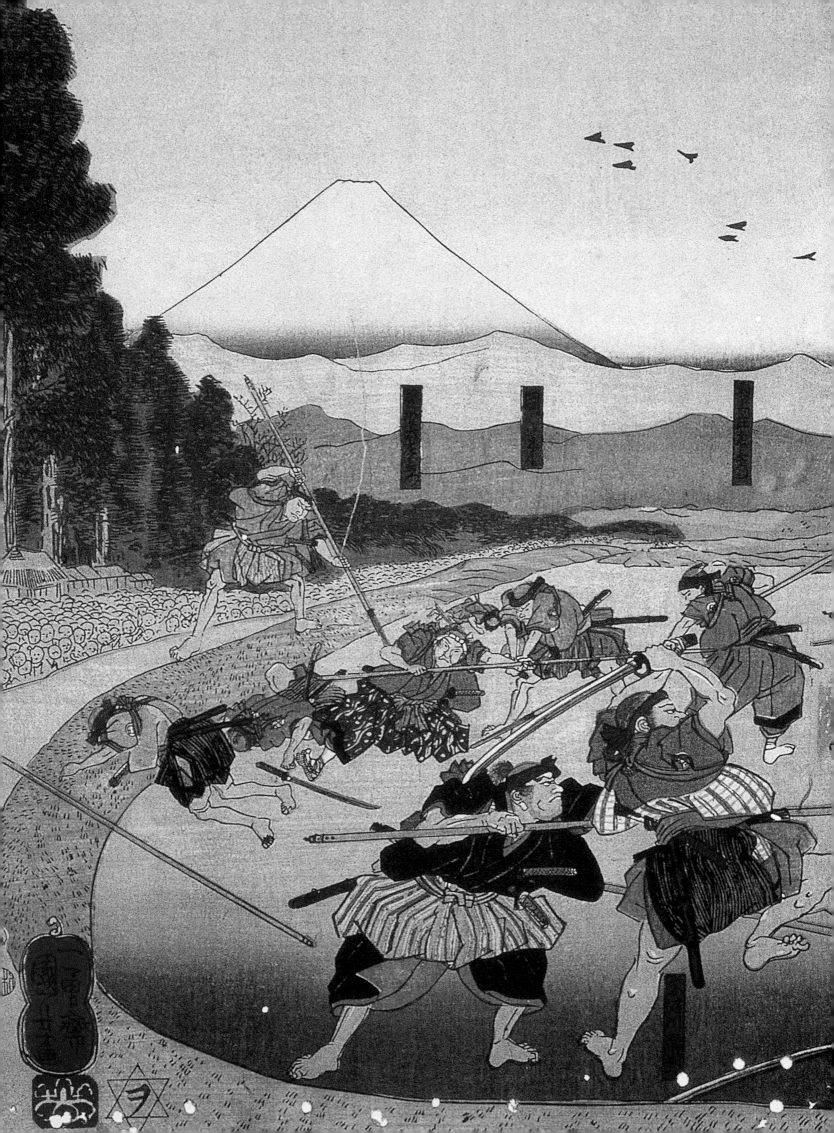

日本語縦書きテキスト

Above: **A samurai is mortally wounded through the neck.**

Opposite: **Matsudaira Masayuki (1611–1621), one of the *daimyō* who made the successful transition to the peaceful Edo period.**

reason for this was the increasing poverty in which many samurai found themselves. To live in a town on a fixed stipend, surrounded by numerous pleasures, rising prices, and obviously wealthy townspeople, was not an environment conducive to a single-minded concentration on the samurai ideal, particularly when there seemed to be little use for their traditional skills. Many took part-time jobs. A few, apparently, pawned their sword blades, replacing them with pieces of bamboo to hold the fittings and scabbard together. Another critic of the samurai character, Murata Seifu (1746–1811), wrote that "only the swords in their belts reminded them that they were samurai." Perhaps it is just as well that Seifu did not examine many swords very closely! There were exceptions of course, and examples can be found of samurai who maintained their training in order to carry out a revenge killing or to serve more loyally as daimyō's retainers. To these men, who patronized the ryūha, sword fighting was indeed an art form. But some facts speak for themselves, such as the observation that by 1720 many of the swordsmiths in the city of Kanazawa spent more time making pots and pans than swords.

The Brave Otokodate

Inactive samurai frequently found that the skills they believed to be theirs alone were far more widely spread within society than they had thought possible. Wanderers out on the high roads, plying their samurai swords for hire, could as easily prove to be absconding peasants or petty criminals as samurai. On many occasions, samurai found themselves up against well-organized gangs of swordsmen every bit as well trained as well armed as they were, skilled in the martial arts, and owing equally firm allegiance to their own variety of daimyō.

In theory, at any rate, this was a situation that could not possibly exist, because, according to law and established precedent, members of the samurai class were the only people allowed to carry swords. It was the wearing of two swords through the belt that defined a samurai. It was his privilege and his right. A series of edicts, beginning with Hideyoshi's famous "Sword Hunt" of 1588, had set this trend in motion, and had theoretically disarmed all but the samurai class. The Tokugawa regime had set the social distinction in stone by the legal separation of the social classes. But in practice, swords, spears, guns, and other weapons were readily obtainable and well used, sometimes by criminals, sometimes by desperate gangs of lower-class citizens defending their rights and their lives against the abuse of power by certain samurai.

These "certain samurai" had not lost their martial skills, and, having no battlefield on which to exercise them, turned to petty crime and intimidation. In the most

knowledge of civil matters. They conduct themselves in the town with their fearful appearance or extended out elbows. With their power to punish they suppress people and create disorder in society. . . . It is the most foolish way to govern the nation. . . . They merely study the stories of warfare and the combative method. Or, perhaps they believe that the mere acquisition of their professional skills, martial arts, is the way of the warrior.[4]

Other writers bemoaned the fact that the bad behavior to which Sorai referred was all that samurai seemed capable of, that their warrior skills had been totally neglected, handing over the practice of the martial arts to the criminal element among the lower classes. In 1650 a law was passed forbidding duelling among idle members of the shogun's guard, and even more extraordinarily, in 1694 another law was passed enforcing the practice of martial arts. Part of the

A samurai reenactor armed with two swords.

extreme cases, samurai gangs were formed, known as *hatamoto yakko* (retainer gangs). The counter to them was provided by equally ruthless men from the lower orders of society, and the most visible of these "nonsamurai samurai" lived in the big cities of the Edo period. They called themselves *otokodate* ("chivalrous fellows") and belonged to the *machi yakko* (town gangs). They walked openly in the streets, in defiance of rules forbidding them to bear swords, and developed the art of combat with other weapons such as the long (six-foot) staff, or *bō*, and the shorter (four-foot) *jō*. Otokodate also became accomplished in the art of the *tantō* (dagger), which could be concealed under clothes, and the defensive use of unusual implements such as the iron war-fan. It is to men like these, rather than samurai, that the development of minor martial weapons owes a great deal.

The word *otokodate* implies resistance to authority by those of the lower classes, but some of the great otokodate were originally of the samurai class. For one reason or another they had become rōnin and moved to find

employment in distant towns. One outstanding example of such an ex-samurai was Banzuin Chobe'e, the "godfather" of the otokodate of Edo. He was originally a samurai from Higo Province in Kyūshū, and was a retainer of the Terazawa clan of Shimabara, the scene of the great Christian upheaval of 1638 known as the Shimabara Rebellion. Following the suppression of the revolt, Chobe'e left Kyūshū as a rōnin and went to Edo, where he was forced to find work and became a *warimoto,* an agent who acted as a go-between for hiring laborers.[5]

Once established in Edo, Chobe'e took the surname of Banzuin, which was the area where he lived, and his "agency" prospered. These were the days of *sankin kōtai* (alternate attendance system), the third Tokugawa shogun's inspired idea for keeping the daimyō in order. In what was little more than a very elaborate hostage system, the daimyō himself lived in the castle town that was the capital of his *han* (fief), but his wife and children lived permanently in Edo under the benevolent protection of the shogun. Every daimyō (except those at a great distance, whose obligation was somewhat reduced) was required to make an annual journey to Edo to pay his respects to the shogun. It was a trip undertaken with great ostentation and at enormous expense, so that the roads leading to Edo were thronged with what appeared to be fully equipped samurai armies, either marching towards the shogun's capital, or marching away from it.

A supply of casual labor was one of the necessities that kept the system running. Chobe'e received 10 percent of the laborers' earnings as commission, and in return provided for them in times of sickness. Banzuin Chobe'e's influence and contacts also came in useful if any townspeople were oppressed by the hatamoto yakko. Because such violence and perverseness among the samurai could not be curtailed by the townspeople alone, former rōnin such as Chobe'e became the natural nucleus for opposition.

Chobe'e's fame was considerable, and this brought him into direct opposition to the leader of one of the most powerful hatamoto yakko, called the Jingi-gumi, one Mizuno Jūrōzaemon. Jūrōzaemon was a samurai with a stipend of 2,500 *koku* (one koku was the amount thought necessary to feed one man for one year). One day it was rumored that Chobe'e was in the vicinity of Yoshiwara, the pleasure quarters of Edo, where Jūrōzaemon's party was meeting. As Chobe'e was in a nearby *soba* (noodle) shop, Jūrōzaemon suggested that Chobe'e should buy him some soba, although he knew that the shop had already sold out for the day. It was a neat way of taunting Chobe'e, but, nothing daunted, Chobe'e gave one of his followers a considerable sum of money and ordered him to buy up all the soba that was available, which the machi

members then proceeded to dump unceremoniously in front of Jūrōzaemon. As the huge pile grew, Jūrōzaemon realized that he could not get the better of Chobe'e, and retired with considerable loss of face.

Not long afterwards, one of Chobe'e's followers caught three of Jūrōzaemon's men making unreasonable demands of a drunken townsman. He set on them and threw them into a ditch. This increased Jūrōzaemon's loathing for Chobe'e, and he planned to lure him into a trap. Jūrōzaemon invited Chobe'e to come to his house for a drinking party, ostensibly as a way of saying thank you for the gift of soba. Chobe'e guessed that it was an ambush, but went along nonetheless. He was attacked by two of Jūrōzaemon's men as he entered, whom he overcame. But before they began to drink together, Jūrōzaemon invited Chobe'e to take a bath—a common courtesy to a visitor. Once Chobe'e was in the bathhouse, Jūrōzaemon's men began to stoke the boiler to raise the temperature of the hot tub and scald him to death. As the hot steam rose, Chobe'e tried to break out, but Jūrōzaemon had locked the door. With his rival cornered, Jūrōzaemon's men thrust spears through the partition. One spear broke his leg, then another pierced his chest, killing the hero of the otokodate in a dishonorable fashion.

The Samurai Policemen

The above account may have given the impression that Edo was a completely lawless place, with no police presence on the streets. In fact there was a very active law-enforcement body, who added their own contribution to the development of the Japanese martial arts. They were the *yoriki* and the *dōshin*, the policemen of Tokugawa Japan.

In common with many other institutions of the Edo period, the nature of the *baku han* system (the mutual support between the shogun and his daimyō) allowed this successful arrangement, which was originally set up for the shogun's direct retainers in Edo, to become the norm for the whole of Japan. By 1631, the organization of policing in Edo was replicated on a smaller scale in every han (fief) in the country. As a daimyō spent much of his time traveling to and from Edo, he would delegate a major degree of responsibility within his own castle towns to *machi bugyō* (town magistrates), who combined within their role the functions of chief of police, mayor, and presiding judge.

In Edo there were two machi bugyō, for much the same reason that ancient Rome had two consuls: each one kept an eye on the other! They worked a shift system of one month on duty, one month off duty, although as the duties became more onerous in the expanding cities, particularly Edo, the off-duty month became no more than an opportunity for writing reports and seeing to other essen-

Two *ninja* disguised as gardeners tend a *daimyō's* garden as they gain intelligence from his visitors.

tial paperwork. The Edo machi bugyō had daily liaisons with the shogun's senior councilors in Edo castle, which alone indicates the high status of the position. Even though the post of machi bugyō was filled by comparatively lowly retainers with a stipend of five hundred koku, it carried an additional allowance of an extra three thousand koku, and a rank within the shogun's court equivalent to that of some daimyō.

Under each of the two machi bugyō were the *yoriki*, or assistant magistrates. There were fifty yoriki in Edo, twenty-five under each machi bugyō. They were chosen from the shogun's direct retainers who had an income of two hundred koku, and, in the case of the Edo yoriki, the appointment became hereditary within certain families, passing from father to son. This resulted in a "police force" that was very familiar with its territory, but also one that became very much a caste unto itself, living in a social limbo between the townspeople, whose lives they controlled, and the samurai of the castle. The latter would

The death of Banzuin Chobe'e, the "godfather" of the *otokodate* of Edo, who was murdered in a bathhouse.

have nothing to do with them because of the ancient Shintō fear of pollution from people who had a connection with death. In fact, the yoriki did not actually carry out executions: that was left to the outcast *hinin,* the "nonhumans," but the mere association with such practices, and their own fierce pride, kept the yoriki apart. The proud yoriki would wear the full samurai costume of the wide *hakama* (trousers) and the *haori* (jacket) and wore the two swords of the samurai. They had a reputation for smartness in appearance, particularly in their hairstyles.

Serving under the yoriki were the dōshin, who played the role of the policeman on the beat. They wore tight-fitting trousers rather than hakama and only carried one sword, although they were regarded as being of samurai status. In Edo there were 120 dōshin under each machi bugyō, and they were instantly recognizable by a distinctive side arm that was a badge of office and a vital defensive weapon. This was the *jitte,* a steel rod fitted with a handle and one or two hooks along the edge of the "blade." Its purpose was to catch a felon's sword blade so that he could be disarmed and taken alive.

The dōshin, accompanied by several assistants from among the townsfolk—ranging from public-spirited citizens to paid informers—maintained a visible police presence on the streets of the castle towns, the yoriki being called to the scene of an arrest only if the situation warranted it. In such cases, the yoriki, dressed in light body armor, would supervise the affair from horseback, with a spear kept as a last resort. The emphasis was always on taking the prisoner alive, which was no mean feat should the felon be an accomplished swordsman. Japanese ingenuity, however, took this obvious danger into account, and in addition to the jitte, the dōshin were armed with a range of fierce-looking hooked and barbed spears, which could keep the swordsman at bay, pin him into a corner, or usefully entangle items of clothing if he tried to escape. Once the man was disarmed, he was rapidly tied up. There existed a whole specialist area of martial arts techniques for quickly and securely roping suspects.

The punishments that the machi bugyō had in their power to dispense ranged in severity up to death, including a horrible form of crucifixion for such crimes as murder. For a samurai, the death penalty could, on occasions, be carried out by the convicted man himself, by an honorable act of suicide. In certain cases, the execution of a condemned criminal could be a means of testing the quality of a sword blade. This was a more realistic test for a sword's quality than the more usual *tameshigiri* performed on a corpse. A story is told of one such condemned man who went to his end with remarkable coolness, telling the sword tester that if he had been forewarned that he was to die in this way, he would

have swallowed some large stones to damage the samurai's precious blade. A much lighter punishment was exile, which had been used for centuries in Japan as a way of dealing with offenses of a political nature.

The great benefits of the system lay in its capacity for crime prevention. To the dōshin's local knowledge was added a topographical system that divided Edo into tightly controllable *machi,* or wards. This arose from the original design of the city, which was deliberately intended to make an approach to Edo Castle difficult for an attacker. As in other big cities, the castle was surrounded by mazes of streets where the *chōnin* (townspeople) lived, and each machi was physically separated from others either by canals, walls, or fences. It was thus a simple matter to control movement from one machi to another by means of gates that were fastened at night, when anyone passing through had to have the appropriate authorization.

Swords and Gamblers

Crime was by no means confined to Edo, nor was the capital the only place where nonsamurai ruled as petty daimyō over their criminal or lower-class kingdoms. The eight provinces of the Kantō Plain, the large area of flatland that nowadays accommodates metropolitan Tokyo, Yokohama, and the Chiba peninsula, acted as a cradle for the criminal element towards the end of the eighteenth century, when crime was actually on the decline in Edo itself. Kōzuke Province attracted more than its share of the criminal element, because it was a wealthy center of textile manufacturing and was also well known throughout the whole country for its *onsen* (hot springs). In earlier days, the recuperative qualities of hot springs were privileges known only to the upper reaches of the samurai class, but as the Edo period wore on, the wealthier among the merchants, who already knew the value of hot baths, gained access to these pleasures. The taking of baths in "spa towns," where the mineral waters had healing properties, thus became a popular way of relaxing, as it is today for all Japanese. Hot-spring resorts vied with each other in the quality of their mineral waters and the range of comforts and entertainments they could provide. The onsen of Kōzuke were convenient places where the textile wholesalers and healing-spring guests could go for relaxation and amusement, and one pastime appealed above all others: gambling.

The provision of gambling dens promised immense profit for those willing to take a risk. They were operating in a very shadowy area of legality, so it is not surprising that controlling gambling became an activity for organized crime. Some gang leaders employed people known as *shika oi,* or "deer chasers," whose job it was to entice customers into the gambling dens, which were often operated under

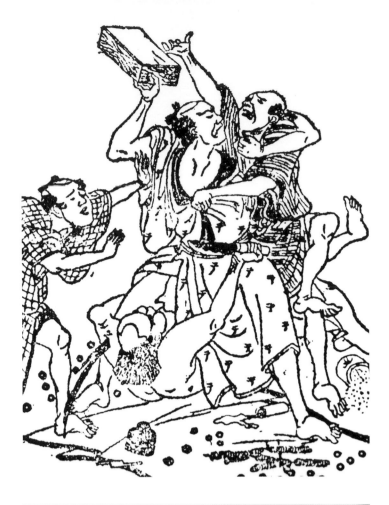

Top: **A fight in a gambling den, the scene of many a brawl, and the motivation for much swordplay.**

Above: **A sleeve entangler, the implement used by the** *dōshin* **to apprehend fleeing criminals.**

Opposite: **The swordsman fugitive Kunisada Chūji, who was crucified in 1850, was one of the most notorious criminal swordsmen of the later Edo Period. Here he examines the head of one of his victims, as proud as any** *daimyō* **of the Age of War. A series of novels and plays made him into something of a Robin Hood character.**

the guise of wayside inns. The gangs acquired territories in which their law held sway, and proficiency at the martial arts was as necessary for their survival as it had been for the samurai of the Warring States period. The swordsmen who arose from such backgrounds maintained a delicate

relationship with the civil authorities. Sometimes their sword-fighting skills were needed for hire, so a careful balance was struck between the two worlds in which they operated.

An outstanding example of success in this milieu is provided by a man called Omaeda Eigorō, who was born in 1793 in Kōzuke. He was a famous gambler and was trained in swordsmanship at the Maniwa Nen-ryū—evidence in itself of the spread of "samurai values" through society. At the age of sixteen he killed his first victim, one Kugūno Jōhachi, who had opened a gambling place within Eigorō's father's territory in Yamagi village, where many townsmen and farmers came to market every month. Eigorō took his father's part, and killed Jōhachi in his gambling den in 1808. Because he could not return to his home, he went to the nearby castle town. It was very late at night, and the one shop that was open was a tofu shop, where he heard people talking about the murder of Jōhachi. Realizing that the police were looking for someone, Eigorō escaped to Mino Province until the affair died down, and was never arrested for the crime. From then on, he seemed to lead a charmed life, helped by his considerable diplomatic skills with the authorities, and no doubt by the occasional handsome bribe. Most reliable accounts of his life say he was impulsive, active, and very fond of fighting, and that his sword technique improved with age. He fought about twenty or thirty times without a trace of a cut. His only injury occurred in Mino, when he killed someone and ran away through the snow, eventually losing two toes to frostbite. His sword technique was outstanding, as was his general health, and he finally died in bed at the age of eighty-two.

In contrast to Eigorū, who built a giant sphere of influence through cooperating with the authorities when it suited him, his follower Kunisada Chūji lived his life resisting authority.[6] He was pursued by officials, and because he opposed samurai authoritarianism, he became the hero of the common people and something of a Japanese Robin Hood figure. Chūji did not, however, cut a very romantic figure, being short and fat. He began his career as a swordsman as a follower of Omaeda Eigorō, but put himself outside the law when he killed his rival Shimamura Isaburō in 1834. Their rivalry, inevitably, concerned the question of spheres of criminal influence. Both controlled networks of gambling dens within the province, and as each territory grew, a collision became increasingly likely. Shimamura Isaburō was twenty years older than Chūji, and clearly resented the growing power of the younger gang leader. The arrangements Chūji made to kill Isaburū smack of military precision and the coldest, most calculating mind. The incident that sparked the

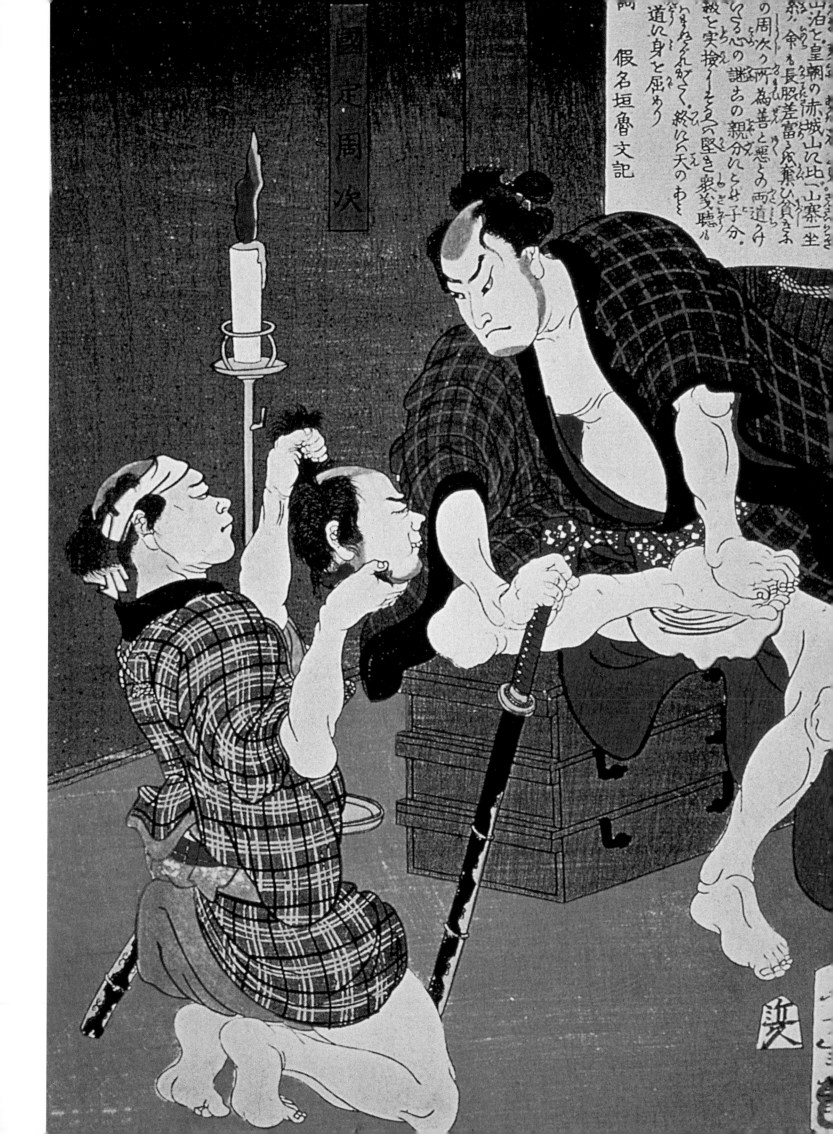

A frame from the comic *Lone Wolf*, showing *yōjimbō* guarding a house. They are armed with the wooden staff, or *bō*.

confrontation occurred when a follower of Chūji, Mitsugi no Bunzō, misbehaved in a sake shop as Isaburō was passing. Isaburō pulled Bunzō out into the street and thrashed him. Bunzū could not forget this incident and told Chūji, who saw an excuse to get Isaburō's territory. Chūji would have liked to announce a challenge to a rival, but decided on a surprise attack because Isaburō was so good a swordsman.

Isaburo was drinking sake in a restaurant along with his men. For some reason, the mouth of the sake bottle cracked, which his followers thought to be a bad omen. With all his henchmen surrounding him for protection, Isaburō left the bar after dark and went to the Chorakuji Temple, which Kunisada Chūji had already surveyed for a possible ambush. He had observed that there were two doors to the south from which one could escape, while the way to the north was across low ground and through a flooded rice field. That was where Chūji caught Isaburo as he approached. Chuji's followers surrounded the house and caused a commotion. The tall Isaburō was wearing a padded kimono with big crisscrosses on it, and was instantly identifiable. It had started to rain, and he had a lantern in one hand and an umbrella in the other, which made it difficult for him to get hold of his sword in the case of a sudden attack. When he passed a hedge, Chūji and Bunzō and ten others came out from behind it. Isaburō was killed in one second by a rapid slash across the chest.

By the time that the yoriki arrived on the scene, Chūji had gone, leaving nothing behind him but Isaburō's body. Chūji then took over his victim's sphere of influence, and his territory began to grow widely. But by so cold-bloodedly murdering a rival, he had set himself clearly outside the law. It was soon no longer safe for Chūji to stay in Kōzuke Province, so he set off on a journey, not as a warrior on a pilgrimage, but as a fugitive. Travel from one province to another in the Edo period was, however, rendered very difficult by the existence of toll-barriers at every crossing point. Chūji determined to flee to Shinano Province, where he could hide among its vast mountains, and he broke down the barrier at Oto to make his exit from Kōzuke, an act that earned him as much notoriety and popular fame as the murder.

He eventually settled in Shinano Province, where he rented a temple and opened a gambling den within it. Here he lived a life of great lawlessness. In 1836, he killed

a man from the Tamura family, followed by the man's brother six years later. In the same year, he killed a police spy who had been sent to gain information about him. Feuds developed among his erstwhile followers until Shinano became too uncomfortable for him, and he unwisely returned to Kōzuke, where he was still a wanted man. The yoriki arrested him soon after his return. His punishment, death by crucifixion, was a savage one, and it is surprising that such an unlikely candidate for heroism should have become a romantic figure.

Bodyguards and Battles

If an unemployed swordsman had neither the power nor the wealth to command his own private army, there was always employment to be had as a yōjimbō, or bodyguard. One of the most entertaining of Toshiro Mifune's film roles is as a yōjimbō in the film of the same name, where he plays two gangs of criminals off against each other.

Among their other duties, the yōjimbō guarded against incursions by burglars, and always kept a bō (long staff) beside their beds, hence the name. They would take the bō if they heard a door being forced, and tackle an intruder using the techniques of bō-jutsu rather than sword fighting. In keeping with the official policy of the dōshin—and in contrast to the popular image from the movies—simply to cut a man down in cold blood was not usually acceptable, so the oak bō was one way in which he could be restrained. It was in fact a very strong weapon. A sword stroke could be blocked and a poorly tempered blade shattered if hit correctly, so the odds were not all on the side of the swordsman.

Some merchants in the cities used their own yōjimbō to give them protection against the samurai gangs. They also hired yōjimbō to protect their palanquin carriers on the road. Disorder and crime were so serious in Edo in the seventeenth century that in 1686 new regulations were introduced to prevent arson and burglary, and in one raid over two hundred machi yakko men were rounded up and jailed. Towards the end of the Edo period, as noted above, gambling became a profitable business, and the big bosses employed yōjimbō to keep others out of their territories. Yōjimbō at this later date were sometimes second or third sons of samurai, who had some experience of learning ken-jutsu while traveling around in the countryside, so their sword fighting was usually very good.[7]

Yōjimbō were involved in 1844, when two of these gang leaders fought a celebrated nighttime sword battle that brought back echoes of the samurai wars of the Warring States period. It happened in Shimōsa, another of the Kantō provinces where crime flourished. Shimōsa bordered the Pacific Ocean, and its fishing industry exerted an economic influence similar to that of the textiles of Kōzuke. Fishing was centered on the port town of Choshi at the mouth of the Tonegawa with its huge flat riverbed. Two leaders had spheres of influence near Choshi: Iioka no Sukegoro and Sasagawa no Shigezō. Neither was a samurai, and their surnames merely refer to their localities, as the possessive adjective *no* indicates. Sukegoro was based in the fishing port of Iioka, and Shigezō held authority in Tosho by the Sasagawa, twelve miles away. Sukegoro had inherited his territory from the gang leader he had served, while Shigezō had been born and raised in a large farming family of the area. Their territories grew rapidly during the early 1840s, and eventually the two spheres of influence reached their limits. Shigezō plotted to murder Sukegoro, but Sukegoro learned of the plot and acted first, attempting to destroy his rival on a grand and dramatic scale. He carried out a night raid on the Sasagawa headquarters on the south bank of the Tonegawa, in the ninth month of 1844. By all accounts, the raid was a ferocious affair, with all the hallmarks of a medieval battle. It even had its fallen hero, in this case a certain Hirate Miki, who was the yōjimbō to the Sasagawa family.

According to one story about his past history, Miki had tried to kill the great sensei Chiba Shūsaku and was defeated. He then asked to become his pupil and was forgiven. He was a very skillful pupil, but because he suffered from tuberculosis he became depressed, lost all ambition, and drank heavily. His behavior became so outrageous that he was finally ousted by Shūsaku. Because he had no chance of serving a samurai family and thought he had little time left, he decided go to Choshi and become a gambler's yōjimbō.

Hirate Miki made a dramatic fight to the death in defense of Shigezō, as the samurai blades flashed in that moonlight raid. According to some versions of the story, he was wounded in twenty places and died in a nearby bamboo grove. The overall purpose of the raid failed, however; Sukegoro did not succeed in capturing Shigezō. This action is known to the world as the "quarrel in the dry riverbed of the great Tonegawa." Because it was inconclusive, both sides remained at odds until matters were resolved three years later, when assassins from the Iioka side murdered Shigezō. This was a murder so underhanded that even their own side did not admire the action, but it brought some peace to the area.[8]

A yōjimbō played his part in another gang battle of the later Edo period. This incident, known as the *Kojinyama no chi kemuri,* or "the spray of blood on Kojin Mountain," has come down to us as a great quarrel, but the reality is that there was no reason for a direct duel

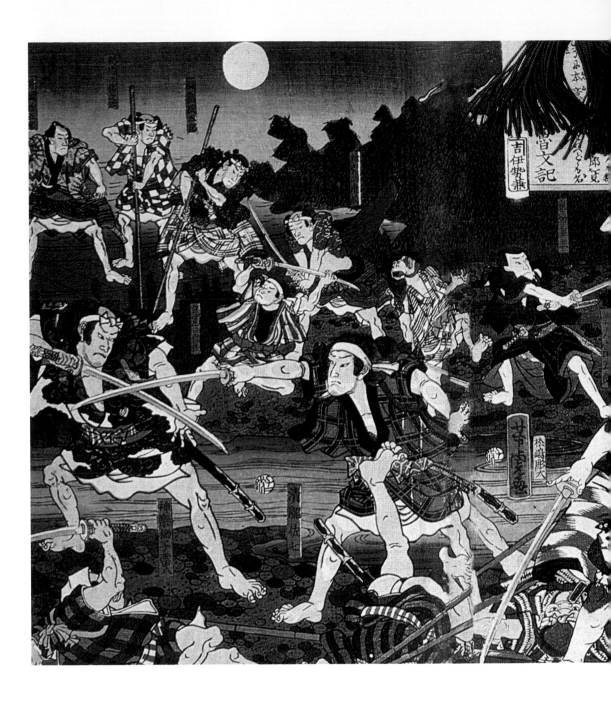

The fight in the dry riverbed of the Tonegawa, one of the largest pitched battles between criminal gangs of the Edo period.

between the protagonists Kira no Nikichi and Anō Toku. It developed into a classic encounter of the time—the Japanese equivalent of the gunfight at the O.K. Corral— and was a savage proof of the martial arts skills of the criminal classes, although it is hardly known outside Japan. It was also probably the last such fight to take place, as it happened while Japan was becoming engulfed in the battles of the Meiji Restoration.[9]

Kira no Nikichi was a gangster. One day, his close associate Kambe no Nagakichi came to him to ask a favor. Nikichi and Nagakichi "shared a sake cup," an expression used to denote an exceptionally close friendship, and the Kojinyama affair began when Nagakichi asked Nikichi to join him in killing a certain Anō Toku. Hearing this, even Nikichi was appalled. Anō Toku was a close friend, treated as a younger brother, and it was said that he had

great influence with the local big boss of Ise: Shimizu no Jirochō. Jirochō had built his territory on gambling, and developed his remarkable leadership skills by evading the numerous traps set for him by yoriki and rivals alike, until he achieved a quasi-official position within his own province. He died in 1893, his life having encompassed the final days of the Japanese daimyō, most of whom he outlived. One of his most remarkable feats was to get parole in compensation for the injuries he suffered when the jail he was in collapsed in an earthquake!

Nagakichi explained why he wanted Ano Tokū dead. He and Anō Toku had been followers of Oiwake no Yūzō, and following the death of their master, his sphere of influence was divided between the two of them. Gradually, they had asserted their independence from the family. There had been a brawl at a shrine festival, and Nagakichi

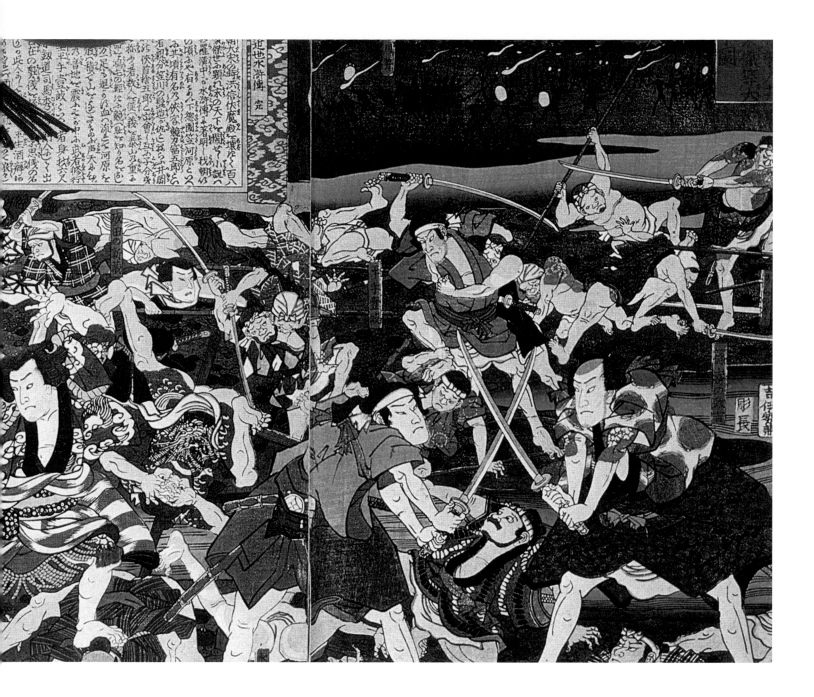

had killed a merchant by mistake, for which he was sent into temporary exile. He had asked a colleague to look after his affairs, but the man was killed by Anō Tokū—hence the enmity and the fierce desire for revenge, as ardent as any samurai vendetta.

To further persuade Nikichi to fight, other followers of Shimizu no Jirochō supported Nagakichi's viewpoint, and heaped calumny on Anō Tokū. They saw the opportunity to settle a few old scores, with a noble ideal of vengeance giving it all a spurious justification. Kira no Nikichi also had personal ambitions. If he killed Ano Tokū, the Shimizu territory would extend into Ise, and he would have a hand in it. Thus a samurai-style vendetta provided a respectable veneer for a gangland feud over territory. So in April 1866, early in the morning, the Kira family group, plus a number of Shimizu swordsmen—about twenty people in all—set off along the river in two fishing boats with all their weapons and food.

Ano Tokū soon discovered the plot and sent messengers to summon help. His supporters gathered at Kojinyama and set up camp, preparing for a "showdown." By then the local yoriki had heard of the affair, and they tried desperately to mediate the dispute, but without success. They finally withdrew, and made ready to return for the bodies. Just after midday, a huge fight began when Kira no Nikichi and all the Jirochō henchmen, though heavily outnumbered, attacked the headquarters of Ano Toku in the temple on Kojinyama.

The unusual thing about this showdown was that it began as a gun battle reminiscent of the Wild West! Nikichi fought with the yōjimbō of Ano Toku, who was called Hakui Moronosuke. First, Nikichi tried to fire a

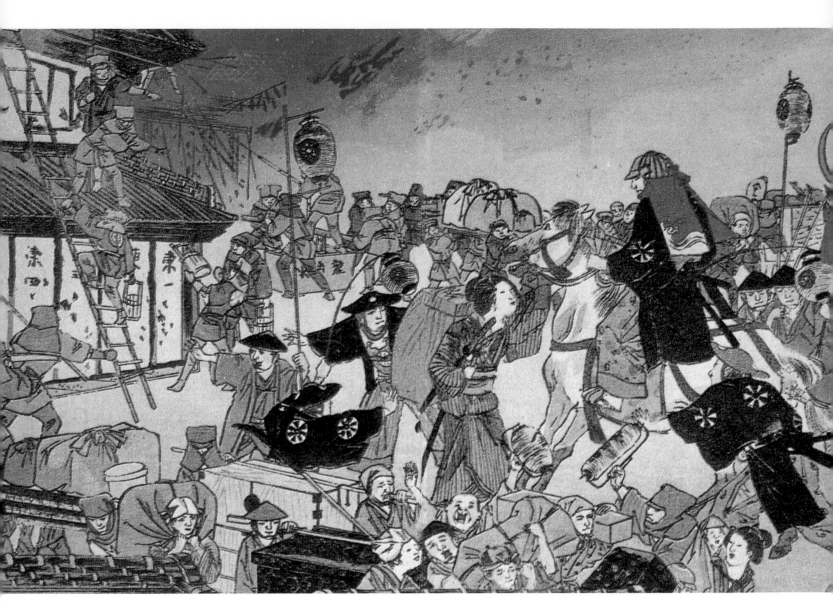

The firefighters of Edo in action. Prevention of fires—an ever-present danger in the city—was part of a *daimyō*'s civil duty.

matchlock gun at him as he brought down his sword, but the gun did not fire. Then Nikichi tried to draw his sword instead, but he was hit by a bullet before he could use the sword, and he dropped it. He attempted to pick the sword up with his left hand but staggered. Seeing that he was in danger, his comrades rushed to his side. One threw a spear at Moronosuke, which wounded him. Moronosuke stumbled, and seeing him fall, another of Nikichi's supporters, Kubi no Saijiro, ran up and killed Moronosuke with a quick sword stroke. Distressed by the death of their *yōjimbō*, Ano Tokū's faction started to withdraw, acknowledging their rivals' victory. But Nikichi did not have long to enjoy his triumph. He died shortly afterwards from loss of blood, at the age of twenty-eight. Thus ended a strange little episode in samurai history, but by this time Japan was on the brink of civil war, and such combats were to be swallowed up in the upheaval of the

Meiji Restoration, when martial arts skills would be needed by all classes—samurai, commoners, and criminals alike. Nevertheless, the "spray of blood on Kojinyama" serves as a grim reminder that wandering lone warriors and their fighting skills were by no means confined to the samurai classes.

The Fighting Firemen

We conclude this chapter with an account of the strangest swordfight of all. The other demanding area of a daimyō's civil duties was the prevention and control of fires. Fire was of course an ever-present hazard in a city built largely of wood. It would spread so rapidly that if a fire started near Edo jail, the prisoners were released on parole, with heavy fines if they did not return once the fire had been brought under control. During the 250 years of the Edo period, there were twenty large fires and

three large earthquakes in the capital. In the fire of 1657, half the city was destroyed, and over 100,000 people lost their lives. In 1772, half the city was again lost to fire, and in 1806, nearly all the retainers' homes burned down.

Considerable responsibility was placed upon the daimyō owners of *yashiki* (mansions). If a daimyō allowed a fire to start within his yashiki, he was punished by a number of days' confinement to his yashiki, but if the fire had not spread to other mansions, the punishment might not be carried out. The daimyō therefore had their own fire brigades, and yashiki belonging to daimyō with stipends above ten thousand koku were allowed to have a *hinomi* (lookout tower) with a mounted bell and striking-beam.

In the early decades of the eighteenth century, orders were issued for the formation of *machi hikeshi* (town fire brigades) in Edo. They were organized in a similar way to the yoriki and the dōshin. They wore protective clothing made of leather and heavy cotton, and helmets similar to battledress helmets, but with a cloak attached at the rear, which buttoned under the chin. Cutting firebreaks was the most effective means of controlling a blaze, and there are a number of exuberant woodblock prints that depict the firemen in action, using hooks to pull burning shingles off roofs (thatch was forbidden, for obvious reasons), and carrying buckets. Standing his ground, in the most visible position he dares to occupy, is the squad's standard-bearer. During the 1760s, water pumps were introduced and, with increased training, many potentially dangerous fires were averted.

There was, however, intense rivalry between the hikeshi, which on one occasion erupted into serious violence. The greatest jealousy occurred between the members of the Edo machi hikeshi and the daimyō's own brigades. The rivalry, which has great echoes of the violence between the hatamoto yakko and the machi yakko, had similar social origins, and the leader of the Edo machi hikeshi, Shimmon no Tatsugoro, had the popularity and the airs of Banzuin Chobe'e. He lived from 1800 until 1876, a time when memories of previous conflagrations made the citizens very frightened of the danger of fire, and they were ready to greet a successful fire chief as the nineteenth-century equivalent of a conquering daimyō.

Tatsugoro's collision with a daimyō hikeshi took the form of a confrontation with the fire brigade of the Arima daimyō of Chikugo Province. One night, Tatsugoro's machi hikeshi arrived at the scene of a fire to find the Arima brigade's standard flying over the scene. Tempers exploded, and the scene of the fire became one of carnage as the two groups of firemen attacked one another with their short swords and their fire axes. By the

A reenactor fires a reproduction musket. Kira no Nikichi and Ano Tokū's late-Edo-period fight began with an attempt at gunfire.

time order had been restored, eighteen men lay dead, a death toll higher than many of the celebrated vengeance feuds that scarred contemporary Japan. Tatsugoro took full responsibility for the lack of control among his men, and surrendered himself to the machi bugyō. His resulting banishment was only temporary, and he was to end his life as personal retainer to the last of the Tokugawa shoguns during the civil war of the Meiji Restoration. He accompanied the doomed shogun during his flight from the imperial forces, and eventually died peacefully at the age of seventy-five, as honored as any warlord.[10]

This was the world outside the samurai class that the daimyō were required to control, a world occupied by corrupt samurai, hereditary policemen, proud firemen, gambling bosses, and bitter gangland feuds. The Edo period may not have been scarred by the wars of the Sengoku era, but it can hardly be called an age of peace.

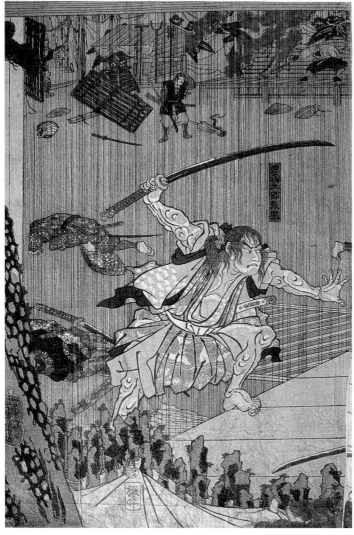

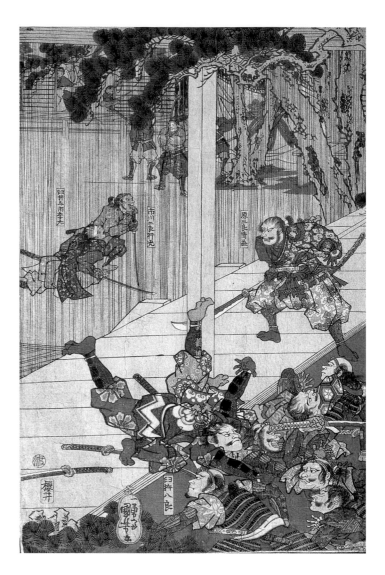

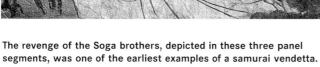
The revenge of the Soga brothers, depicted in these three panel segments, was one of the earliest examples of a samurai vendetta.

Once the deed was done, the avenger was required to report immediately to the nearest authorities and explain the circumstances of his revenge. He would be interrogated on the details by the magistrate and asked the name of his family and of his daimyō. He would then be required to present satisfactory proof that he had in fact been authorized to carry out the deed. Once his revenge was acknowledged as having been accomplished according to the rules, he was released from custody and walked away a free man, as in this account of the vengeance of the great swordsman Miyamoto Musashi:

> Miyamoto having encountered his enemy on the way, struck him and killed him. Having revenged himself in that manner, he narrated what he had done to the daimyō of the province, who, instead of blaming, congratulated him and sent him back in security to his lord's territory.[6]

Revenge in Japan, therefore, was both a right and a duty. The man who avenged himself was a man of honor, while the man who failed to do so was despised by his contemporaries, and might even be forced to flee from his neighboring district. The famous deception practiced by the Forty-Seven Rōnin of Ako (related below) exemplifies this attitude. In order to put their victim off guard, they pretended to have no interest in revenge and instead turned to drink and dissipation, producing a fierce reaction from a certain samurai from Satsuma. He was passing in the street and recognized the drunken form of Oishi Kuranosuke, the former chief retainer of the Ako daimyō. The visitor spat in his face, called him a faithless beast, and proclaimed that someone who had not the courage to avenge his dead lord was not worthy to be called a samurai. No doubt the incident was related back to the intended victim by his spies, and thus made the eventual assassination that much easier to perform.

But what if a man should die before discharging this most solemn obligation? In such a case, the duty passed to his sons, and then to his grandsons and great grandsons,

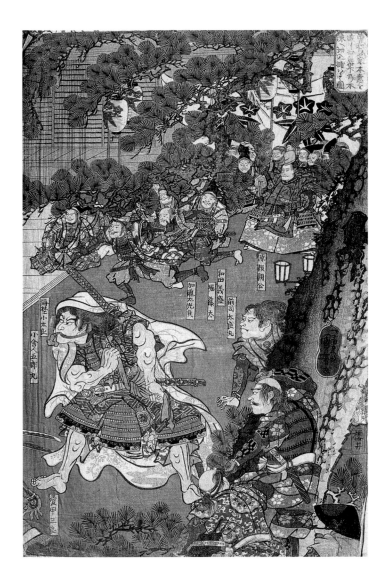

province of which Ueno was the capital), to distinguish it from the better-known Ueno, which is a district of metropolitan Tokyo. Nowadays, Iga-Ueno is a mecca for tourists interested in the famous ninja bands who had their headquarters in these remote valleys. This is a modern phenomenon, however; for centuries, Iga-Ueno was known for a very different reason: as the site of one of the most dramatic acts of vengeance in Japanese history—the Igagoe Vendetta.[7]

The Igagoe Vendetta has as its origin the murder of a certain Watanabe Gendayū by Kawai Matagorō, a retainer of the Okayama han, a long way from Iga-Ueno on the shores of the Inland Sea. The Okayama han, which was under the control of the Ikeda family, had for some time been troubled by dissension among the samurai retainers, and between the retainers and the daimyō. The murder of Gendayū, which was in a sense the culmination of these troubles, happened on the night of the lively Bon Odori festival in 1630, in Okayama, the castle town which was the han capital. That night, Matagorō, accompanied by some companions, was visiting Watanabe Kazuma. A brawl developed, and Matagorō and his associates mortally wounded Kazuma's younger brother, Gendayū, and took flight. Gendayū died very shortly afterwards, so Kawai Matagorō fled from Okayama and went to Edo.

Watanabe Kazuma, who now had the responsibility of avenging his brother, was only sixteen years old, and at first seems to have hoped that the Ikeda daimyō would bring Matagorō to justice on his behalf. But relations within the han had become so strained that Matagorō was safe in Edo, where a comrade, called Ando Jiemon, willingly sheltered him. Even the daimyō himself, Ikeda Tadao (1602–1632), could not enter unannounced, but hoped that, by employing various stratagems, he could capture Kawai Matagorō, who had caused him a great deal of trouble in the past. A raid was, in fact, carried out, but was seriously bungled. The attackers overcame Ando Jiemon but let Matagorō escape.

Before long, Ikeda Tadao died of a disease, smarting from the humiliation caused to him by this public evidence of dissension among the retainers. Such was his tenacity of purpose that his dying wish is supposed to have been: "For my memorial service, above everything else offer on my behalf the head of Kawai Matagorō." His younger brother, Ikeda Teruzumi (1603–1663), took to heart his elder brother's dying wishes, and relations among the retainers, some of whom openly supported Matagorō, increasingly took a dangerous turn. The be-all and end-all was Watanabe Kazuma, who sought revenge, and whose unfulfilled duty acted as a constant reminder of the existence of unfulfilled samurai honor within the troubled Okayama han.

until the enemy's head could be laid on the tomb of the father. The Kameyama Vengeance, which was carried out twenty-eight years after the original killing, is the classic example of this. The most famous vendetta of all, the classic tale of the Forty-Seven Rōnin, is most interesting for the way the avengers were required by circumstances to put themselves outside the legal framework in order to achieve the surprise necessary for success. Our first example, however, although bloody in its execution, was conducted completely within the law. This is the Igagoe Vendetta, which we will study in some detail because of the illustration it provides of the legal requirements surrounding the vendetta, outlined above. It also shows how wide the legal compass actually was.

The Igagoe Vendetta

The city of Ueno lies about sixty miles due east of Osaka, among the wooded mountains of Mie Prefecture. It is commonly called Iga-Ueno (Iga being the name of the old

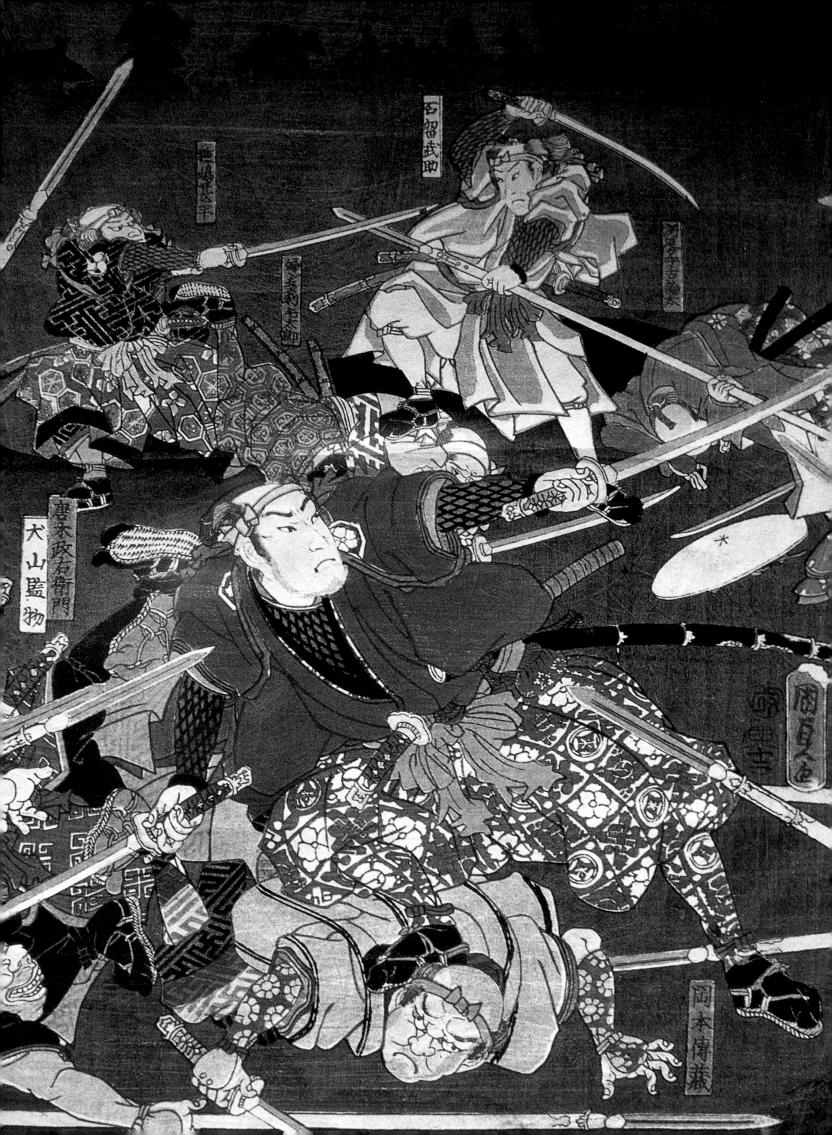

Right: **The Igagoe Vendetta as depicted in a woodblock print.**

Left: **A detail from a print depicting the Igagoe Vendetta in Iga-Ueno Castle.**

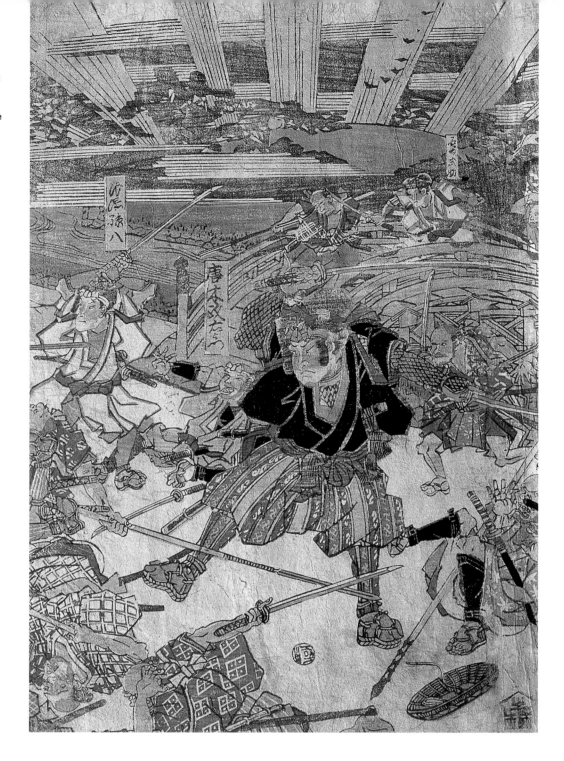

Eventually, the bakufu stepped in and officially ordered the exile of Kawai Matagorō. As it was the shogun's orders, a samurai had to submit and thereby preserve the honor of the Okayama han. This gave Kazuma an opportunity to discharge his obligation of revenge. He was now eighteen years old and able to save his own honor as well as that of the Okayama han, so he applied to the Ikeda family for discharge and, with official approval, began to search everywhere for Kawai Matagorō. Kazuma left the service of the Ikeda family in the ninth month of 1832. At the end of much hardship and long journeying, he located Kawai Matagorō, in the eleventh lunar month of 1834, in the neighborhood of Iga-Ueno. By now, Watanabe Kazuma had been joined in his revenge by his sister's husband, Araki Mata'emon, one of the foremost swordsmen of the day.

Araki Mata'emon was a swordsman of the celebrated Yagyū Shinkage-ryū and had been taught by Yagyū Mitsuyoshi. He served the Matsudaira family of Yamato-Koriyama, to whom he gave instruction in ken-jutsu. He seems to have combined intelligence with his sword-fighting skills, as revealed by an anecdote about Mata'emon fighting a swordsman called Yamada Shinryukan. Shinryukan's favorite weapon was the kusarigama, a very sharp sickle with a long weighted chain attached to the handle, as described in Chapter 4. The method of using the kusarigama was to whirl the chain at high speed, thus either keeping a swordsman at bay or entrapping his

waited for Matagorō's company to arrive along the road from Osaka. One man of their party stood guard, and the time passed very slowly. Apparently Matagorō's uncle, Kawai Jinzaemon, had complained of a chill, and their pace had slackened, so they entered Iga-Ueno later than Mata'emon had anticipated.

The law prevailed throughout the conflict that erupted right there at the crossroads. Mata'emon first struck the old man, Jinzaemon, and also killed the followers who were surrounding Matagorō. The story was eventually to grow to put the number slain by Mata'emon at thirty-six, but this is certainly exaggerated. Mata'emon may have been the better swordsman, but he had no intention of killing Matagorō. Kazuma was the one to do that, as the law demanded, so Mata'emon pushed Matagorō to Kazuma's side. He himself patiently joined his companions and did not invite them to join in. The Igagoe Vendetta was to be a duel between Kazuma and Matagorō, and nothing must inconvenience it, nor must there be any unnecessary deaths.

The duel between Kazuma and Matagorō continued for six hours until the hour of the ram (2:00 P.M.). Both became so weakened in mind and body that they could not even see their opponent. Nevertheless, Mata'emon still did not intervene. In a hoarse voice, he encouraged Kazuma, and at one point was able to head off Matagorō from escaping. Discipline was also maintained by Matagorō's men, who had supported him during his exile. It was equally necessary for their side to be seen to be behaving according to the law and the dictates of samurai honor. If Matagorō behaved properly, he might receive a pardon and regain the daimyō authority following a victory. So he made a desperate effort. Much more than samurai honor was at stake.

By now the sun was sinking, and the area around the Kagiya crossroads was dotted with corpses. Only Kazuma and Matagorō were still fighting. Then suddenly Kazuma struck home on Matagorō, and just before Matagorō had a chance to respond, Kazuma's sword cut an artery. As Matagorō fell, Kazuma dealt him a final blow to the neck. The law had priority to the bitter end. Mata'emon and the others carried out the appropriate procedures afterwards and surrendered themselves to the local daimyō.[8]

The Kameyama Vengeance

One important aspect of the Igagoe Vendetta is that the revenge killing was actually carried out by the immediate kin of the murdered man. If this proved impossible—the passage of time, for example, having prevented such an act from taking place—then the duty of revenge passed from that man to his son, and so on, theoretically, until the final generation. The outstanding example of this is the Kameyama Vendetta.

sword. The weight could also be spun to catch the opponent's leg and pull him over. When faced by this weapon, Araki Mata'emon enticed his enemy into a bamboo grove, where the kusarigama could not be used effectively, and swiftly overcame him. Sometime during the period of Kazuma's quest for revenge, Araki Mata'emon took his leave of the Matsudaira han, and volunteered his services as his brother-in-law's "second." The alliance caused great concern among Matagorō and his followers, because one of their number had once been defeated by Mata'emon in a fencing match.

On the seventh day of the eleventh month of 1834, Watanabe Kazuma, Araki Mata'emon, and two others waited for Kawai Matagorō's faction at the Kagiya crossroads in Iga-Ueno. They had been reliably informed that Kawai Matagorō was en route from Osaka to Ise, a journey that would take him that way. That morning the road was frozen. At the hour of the dragon (8:00 A.M.), Mata'emon and his followers entered a nearby shop and

Above: **Araki Mata'emon, hero of the Igagoe Vendetta.**

Opposite: **The site of the Igagoe Vendetta, the teahouse beside the crossroads, now rebuilt.**

The act of revenge took place on the morning of the ninth day of the fifth lunar month of 1701, beneath the Ishigaki Gate inside Kameyama Castle. Akabori Sui-no-suke, a retainer of Itagaki Shigefuyu, the keeper of Kameyama Castle, was heading for guard duty when his attendant heard the voices of two men, and a sword stroke slashed down from his forehead to his neck. As he fell, the two men gave him a finishing stroke. After this, they tied a message by a cord to Sui-no-suke's hakama, and departed calmly, the deed having been accomplished. Some retainers of the Kameyama han spotted them and chased after them, but the two men got away. According to the message they found, the two men who murdered Akabori Sui-no-suke were Morihei, a sandal bearer, and Hanemon, an attendant, and it became clear that they had killed the man who had killed their father. They had carried out this vengeance, they wrote, in accordance with the traditions of the samurai class, and after a wait of an amazing twenty-eight years![9]

All those years before, their late father, Ishii Uemon, had been a samurai who received a stipend of 250 koku as a retainer of the keeper of Komoro Castle in Shinano. On the twenty-ninth day of the third month of 1662, his

daimyō agreed that he should become the warden of Osaka Castle, and he moved to Osaka together with his four sons. Uemon was a friend of a rōnin from Otsu in Omi Province, called Akabori Yugen, and he was asked if Yugen's adopted son, Gengoemon, might come and study in Osaka. Uemon gave his wholehearted consent and summoned Gengoemon to Osaka, on the understanding that he would apply himself diligently to the martial arts. However, this Gengoemon was an arrogant young man, and made little progress when he began instruction in spear fighting with the assembled pupils. On being reprimanded by Ishii, Gengoemon got very angry and challenged him to a contest. Ishii Uemon reluctantly agreed to a contest with wooden swords, but Gengoemon used a real spear, yet was easily defeated. As a result, Gengoemon lost face with his fellow pupils and, when the opportunity presented itself, he murdered his master Uemon and fled.

Uemon's son, Hyoemon, was eighteen years old at the time, and personal retainer to the daimyō Munetoshi. That night he was on guard duty, and on learning of his father's death, he applied for leave of absence and set off in search of revenge. However, the assassin was nowhere to be seen.

The reconstructed outer defenses of Banshū-Ako Castle, the base of the Forty-Seven Rōnin.

A long search began, and that winter Hyoemon killed Gengoemon's father, Akabori Yugen, in Otsu. It was an eye for an eye, but according to the complex attitudes governing revenge, to kill the father of one's father's murderer did not constitute revenge. The killing was performed just so that Gengoemon might show himself, but he did not appear. Now Gengoemon also thirsted for vengeance for his father, and he tracked down Hyoemon to a bath house. Gengoemon attacked him suddenly from behind. Hyoemon drew his sword at the same time and thrust for Gengoemon's thigh, but a deep wound from the first sword stroke led to his death.

Gengoemon's vengeance was thus complete, but for the Ishii family the need for vengeance had now doubled, and the duty of carrying it out had passed to the late Hyoemon's younger brother, Hikoshichiro. He set out on a quest for vengeance, but ill luck led to his early death. Two young brothers were left, who were being cared for by a relative called Aki. The elder of them, Genzo, was six years old, and the fourth son, Hanzo, was only three. Gengoemon felt a sense of relief because the remaining

sons were just young children, but a wise relative recommended vigilance. The relative was a retainer of the Itagaki family and proposed that Gengoemon should enter the service of the Itagaki at Kameyama Castle. Gengoemon was given a stipend of 150 koku, and changed his name to Akabori Sui-no-suke.

Through Aki, Genzo and Hanzo nurtured their desire for revenge, and through him also heard of their enemy's change of name and learned that he had become a retainer at Kameyama. By then, Genzo was fourteen years old and wanted to comply with the wishes of his family. He was still too young, so he sent Aki on a quest for revenge on his behalf. Aki came to Kameyama and sighted Sui-no-suke, but there was no way for him to sneak into the castle, so he abandoned his plans.

In 1688, the youngest son, Hanzo, became seventeen, and the brothers felt confident enough to take matters into their own hands. Leaving Aki behind, the two went to Edo, disguised as pedlars, and studied the comings and goings of the Itagaki clan on the sankin kōtai. Then they got the chance to serve Hirai Zaiemon, a senior retainer of the Itagaki daimyō. When Zaiemon was to accompany his daimyō on the sankin kōtai, the two Ishii brothers went along as *chūgen* (low ranking samurai). No sooner had they

Above: **Oishi Yoshio's house in Banshū-Ako. This is a modern reconstruction, but the mansion of Kira in Edo that the Rōnin attacked would have looked very similar.**

begun to rejoice on being able to enter the castle than Zaiemon unfortunately died a natural death. The brothers were dismissed and saw their quarry departing for Edo while they were unable to prevent it.

However, their lowly service had at least brought them within the outer circle of the Itagaki retainers. Genzo changed his name to Morihei, and Hanzo to Hanemon, and both impressed the bugyō by their soberness. Soon they grew to have the confidence of the castle family. The two frequently met and talked about their revenge, and as fellow retainers they kept watch on their enemy, Akabori Sui-no-suke. Then came the day when their ambition could be realized. In the morning of the ninth day of the fifth month of 1701, at the hour of the dragon (8:00 A.M.), Akabori Sui-no-suke was making his way under the Ishigaki gate, accompanied by his sandal bearer. The brothers came up from behind and shouted simultaneously, "We are the sons of Ishii Uemon, Genzo and Hanzo, and you are our father's enemy Akabori Gengoemon. Fair play!" They cut him from forehead to neck. Sui-no-suke unsheathed at the same time, but the wound was too severe, and he fell. Sui-no-suke's sandal

bearer fled. The two brothers tied the message to his hakama, fled from Kameyama and wrote a letter to their family, expressing satisfaction at the outcome. Then they went to Edo via the Nakasendo Road, and reported to the machi bugyō, but neither received any punishment for their deed. Instead, because of the talent they had shown, they were enlisted by Aoyama Tadashige, keeper of Hamamatsu Castle in Tōtōmi and were each given a stipend of 250 koku.

The Forty-Seven Rōnin

The most famous act of samurai revenge in Japanese history occurred just one year later. It was carried out in 1702 by the forty-seven loyal retainers of the daimyō of Ako. These dispossessed warriors plotted in secret, carried out a daring assassination, and then paid for their crime by a mass act of seppuku (ritual suicide).[10]

Few incidents in Japanese history have spawned more plays, books, and prints than the revenge of the Forty-Seven Rōnin. To some of the eighteenth-century play-going citizens of Edo who watched enthralled as the story unfolded, the famous Forty-Seven Rōnin of Ako were the ultimate warriors, whose revenge for the death of their master set the standard for samurai behavior. But when the act actually happened, it had shocked contemporary Japan to realize that

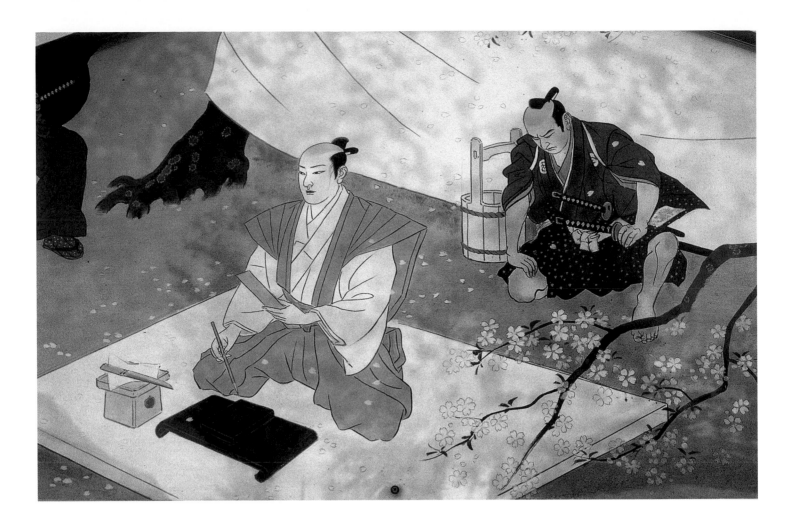

some samurai took bushidō very seriously indeed. So what really lay behind this classic tale of vengeance? Was it just one murder for another, or did it represent something very special in the world of the samurai swordsman? We will examine the well-known story in comparison to the two other accounts of revenge related above. In both those cases the avengers were unpunished, while the gallant forty-seven paid with their lives. What went wrong?

The background to the act of revenge is well known and may be stated succinctly. The loyal forty-seven samurai were retainers of Asano Naganori (1667–1701). He belonged to a cadet branch of the Asano family and possessed a fief of 55,000 koku based in the town of Ako, in Harima Province. Ako is now known as Banshū-Ako, where the memories of its heroes are commemorated and treasured. In 1700, Asano, together with a certain Kira Yoshinaka, was commissioned to entertain envoys of the emperor at the court of the shogun, Tokugawa Tsunayoshi. Kira Yoshinaka held the office of "Master of Ceremonies" in the shogun's court, and it was the custom for his colleague to give him some presents in order to get instruction from him and thus avoid any error of etiquette. However, Asano brought no gifts, and Kira, deeply offended, spared no opportunity to scorn his colleague. One day he went so far as to rebuke him in

public. Asano lost his temper, drew his short sword, and wounded Kira on the forehead. Even to draw a weapon in the presence of the shogun was a very serious matter, so Asano was arrested. His punishment was swift. He was ordered to commit seppuku, and actually carried out the act the same day as he had attacked Kira.

When the news of this rapid and rough justice reached the castle town of Ako, his followers urgently discussed what action to take. Some were for barricading themselves in the castle and making a demonstration so dramatic that the shogun might even send an army to besiege it. Others argued that they should perform the act of *junshi*, "following (their lord) in death," by committing suicide. This was the course of action initially supported by the chief of these former retainers, Oishi Yoshio Kuranosuke, but he was mindful of the effect this might have on the future of the Asano family. So instead he sent a petition to the shogun requesting that the fief be transferred to Asano's younger brother, Daigaku, but this was refused.

A year went by, and the shogun added to the agony by

Above: The *seppuku* of Asano Naganori, his punishment for wounding Kira Yoshinaka in the year 1700.

Opposite: Two exhausted *Rōnin* stagger out of the mansion.

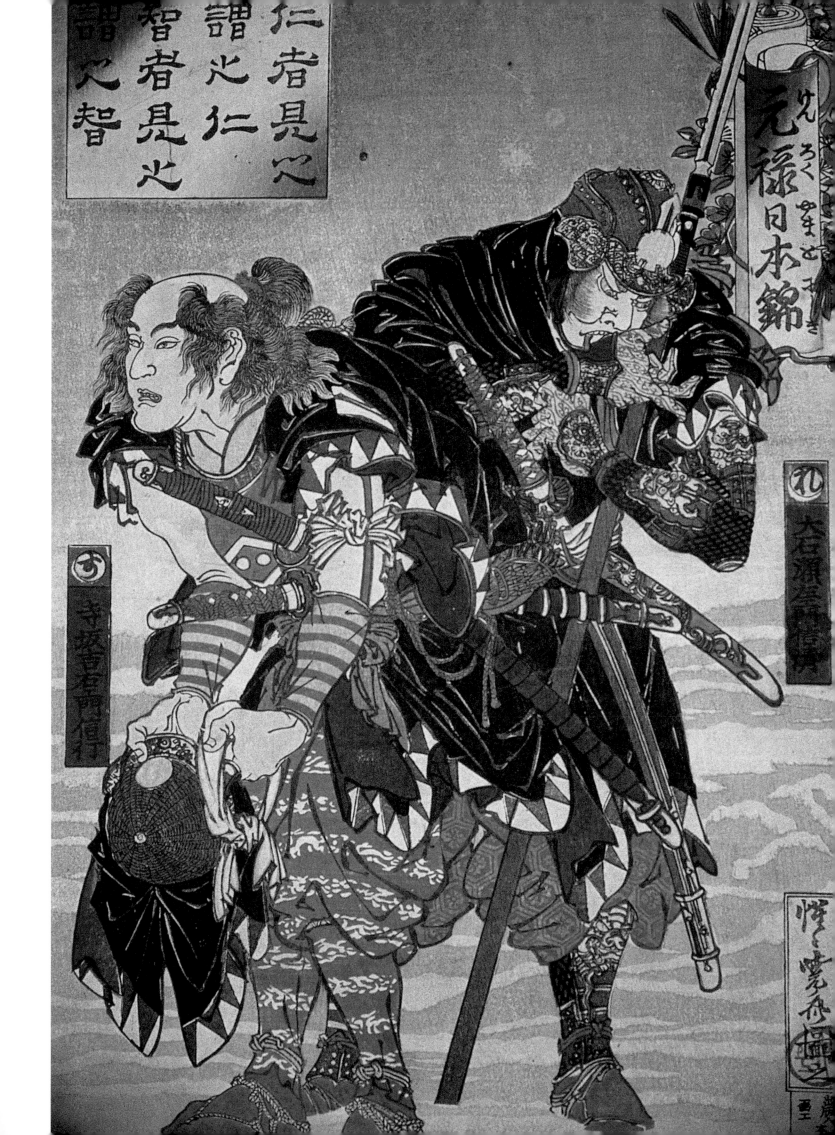

仁者見之
謂之仁
智者見之
謂之智

元禄日本錦

大石瀬左衛門信清

寺坂吉右衛門信行

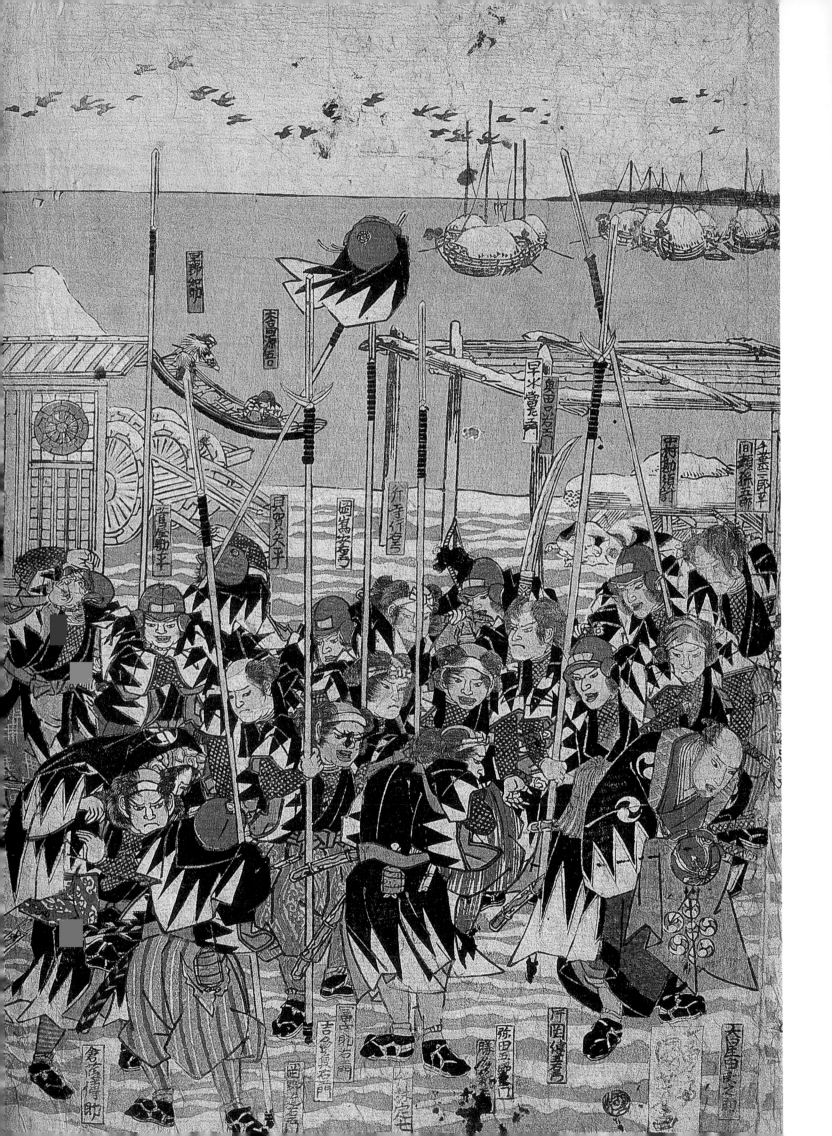

村松三太夫　藤原高直　二十七歳

岡嶋八十右衛門　藤原常樹　三十八歳

吉田澤右衛門　藤原兼貞　二十九歳

矢田五

早水

大石

deciding that the territory of Ako should be confiscated as punishment. By this act Asano Naganori's retainers were to be made unemployed and dispossessed. They would become rōnin, and it was at this point that they decided to avenge their dead lord. Oishi Kuranosuke retired to Kyoto, where he began to plot a secret revenge with the forty-six others, all of whom pledged to remain loyal to the memory of their dead master. They also swore to be silent about their plans, and this blanket of concealment was to become the most famous characteristic of the vendetta. It was also the factor that eventually led to their deaths.

When the news of the confiscation reached him, Kira Yoshinaka feared that there might be a plot against him, so he sent men to watch Oishi Kuranosuke. His spies did their job well, but found only a man addicted to drink and given to pleasure. He was seen frequenting brothels and drinking houses, and was once found drunk in the street. No one so dissipated could be plotting revenge! But this was only a front that Oishi kept up for nearly two years. In a similar way, his forty-six companions adopted new lives that aroused no suspicion whatsoever.

Finally, on a snowy night in December 1702, the loyal forty-seven, wearing protective armor that they had manufactured secretly, came together to launch a raid on Kira's mansion in Edo. The guards were taken by surprise, and none of Kira's neighbors intervened, partly because they had been assured by the plotters during their advance on the mansion that it was an act of private vengeance and nobody else's business. The doors were broken in by huge mallets, and a fierce swordfight ensued. Oishi Yoshio Kuranosuke cut off Kira's head and placed it on Asano's tomb in the Sengakuji Temple, in recognition that a solemn duty had been fulfilled.

One of the rōnin had been killed in the raid, so it was the remaining forty-six who went to the authorities and proclaimed what they had done. The government had thus been placed in a quandary. Oishi Yoshio had been a pupil of the respected Confucian thinker Yamaga Soko, whose exposition of bushidō

Above: **Two fierce-looking members of the Forty-Seven Rōnin, as depicted in a hanging scroll in the Oishi Shrine in Banshū-Ako.**

Opposite: **The Forty-Seven Rōnin return from their mission.**

Above: **As the raid proceeds, Kira is seized by the Rōnin as they break into his mansion.**

Opposite: **A team carrying the palanquin of Oishi Kuranosuke, leader of the Forty-Seven Rōnin.**

as "duty above all" had earned the highest regard from the leaders of samurai. The forty-six had fulfilled their duty. The government did not know whether to punish them for murder by vendetta or reward them for behaving more like true samurai than any others for more than a century. The decision they reached was that the law must be upheld at all costs. The possible consequences of giving official approval to an unauthorized vendetta were too ominous to contemplate, so the rōnin were ordered to commit seppuku, a course of action for which they had been prepared from the start.

Rōnin and Reality

Just as the works of Shakespeare have clouded our vision of English history by demonizing characters such as Richard III, any examination of the Forty-Seven Rōnin story is inevitably influenced by images originating from romance and drama. The first problem to be confronted is the actual cause of

Asano's attack on Kira. Why should a well-respected and experienced samurai do such a stupid thing as attack a colleague with a sword inside the shogun's court? Fortunately, we actually have an eyewitness account of the incident. A certain Kajikawa Yosobei was also on duty, and had gone in search of Kira in the course of his errands. Kajikawa was talking to Kira when someone came up from behind him and struck at Kira. The man shouted, "Do you remember my grudge from these past days?" It turned out to be Asano. Kira whirled round in surprise and tried to escape, whereupon Asano struck him a second time, and he fell to the floor facedown. At that moment, Kajikawa leapt at Asano and restrained him by the arms. Guards raced up and escorted Asano out of the reception room. He apparently repeated words to the effect that "I have had a grudge against Kira for some time, and although I much regret the time and the place, I had no choice but to strike at him." He spoke in such a loud voice that others sought to calm him.

In another report by another official on duty that day, the same mention of a grudge occurs. There is further confirmation in the account by Tamura Takeaki, into whose custody Asano was placed within less than two hours of the attack. Shortly before 4:00 P.M. that same afternoon, the order arrived that Tamura was to ensure Asano's death by seppuku. Asano asked to be allowed to write a letter to his retainers. This was refused, but he did give an oral message that was later written down and handed to his followers. It included the words, "what happened to day could not be helped, and it was impossible for me to let you know."

These three accounts constitute the totality of what we know about the motivation behind Asano's strange behavior. In their correspondence about the matter, none of his loyal forty-seven refer to the cause of the attack, and the popular view that Kira expected gifts, or more likely bribes, in order to educate a country bumpkin remains the likely explanation. It would certainly appear that Kira ridiculed Asano to a point unbearable for a samurai's honor.

As for Kira Yoshinaka, it is clear that the shogunate regarded him as an innocent victim. The loyal forty-seven thought that this was particularly unfair. One reason for their anger was that their lord's attack was not the first incident of that sort to have happened in Edo. In fact four similar events had occurred over the previous six decades. In three of the cases, the perpetrators were sentenced to death by seppuku, just as Asano had been. In the fourth instance, the attacker had been killed on the spot. Where the circumstances differed was the treatment of the victims. Those who had not been killed in the attack were regarded as partially guilty and had been banished. Kira Yoshinaka had not been regarded as having contributed in any way to his fate.

Did Asano intend to kill Kira or just wound him? This is

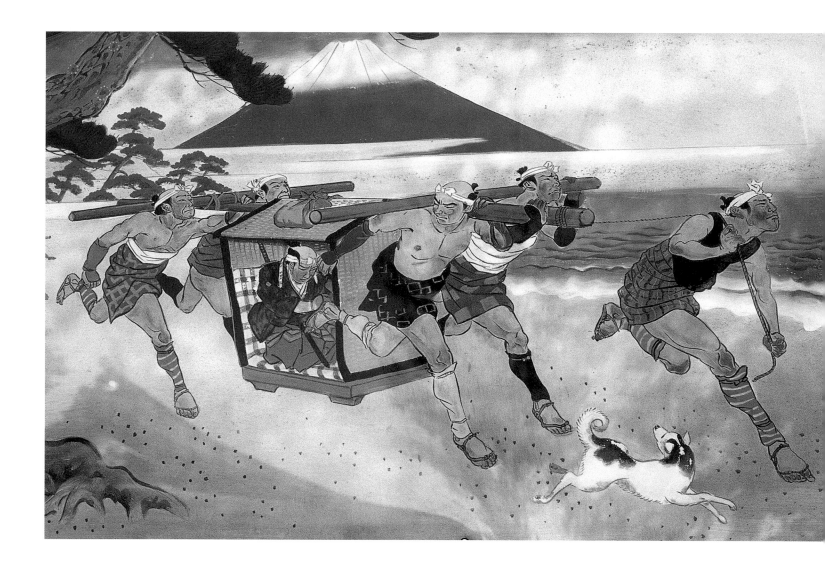

an interesting point, because one other important factor in the Asano affair was the view that Asano was somehow deficient in the martial arts because he failed to accomplish his mission of killing Kira. This of course presumes an intention to kill Kira outright, and that cannot be proved either way. In fact, those who defended Asano's action claimed that his failure to kill Kira this proved that his act was entirely spontaneous and not an assassination attempt. By contrast, those who thought he was an assassin, and a poor one at that, pointed out that Asano should have known that the way to kill someone with a wakizashi was to stab and not slash.

Legacy of Loyalty

Unlike the mystery surrounding Asano's attack, the motivation and course of action followed over the next few months by his loyal followers are not under great dispute. A siege or suicides were both considered, and it is clear that they found the shogun's sentence totally unexpected and unfair. It was their subsequent decision to take direct and personal revenge on Kira that had such major consequences.

The first consideration dealt with the legality of their revenge. The existing precepts did not actually allow for

avenging the death of one's lord, only that of a relative. That was the first complication for the Ako samurai. The second problem was that their vendetta depended upon launching a surprise attack on the well-defended Kira, so registration with the authorities was impossible. Further, although Kira was the target, Asano's death had actually been authorized by the shogun, and they could hardly register an act of vengeance against him!

Linked to this second problem was the matter of the conspiracy. Although revenge killing could be legal under certain controlled circumstances, conspiracy was not. In the event, the crime that the Forty-Seven Rōnin were actually charged with was conspiracy, and their sentence was death by seppuku. It is interesting to note in this context that the gallant retainers could simply have committed suicide in the Sengakuji Temple. That was, after all, their inevitable fate, and by surrendering to the government they were taking the grave risk of being executed as common criminals rather than being allowed the samurai's privilege of death at one's own hand.

When the loyal retainers laid the head of Kira upon the tomb of their master, they left a written account of their

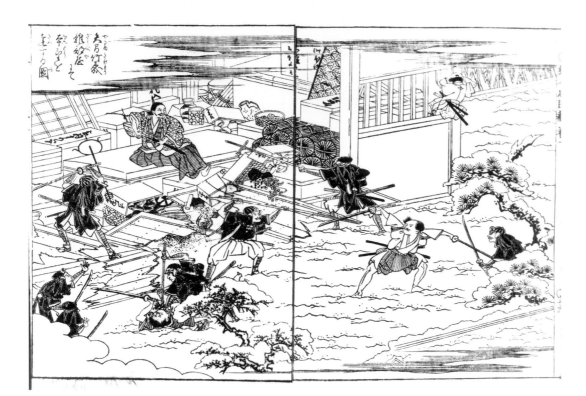

Left: **The raid by the Forty-Seven Rōnin, who are using their samurai swords to good effect.**

motive in a moving address to Asano:

> We, who have eaten of your food, could not without blushing repeat the verse, "Thou shalt not live under the same heaven nor tread the same earth with the enemy of your father or lord," nor could we have dared to leave hell and present ourselves before you in paradise, unless we had carried out the vengeance which you began.[11]

In other words, his retainers saw their act as a continuation of the process that Asano had started by wounding Kira. That was the essential point for them in the loyalty they still owed to their dead lord. His work had to be finished. There had to be completion. There had to be closure.

> The old and decrepit, the sick and ailing, have come forth gladly to lay down their lives. Men might laugh at us, or mock us as grasshoppers trusting in the strength of their arms, and thus shame our honoured lord; but we could not halt in our deed of vengeance.[12]

In spite of the adulation heaped upon them by later generations, the contemporary reaction was less enthusiastic. A passage in *Hagakure*, the famous treatise on bushidō, criticizes the Forty-Seven Rōnin with these words:

> After their night attack, the rōnin of Lord Asano made the mistake in failing to commit seppuku at Sengakuji. Furthermore, after having let their lord die, they delayed in striking down his enemy. If Lord Kira had died of ill-

ness in the meantime, it would have been to their everlasting regret. These Kamigata types [i.e., from central Japan as distinct from sophisticated Edo] are clever and good at doing things that earn them praise . . . but they are unable to act directly without stopping to think.[13]

The author clearly preferred an act of revenge to be carried out in a death frenzy, "without stopping to think," rather than slowly, carefully, with planning and secrecy. In his opinion, the former course of action was in line with the true spirit of bushidō that was derived from the Sengoku period, while the rōnins' approach was "new bushidō," formulated under Confucian influence. It was a very different attitude, and was also one that did not condone throwing away more lives for the sake of avenging a loss. To the rōnin *junshi*, the act of following in death, was essentially wasteful and therefore implicitly disloyal. This is neatly demonstrated by a little-known sideline to the story. When the sentence on Asano Naganori was handed down, Oishi Yoshio hurried back to the castle in Ako, covering the four hundred miles in five days. The reason for his haste was that the Asano territory, in common with many other daimyō's possessions, had issued currency notes. On examining the Asano treasury, he found that their gold only covered 60 percent of the note issue, so he had the notes converted at this rate. This enabled the holders to recover something before the confiscation order descended, and incidentally deprived the shogun of a sizable sum of money. From this, Oishi went on to his better-known form of revenge. Bushidō may have had its own

Left: The Forty-Seven Rōnin are greatly revered. Here a modern Japanese businessman burns incense in front of the graves of the Forty-Seven Rōnin, in Tokyo's Sengakuji Temple.

Right: Oishi Kuranosuke Yoshio, leader of the Forty-Seven Rōnin, shown here in a statue outside the railway station at Banshū-Ako, the provincial capital of his master, Asano Naganori.

requirements of duty, but even in this classic account of its execution, economic reality is never far behind the wielding of a sword.

Time has proved that no other act of samurai duty was to have such an effect as the exploit of the Forty-Seven Rōnin. With their deaths they became martyrs to the cause of bushidō, and even though the years leading up to the Meiji Restoration were to see many such assassinations, none would produce adulation, nor spawn plays, stories, woodblock prints, and mementoes by the score. Their memories are particularly cherished in two places today. The first is the castle town of Ako, now known as Banshū-Ako, where an elaborate Shinto shrine is dedicated to Oishi Yoshio Kuranosuke and his comrades, whose likenesses appear all over the grounds, from statues to souvenir key rings. Much smaller, and more moving, is the Sengakuji Temple in Tokyo. In the grounds is the pond where Kira Yoshinaka's severed head was washed, and one may also visit the actual graves of the Forty-Seven Rōnin. Their devotion to duty is clearly still an important motivational example in modern Japan, because the Sengakuji is a popular destination for businessmen who wish to pray for success.

As to their motivation and reasoning, the debate will go on for centuries more, but to the founding fathers of modern Japan, revenge killing was an anachronism that had to be abolished. The imperial decree from the Meiji emperor to forbid revenge was issued in February 1873, and read as follows:

Assassination being absolutely prohibited by the laws of the Empire, the Government's duty is to punish any individual who kills another.

According to ancient habits, it was an obligation on a son or younger brother to revenge a father or elder brother, nevertheless, personal interest must not lead one to transgress the law and despise the public powers by revenging himself. Whoever so acts cannot be pardoned, the more especially because in that case it is impossible to know who is in the right and who is in the wrong. Therefore, from this day, no one shall have the right to avenge or pass judgement for himself. If unfortunately someone has done wrong towards a member of your family, take your complaint and explanations to the authorities, but do not follow the ancient custom, or you will be punished according to the law.[14]

There were many more decrees to come out of the new Meiji government, such as the abolition of the wearing of pigtails, and the restriction of the carrying of swords to the armed forces, but none would so eloquently reverse the duties and obligations of a previous age than the abolition of a samurai's sacred duty of revenge.

CHAPTER 8

SWORDS AND SISTERS

The topic of the samurai swordswoman or the female samurai is one that has been almost totally neglected in the history of the Japanese warrior. For example, it is mentioned briefly in *Bushidō: The Soul of Japan,* by Inazu Nitobe, the most famous writer of the last century on bushidō, but even he adopts a tone that swings between admiration and dismissal:

> Young girls, therefore, were trained to repress their feelings, to indurate their nerves, to manipulate weapons—especially the long sword called naginata, so as to be able to hold their own against unexpected odds. Yet the primary motive for exercise of this martial character was not for use in the field; it was twofold—personal and domestic. A woman owning no suzerain of her own formed her own bodyguard. With her weapon she guarded her personal sanctity with as much zeal as her husband did his master's. The domestic utility of her warlike training was in the education of her sons. . . .[1]

Nitobe goes on to say that "fencing and similar exercises, if rarely of practical use, were a wholesome counterbalance to the otherwise sedentary habits of women," a comment that might also apply to the extremely sedentary habits of numerous male samurai during the Tokugawa period![2] But Nitobe believed also that the Japanese woman was made of stern stuff and had to be as prepared as her husband for the possibility of taking her own life:

> Girls, when they reached womanhood, were presented with dirks [*kaiken,* pocket poniards] which might be directed to the bosom of their assailants, or, if advisable, to their own. Her one weapon was always in her bosom. It was a disgrace for her not to know the proper way in which she had to perpetrate self-destruction. For example, little as she was taught in anatomy, she must know the exact spot to cut in her throat; she must know how to tie her lower limbs together with a belt so that, whatever the agonies of death might be, her corpse be found in utmost modesty with the limbs properly composed.[3]

He gives the example of an unnamed young woman who, having been taken prisoner, seeing herself in danger of violence at the hands of the rough samurai, says that she will submit to their pleasure, provided that she is first allowed to write a letter to her sisters, whom war had scattered in every direction. When the letter is finished she runs off to the nearest well and saves her honor by drowning. The soldiers find the letter and discover that she has composed a farewell poem as noble as any from the brush of a departing samurai:

> For fear lest clouds may dim her light
> Should she but graze this nether sphere
> The young moon poised above the height
> Doth hastily betake to flight.[4]

Women practicing unarmed combat; one has the other in a *jū-jutsu* lock. Martial arts allowed a woman to "form her own bodyguard."

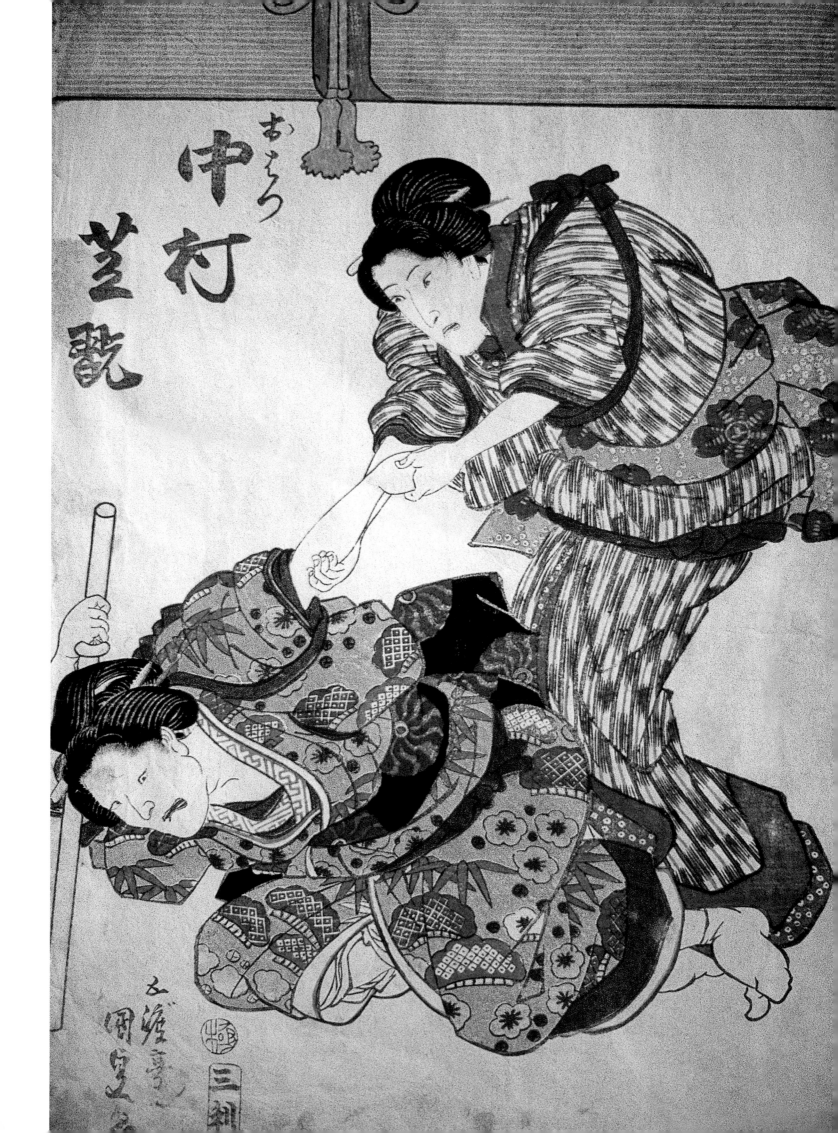

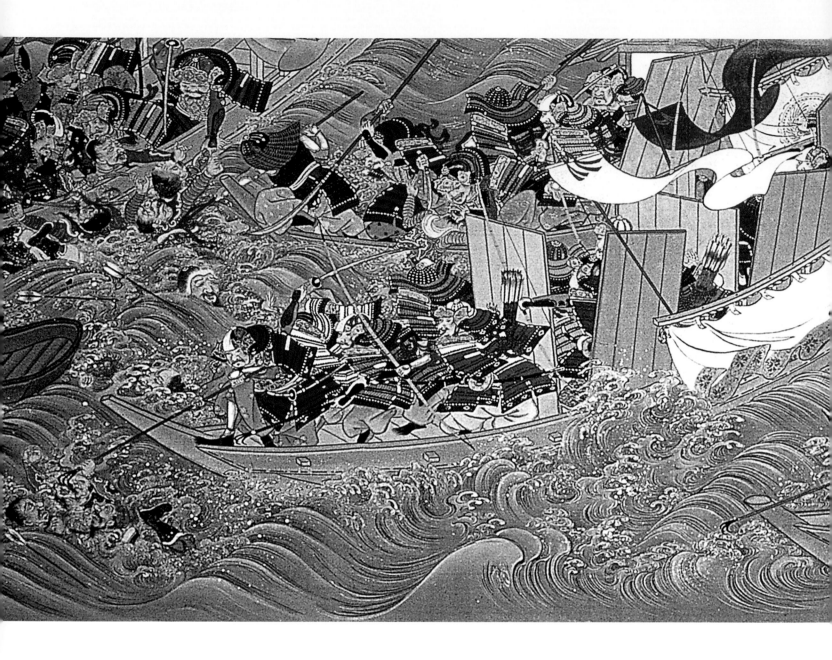

There may not have been many suicide poems by women, but examples of female courage may be found throughout samurai history, where we read of women fighting on the battlefield, helping to defend a castle, and even exacting revenge. The tales of ancient Japan tell us how the semilegendary Empress Jingō-kōgō led an invasion of Korea while pregnant with the future Emperor Ojin, whose birth she delayed by putting a heavy stone inside her robe. He was to be deified as Hachiman, the kami of war.[5]

Tomoe Gozen—the Beautiful Samurai

It is in *Heike Monogatari* that we find Japan's most famous female warrior, Tomoe Gozen, who makes a brief appearance in the Gempei Wars. Among the enemies that Minamoto Yoritomo had to overcome on his road to becoming shogun was his cousin Minamoto Kiso Yoshinaka. Even though they were of the same family, Yoshinaka's success in defeating the Taira in 1183 had

made him Yoritomo's rival, so Yoritomo's brother Yoshitsune was sent to deal with him in 1184. Yoshitsune defeated Yoshinaka at the battles of Uji and Awazu, from which latter battlefield Yoshinaka fled, accompanied by a beautiful girl called Tomoe Gozen.[6]

The character of Tomoe Gozen is such an unusual inclusion in a narrative of a samurai battle that this uniqueness has guaranteed her a place in legend, if not entirely in history. But there are several mysteries about her. First of all, her relationship to Yoshinaka is by no means clear. One textual variation of *Heike Monogatari* introduces her as an attendant or servant.[7] The version translated by Sadler, used below, describes her as a "beautiful girl," from which speculation has added references to her as Yoshinaka's mistress or even his "warrior wife." But there is no vagueness in the claims about her martial accomplishments. The account of her fighting at the Battle of Awazu in *Heike Monogatari* is so brief that it

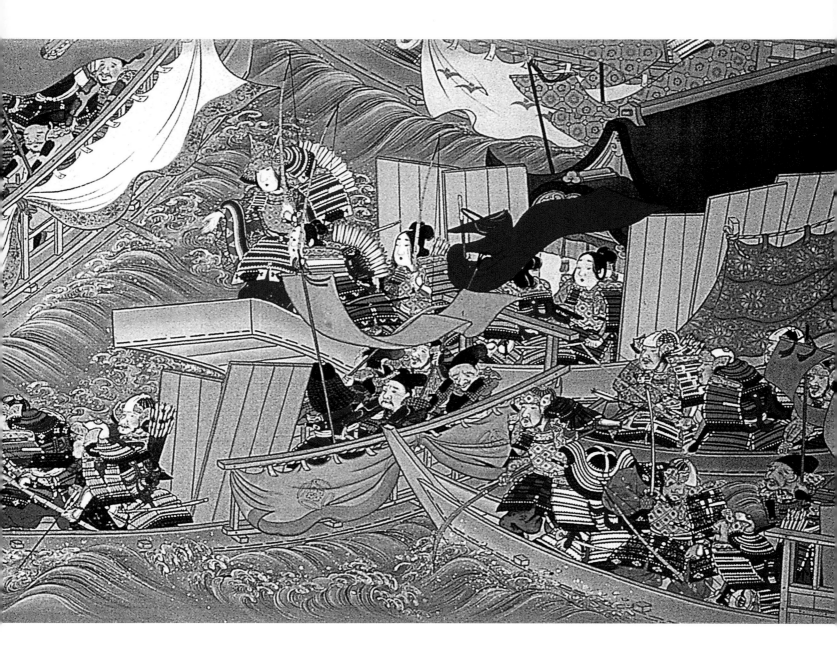

can easily be recounted in full, and it is fascinating to note that the chapter that contains it, entitled "The Death of Kiso," begins by telling us that Yoshinaka had brought with him from Shinano not just one "beautiful girl," but two. The other's name was Yamabuki, but she had fallen sick and had stayed behind in the capital.

Tomoe had long black hair and a fair complexion, and her face was very lovely; moreover she was a fearless rider, whom neither the fiercest horse nor the roughest ground could dismay, and so dexterously did she handle sword and bow that she was a match for a thousand warriors, and fit to meet either god or devil. Many times she had taken the field, armed at all points, and won matchless renown in encounters with the bravest captains, and so in this last fight, when all the others had been slain or fled, among the last seven there rode Tomoe.[8]

After describing Yoshinaka's final maneuvers, the account returns to Tomoe Gozen:

But now they were reduced to but five survivors, and among these Tomoe still held her place. Calling her to him Kiso said, "As you are a woman, it were better that you now make your escape. I have made up my mind to die, either by the hand of the enemy or by mine own, and how would Yoshinaka be shamed if in his last fight he died with a woman?" Even at these strong words, however, Tomoe would not forsake him, but still feeling full of fight she replied, "Ah, for some

Above: **Empress Jingō-kogō led an invasion of Korea while pregnant with the future Emperor Ojin, whose birth she delayed by putting a heavy stone inside her robe. He was to be deified as Hachiman, the *kami* of war.**

bold warrior to match with, that Kiso might see how fine a death I can die!" And she drew aside her horse and waited. Presently Onda no Hachirō Moroshige of Musashi, a strong and valiant samurai, came riding up with thirty followers, and Tomoe, immediately dashing into them, flung herself upon Onda and grappling with him, dragged him from his horse, pressed him calmly against the pommel of her saddle and cut off his head. Then stripping off her armour she fled away to the Eastern Provinces.[9]

So far—so puzzling! The above paragraphs are all we are told about this unique person, who then rides off and is never mentioned again in *Heike Monogatari*. We therefore have the inclusion, as if from nowhere, of the only woman warrior to be described in any detail in any gunkimono (war tale). Apart from the intriguing mention of Yamabuki, left behind to recuperate, Paul Varley, in his study of the gunkimono, could find only one other reference to a female samurai in the whole of the genre. This is in the *Gempei Seisuki* account of the death of Kiso Yoshinaka, and she is said to have been killed the year before.[10] So was the impetuous Yoshinaka given to having female samurai as his fighting companions? This seems unlikely, because even though Tomoe is highly praised for her martial accomplishments, *Heike Monogatari* tells us that he wanted her to leave the battlefield when he faced certain death. This was not out of any particular concern for her safety, but so that he would not be dishonored by dying next to a woman.

It would appear that Tomoe was a woman who had been trained in the martial arts in the way Nitobe describes above, but had so excelled at them as to excite comment. Tomoe would clearly have been more than capable of defending her honor, and when she was thrust into an actual battlefield situation, the warrior ethos and all her training came together as a reaction to the prospect of seeing the man she loved go to his death. The uniqueness of Tomoe Gozen, therefore, lies less with her martial accomplishments, superlative though they were, than with the unique situation in which she found herself, and the unique opportunity that situation provided for her to exercise those skills.

Even though *Heike Monogatari* is silent about Tomoe's ultimate fate, *Gempei Seisuki* tells us more, adding that Yoshinaka expressly directed her to take the story of his final battle back to his home province of Shinano. But before leaving the field, she was attacked by Wada Yoshimori, one of Yoritomo's chief retainers, using a pine trunk as a club. She twisted the trunk in her hands and broke it into splinters, but Wada Yoshimori caught her and made her his concubine. She bore him a son, the celebrated strong man Asahina Saburō Yoshihide, who was killed in 1213 when the Wada family was destroyed by the Hōjō family. Tomoe then became a nun and lived to the age of ninety-one.[11]

Whatever the truth behind the Tomoe story, she lives on as the female samurai warrior, and woodblock print images abound of her on horseback, wielding a naginata, the traditional woman's weapon, in spite of the fact that the *Heike Monogatari* account makes no reference to this weapon. From prints she has moved to stories, films, and historical reenactments, and in the 2005 performance of Kyoto's annual and colorful *Jidai Matsuri* (Festival of the Ages)—a spectacular parade through the city streets of people dressed in historic costumes—I witnessed a rather fine-looking Tomoe Gozen riding alongside the male samurai heroes of Japan.

The Nun Shogun

Even if a woman was regarded as inferior to her husband while he still lived, she could inherit more than wealth if that husband died. The figure of the widow is one of the more powerful images of women to emerge from the early years of samurai rule in Japan, and it is with one very famous widow that we continue the search for female samurai.[12] The first shogun, Minamoto Yoritomo, married Hōjō Masako, a woman who was remarkably strong-minded. Being intended by her father for someone else, Masako would have no one but Yoritomo, and when her father locked her away she escaped and stayed with the future shogun for the rest of his life. When Yoritomo died in 1199 from a riding accident, Masako became the real power behind the throne. She had entered the religious life on widowhood, but this did nothing to diminish her power, as is indicated by the title by which she is known: the "Nun Shogun." Masako deprived her son Yoriie, the second shogun, of absolute power, and set up instead a ruling council with her father and other Hōjō family members in high places. When an uprising, led by Yoriie's father-in-law, Hiki Yoshikazu, began in the name of the rightful shogun, Hōjō Tokimasa, supported by his wily daughter, defeated the insurgents and had Yoriie assassinated.

Power remained in Masako's hands when Yoriie's son Kugyō was passed over in succession and Masako's second son, Sanetomo, became the third, and last, Minamoto shogun. He was only twelve years old, and a

Right: **Tomoe Gozen, the most famous female warrior of all, shown in full armor with a court cap on her head.**

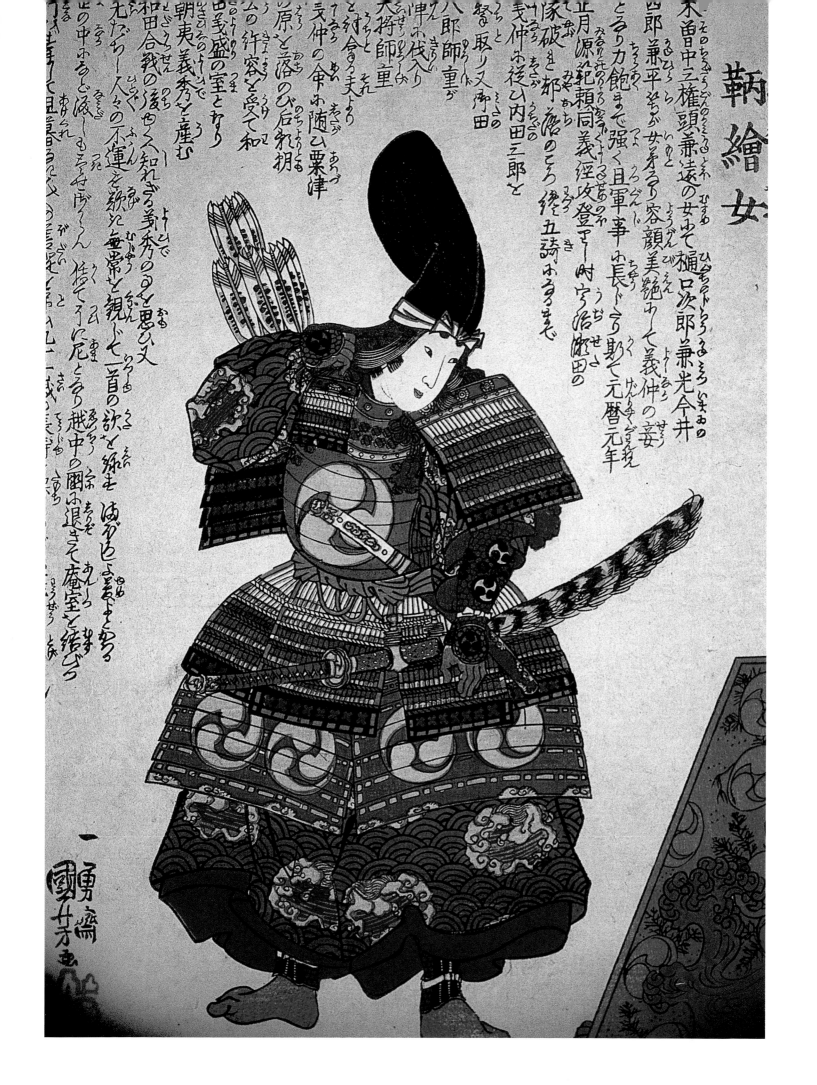

木曽中三権頭兼遠の女にして樋口次郎兼光今井
四郎兼平そらが女きり容顔美麗にして義仲の妾
とてり力飽まて強く且軍事に長す弓馬に元暦元年
正月源範頼同義経攻登さ一時宇治瀬田の
塚破と郡摩のころ緯を五騎ふるまそ
巴後乙内田三郎と
の警取リ又所田
八郎師重
と対合さ夫より
寒仲の命ふ随ひ栗津
原と落のひ后礼拐
の行容を受て和
田義盛の室となり
朝夷義秀を産む
和田合戦の後やく知れざる義秀のみを思ひ又
のなち一人々の不運を歎て無常を親やぞ一首の歌を孫ま
はかな越中の岡ふ退きて庵室と結ぐら
尼とら里

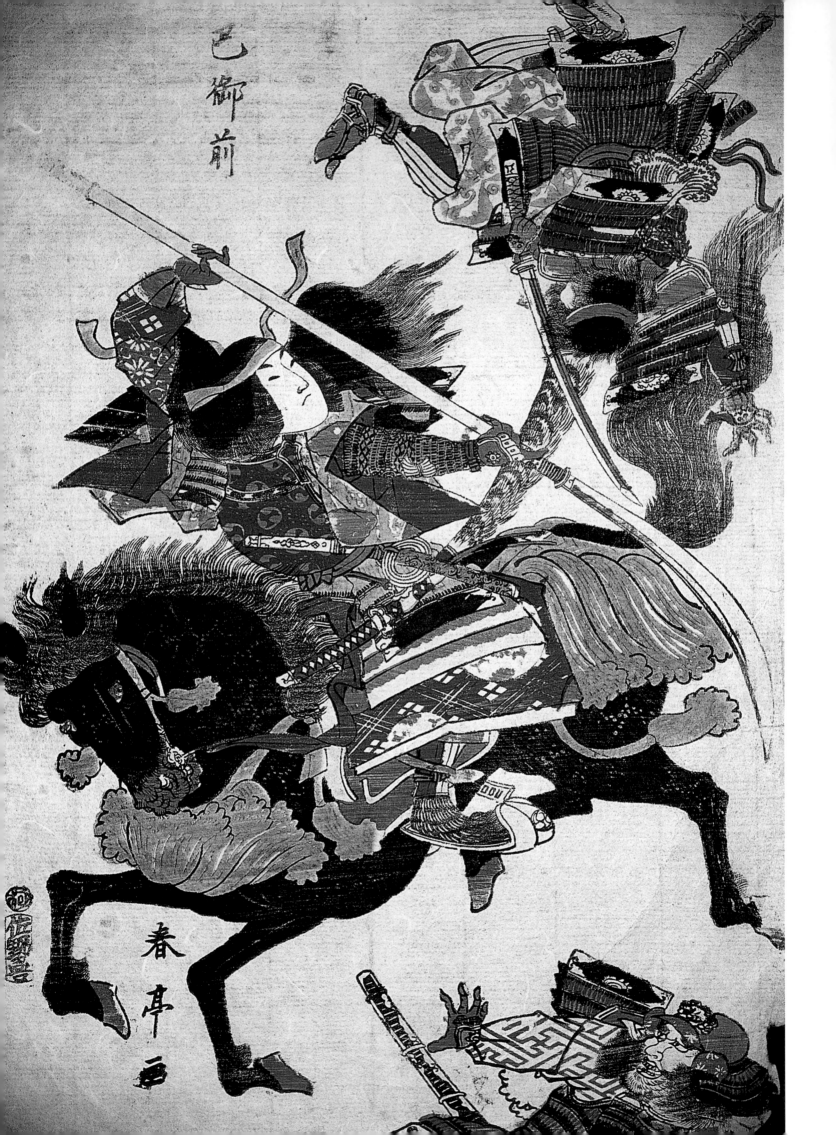

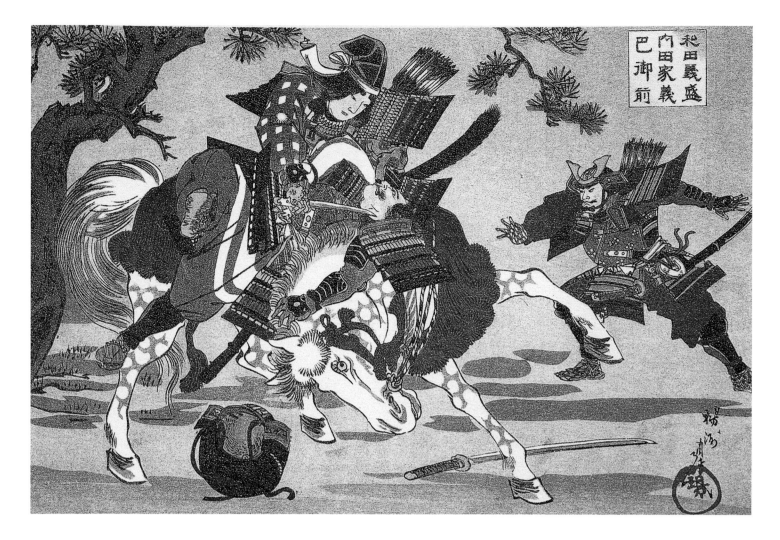

Left: **Tomoe Gozen on horseback, wielding her** *naginata* **to great effect on the battlefield.**

Above: **Tomoe Gozen takes a head during the Battle of Awazu, in 1184.**

year later his grandfather turned against him, proposing his own son-in-law as an alternative candidate for shogun. But such was Masako's hold on bakufu affairs that she succeeded in having the aspiring shogun murdered and her father packed off to a monastery. But poor Sanetomo enjoyed for only a few years the dignity of shogun. In 1219 he was assassinated within the precincts of the Tsurugaoka Hachiman Shrine, in Kamakura. The murderer was the aggrieved Kugyō, and when he was killed in revenge, the line of the Minamoto died out, leaving Masako's relatives free to become rulers of Japan. They were the Hōjō shikken (regency), whose descendants were to face the Mongol invaders.

Women in the Age of War

Masako, of course, never wielded a sword in anger, but the accounts of the fighting that took place during Japan's Age of Warring States include several references to women, although very few concern actual participation in battle. Samurai had to accept that all the members of their families were obliged to serve their lords, and there

were many occasions when women had to perform the duties of their menfolk. Hōjō Ujikuni's orders of 1587 for the maintenance of the walls of Hachigata Castle required his followers to make repairs after typhoon damage, before mending their own homes, and if they were away on campaign, the work had to be done by their wives and maidservants.[13]

But although the wives and mothers of samurai may not have participated directly in sixteenth-century battles, there were several occasions when they shamed their menfolk into doing so. One example is the Battle of Imayama, in 1570. Otomo Chikasada had laid siege to Ryūzōji Takanobu's Saga Castle. Saga had a garrison of only five thousand men against Otomo's probable sixty thousand, who were spread in a huge arc round Saga, anchored at each end on the sea coast. Scouts, however, brought news that Otomo Chikasada was planning to hold some form of celebration inside his field headquarters one night, prior to attacking Saga the following morning. The base was located on the hill of Imayama, about four miles northwest of Saga Castle, and three thousand of his body-

guard were there with him. To Nabeshima Naoshige, the Ryūzōji's leading retainer, it was an ideal target for a night raid, but most of his colleagues did not agree. It was apparently Ryūzōji Takanobu's mother who shamed them into following Nabeshima's advice, with the words, "Isn't your attitude towards the enemy forces like a mouse in front of a cat? If you are real samurai then carry out Nobushige's night raid on the Otomo headquarters. Decide between life or death and victory or defeat!"

That night a detachment of Ryūzōji samurai and foot soldiers, keeping their advantage of height, silently approached the curtained area on the lower slopes of Imayama and waited until dawn. The Otomo troops had clearly enjoyed their prebattle party, and were sleeping off the effects of the sake. Even the guards must have been lulled into a false sense of security by their own overwhelming numbers, because without any warning being given, Nabeshima Naoshige ordered his arquebusiers to open fire, and eight hundred samurai charged down into the position. They first extinguished all the Otomo's pine torches, which provided the only nighttime illumination, and then began to extinguish the Otomo samurai. Otomo Chikasada was cut down, and two thousand out of the three thousand men in the headquarters area were also killed. Taking advantage of the confusion, Ryūzōji Takanobu led another attack out of the castle against a different section of the siege lines. So devastating was the night raid that Otomo Sorin withdrew the rest of his troops and left the Ryūzōji alone. After this victory, Ryūzōji Takanobu's territory grew considerably, and no doubt his mother was very proud![14]

In this particular situation, the siege of an isolated castle, everyone was needed for its defense: men, women, and even children. When Suemori Castle was attacked by Sasa Narimasa in 1584, Okamura Sukie'mon was ably assisted by his wife in its defense. She walked the walls and inspired the men until Maeda Toshiie rode to their relief. Among the tasks traditionally performed by the women within a castle in a war situation were casting bullets, treating the wounded, and preparing enemy heads for the head-viewing ceremony. There is a rare eyewitness account that was recorded by the daughter of a samurai living in a castle during a battle. The young girl, later known as Oan, the daughter of the respectable samurai Yamada Kyoreki, experienced the horror of sleeping beside a collection of severed heads in Ogaki Castle in Mino Province, at the time of the battle of Sekigahara in 1600. The castle was under constant attack from the superior forces of Tokugawa Ieyasu. The women gradually got used to the roar of the guns, and helped to cast bullets in the keep. One day, a samurai appeared and

tried to calm the women by telling them that the enemy had retreated, but just at that moment Oan's brother was hit by a bullet before her eyes, "and died after wriggling a bit," but because of the privation she had already experienced in the besieged castle, she was too numb to cry. "I did not even have a sense of being alive." she wrote. "All I could feel was fear and terror. But then, afterward, it didn't seem like much of anything at all." Severed heads taken by the garrison were brought together in the keep for Oan, her pregnant mother, and the other women to prepare. They attached a tag to each head in order to identify them properly, then they repeatedly blackened the teeth—the ancient sign of a distinguished man—by applying a generous coat of ohaguro (dental dye) to any heads with white teeth. Oan later narrowly escaped with her family from the doomed fortress by climbing up a ladder and down a rope. Only four of the women got out, one of whom was Oan's mother, who had hardly gone one hundred yards before she felt labor pains coming on and gave birth to a baby girl in a rice field. Oan herself lived to the age of eighty, eventually dying in the year 1660.[15]

Another woman of the samurai class who experienced a siege and lived to tell the tale was Okiku, the daughter of Yamaguchi Mozaemon. She was a lady-in-waiting to Toyotomi Hideyori's mother, Yodo-gimi, and was present within Osaka Castle at the time of the great siege of 1615. Okiku was twenty years old, and experienced the shock of seeing bullets hitting the kitchen tables. One tore the edge of a tatami (straw mat) and killed a maid. Okiku picked up one of the bullets in her palm. Yet she was so confident that Osaka would not fall that, later on, when she heard her maid shouting "Fire!" she assumed that the girl was referring to the noodles she was cooking. But the maid has spotted flames coming out of the Tamatsukuri Gate of the castle. When the fire spread to the huge yashiki that provided the reception rooms and living quarters in the castle courtyard below the keep, Okiku knew that she would have to evacuate the place. She put on three layers of clothing and paused only to collect a mirror that Toyotomi Hideyori had once given her. Wounded soldiers called out for help as she passed. On escaping from the castle, she met up with other women with whom she shared her extra kimono.[16]

At no time did a samurai's wife show herself in a better light as a brave warrior than when she faced the defeat of her clan, the fall of her castle, and the death of her husband. The situation of women was such that these are the scenarios that dominate the historical narratives of women in action. In 1536, the castle of Sakasai was attacked on behalf of the Hōjō family by Daidōji Suruga no kami. The head of the family, Sakasai Muneshige, was

Women practicing with *bokutō*.

This wax figure in the Sakamato Ryōma History Museum, Noichi, Kochi Prefecture, shows the niece of Chiba Shūsaku, who practiced *ken-jutsu* with Sakamoto Ryōma.

killed in the fighting, and his wife, the nineteen-year-old Tomohime, decided to follow her husband in death, as befitted the consort of a brave daimyō. She therefore took the bronze temple bell from the castle that was used for signaling, an heirloom that had been in the family for generations, and slipped it over her shoulders. She then jumped into the castle's moat, and the weight of the bell held her under the water until she drowned.[17]

However, it must not be thought that all women were invariably loyal to their husbands to the point of death. The higher up the social scale one looks, the more common it is to find a wife who is no more than the reluctant pawn in a political marriage. That some of these pawns could became instrumental in the downfall of the families into which they had been forcibly married is suggested by the existence of various warnings such as "She may have borne you seven sons, but never trust a woman." "Even when a husband and wife are alone together, he should never forget his dagger"—although the latter probably has

more to do with the possibility of intrusion during intimate moments. "Regard another man's pretty daughter as your enemy and never visit her house" was taking it even further. Oda Nobunaga was not above using his wife in a more subtle way. He married the daughter of Saitō Dōsan, whose territory he coveted, and told his wife, quite falsely, that he was plotting with her father's chief retainers to murder him. Having been placed in a cruel dilemma of loyalty she eventually decided to pass on the information to Dōsan, who obligingly did away with several of his most loyal and innocent retainers.[18]

Women could also meet horrible deaths when they were manipulated for political ends. When Akechi Mitsuhide besieged Hatano Hideharu on behalf of Oda Nobunaga, in 1574, he promised to spare Hideharu's life and keep him on as commander of the castle if he surrendered. As earnest of his intentions, Mitsuhide gave his mother to Hideharu as hostage. But when the surrender came, Oda Nobunaga overruled Mitsuhide and had Hideharu crucified. Even though this was not of Akechi Mitsuhide's doing, the Hatano samurai executed his mother. It is no wonder that eight years later Mitsuhide became the destroyer of Oda Nobunaga.

Women of the Ikkō-ikki

If, in our search for female samurai, we take the definition of "samurai" to include all Japanese fighting men (the common Western perception), rather than a narrower definition that limits the word to the aristocracy, then there is ample evidence of active female participation in combat during some of the bitterest struggles of the Sengoku Period. Most of these instances concern women from lower social classes taking on their betters, because as an alternative to accepting the rule of one of the up-and-coming daimyō, certain communities—particularly those united by a common religious belief—chose to form *ikki*, or leagues, in which low-ranking samurai, village headmen, and small landowners came together in a self-supporting alliance. The ikki, who were known to use rioting to get their way ("riot" is an alternative translation of *ikki*), often faced furious opposition and considerable military action from local daimyō whose position they threatened. In the case of Kaga Province, the local ikki rebelled, ousted the daimyō, and began to rule the province themselves, so they were a force to be reckoned with.

A very fierce war was conducted by Oda Nobunaga from 1570 to 1580 against the most famous ikki of all: the Ikkō-ikki, the armies fielded by the self-governing communities who followed the Jodō-Shinshū sect of Buddhism. Having arisen about the time of the Gempei War, the preachers of Jodō-Shinshū had addressed the needs of the

common people rather than their betters, and the sect grew enormously in size and power. Jodō-Shinshū shifted the emphasis of Japanese Buddhism from the monastic life to the ordinary lives of ordinary people. Jodō-Shinshū fortified temples housed whole communities to whom the practice of their religion was a fundamental part of life.

Jodō-Shinshū and its Ikkō-ikki armies threatened the growing daimyō both militarily and economically, and Oda Nobunaga's ten-year campaign against their headquarters of Ishiyama Honganji (built where Osaka Castle now stands) was destined to be the longest siege in Japanese history. When their fortified temples, which resembled castles with religious buildings added to them, were threatened by an attack, the daily life of their communities was placed on to a war footing. Just as every member of Jodō-Shinshū shared fully in its peacetime activities, so did they share in the responsibilities when conflict loomed. Every man, woman, and child became involved. All hands were needed, and certainly by the 1580s the experience of a century of war had taught them that if they lost to a samurai army, a massacre of every member of the community would follow.

In 1575, Oda Nobunaga swept through Echizen Province to recapture it from the Ikkō-ikki forces. He first attacked Fuchu (now the town of Takefu), and wrote two letters from the site to Murai Sadakatsu, the governor of Kyoto. One contained the chilling sentence, "As for the town of Fuchu, only dead bodies can be seen without any empty space left between them. I would like to show it to you. Today I will search the mountains and the valleys and kill everybody." By November, he could boast to the daimyō Date Terumune that he had "wiped out several tens of thousands of the villainous rabble in Echizen and Kaga." In Shinchokoki, Nobunaga's biographer reports:

From the 15th to the 19th of the eighth month, the lists drawn up for Nobunaga recorded that more than 12,500 people were captured and presented by the various units. Nobunaga gave orders to his pages to execute the prisoners, and Nobunaga's troops took countless men and women with them to their respective home provinces. The number of executed prisoners must have been around 30 to 40,000.[19]

We may safely assume that the "warrior women" of the Jodō-Shinshū communities were fully involved in the armed resistance. A dramatic account, which includes an interesting reference to the humiliation the attacking samurai felt at having to face women, occurs in the *Oū Eikei Gunki* description of a battle fought by another ikki. This was the siege of Omori Castle in 1599. Omori,

A *naginata*, the traditional weapon of the warrior monks.

in the far north of Japan, was defended by a peasant army who had joined forces with samurai in an ikki against an overbearing landlord. Their leader had "skillfully made from brushwood [a term that probably means rough timbers] things for throwing stones. Used by women and children, they could easily project them about one *chō* [120 yards]." Such a range, which is about one-third of the distance the foot soldiers of the Onin War could hurl their stones, sounds consistent with machines being operated by untrained women and children, but the effect was devastating:

Every single one of the two or three hundred women from inside the castle came out and began to throw down an abundance of large and small stones which they had already prepared, shouting as they defended, whereupon more than twenty men were suddenly hit and died. Many more were wounded. In fact, and regrettably, because of the women's act of opportunity in throwing stones, driven by necessity and scrambling

to be first they jumped into the moat and fled outside the palisade. This treatment inspired those within the castle. [Then] about twenty arquebuses opened fire. This was not enough to frighten [the women], and the throwing of small stones from the shadows of the moat was like a hail storm. To the irritation of Shiyoshi, they struck Ishii Ukon Koremichi in both eyes and killed him. Similarly, they struck in one eye the horse that Kutsuzawa Gorō was riding. Saying "to stay too long in that place and be hit by women's stones would be a failure bringing ridicule for generations to come," they returned to the original place of attack.[20]

A similar attitude regarding desperate defensive measures is seen in the defense of Hara Castle, the culmination of the Shimabara Rebellion. When this largely Christian rebellion was crushed by Tokugawa forces, women and children fought beside their menfolk, wielding pots and pans.[21] On the painted screen of Hara, there are numerous details showing female involvement in the defense of the castle. In one section, the women and children of the community are preparing a meal for the defenders. Boiled rice is being poured into a large wooden tub. Another woman carries a yoke holding two buckets, which may be for water, while a little girl is handing out water in bamboo ladles. Just inside the palisade, near to them, lie two decapitated bodies, and the artist has taken pains to show that they are female.[22]

Women and Vengeance

With the resolution of the Shimabara Rebellion, we enter the time of the Tokugawa Peace, and even though there appear to be no female kengō undertaking warrior pilgrimages, the stories of samurai revenge include one tale where the duty of vengeance has passed down to female members of the family. One of the most dramatic accounts of women wielding swords in anger concerns this revenge killing, in which the avengers were the man's two daughters: Miyagino and Shinobu. They carried out their vendetta with exemplary attention to the legal processes outlined in the previous chapter.

Popular accounts of this affair exist in many versions. The factual basis of the story concerns a samurai called Shiga Daishichi, who was on the run because of a misdemeanor and hid in a paddy field, in a village near Shiroishi Banashi in Mutsu Province. By chance, he was observed by a farmer, Yomosaku, who had been transplanting rice seedlings, and in his surprise Shiga Daishichi panicked and killed him. Yomosaku had two daughters, the eldest of whom, Miyagino, had (according to the more romantic versions of the tale) been engaged to be married to a samurai,

but through poverty had been sold into prostitution and become a *tayu*—a courtesan of the highest status—in Yoshiwara, in Edo. The younger daughter, Shinobu, went to Edo, found her sister, and told her of their father's death. They then secretly slipped away from Yoshiwara in order to seek revenge for their father's death, and began to study the martial arts under the guidance of Miyagino's samurai fiancé. They were eager in their pursuit of knowledge, and the result was the vengeance on their father's enemy, Shiga Daishichi, in 1649.

The sisters were determined to carry out the revenge themselves, and the details are largely historical. When the time was ripe, they went through the formalities of asking their daimyō for authorization to avenge the death of their father. There was, in this case, no need for a long search for the enemy, as he had remained in the daimyō's service. The lord accordingly ordered him to be brought before him, and, according to the popular accounts, the girls set on him there and then. Miyagino was armed with a naginata, while Shinobu wielded a kusarigama, the sharpened sickle with a long weighted chain. Shiga Daishichi's sword was rendered ineffectual with the aid of the chain, and the other sister dispatched him with her naginata. It was a far cry from the subterfuge of the Forty-Seven Rōnin of Ako, but the women had their revenge and were much admired for it.[23]

The Women Warriors of Aizu

By the time that the "armchair samurai" of the Tokugawa Period had begun compiling their lists of the martial arts, and classifying weapons accordingly, the naginata, once the preserve of the warrior monks, had come to be regarded as the proper weapon for women. They were used to provide girls with basic instruction in the martial arts, for the reasons outlined above by Inazu Nitobe. But women's naginata were sometimes used in anger, and as the Tokugawa period drew to its violent close, naginata were wielded by women in a bloody battle. This extraordinary episode concerns the warrior women of Aizu.[24]

The Meiji Restoration of 1867, by which the Tokugawa bakufu ended its days in favor of an imperial restoration, was by no means the popular and bloodless revolution it is often supposed to be. Modern Japan was born out of years of feuding and tension, culminating in the Boshin Civil War between the newly established government under young Emperor Meiji and supporters of the ousted shogun. On the imperialist side, the chief protagonists were the leaders of the two han of Satsuma and Chōshū, while the han most loyal to the shogun was Aizu, situated in the north of Japan, and as far away from Satsuma and Chōshū as it was possible to be, both

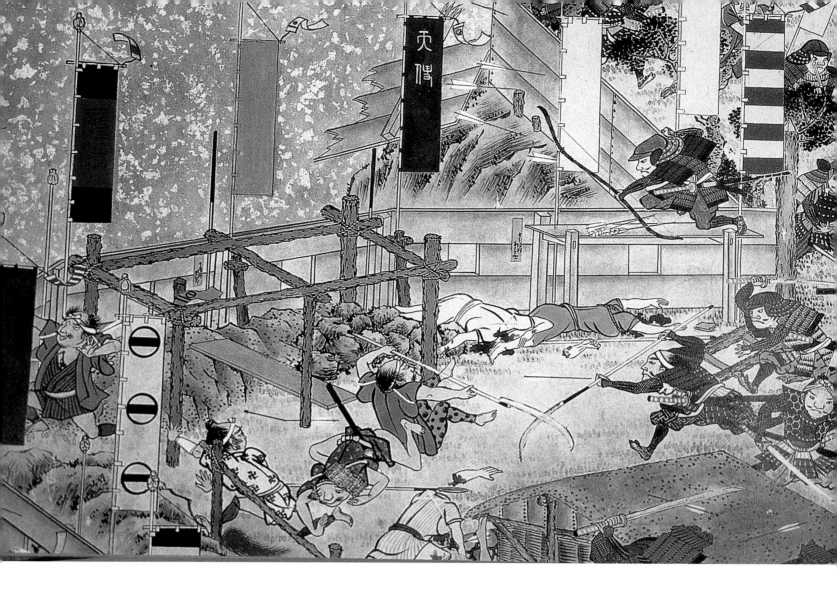

in terms of geography and politics. The Matsudaira family of Aizu was a branch of the Tokugawa.

The actual Meiji Restoration took place when a newly formed army of conscripts, together with the more traditional forces of Satsuma and Chōshū, captured Kyoto, and the emperor dismissed the shogun from office. In January 1868, Aizu and other supporters of the shogun attempted to recapture the city, but were heavily defeated at Toba-Fushimi. This was the beginning of the Boshin War. The imperial army then marched on Edo, where they captured the ex-shogun without bloodshed. The city was renamed Tokyo ("Eastern Capital") and became the seat of the new Meiji government, which quickly found that it could not ignore the sizable core of pro-Tokugawa support that still existed in northern Japan. The neighboring han of Sendai refused to attack Aizu, so three thousand government troops arrived in Matsushima Bay to put pressure on the han's rulers. But the heavy-handed treatment of Sendai backfired and provoked instead a loose alliance of northern han loyal to the shogun, who were determined to resist imperialist rule from the far western domains. The government's strategy was to conquer the northern domains one by one. Their opponents fought

bravely, but most surrendered quickly against the better-armed and better-organized imperial troops. The Meiji government had originally planned to leave Aizu to the last, but General Itagaki Taisuke pressed for an immediate attack before the snow started to fall. Soldiers from the warm climes of Satsuma would not fare well in the northern Japanese winter. The events of the bitter Aizu campaign were to provide some of the saddest chapters in the history of the samurai.[25]

Among other records of the operation, there exists a remarkable account written by a man called Shiba Gorō.[26] At the time of the attack on Aizu-Wakamatsu Castle, he was only ten years old, and so was sent away from the fighting. He later wrote his memoirs, and included details about the battles and the sad fate of his family. He describes watching his sisters practicing with their wooden naginata in the garden "with white bands tied around their hair and kimono sleeves tucked up." The rumors he was hearing about the war confirmed

Women's corpses appear within the palisade of Hara Castle, during the Shimabara Rebellion of 1638. This is clear evidence that women took part in combat alongside their menfolk when the situation was desperate.

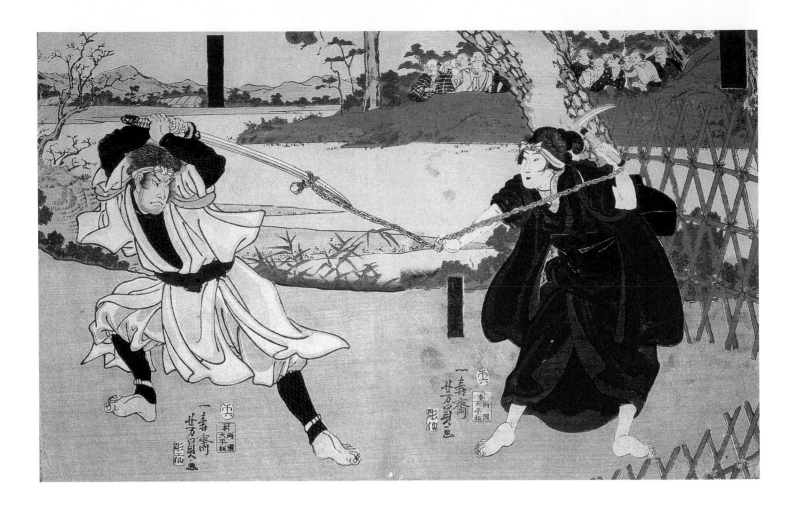

everyone's feeling that even women might have to fight:

> Rumours circulated of troops running wild. According to one rumour, rōnin from Satsuma and Chōshū were setting fires and murdering people in Edo and other places to stir up unrest, bringing further dishonour to the Tokugawa and foment hatred of Aizu. According to another rumour, the enemy troops left in their wake the corpses not only of soldiers, but also of innocent townsmen, peasants, women and children.

Aizu's women were the most authentic women warriors in the whole of Japanese history. They received expert training in the use of naginata, and were educated to be proficient in both pen and sword. Their weapons were to be used in the defense of their han, their daimyō Matsudaira Katamori, and their families—in that order.[27] It was a characteristic they shared (although they probably did not know it) with the wives of their deadliest enemies, because the women of Satsuma, similarly armed with naginata, were to take part in the disastrous Satsuma Rebellion of 1877.[28]

The advancing government army was soon in possession of a gate in the northern outer wall of Aizu-Wakamatsu Castle. At this point, the Aizu leaders rang the fire bell, which was the signal for the elderly men, the women, and the children to seek safety in the castle. They had, however, been advised by Matsudaira Katamori that, although it was his intention to "fight to the death to wipe out the stain on Aizu's honor," the noncombatants were free to act as they wished. One samurai's fourteen-year-old son, wrote afterwards:

> I hastened to the inner enclosure of the castle. I knew of course I would never return home. . . . not that I had the time to think of such matters. . . . All the women in my family had resolved to die, and yet, as I took leave, not one person shed a tear.

Many of the noncombatants stayed at home simply because they felt that their presence within the castle would hinder the fighting men and needlessly consume vital food supplies. This was a particularly brave decision in view of the rumors of Satsuma and Chōshū samurai slaughtering civilians in Edo. It may have been this fear of being killed, rather than the demands of samurai tradition, that led to the remarkable events that followed, because 230 noncombatants are known to have taken their own lives as Aizu-Wakamatsu fell. Young Shiba Gorō had been moved to a place of safety, but while he

Left: A scene from the revenge of the daughters of Yomosaku, showing Shinobu wielding her *kusarigama*.

Right: A woman kills an intruder. Women were expected to train in the martial arts to protect their own honor and the lives of their families.

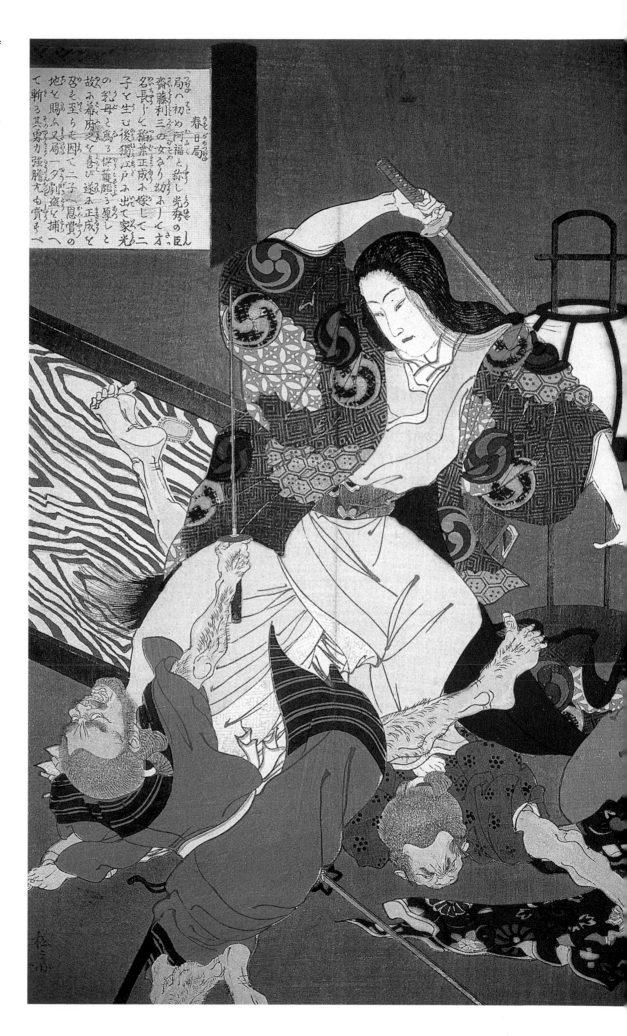

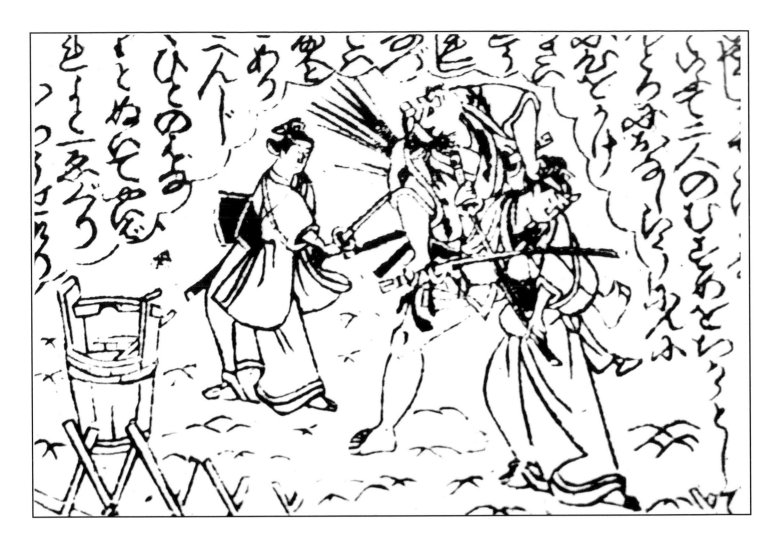

was away, his grandmother, mother, oldest brother's wife, and two sisters killed themselves. In the family of Saigo Tanomo, a senior retainer of the Aizu han, his mother, wife, five daughters, and two sisters killed themselves. Other women in his extended family also committed suicide, making a total of twenty-two female deaths from this one family. His sisters and daughters even composed farewell poems. These were the words left behind by his older sister:

Each time I die and am reborn in the world
I wish to return as a stalwart warrior

The younger wrote:

I have heard that this is the way of the warrior
And so I set out on the journey to the land of the dead

Other women accompanied their menfolk to the castle, where they assisted in the defense and were fully prepared to go into battle themselves. Some of them only fought after they had already dispatched members of their own families in an orgy of assisted suicide. This was not done for some abstract concept of loyalty or samurai honor. They firmly believed in the rumors that the imperial troops would slaughter them all or sell them as slaves. In one extraordinary instance, Kawahara Asako, the wife of the magistrate Zenzaemon, cut off her hair and decapitated her mother-in-law and daughter before seeking death in battle, naginata in hand, and drenched in blood. In this she was initially unsuccessful, because she was swept back inside the castle's walls by a wave of retreating Aizu warriors.[29]

The name *Jōshigun* was later to be given to the platoon of up to thirty samurai women who fought alongside the men in the defense of Aizu-Wakamatsu Castle when the enemy broke in. They cut their waist-long hair to shoulder length and tied it back in the young man's hairstyle. They were armed with naginata and with swords, which they used against the Satsuma and Chōshū soldiers. One mother and her two daughters joined in a mixed-gender sortie out of the castle, but were left outside when the defenders barred the gate. They decided to make their way to where other Aizu forces were active. But no sooner had

Above: **The revenge of the daughters of Yomosaku, Miyagino and Shinobu, who carried out their vendetta to avenge their father's death with exemplary attention to the legal processes.**

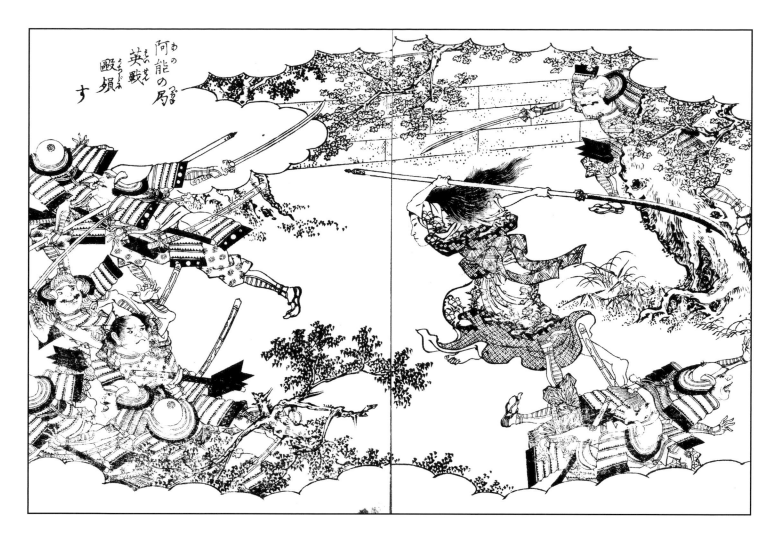

あの阿能の局英戦奮殿う

Above: **The *naginata* developed from a fierce polearm to a weapon regarded as suitable for women to exercise with. In this picture from the *Ehon Taiko-ki*, a woman uses it for its original purpose.**

they joined up with their comrades than they came under attack near Yanagi Bridge. Committed to their cause, and determined not to be taken alive, the Jōshigun women charged into the fire of the imperial army's modern rifles, wielding only their naginata and swords.

What followed was a bloody encounter that would have been more in keeping with the times of Tomoe Gozen than the year 1868. When the imperial troops realized that they were facing women, the cry went up to take them alive, but holding their fire meant that the women were soon upon them. Nakano Takeko killed five or six men with her naginata before being shot dead. In an another extraordinary echo of a medieval battle, her sister Masako then attempted to cut off Takeko's head so that it would not be taken as a trophy. The exhausted Masako was helped by a male comrade, and the severed head was safely taken back to a local temple. Outgunned and defeated, the survivors, both male and female, eventually made their way back to Aizu-Wakamatsu Castle.[30] The siege lasted thirty days in all. Shiba Gorō writes about his conversation with a survivor:

According to Shiro, the women in the castle had played an extremely courageous part in the defence. Whenever a cannonball landed they ran to the spot and covered it with wet mats and rice sacks before it could explode. They cooked meals and nursed the wounded without respite, heedless of the damage done to their clothes. Bespattered with blood, they had outdone themselves in helping the men. And they had been fully prepared, if necessary, to change into their white kimono and charge into the enemy with their naginata.

Further confirmation of the bravery of the women of Aizu comes from an unusual source. Dr. William Willis was a British doctor who accompanied the government troops during the Aizu campaign to help the wounded. On entering the town, he treated several hundred of the Aizu wounded, whom he found "in a deplorable state of filth and wretchedness," and in a memorandum, Willis refers to the bravery and energy of the women in the castle, who "cut off their hair, busied themselves in preparing food, nursing the wounded, and in not a few instances, shouldered the rifle and bore a share in the fatigues of watching." The defense continued with night raids being launched on the government positions, and at

least one woman took part in them. This was Yamamoto Yaeko (1845–1932), whose father was killed while defending the castle. Yaeko was competent with modern rifles as well as naginata, and began participating in night raids armed with a Spencer rifle and samurai swords.[31]

On October 29, Itagaki launched an all-out offensive. His troops burned the samurai houses in the outer castle precincts, while fifty cannon pounded the castle day and night, some from over a mile away. The Aizu troops responded with old-fashioned four-pound mortars with a range of only eighty-five yards, but on November 6, one month after the siege had begun, a white flag was raised above the northern gate. A few months of resistance in other parts of Japan ensured that the Boshin War was not to end until June 1869, but nothing was lost as gal-

lantly as the han of Aizu. During the nine months between the battle of Toba-Fushimi and the fall of Aizu-Wakamatsu Castle, 2,973 Aizu people had died in action. Of these, 2,558 were soldiers, 130 were men over the age of sixty, 52 were children, and 233 were women. Some of the women had died from injuries sustained from the artillery bombardment. Others had killed themselves. But a small, proud number had written their own unique chapter in samurai history.

Above: The female warriors of Aizu, the brave women who fought against the government armies at Aizu-Wakamatsu, in 1868.

Right: The name *Joshigun* was later to be given to the platoon of up to thirty samurai women who fought alongside the men in the defense of Aizu-Wakamatsu Castle when the imperialist army broke in.

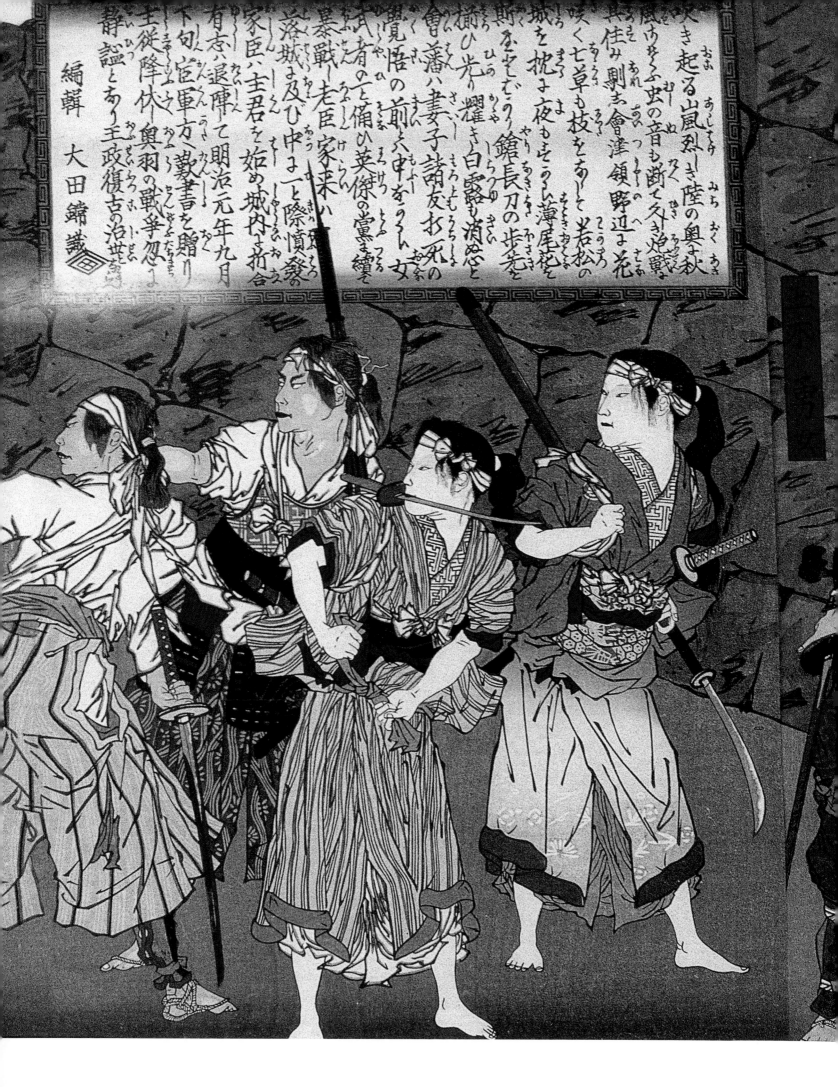

CHAPTER 9

SWORD OF PEACE

The experience of Japan's female samurai paralleled exactly that of their male counterparts, as the age of the samurai swordsman moved inevitably towards its close. From the heroism and strife of the Age of Warring States, Japan settled down to the debilitating years of the Tokugawa Peace, when swords were wielded largely by criminals or in revenge killings. Throughout this time, the art of the samurai swordsman flourished under the inspiration of devoted kengō and sensei, until, with the upheavals of the Meiji Restoration, samurai sword blades flashed in anger for the last time.

The Tokugawa Peace

With the crushing of the Shimabara Rebellion in 1638, Japan entered into a unexpected period of two centuries without war. This was, of course, a situation that could not have been foreseen at the time, and for many years the leading sensei of their day taught sword-fighting skills in the firm belief that one day those skills would be used again. But the context in which this tradition was maintained was that of Japan's increasing isolation from the outside world, because in 1639 the Tokugawa government enacted the final *Sakoku* ("Closed Country") Edict. With certain notable exceptions, no foreigner was allowed to land in Japan, and no Japanese person was allowed to leave. All traders and missionaries from the Catholic countries of Europe, who had been suspected of aiding anti-Tokugawa factions, had already been banned by this time, and in May 1641, the Protestant Dutch traders on Hirado island were suddenly and forcibly removed to Dejima, a tiny artificial island in the middle of Nagasaki Harbor. This little outpost was to become Japan's only window to the West for the next two centuries. China

and Korea continued to have trade relations, but there was no other contact with Europe, even though the English East India Company tried unsuccessfully to reopen trade with Japan in 1673. They brought along two brass guns and one mortar as presents for the shogun, but the Dutch, who feared losing their monopoly, informed the Tokugawa that the English were in alliance with the Portuguese. This was not strictly true, but Charles II had a Portuguese queen, Catharine of Braganza, and that was enough reason for the ship to be turned away.[1] It was not until the founding of Hong Kong that the East India Company came into contact with the Japanese again.[2]

The Japanese belief that the Sakoku policy was more beneficial to Japan's security than the acquisition of Western military technology lasted until the beginning of the nineteenth century, when both this policy and the certainty of eternal peace became increasingly questioned. Foreign ships were appearing in Japanese waters once again. Russia, America, and England were expanding their interests in the East, and it looked very likely that one of these nations would soon try to make new contact with Japan. When it eventually happened, it threw the whole of Japanese society into turmoil, caused a revolution, and led to the emergence of modern Japan.

The Thinking Samurai

All these developments, of course, lay far in the future, as the increasing years of peace went by. Thus, to the chal-

Apprehending a *ronin*. In a scene from a *kabuki* play, a wild-eyed swordsman is tackled by two samurai.

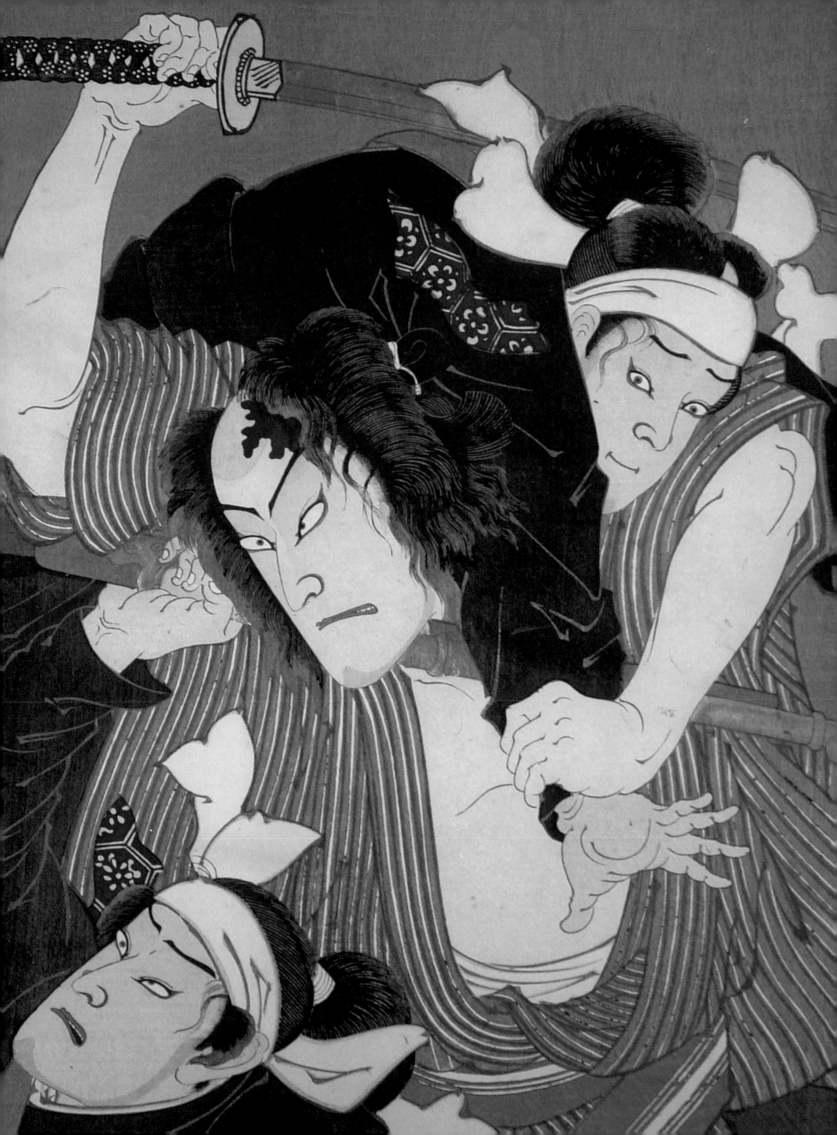

lenge of how to maintain a high standard of swordsmanship was added the further knotty problem of why such a standard needed to be maintained, when war looked increasingly unlikely. This topic was very closely bound up with the practical issues of what to do with idle members of the samurai class, and it occasioned a lively debate. Early discussions focused on the writings left by the great kengō and sensei of the Age of Warring States, whose works eventually formed the basis of the familiar ethical system known as bushidō. But although their thoughts laid its foundations, the notion of martial arts as something divorced from real combat, or even practiced as a sport, would have been totally unintelligible to these men.

In the sixteenth-century *Kōyō Gunkan,* the warrior's code is best expressed in terms of the two-way relationship between master and follower. Kōsaka Danjō derives his image of the ideal warlord from his beloved leader Takeda Shingen and from the contrast seen in his heir, Katsuyori, whose ways led to the Takeda clan's downfall. In a nutshell: A good leader won battles, while a bad leader lost them. But the crucial point is that of the relationship formed between the lord and his followers, exemplified best by the willingness of Shingen's old retainers to serve his son Katsuyori both on and off the battlefield. It was the *makoto* ("sincerity") of their calling that led the old generals of the Takeda to charge the guns at the Battle of Nagashino, in 1575. Kōsaka Danjō also praises the notion of the individual warrior, because the dependence that the samurai has on his daimyō must never become one of over reliance. Makoto is an important expression found elsewhere in writings on bushidō. It is often used as the ultimate justification for an otherwise apparently wasteful act of self sacrifice by a defeated samurai who is surrounded by enormous odds, and goes willingly to his extinction because of his sincerity. The sincerity of his intentions is part of the purity of his mission, which requires from him an unflinching devotion to a seemingly hopeless cause. It also implies total commitment to an ideal and to a focus on service. The Japanese ideogram for *makoto* was inscribed on the flags of the notorious Shinsengumi—the ruthless Tokugawa murder squad of the Meiji Restoration.

For a samurai of the Age of Warring States, the greatest sincerity of all lay in recognizing that the duty and service he owed his master was rendered as recompense for the benevolence that the lord showed to him, and the blessings he had received at his hands. It is a concept expressed in writing at the very top of the samurai tree by the first Tokugawa shogun, Ieyasu, who received sword-fighting training from top sensei while dispensing "benevolence" to his subjects. A summary of Ieyasu's thoughts are contained in the so called Legacy of Ieyasu, which the first Tokugawa shogun left for the instruction of his followers on his death in 1616. The following selection of passages reflects several aspects of his views on swords and on bushidō:

The civil and military principles both proceed from benevolence. However many books and plans there may be, the principle is the same. Know therefore that herein lies the way of ruling and administering the Empire.

The Empire does not belong to the Emperor, neither does it belong to one man. The thing to be studied most deeply is benevolence.

The right use of a sword is that it should subdue the barbarians while lying gleaming in its scabbard. If it leaves its sheath it cannot be said to be used rightly. Similarly the right use of military power is that it should conquer the enemy while concealed in the breast.

A warrior who does not understand the Way of the

Warrior and the samurai who does not know the principles of the samurai can only be called a stupid or a petty general.

The sword is the soul of the samurai. If any forget or lose it he will not be excused.[3]

One of Tokugawa Ieyasu's retainers, Okubo Tadataka, wrote a book called *Mikawa Monogatari* in 1622, wherein he acknowledged that Ieyasu's triumph in reestablishing the Shogunate was due to the close spiritual cohesion he had achieved between a lord and his followers. The word "benevolence" is used by Okubo in exactly the same context as by his lord:

The loyal warriors would fight in battle for their lord, having themselves completely prepared for death without having any concern for their wives and children left behind them. . . . As long as it is my duty towards my lord, I would like to die in battle in front of his eyes. If I

die in my home, though death itself may be for the same reason, it will be death without the primary objective of a warrior, martial prowess. Further, people may not find my true motive for it, and then there will be no significance attached to it.[4]

But perfection was also to be sought in a samurai's everyday behavior. This was tied in very closely with the Daoist notion of *do* ("the way"—hence *bushido*). In the *Gorinshō (The Book of Five Rings)*, for example, Miyamoto Musashi explained that the swordsman should have total commitment in his striving for excellence and perfection. If this is the warrior's attitude, then there will be no room for the sin of ostentation (Musashi's personal bête noire), and the only limit to achieving this perfection will be death, which is the ultimate proof of service. In common with all his contemporaries, Miyamoto Musashi insisted that a warrior's life should not be wasted by being thrown away in a street brawl. Such an ignominious end was not in accordance with bushidō.

The decades following *Kōyō Gunkan* and *Mikawa Monogatari* saw two other classics of writing about bushidō and swordsmanship. Kofujita Toshisada's down-to-earth and practical *Ittōsai Sensei Kemposhō*, written in 1653, is a record of his grandfather's talks on the swordsman Itō Ittōsai. The work is a practical discussion of combat techniques and their application to different situations and opponents. By contrast, the *Fudochi Shinmyoroku* of the Zen priest Takuan Sōhō, who taught Zen meditation to the great swordsman Yagyū Munenori, is a very difficult text to understand, having as its essence the concept of *fudochi* ("permanent wisdom"). It means that the working mind, though always changing, is always attached to nothingness, and therefore to the eternal universe.

Another influential figure of the time was Yamaga Sokō (1622–1685). Sokō was the tutor and inspiration for Oishi Kuranosuke, the leader of the Forty-Seven Rōnin of Ako, whose dramatic revenge astounded contemporary Japan. Sokō concentrated on the military aspects of the samurai. He was an early advocate of the need to study Western warfare and equipment, a need that was only recognized at a national level two centuries later. He was also profoundly concerned with the inactivity of the samurai class, and a need to find a new role to replace the now unnecessary one of fighting battles. Yamaga Sokō believed that the samurai had to serve as a model for society, serving his lord with exemplary devotion, and with no thought of personal gain. He stressed the traditional samurai values of austerity, self-discipline, and readiness to face death. Yet Sokō was also wise enough to recognize the difficulty of applying these ideals to the days of peace.

A priest holding the blade of a *nodachi*, an extra-long sword, left as an offering in his temple.

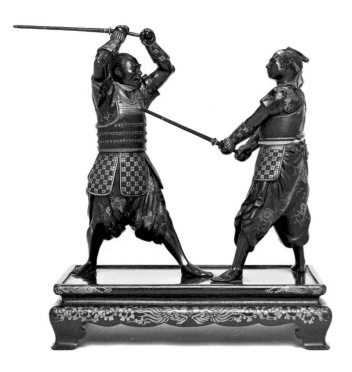

The present-day sport of *kendō* uses protective armor very similar to that developed during the eighteenth century. These combatants form a pair of bronze figurines. (Courtesy of Sotheby and Co.)

The Martial Arts in Peacetime

While thinkers like Yamaga Sokō strove to fill the warrior's mind with noble thoughts about his calling in life, the sensei of the Edo period concentrated more on his body, which the bureaucrat warrior often neglected. The attitude of the nonfighting samurai of the Tokugawa period is brilliantly summed up by Karl Friday as follows:

> For, even under the warless conditions of the eighteenth and nineteenth centuries, when the samurai had long since evolved from battlefield warriors to sword-bearing bureaucrats and the number of true experts in the martial arts was probably not appreciably less than it is today, it would have been as unthinkable for a samurai to confess to complete unfamiliarity with his swords as it would for one of his contemporaries in New England to confess to total ignorance of the Bible. Nearly all Tokugawa Period samurai had at least a nodding acquaintance with swordsmanship; most had or feigned more, and a significant few made it the focal point of their lives.[5]

It must not be thought, however, that the ideal training for the samurai's mind was completely divorced from the ideal training for his body. This is very much a modern view, and has arisen because of confusion about the contemporary use of three important words: bugei, bu-jutsu and budō. *Bugei* is used as an umbrella term for the Japanese martial arts, in which are included both *bu-jutsu* and *budō*. *Bu-jutsu* was, and still is, a practical concept, involving techniques and physical skills. During the early Edo period, the whole tenor of bu-jutsu was one of learning and practicing actual fighting techniques that would be applied in battle once wars came again. But once the practice of *bugei* begins to transcend the purely physical, then bu-jutsu moves to a higher plane and becomes budō. The suffix *-dō* has the same meaning as *michi*, "the way," as in "the way of horse and bow." The practice of martial arts then acquires a spiritual dimension and becomes of process of self-realization. As Karl Friday points out in his excellent analysis, pre-Meiji sources use *bugei* and *bu-jutsu* interchangeably, but *budō* tends to have this special connotation. The important point is that, in premodern times, there was no artificial separation between the practical and physical on one side, and the philosophical and spiritual on the other. They were seen as a continuum—a spectrum of martial experience—and were so thoroughly mixed together that old writers happily switched from one expression to another.[6]

The modern use of budō is of course not immediately concerned with the spiritual side of martial arts, and refers to activities such as kendō, aikidō, and the like, which are comparatively recent derivatives, far removed from the actual combat situation, substituting friendly combat for life-or-death duels. A spiritual side is certainly possible, but most modern budō forms have a competitive or a sporting context, although this is by no means universal. There is often a reduced emphasis on kata, the safety element being taken care of by modifying either the weapons used, the protection worn, or the moves carried out. There are still several examples of existing bu-jutsu ryūha in Japan, such as the Maniwa Nenryū and the Tenshin Shōden Shintō-ryū, both of which have managed to preserve their traditions and avoid the "sports" element of modern budō. Their students practice in a way that would have been very familiar to sensei such as Chiba Shūsaku. So ken-jutsu teaches sword techniques using wooden bokutō in kata, while kendō practitioners fight with shinai in a way that is very different from the use of a real sword, or even shinai use, in the early Edo period, when there were no restrictions on targets. Modern budō also customarily uses a ranking system based on a series of pupil grades (kyū) and teacher grades (dan), denoted in many cases by the wearing of different colored belts. Existing bu-jutsu stay with the menkyō system of "licence to teach," which arises from the traditions concerned with passing on a ryūha's secrets, mentioned in chapter 5.

Mass participation in ancient bu-jutsu forms would of course be both inappropriate and impracticable, but modern budō such as karate or aikidō, practiced sincerely and

A *ninja* reenactor armed with a *kusarigama*.

A young practitioner of *i-ai* draws her sword.

with sensitivity to their history and origins, are for most people the best expression of the martial arts ethos for the current century. They provide fitness, comradeship, and the satisfaction of success in skills that have to be practiced to perfection. They also provide a genuine link with the past, which can be very rewarding. The practice can also provide the spiritual dimension expressed by the original meaning of budō. Self-realization, self control, and personal fulfilment are all possible for the earnest disciple. It is only when the differences between old and new forms are forgotten that problems arise, and followers of a particular style argue for the "purity" of their own interpretation, or cling stubbornly to a supposedly ancient tradition that may not be more than half a century old.[7]

Classifying the Martial Arts

The "armchair samurai" of the Edo period, however, had another pastime to put beside that of rewriting bushidō. This was the classification of the "eighteen varieties of the martial arts." One example, from 1815, is as follows, and includes one or two very unfamiliar activities:

1. kyū (archery)
2. uma (horsemanship)
3. dakyū ("polo")
4. kisha (equestrian archery, yabusame)
5. suiba (swimming a horse)
6. suihei (swimming)
7. yari (spear)
8. kusarigama (sickle and chain)
9. naginata (curved halberd)
10. ken (sword)
11. yawara (grappling, jū-jutsu)
12. i-ai (sword drawing)
13. hojō (roping)
14. hana-neji (baton)
15. yoroi-gumi (grappling in armor)
16. shūriken (throwing weapons)
17. sekkiya (gunnery)
18. teppō (firearms, arquebus)

Several separate techniques fall under the heading of "horse and bow–jutsu." Dakyū, mentioned earlier, was the Japanese equivalent of polo, and from illustrations of people performing dakyū it looks somewhat more like a form of mounted lacrosse. Although of obvious use as a form of training for a man wielding a spear from horseback, dakyū was never very popular. It was played between two teams of seven men, each of whom carried in his net a ball of the same distinctive color as his team's costume. The object of the game was for each member of the team to throw his ball into a goal set up in the middle of the field, which consisted of a netting bag inside a wooden screen. The winning team was the first to get all seven balls into the net.

Yabusame was mentioned in connection with the Gempei period, and unlike dakyū, it has remained a recognized martial accomplishment still performed at certain festivals today. It is very spectacular to watch, as the archers, dressed in hunting gear, fire their humming-bulb arrows at small targets. Similar to yabusame, but more difficult to perform, was a training exercise and sport that does not appear in the above list, called inu-oi, "dog-shooting." Shooting dogs with the bow trained a mounted archer in hitting a moving target, and was apparently very popular with the Hōjō family of Odawara in the sixteenth century. During the Edo period, it provided an alternative to hunting. The dog was released from within a small roped circle. The archer would canter round the outside of the circle, inside a further roped enclosure. Once the dog was free, it would try to escape, and the archer had to shoot it before it passed either the outer or the inner boundary.

Sumo, associated in the West with the huge professional wrestlers, has always had an amateur following among those who are much less heavy. The kengō Chiba Shūsaku was very good at sumo. Yawara and jū-jutsu are two expressions for the grappling arts, which include those performed in armor as yoroi-gumi, an important fighting skill in the Gempei War, described in detail earlier in this book. During the Edo period, armored grappling declined greatly, to be replaced by the techniques more familiar today. The essence of jū, which is the Chinese reading of the character *yawara*, is to use an opponent's strength against himself. Masters of jū-jutsu were almost as highly regarded as master swordsmen, and there are several stories told about them. One such tale concerns Sekiguchi Jūshin, whose daimyō, to test him, tried to push him off the edge of a bridge. Sekiguchi sidestepped, and the young lord found himself dangling almost in midair, with a small knife thrust through his sleeve as a friendly warning and confirmation of his sensei's tremendous skills. One of the Yagyū family was also skilled at jū-jutsu, and in the year 1624 was umpiring a match when one of the contestants challenged him to a con-test. Yagyū declined, at which the man became angry, so Yagyū promptly swept his legs from under him, giving him his contest with style and efficiency! Another later master, Terada Goemon, being commanded to bow before the procession of the Mito daimyō, refused to do so until the actual daimyō's palanquin came in sight. He explained that he had chanced upon the procession by mistake, and that to prostrate himself before fellow samurai was not in keeping with his rank. The enraged samurai attendants tried to seize him, and by the time the lord's palanquin did arrive, he had put six armed men on their backs.

Jū-jutsu came to the attention of the West when rowdy sailors felt the force of it in the treaty ports. Rudyard Kipling made a famous comment upon jū-jutsu in an article in the *Times* of 1892, referring specifically to the use of it against drunken British seamen:

He has a grievance against the Japanese policemen. A Japanese policemen is required to have a workable knowledge of Judo [sic] and is paid a dollar for every strayed seaman he brings up to the Consular Courts for overstaying his leave and so forth. Jack says that the little fellows deliberately hinder him from getting back on his ship, and then, with devilish art and craft of wrestling tricks—"there are about a hundred of 'em and they can throw you with every qualified one"—carry him to justice.

Jū-jutsu does not necessarily imply purely unarmed combat, which is how it has tended to evolve nowadays. Many weapons were used, such as tantō and chain weapons. Kusarigama was the technique of using the fearsome sickle and chain. As we noted earlier, Miyamoto Musashi overcame one by throwing a shūriken, and Araki Mata'emon of the Yagyū Shinkage-ryū defeated an opponent whirling a kusarigama by the sensible expedient of walking slowly backwards until the duel ended up in a dense bamboo grove. The manriki-kusari, or "thousand power chain," consisted of a forged iron chain with a counterweight at each end, which was flung from the hand or swung.

Hana-neji, when literally translated, has the alarming meaning of "nose-twisting." The nose, however, is that of an unruly horse, and it was apparently the custom to control an unruly animal by placing a loop of cord around its nostrils. When it became troublesome, a short baton was inserted in the loop and the horse's nose given a hard twist. The baton so used was also found useful as a primitive form of policeman's truncheon, though not, strangely enough, by the dōshin, who preferred their steel jitte, the traditional sword catchers. The techniques were used by

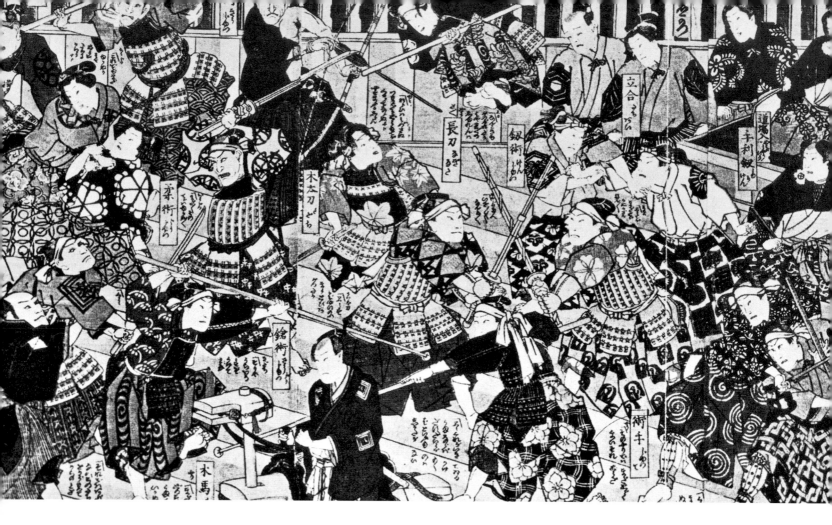

An unusual, but unfortunately poor-quality, woodblock print showing one version of the eighteen martial arts.

yōjimbō, however, as an alternative to their bō, and the hana-neji baton may be regarded as a direct forerunner of the Japanese riot policeman's baton.

Throwing weapons have never been much used in Japan. There is no equivalent to the javelin, for example. Shūriken range from small darts to wakizashi. In the *Taiheiki*, a certain samurai had "thirty-six large arrows carried on his back, which he threw by hand at the enemy and pierced them. . . ." Specially manufactured *uchine*, or throwing arrows, followed. There are not many cases of throwing a wakizashi, however, although one occurs in the *Osaka gunki*, when Ogasawara Tadamasa throws his wakizashi as a shūriken and makes his escape. In 1574, Takeda Katsuyori was about to capture a castle from Suganuma Sadamitsu. At the very last moment, Suganuma went off with Yamaguchi Gorōsaku and one other close associate on three horses, hotly pursued by the Takeda. They fired their two remaining arrows, and as a last resort Gorōsaku drew the wakizashi that he had with him, and threw it as a shūriken. It skimmed over the samurai's head, but Gorōsaku was killed. A battle of the Sengoku period gave no little scope for such unconventional techniques to be developed, but it was in the dark streets of Edo that such things as the shūriken came into their own.

The old chronicles contain numerous references to the techniques of swimming with horses, particularly when crossing a river to start a battle. The best known occur at the three separate battles fought at Uji, when horse-swimming was a means of gaining the supreme honor of being first into battle. At the 1184 battle, two samurai competed to be first across. When halfway across, the eventual winner hindered the other by telling him that his saddle-girth was loose. Swimming while armored, helped by floats, was another accomplishment. Some skilled swimmers could fire a bow and arrow from a floating position!

Different compilers of the "eighteen varieties" made different lists. Some include the war-fan, which was best demonstrated by Takeda Shingen when he used it to defend himself against his rival Uesugi Kenshin's surprise attack at the Fourth Battle of Kawanakajima, in 1561. We may also note the jō, a shorter form of the longer staff called the bō, as used by the yōjimbō. Its invention is credited to a warrior called Muso Gonosuke, who had been defeated by Miyamoto Musashi. Muso meditated on his defeat and conceived the idea of using a short staff that could be rotated easily, using both ends to strike. On their subsequent encounter, he managed to stop Musashi

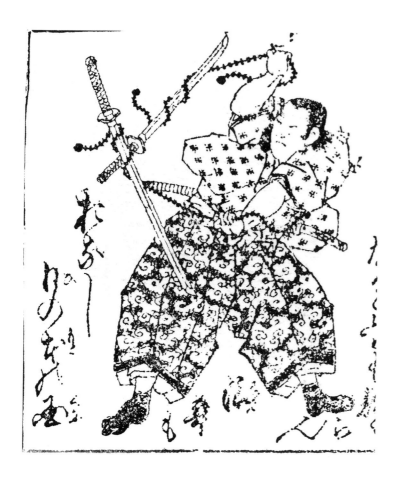

The *manriki-kusari* or "thousand-power chain" in action against a sword.

The *kusarigama* was a sickle to which was attached a long chain with a weight on the end. It was a formidable weapon in the hands of an expert, making even top-class swordsmen hesitate before attacking.

from striking him, which was no mean feat. The jō is a fascinating weapon to watch in action, as its jōdō techniques include various strikes and catches.

Sensei for a New Age

Whatever form of classification of martial arts was applied, and no matter what were the skills of the sensei who taught them, one inescapable fact was that the development of the Japanese martial arts was taking place in a society isolated from almost every other nation on earth. The samurai sword may have been the world's finest edged weapon, but the Western interlopers who appeared from the early 1800s onwards had artillery, and the cannon carried on their ships were far more formidable than the seventeenth-century pieces with which the Japanese were familiar. The Russians who visited Hokkaidō between 1811 and 1813 noted old Dutch cannon mounted on the forts at Hakodate, and commented that "the firing of one such cannon might put savages to flight, but it would hardly scare Europeans."[8]

The Tokugawa government reacted to these developments with a mixture of fear and cautious curiosity, and along with a renewed appreciation of European weapons, a covert revival of interest in European military lore began.

Translations from European military works, obtained via the Dutch traders on Dejima, were made by a devoted band of scholars of *rangaku* ("Dutch learning"), and a limited re-armament program was begun. The techniques available to the Japanese, however, were by now two centuries out of date, and a fierce debate began over the paradox of making contact with foreigners in order to learn the new technology so that the foreigners might then be repelled.

But no such debate developed at the level of the martial arts. Artillery meant little to the sensei of the early nineteenth century, who experienced a welcome upsurge of enthusiasm for their expertise, in blissful ignorance of the effects of modern Western firepower. For them, the threat of Western intervention simply brought about the revival of bugei in a way that an encouragement to emulate Confucian values had never been able to achieve. Just as the Mongol invasions had made Japan look at her preparations for defense, so the idleness and lack of skills bemoaned by writers such as Murata Seifu and Ogyū Sorai were flung suddenly into reverse. New sensei appeared, fired by a genuine enthusiasm for sword fighting that could be disseminated among a new generation of swordsmen, who knew they would need good techniques for the war that was increasingly seen as inevitable. Where the various swordsmen differed was in their perception of

why there would be a war, and against whom it would be conducted. Some had a burning desire to serve the shogunate as it faced difficult challenges in dealing with the foreign incursions. Others belonged to the new underground movements that sought to expel the foreigners and later developed into a movement to depose the shogun. The wheel of bugei had now almost turned full circle. Sword fighting had long since become an art form and left mere technique behind, but as the prospect of war came anew, the sword reverted to its original function as a device for killing people, and the gentle shinai prepared to give way to the naked blade.

The revival of the martial arts preceded the bloody events of the Meiji Restoration by about thirty years, making the 1830s and 1840s the "Indian summer" of Japanese swordsmanship. Sensei arose who, in their fighting skills and their unquestionable authority, equalled any from the Sengoku period.[9] The main difference between them and their predecessors was the lack of opportunity these later sensei had of demonstrating their skills with real swords. None could risk his life in a duel, or have the satisfaction of defeating an opponent with a devastating hitotsu tachi stroke. Their techniques were confined to i-ai, bokutō, or shinai, and consisted largely of kata. Nevertheless, sword fighting enjoyed enormous popularity, and by the end of the Tokugawa period, there were seven hundred ryūha in existence, and well-established schools such as the Yagyū

Shinkage-ryū and the Ittō-ryū had split into several branches.

One of the best examples of such a sensei at his anachronistic best is the story of the challenge made by a certain Shimada Tora-no-suke to the great sensei Otani Nobutomo, a man who exhibited all the personality of the earlier masters. Shimada Tora-no-suke was the son of Shimada Chikafusa, a samurai of the Nakatsu han of Buzen, who went to Edo to seek his fortune at the age of twenty-four, in 1837. His sword-fighting skills were considerable, but so was his fiery temperament, and he created havoc in Edo when he challenged others to fierce bouts in which he seemed never to be defeated. This made the young Tora-no-suke very conceited—a personality weakness among swordsmen that we have noted several times in the past. He eventually issued a contest challenge to Otani Nobutomo, an older man, well-respected as a sensei, who was regarded as the best swordsman in Edo at the time.

Nobutomo accepted the challenge, much to the disgust of his companions, who felt that the precocious Tora-no-suke was beneath their sensei's dignity. They fought with bokutō, and Nobutomo took the first blow. Tora-no-suke took the next blow from Nobutomo, then the third blow from Tora-no-suke hit Nobutomo in the eye, and the contest was brought to a halt. Young Tora-no-suke, having received only one blow from Nobutomo, became more conceited than ever, and was convinced also that

Right: **A sketch by Hokusai of practice with the dartlike versions of** *shuriken*, **using a target with a face painted on it.**

Opposite top: **A bartender in Yokohama prepares to clear the establishment of drunken sailors. Incidents like this in the treaty ports often led to a Westerner's first appreciation of the skills of** *jū-jutsu.*

Opposite below: **The martial art of** *hana-neji* **("nose-twisting"), using the form of short baton otherwise employed to control an unruly horse. This is the forerunner of modern police baton techniques.**

Pages 172–173: **The race to be first into battle during the Battle of Uji, in 1184.**

Nobutomo was not the great swordsman he had been told about.

What Tora-no-suke did not know was that it was Nobutomo's custom to treat all aspiring young martial artists in this way. First he would let them gain an easy victory, to test how well they responded to the elation of success. Then there would be a rematch, and Nobutomo would give them a sound beating. Oblivious of this, Tora-no-suke went on to challenge others who had a less generous approach to young braggarts. Hearing of the reputation of a certain Inoue Gensai, Tora-no-suke sought to challenge him to a contest, but Gensai considered that to be pitted against the sword of a rustic-trained countryman like Tora-no-suke was not consistent with his rank. Tora-no-suke then changed his tack and asked if he could join his pupils, to which Gensai replied, "I have achieved the highest standard of swordsmanship in Edo. A young person of promise like you would not be satisfied by an old master like me. However, there are in Edo men who would fulfill your requirements. Have you visited Otani-sensei?"

Gensai already knew what had happened when Tora-no-suke had visited Otani, and smiled to hear Tora-no-suke say, "Oh, yes, I have visited him. Of three blows delivered only one was on me. I think he is a person of lesser skill than I."

"Perhaps he did not fully appreciate your abilities as an opponent," said Gensai. "Let me give you an official

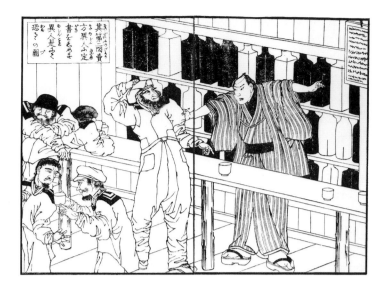

letter of introduction to Otani-sensei. You can visit him once more."

Tora-no-suke took the letter of introduction and visited Otani for a second time, and as Gensai had anticipated, the results of their combat were very different. Tora-no-suke never succeeded in landing the slightest blow on Otani, who vanquished him utterly. By that defeat, Tora-no-suke was enlightened, and it taught him a very valuable lesson. The experience turned him toward a more realistic pursuit of

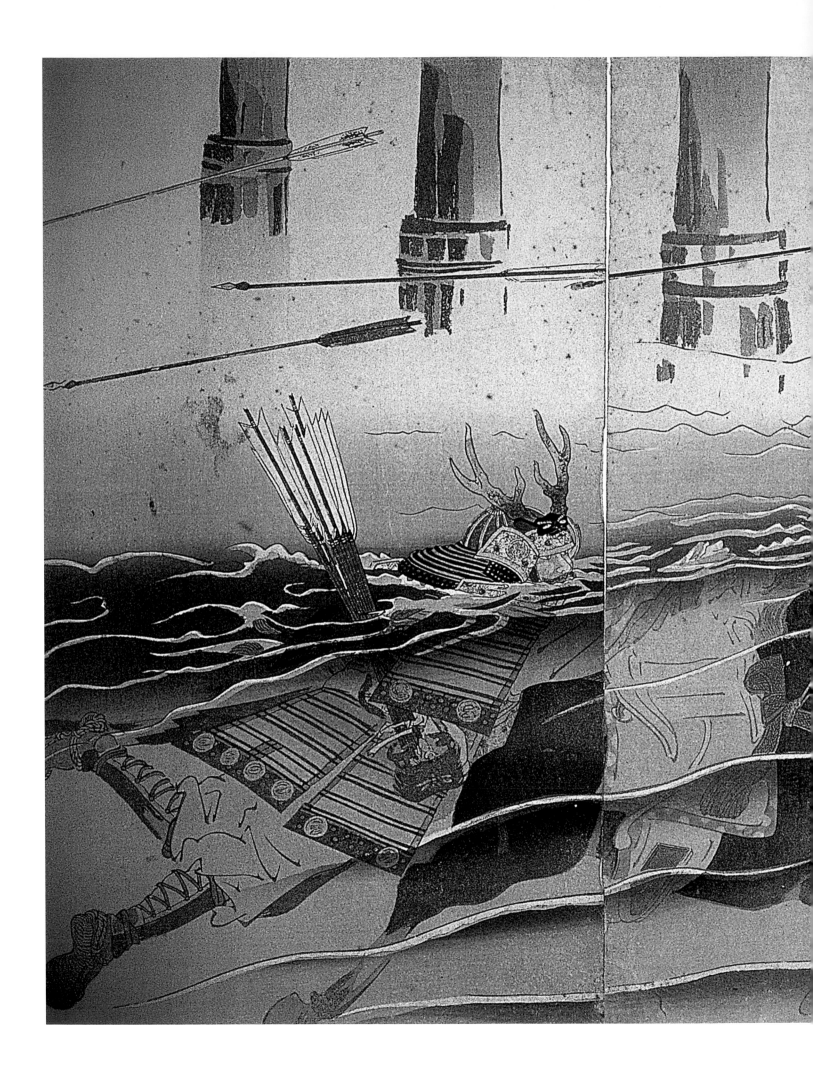

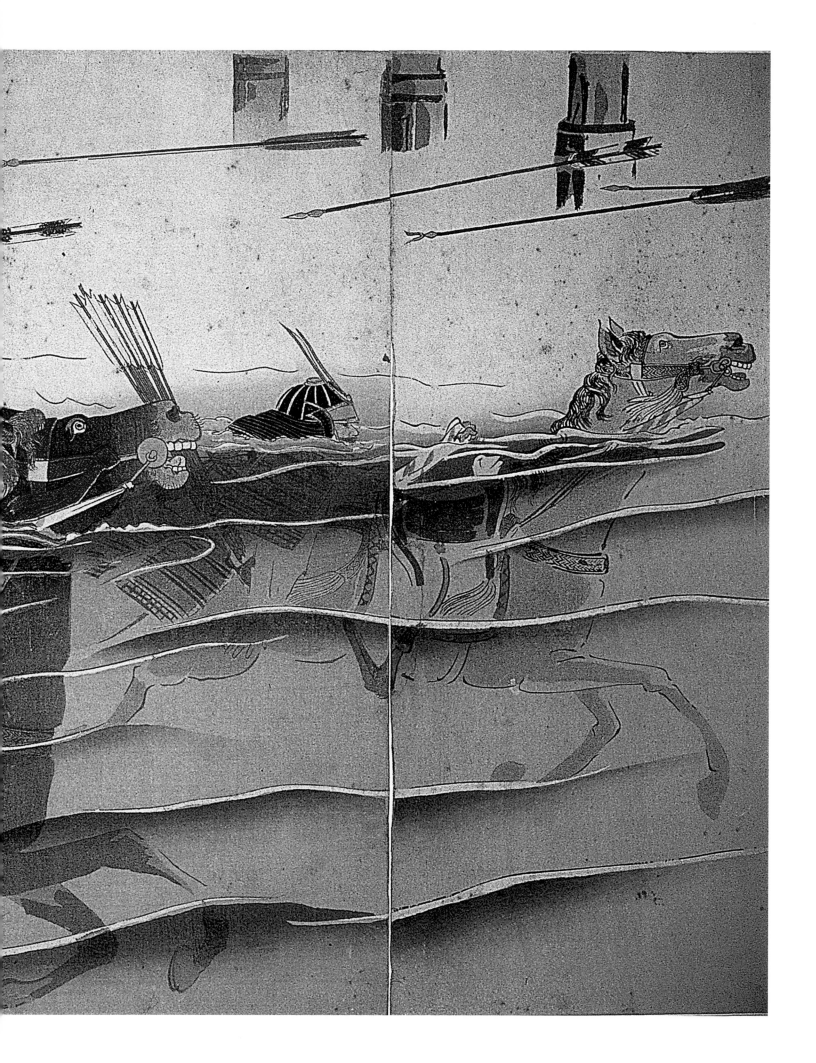

knowledge, and instead of returning to Gensai, he became a pupil of Otani Nobutomo, who had already recognized that there was a latent talent behind all that bravado. Tora-no-suke stayed with Otani's school for the rest of his life.[10]

Chiba Shūsaku

Another outstanding sensei of this period was Chiba Shūsaku. He was the son of a former samurai doctor, and went to Edo from his home province at the age of sixteen, in 1809. Chiba Shūsaku studied at the Ittō-ryū dōjō under the sensei Takai Matashichirō, who was so surprised by Shūsaku's progress that he decided to have a personal contest with him. To be allowed to fight one's own sensei was a rare honor in those days, when a master's pupils were numbered in their thousands. Nakanishi Chube'e's dōjō, then one of the best known in Edo, was selected as the venue—evidence of how seriously Takai-sensei viewed the confrontation. It would have been no disgrace for Shūsaku to be beaten by Matashichirō, so he could put all his energy into it, win or lose. Shūsaku did not have confi-

dence in a win, but realized that he had been given a golden opportunity to find out how good his technique really was. If he did win, of course, his name would become very famous.

The result was duel that would have been remarkable at any time in samurai history. The sensei Takai Matashichirō had a strange technique. No matter whom he fought, would never let opponents touch his shinai. He followed them pace for pace and at a good distance. At the moment of closing, when the swordsmen are a crucial distance apart, he controlled everything and everyone, and was best known for his soundless *kamae*. The kamae was the situation when both swordsmen were eyeing each other, ready to strike, and practically trying to stare each other down. Matashichirō always stood perfectly still, but also looked as if he had no intention of fighting. If the opponent tried to intimidate him, Matashichirō gave no reaction whatsoever, leaving the opponent confused. Of course, anyone who was impatient would be really frustrated, and his mind would begin to wander. When the opponent was at the end of his patience, then Matashichirō would suddenly strike. This unnerving period of waiting was what was called his soundless kamae.

Up to then, many people had fought with Matashichirō, but nobody had been able to break his kamae. Shūsaku had witnessed it on several occasions, and knew very well that patience was the vital factor. So Shūsaku waited also and did not move, so that they looked like two people who had forgotten about fighting. Nakanishi Chube'e and his other pupils were watching, nobody making any noise, feeling that if they blinked, the fight would be over. Shūsaku continued to stand still, forcing himself not to start the fight, because once he started, at that moment he would have a weak point and Matashichirō would take advantage of it. Matashichirō in fact showed a little genuine frustration, and an ordinary person waiting such a long time would have attacked, but Shūsaku still held his guard, because he knew it was the only way he could possibly win.

After a seemingly endless wait, even the dōjō master, Nakanishi Chube'e, became impatient and thought he would separate them—but suddenly they both moved simultaneously, and the swords met. The famous soundless kamae was replaced by a clash of shinai, and almost immediately afterwards a loud crack! The floor of the dōjō had split beneath Shūsaku's feet! It was a very thick floor, and such a thing had never happened before, evidence of the tremendous power of Shūsaku's *kiai*, the explosive energy of a swordsman released in a huge burst. The dōjō owner later cut out the piece of flooring and displayed it for the pupils to see, as an example of the supreme quality of swordsmanship.[11]

The activity of Shūsaku's that caused the greatest stir was his confrontation with one of the greatest schools in Japan: the Maniwa Nen-ryū. He had just come to Takahashi, home of the Maniwa Nen-ryū, on his musha shugyō pilgrimage. Shūsaku defeated a certain Koizumi in a contest, and this Koizumi was rumored to be first among bokutō in the country. Because of this, hundreds of novice candidates had gathered to see Shūsaku, and all hoped to avenge Koizumi, while Shūsaku's own pupils naturally supported him. This was in 1822, and it was only the persuasive power of the chief magistrate of the locality that gradually settled the affair without a riot or major bloodshed.

By the later Edo period, about two hundred schools of martial arts were in existence, and among them were many swordsmen of remarkable talent. Many people wanted to challenge them, which led to the creation of rules to govern challenges. Only certain types of contests were allowed, and to control them, both practice times and places were regulated. Within this framework, con-

tests were usually encouraged, and some sensei even ordered their pupils to take part in them. But there are also records of fights being fixed, or bribes changing hands as a money-bag was slipped into a sleeve. By this time, however, the martial arts were beginning to acquire the nonmilitary ethos of today. Ken-jutsu was no longer confined to samurai, but had spread to the lower classes. Chiba Shūsaku used dōjō yaburi as a means of polishing his skill in a similar way to that of the swordsmen of earlier times. In his lecture *Kempō hiketsu*, he lays out the rules for contests between schools:

When rival schools meet, there is sufficient fear in excited eyes and tightened shoulders, and in contrast to this, one approves of a spirit of gentleness and calm. There is a certain time when a man challenges someone to a contest, and everything in his body is humble. Think of our fellow students who are inexperienced in ken-jutsu . . . do not despise anyone sent to the contest, think of them as skillful. . . receive them and allow for their behavior, strong or weak.

He adds that the greatest danger comes from the unknown adversary. Chiba Shūsaku set up his own school, the Hokushin Ittō-ryū, and was to exert an enormous influence on some of the finest and most notorious swordsmen of the Meiji Restoration. He died in 1855, the last of the old-style sensei who could devote themselves entirely to the practice of the martial arts. His successors were not so lucky.

The Last of the Old Sensei

The chapter that follows will trace the careers of men who received training from sensei like Chiba Shūsaku, and then went on to wield their swords in almost indiscriminate acts of terrorism. But many of the top swordsmen served their country, and its reconstruction under The Meiji regime, in positive and peaceful ways. Some behaved as nobly as any old sensei, combining public service with a keen appreciation of the place of the martial arts in the emerging modern state of Japan. But all had their lives disrupted by war, and two of the best examples are Sakakibara Kenkichi and Takahashi Deishū.[12]

The Sakakibara family were shogun's vassals over several generations, and Kenkichi was born in 1830. At the age of thirteen, he became a pupil of Otani Nobutomo's Jikishinkage-ryū and studied ken-jutsu, eventually becoming his best student. As the family was poor, they thought

they would have to defer his receipt of a licence to teach, but the master, Nobutomo, realizing this, granted it free of charge. In 1856, Kenkichi was appointed on the recommendation of Nobutomo to the post of professor at the Kobushu, a newly formed office of the shogunate in charge of training, including Western-style army organization and gunnery. There was to be reform in military organization, with a regular army of three divisions: foot soldiers, cavalry, and artillery. As a result of this involvement, Sakakibara Kenkichi became a close confidant of the shogun Iemochi and served as his bodyguard.

Traditional martial arts were not forgotten, however, and Kenkichi had a famous contest with one of his contemporaries, Takahashi Deishū. Deishū had been born in 1835, and was thus five years younger than Kenkichi. When he became a master of yari-jutsu, Deishū had had a famous contest with a certain Ii Kanehira, who had over thirty years' experience. Kanehira's speciality was to tease his opponent with his spear, holding it firmly at a distance, and then, seizing the moment, making a wide slash and sweeping the opponent's legs away from under him with a cut called *ashi guruma*. This technique had won him many contests. The experience had stood Deishū in good stead, and he was now said to be the best in Japan at spear techniques.

The contest between Kenkichi and Deishū was bound to be an unusual one, as it was to match a sword against

Left: **A photograph showing Ohara Masako, a *sensei* of the Maniwa Nen-ryū, in action with wooden weapons.**

Right top: **Equipment for practice sword fighting.**

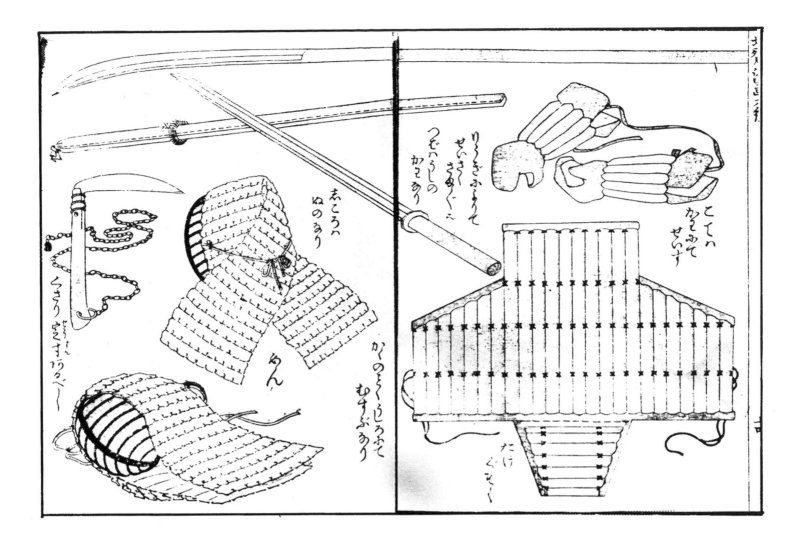

a spear. Because both men were in the favor of the shogun Iemochi, it was decided that the contest should be held in his presence, an immense honor, and one that was almost unique since the days of Yagyū Munenori. The contest took place in 1860 amid great ceremony, and both men appear to have risen to the occasion. Kenkichi began by lifting his sword to the jōdan position, taunting Deishū to thrust at an apparently unguarded point. Deishū was cautious, holding his spear out before him, and instead of aiming at Kenkichi's chest, he drove a blow at his face. Kenkichi dodged, and landed several blows with his shinai on Deishū's spear. From then on, the contest became fast and furious as each scored points off the other. However, Deishū had the advantage of youth over the older Kenkichi, and after much contact, he gained an advantage. At that point, the shogun, well satisfied, stopped the two men from fighting further.

This brilliant display of martial arts was probably the last friendly encounter with weapons that any shogun was to witness. When the Tokugawa administration collapsed, and the Tokugawa family moved to Suruga, the samurai who had supported him were split up, and Sakakibara Kenkichi was employed as a prison guard at the Metropolitan Police headquarters. These were dark days for martial artists. The samurai were abolished as a class, sword wearing was banned to all except the armed forces, and the anachronistic rebellions, which I shall describe at the end of this book, cast a shadow over the noble traditions of the old sensei.

Sakakibara Kenkichi was one of the few who tried to raise the popularity of the traditional arts by making an entertainment of a ken-jutsu match, but even this had an air of desperation about it, of trying to revive something that was virtually dead. The most bizarre example of this was a "sideshow" he put on in 1889, called *kabuto wari* (helmet breaking), a form of martial arts entertainment that makes one wince to think about it. The object of the contest was to use swords to cut through a helmet, an exercise that can have done no good either to helmet or to sword. The helmet used was a Myōchin-forged, pear-shaped design of foreign steel—in other words, a masterpiece by the leading school of armor makers in Japan. The swordsmen Itsumi Sōsuke and Ueda Uma no jō, and others, were among the great names who competed, but although the helmet was scarred, it could not be cut into. Then Kenkichi had a try. He used a dōtamune stroke, and swung it at the brow, making a

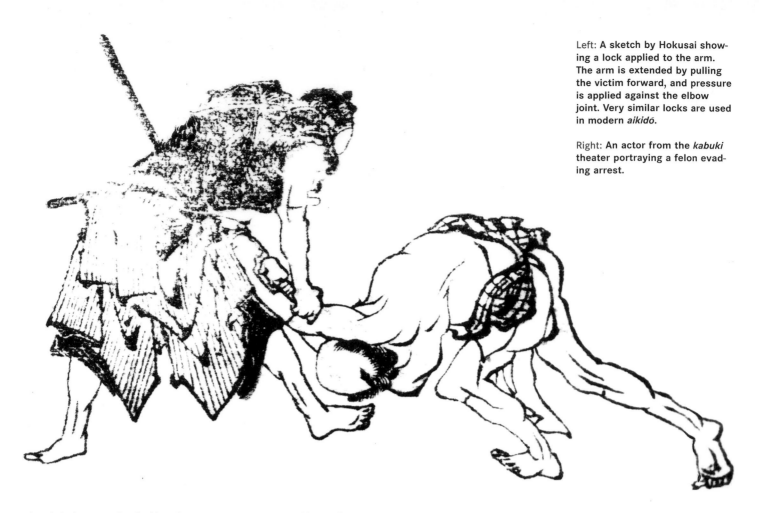

splendid three-and-a-half-inch cut in it. He was well satisfied at this display of skill, and we are told that his reputation grew. Fortunately for the future antique trade, no more such contests are on record, and the development of the martial arts turned more in the direction of budō and the sports-orientated forms we are used to today. Kenkichi died in 1895 and was compared to the finest swordsmen who have ever lived. The same could be said of his former rival Takahashi Deishū, who served as land registrar under the Meiji government and outlived every other contemporary swordsman to die peacefully in 1903.

We must also mention the name of Yamaoka Tesshū, another late master, whose career includes many elements of the great sensei, expressed in a modern context. He was born in 1836, and trained under Chiba Shūsaku. He was devoted to ken-jutsu, and at the age of twenty-seven, he challenged Asari Matashichirō, the current master of the Ittō-ryū, to a match, but he failed to beat the master. This failure made him devote himself to training in swordsmanship and Zen Buddhism, with the aim of meeting Asari Matashichirō again one day. His training was interrupted by the wars of the Meiji Restoration, in which, as a loyal Tokugawa retainer, he served in the shogun's guard. His most worthwhile contribution to the war was made by diplomacy, not by fighting—proving that the discipline of the swordsman could have very real value in a peaceful

context. Following the defeat of the shogun's army at Toba-Fushimi, near Kyoto, the shogun withdrew to Edo, pursued by the imperial army. Yamaoka Tesshū was entrusted with a vital mission. He was to go and meet the commander of the imperial army halfway and negotiate a settlement, so that Edo would not be attacked. This he succeeded in doing, thereby undoubtedly saving many innocent lives.

In 1880, with Japan at peace, Yamaoka Tesshū finally got a chance to meet Asari Matashichirō again, after a gap of seventeen years. They made a challenge—an almost unique arrangement for two old masters at this late date—and faced each other across the dōjō floor, each with his shinai at the ready. But Asari Matashichirō noticed the change that had taken place in the younger man over the passing of time. He recognized the new quality in his opponent, his new confidence and his obvious spiritual insight. Therefore, in a chivalrous gesture that would not have been out of place in the age of Kamiizumi Nobutsuna, instead of fighting with him, he immediately conferred upon him the menkyō kaiden of the Ittō-ryū. Yamaoka Tesshū eventually died in 1888, and five thousand people from among the grateful citizens of Edo watched his funeral procession pass the Imperial Palace. Even Emperor Meiji, it was said, watched the cortege from a window. It was the end of an era.[13]

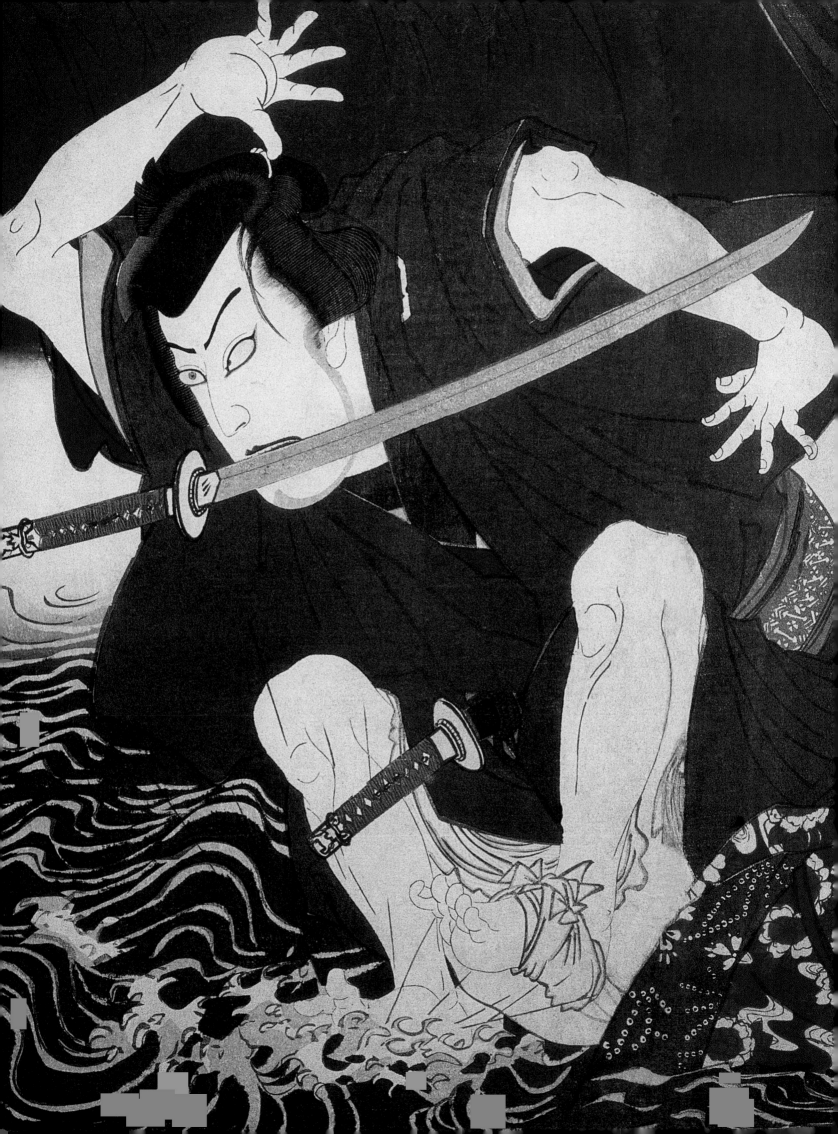

CHAPTER 10

SWORD OF REVOLUTION

In the spring of 1863 in Kyoto, the city that was to remain the capital of Japan for only a short time, a very unusual thing happened. Nine men broke into the Tōji-In Temple. They were all political activists of the samurai class who were loyal to the emperor and opposed to the continuing rule of the Tokugawa shogun. In their view, the shogunate had betrayed Japan by opening up trading links with the barbarian West, and they were about to show their opposition in a most unconventional way. The raiders tied up the priest who was on duty, forced their way into an inner room, and cut the heads off their intended victims. Beheadings were not uncommon in Japan during that turbulent time, but these decapitations were very different, because the heads, which were afterwards displayed for all to see, came from three wooden statues.[1]

The effigies were of three shoguns, but they were not from the ruling Tokugawa family to whom the insurgents were so violently opposed. They were instead statues of the first three shoguns of the Ashikaga dynasty: Takauji (1305–1358), Yoshiakira (1330–1368), and Yoshimitsu (1358–1408). All had lived centuries before the Tokugawa rose to power. The raiders were arrested and jailed, and one of them wrote a long poem when he was in prison following the incident. It gave a clue to their motivation by explaining that the Ashikaga had once betrayed their country by ousting the rightful emperor of the Southern Court. The analogy with the Tokugawa regime was clear, and he spelled it out in the words:

Takauji, you and your disgusting son betrayed the emperor and tormented the princes. You are unparalleled

traitors to the country. The mad and treacherous Yoshimitsu is a criminal who went begging to the king of China, demeaning himself to become the king's retainer, and polluting the divine country. Today many people clearly surpass these traitors. . . . If they do not immediately repent these ancient evils and offer loyal service to expunge the evil customs existing since the Kamakura Period and offer their assistance to the court . . . then all the loyalists on earth will rise up together and punish them for their crimes.[2]

"Assistance to the court" meant that the Tokugawa shogun should expel the foreigners, in which process the loyalists would patriotically assist him. But by the time these words were written, "loyalists" had indeed risen up, and others who regarded themselves as equally loyal had similarly risen up to oppose them. Japan was changing rapidly, and by the time of the Tōji-In raid, many human heads had already preceded the wooden ones to an ignominious decapitation.

Men of High Purpose

The shaking of Japan's foundations began one year before the death of the last of the old peacetime sensei, Chiba Shūsaku, with the arrival off the Japanese coast of an American fleet commanded by Commodore Matthew Perry, in 1854. The Americans were not frightened away by the sight of armed samurai warriors glaring at them from the beach, and Perry's subsequent landing ended the two centuries of Japan's self-imposed isolation. Trade negotiations followed. Ports were opened up, and foreigners in strange

Okada Izō Yoshifuru, as depicted in the Sakamato Ryoma History Museum, Noichi, Kochi Prefecture. He was a Tosa samurai who was involved in the killing of Homma Seiichirō. He was arrested, and in 1865 he was sentenced to be beheaded.

outlandish clothes began to walk the roads of Japan for the first time in two and a half centuries.

The opening up of Japan was a development that was far from welcome to many in Japanese society. The threat the events posed also brought many dissenters out into the open—people who had been dissatisfied in general terms with the rule of the Tokugawa family, and now found a vital issue on which to oppose them. They had their own ideas of how to face the new threat posed by foreign nations. Whereas the supporters of the shogun tended to cooperate with the Western nations by signing treaties and promoting trade, their opponents believed that the shogun's acquiescence to Western demands was a sign of weakness and a betrayal of traditional Japanese values. The rallying cry of these young activists was *Sonnō-jōi!* ("Revere the emperor and expel the barbarians!"). This "loyalist," or "imperialist," movement eventually came to believe that the main obstacle to the expulsion of the barbarians was the continued existence of the shogunate, which should be replaced by the restored rule of the emperor. The most extreme among this faction called themselves *shishi*, which means "men of high purpose." Hungry for change, they worked hard at improving their skills in the martial arts for the conflict they expected at any time. It is not surprising that they were joined by a new breed of "lone warriors," eager to demonstrate their martial skills, and a whole new era began for the art of the samurai swordsman.

The shishi swordsmen's training was undertaken at various dōjō around the country. Edo provided an excellent opportunity for the young activists to meet, because much of their time was spent there when their daimyō was in Edo

for his spell of residence, as required by the shogun's sankin kōtai system. As well as contests between individuals from different dōjō, the later Tokugawa period also witnessed some large-scale fencing matches between groups of rival schools. Probably the greatest contest of this sort took place in 1857 at a meeting on the Kajibashi estate of the Tosa han, in Edo. Through the generosity of the daimyō Yamauchi Yōdo, martial arts enthusiasts from many provinces gathered to compete and compare their skills. The program for the contests lists many famous samurai of the day, such as Sakamoto Ryōma from Tosa, and it is very interesting to note that the vast majority of them were the young revolutionaries who, within a few years, were to overthrow the shogunate and restore the emperor.

These contests may have been a gathering of famous swordsmen and martial artists from all over Japan, but there is some evidence that the real reason for holding them was to provide cover for meetings between revolutionaries from distant provinces. Some of the competitions may even have been fabricated. It is interesting to think that the shishi from different fiefs could not contact one another except in this way, and this adds a whole new dimension to the reasons for the popularity of the martial arts among these lower-class samurai at the end of the Edo period.[3]

With their sword-fighting skills honed, and their political awareness raised, the shishi took to the streets. From the late 1850s onwards, the niceties of dōjō behavior, with old sensei behaving as if they were living in the sixteenth century, gave way to a time of violence, as the young samurai divided into two armed camps and started murdering politicians and each other. On one side were those who sup-

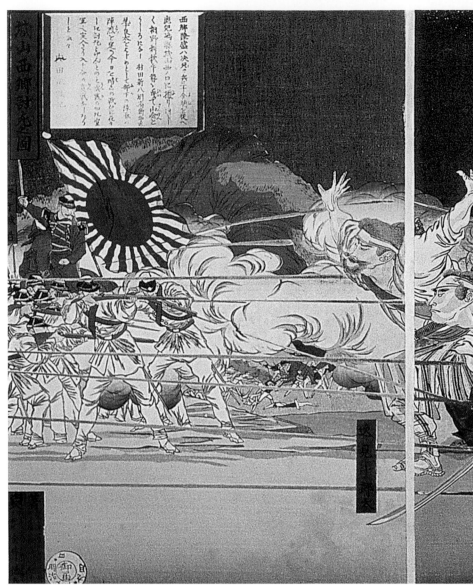
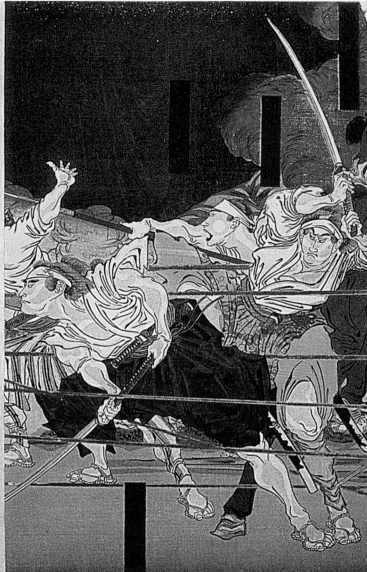

ported the continuation of the shogunate and the policy of opening up Japan to the West, while the others, the shishi, saw in the emperor a way of uniting the country and expelling the barbarians, as they called the Western interlopers. Few of their acts of terrorism were admirable in any way. Little martial arts skill is involved in the murder of a politician or a police spy, particularly when it is accompanied by the anachronistic and sickening act of displaying his head.

Three men—Kawakami Genzai, Tanaka Shinbe'e and Okada Izō—are good examples of this trend. Kawakami was the second son of a low-ranking samurai of the Higo han, and was adopted into the underling Kawakami family, served as a cleaning boy, and at puberty joined the loyalist party. In 1862 he became a member of the imperial court guard. Later he became deeply involved with the shishi of Chōshū, and in 1864 he murdered a student of Western learning called Sakuma Shōzan, in Kyoto. Genzai also became displeased with the new Meiji government, and was sentenced to death because of his antigovernment

movement. The public called him Hitokiri Genzai, "Genzai the killer."

Tanaka was the son of a sea captain, and became a Satsuma samurai with the assistance of wealthy merchants. He mixed with shishi of many provinces on their journeys to Kyoto, and was transformed into one of the bad elements of the radicals. Tanaka was said to be involved in the assassinations of the government supporters Shimada Sakon, Ukyō Omokuni, and Homma Seiichirō, and he eventually took the title of *ansatsu taichō* ("the captain of assassins"). He was eventually arrested as the criminal assassin of a young woman called Komichi. When he was examined, all the evidence pointed toward him, but at that moment he ended his life by seppuku with his own sword. Okada Izō Yoshifuru was a Tosa samurai who was involved in the killing of Homma Seiichirō. He was arrested, and in 1865 he was sentenced to be beheaded.[4]

The most high-profile murder that any shishi carried out was that of Ii Naosuke. He had ruled as regent of Japan dur-

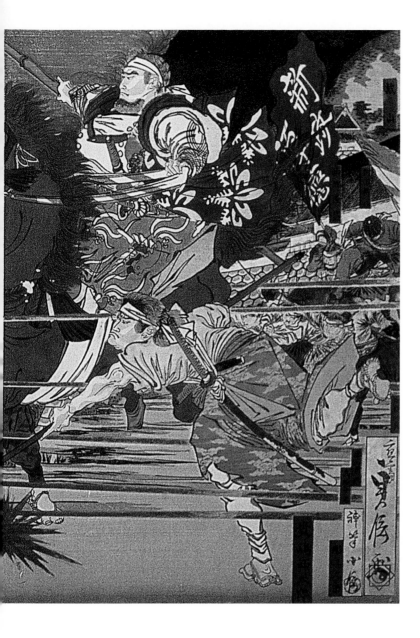

Above: **The Satsuma Rebellion, the final action involving samurai swordsmen. The Shinsengumi were widely feared and ruthless.**

many fanatics who were not averse to using their swords for political ends. To counter them, Ii Naosuke launched a purge of activists, and a large number of shishi were executed or thrown into prison. Their comrades took a bloody revenge. One snowy winter's morning in 1860, Ii Naosuke was torn from his palanquin in Edo and was hacked to death by a group of these anti-shogun and anti-Western terrorists.

The murder of Ii Naosuke launched a wave of terror, and the extremist samurai in the loyalist movement found their ranks swelled by other lawless elements, as soon as the rule of law was perceived to be weakening. In 1862 a leading bakufu supporter, Shimada Sakon, was killed by an assassin. His head was exposed at Shijōgawara, to the astonishment and disgust of the Kyoto people.[5] This was to be known as the "first installment of *tenchū*" ("heavenly punishment") in Kyoto, and the assassins made it clear that they had killed him as a reaction against the bakufu's authority. Later that year, Homma Seiichirō became another victim of tenchū, and his bloody head was similarly exposed at Shijō.[6] In the following year, Anegakōji Kintomo was attacked by three assassins who ran along the old imperial palace wall as he was leaving the gate. His companion Yoshimura Ukyō fought hard, but in vain, and, seriously wounded, he was carried to his residence and there died. The assassins of these men were not ordinarily thought of as terrorists, simply as passionate and misguided young samurai who felt they had to kill recklessly and with blind devotion. One distinctive feature of the shishi was that they were at the end of their youth, aged between twenty-five and thirty, and of the lower samurai rank. There was little approval of their acts, and many of their political sympathizers considered them as a hindrance to the revolution, and assassination as a cowardly and most evil way of justifying their position.

The Protector of Kyoto

By 1862, the situation in Kyoto was getting completely out of control, so an unprecedented decision was made. The shogun would visit Kyoto and report to the emperor, assuring him that his ultimate aim was to expel the barbarians. This, it was hoped, would help restore calm and reinforce the flagging authority of the shogun far away in Edo. But Kyoto was now a very dangerous place for anyone who openly supported the shogunate and its accommodative policies, so another innovation was produced: the creation of a post entitled "Protector of Kyoto." Matsudaira Katamori of Aizu was appointed to this most difficult of positions. His duties required him to take control of the security of the emperor and palace and the policing of the city. Two of his senior counselors in Aizu warned him against accepting the job—comparing it to

ing the minority of the twelve-year-old shogun, who came to the throne in April 1858. Although one of the most senior members of the samurai class, Naosuke had probably never wielded a sword in anger in his life. His death came about as a result of his diplomatic activity on behalf of the Tokugawa shogun, to whom he was unwaveringly loyal. Ii Naosuke had been closely involved in the negotiations between the shogunate and the envoys of countries such as the United States, who sought to establish trading links with Japan, and his efforts resulted in the signing of a commercial treaty in June 1858. In establishing this treaty, the shogunate showed itself to be considerably far-sighted, but it was not to the liking of those who wanted to expel all the barbarians. Ii Naosuke persisted in his belief that Japan should open its doors to the outside world, but the opposition contained

trying to put out a fire while carrying firewood—but the demands of loyalty to the shogun that had sustained the Aizu domain for two centuries made him accept.

Policing Kyoto proved to be no easy matter, and the assassinations continued into 1863. Early in that year, Hayashi Suke, a bakufu official, was murdered in his home in Kyoto by a loyalist gang. Eight days later, Ikeuchi Daigaku, a Confucian scholar, was killed and had his ears severed from his body.[7] They were thrown into the courtyard of the residence of another intended victim, with a note claiming that Ikeuchi had once been virtuous but had since joined the ranks of the evil pro-shogun officials. On other occasions, the victim's hands, and even one head, were used for the same purpose. Faced with atrocities like these, the Tokugawa government introduced one further innovation. With killers on the streets, the Protector of Kyoto needed killers of his own, so a virtual army of "loyal and patriotic" swordsmen was dispatched from Edo to Kyoto with a commission to restore law and order in the imperial capital. In an extraordinary precedent, the men were not recruited from among the shogun's own retainers, but from rōnin and nonmembers of the samurai class. The authorities who enlisted them, however, preferred the more splendid title of rōshi to that of rōnin, substituting the character for "samurai" in place of the character for "man." The recruitment net was cast wide, with convicted murderers being released to join the ranks. But whatever their backgrounds, they all had in common superb skills in sword fighting and a supposed loyalty to the shogun who had plucked them from obscurity and made them into samurai overnight.[8]

It was the latter quality—loyalty to the shogun—that the Tokugawa government got so badly wrong. Two hundred and fifty "loyal and patriotic" neosamurai left Edo for Kyoto on February 8, 1863, under the command of Kiyokawa Hachirō. Even though he had once openly espoused anti-Tokugawa views, he had been pardoned under the amnesty and was regarded as the ideal choice to attract rōshi like himself to the Tokugawa banner. The decision could not have been more wrong. The rōshi arrived in Kyoto the day after the shishi had decapitated the Ashikaga statues, but instead of sending his men out against them, Kiyokawa began advocating loyalty to the emperor, and urged his men to consider that their mission was not to protect the shogun but to expel the foreigners. The shogunate's innovative plan was beginning to fall apart.

Some in the government advocated having Kiyokawa assassinated, but a more peaceful means of reining in the rōshi had just presented itself. The previous year, a young Englishman called Charles Richardson had been out riding when he unfortunately encountered the entourage of the

daimyō of Satsuma. When ordered to dismount by one of the Satsuma samurai, Richardson had refused and was cut down. Great Britain was now demanding reparation, and was threatening an invasion should it not be forthcoming. Kiyokawa, whose enmity towards anything foreign exceeded his enmity towards the shogun, proposed that his rōshi army should return to Edo to provide a defense force. This gave the Tokugawa government the perfect excuse to withdraw Kiyokawa from Kyoto to a place where he could be controlled. But on his return he decided to preempt any British assault by attacking the foreign settlement in Yokohama. His plot was discovered, and the Tokugawa government had him assassinated.

The departure of Kiyokawa had not, however, left the Protector of Kyoto defenseless, because when Kiyokawa and the majority of his rōshi returned to Edo, thirteen of their number stayed behind. Unlike their erstwhile leader,

Above: **Wooden statuette of Kondō Isami of the Shinsengumi.**

Right top: **The shrine to Kondō Isami in the grounds of the Mibudera in Kyoto. Near a bust of the Shinsengumi leader, visitors have left prayers written on** *ema* **(prayer boards) that bear his likeness.**

they were genuinely loyal to the shogunate, so they petitioned the Protector of Kyoto to allow them to withdraw from the rōshi and place themselves under his command. They would then fulfill their original aim of protecting the shogun while he was in the capital. Their plea was accepted, and as they had been "newly selected" for this demanding role, that was the name they were given: the "newly selected unit"—the *Shinsengumi*. This was the genesis of the most feared and ruthless group of samurai swordsmen that Japan had seen for hundreds of years.[9]

The Shinsengumi

Although less well known in the West compared to the activists of the loyalist movement (who were, after all, the eventual winners in the wars of the Meiji Restoration), the Shinsengumi are lauded in Japan, where a recent spate of books and television features has celebrated as heroes these most unromantic of samurai swordsmen.[10] The Shinsengumi originally had two leaders, each of whom was suspicious of the other. Serizawa Kamo was born in 1830 and was the son of a wealthy but low-ranking samurai. He had been a passionate and violent antiforeign activist in his native Mino Province, for which he had been imprisoned and sentenced to death. But, like Kiyokawa, he had been released under the general amnesty proclaimed by the shogunate in order to recruit men for the rōshi. As a samurai, Serizawa had expected special treatment, even deference, among the rōshi. This set him at odds with the other chief founder of the Shinsengumi, Kondō Isami, who was born in 1834 in Musashi Province, of farming stock. He was an expert swordsman, and was as committed to perfection in sword fighting as anyone born within the social class into which he had so unexpectedly been thrust. His determination to succeed was shown by the robe he wore when training, which bore a white death's head on the back. Kondō's closest friend was the man who would become a deputy commander of the Shinsengumi. Hijikata Toshizō was a year younger than Kondō and came from a similar social background. He too was committed to the art of swordsmanship, and had performed a nineteenth-century version of the musha shūgyō when he traveled the country seeking out opponents, supporting himself by selling patent medicine. The concoction cured a variety of ailments, including the bruises produced by Hijikata's bokutō![11]

The first center of operations for the Shinsengumi was the village of Mibu, to the southwest of Kyoto. Although it is now part of the city of Kyoto, Mibu still preserves a village atmosphere, and the houses associated with the Shinsengumi are lovingly preserved. Because of its size, the Mibudera temple had earlier been chosen to accommodate the rōshi army on its arrival. The Shinsengumi's headquarters were in the nearby Maekawa residence, while most of the officers lodged in the house of Yagi Gennojō, the village headman. From Mibu, the Shinsengumi members patrolled the streets of Kyoto, and were instantly recognizable by the garish uniform they chose for themselves—a light blue haori (jacket) with pointed white stripes on the sleeves. They wore headbands and carried a flag on which was inscribed the ideogram *makoto* ("sincerity"). Their appearance was equaled in drama by the severe code of conduct they drew up for themselves, violation of which was punishable by seppuku. Needless to say, many hours were given to the practice of sword fighting, including methods that went far beyond any seen in a martial arts dōjō. In order to prepare the members for the rigors of street fighting and the ever present dangers of a surprise attack, sleeping Shinsengumi members could be woken by a comrade wielding a real sword and ordered to defend themselves. It was a world of violence that the Shinsengumi began to export to the streets of Kyoto:

Every day the men would go out and cross swords with the enemy. One corpsman claimed that the blood of a man he had killed today splattered on the ridge of the adjacent house. Another said that the blood hadn't splattered beyond the white panelled wall. Still another boasted that the blood of the man he had cut down had reached the roof of the house.[12]

While the Shinsengumi carried out their savage armed patrols on the streets of Kyoto, the remorseless trend of Japanese politics continued elsewhere in the imperial capital. In this context it was to the advantage of the shogun's supporters that the two leading players in the anti-bakufu, antiforeign movement were suspicious of each other and jealous of each other's position. These factions were the han of Satsuma and Chōshū. Satsuma was the han of the Shimazu family at the southern tip of Kyūshū. Chōshū, at the western end of Honshū, was by far the more militant, and put pressure on the shogun to set a definite date for the expulsion of the foreigners. If the shogun would not expel the barbarians, then the emperor himself should lead his troops. The attitude being shown by Chōshū, which held the dominant position in Kyoto, greatly alarmed other han. Many shared their views about foreigners, but feared that Chōshū's belligerence would lead to disaster. Further vacillation by the shogun prompted a new round of terror, but because of the reputation of the Shinsengumi, any newly arrived shishi chose to base themselves in Osaka rather than Kyoto. The Shinsengumi were consequently ordered to patrol Osaka as well, so their influence spread that much farther.

This prominent sword cut in a lintel in the Yagi house was made during the assassination of Serizawa Kamo, one of the Shinsengumi leaders.

The Protector of Kyoto, Matsudaira Katamori of Aizu, was a key figure in these events, and in the autumn of 1863, he joined the other influential han of Satsuma in carrying out a coup against Chōshū. Heavily armed Aizu and Satsuma troops, including men of the Shinsengumi, seized the gates of the imperial palace and banished the Chōshū representatives. Chōshū's influence at court was greatly curtailed following this incident, and the confusion surrounding the anti-Chōshū coup also provided the opportunity for a little bloodletting within the ranks of the Shinsengumi. Serizawa Kamo had disturbed his colleagues by his quick temper and his blood-thirsty behavior, which went far beyond the severe ruthlessness that the Shinsengumi demanded. Eventually a report was issued to the Protector of Kyoto stating that Serizawa and his closest comrades had been murdered in their sleep at the Yagi house by unknown assassins.[13] Their funeral was a splendid affair attended by all the Shinsengumi members— including Kondo Isami and the other four men who had killed them. The Protector of Kyoto was nonetheless pleased with the service rendered by his loyal Shinsengumi, and in October 1863, they received the honor of being raised to the rank of *hatamoto*—direct retainers of the Shogun—an ancient term that had first referred to their position literally "under the standard" on a medieval battlefield.

Their Finest Hour

The greatest moment in the service to the shogun rendered by the Shinsengumi was about to come, and concerned the aggrieved han of Chōshū. Chōshū's plans to hit back at the shogun and his allies who had humiliated them were of a dramatic nature, reminiscent of the Gempei Wars. Chōshū samurai would return to Kyoto, set fire to the imperial palace and kidnap the emperor. The Protector of Kyoto would rush to the scene, and in the confusion he and his allies would be cut down. By then safely ensconced in Chōshū, the emperor would issue an imperial decree to attack the shogunate, and the daimyō of Chōshū would be his right-hand man. That these plans were frustrated was largely due to the efforts of the swords and spies of the Shinsengumi.

Ever since the coup against Chōshū, rumors had circulated within Kyoto that among the shishi who continued to take "heaven's revenge," in spite of the Shinsengumi, there lurked plotters from Chōshū who were planning something far more serious than the assassination of individuals. At the end of May 1864, the Shinsengumi learned that some Chōshū samurai and rōnin had been meeting at the Ikedaya, an inn located close to the imperial palace. They already knew that a man called Furudaka Shuntarō, who lived in a nearby shop called the Masuya, had sheltered loyalists. Undercover work revealed that a very important loyalist called Miyabe Teizō was currently living there, and although a raid by the Shinsengumi failed to find him, a cache of weapons and documents was found there that confirmed the rumors concerning the intentions of the Chōshū plot. Furudaka Shuntarō was taken back to the Maekawa house in Mibu and tortured while being hung upside down from a rope in the storehouse.[14]

The arrest of Furudaka alarmed the Chōshū plotters. None dared speculate how much their landlord might divulge of their plans, but the methods of the Shinsengumi for extracting information were well known. Some were for abandoning their plans and fleeing from Kyoto. Others proposed a raid on the Shinsengumi headquarters in Mibu to rescue Furudaka, but the Shinsengumi acted first. While the plotters were gathering at the Ikedaya, groups of Shinsengumi men were raiding inns and lodging houses, and ten of their finest swordsmen, including their commander, Kondō Isami, headed for the Ikedaya. Upon entering, Kondō and three others ran up the rear stairs, while the six other members stood guard. They found twenty men in the upstairs room, one of whom drew his sword and killed one of the intruders—the only Shinsengumi man to perish in the raid. Kondō wisely retreated downstairs and waited for the plotters to follow him. By this time, Hijikata Toshizō had arrived with reinforcements, and one of the fiercest sword battles of the Tokugawa period began. Nagakura Shinpachi, whose memoirs were to provide a valuable primary source for the Shinsengumi, describes how he followed the example of his leader, Kondō Isami. He first finished off one man who had been stabbed with a spear, and as another man fled, Nagakura delivered a blow so furious that it cut him cleanly in two from one shoulder to the opposite side. More pro-bakufu samurai arrived. Nagakura blocked an attack to his wrist and immediately delivered a counter stroke that cut his assailant from the left side of his face to his neck. One of the plotters fell through the ceiling and was swiftly dispatched. Kondō Isami later wrote:

> We fought against a large number of rebels. The sparks flew. After we had fought for a couple of hours Nagakura's sword had been broken in two, Okita's sword had been broken off at the tip, the blade of Tōdō's sword had been cut up like a bamboo whisk. . . . My sword, perhaps because it is the prize sword Kotetsu, was unscathed. . . . Although I have been in frequent battles . . . our opponents were many and all courageous fighters, so that I nearly lost my life.[15]

Miyabe Teizō, the leader of the plot, committed seppuku at the foot of the stairs, rather than be taken alive. Elated by their victory, the Shinsengumi marched back to Mibu watched by crowds of onlookers, who gasped when the victorious samurai brandished their broken swords. The horrific scene they had left behind at the Ikedaya was later described by Nagakura Shinpachi as follows:

> Not one of the paper screens was left intact, all of them having been smashed to pieces. The wooden boards of

the ceiling were also torn apart when men who had been hiding under the floorboards were stabbed with spears from below. The tatami mats in a number of rooms, both upstairs and downstairs, were spotted with fresh blood. Particularly pitiful were arms and feet, and pieces of facial skin with the hair still attached scattered about.[16]

News of the Ikedaya incident reached the Chōshū han four days later and provoked outrage. By the end of June, some two thousand Chōshū troops were in Kyoto to demand justice and the arrest of those responsible for the Ikedaya massacre. Should the Shogun not comply, they would carry out to the letter the intentions of the plotters and take the imperial palace by force. The response was negative, so the Chōshū men attacked. The ensuing battle involved Satsuma samurai firing artillery against the outnumbered Chōshū men, and the swordsmen of the Shinsengumi had no chance to participate.

Humiliated for a second time, Chōshū became more militant and more fanatic than ever. Realizing that the shogun had no intention of expelling the foreigners, this most antiforeign han took matters into its own hands, and foreign ships were fired on as they passed through the Shimonoseki Strait. As the bakufu gleefully expected, this provoked a massive counterbombardment from a joint fleet of Great Britain, France, Holland, and the United States. Within a day, the Chōshū forts had been demolished and their troops defeated by foreign landing parties who were doing the shogun's work so well for him.

It seemed to the bakufu that the time had come to march against Chōshū, and 150,000 samurai were poised at its borders by early 1865, ready to attack. But Chōshū's military affairs were now in fresh hands. A young samurai called Takasugi Shinsaku had created Japan's first modern militia, which he called the Kiheitai ("extraordinary corps").[17] It was extraordinary because, like the Shinsengumi, it drew its recruits from outside the samurai class, a remarkable development for such a traditional samurai han. Sakamoto Ryōma, a loyalist activist from the Tosa han on Shikoku island who was sympathetic to Chōshū, described how the Kiheitai battalions had regular daily drill, and reported that "there was nothing like it anywhere else in Japan."[18] Similar reports were forwarded to the shogun by Kondō Isami of the Shinsengumi, who bravely traveled to Hagi, the center of Chōshū's resistance, to gain intelligence. But what Kondō did not know was that Sakamoto Ryōma had been in negotiations with Satsuma's leader, Saigō Takamori, to support Chōshū and supply its army with modern weapons obtained from foreign traders in Nagasaki. This was the beginning of an important alliance between Satsuma and Chōshō that would change the map of Japanese politics.

Sakamoto Ryōma, who is now regarded as one of the founding fathers of the Meiji Restoration, suffered an attempt on his life by a bakufu murder squad in 1866. His assailants were not from the Shinsengumi, although any of them would have wished him dead and might have completed the task more successfully. As it was, Ryōma and his friend Miyoshi Shinzō were going to bed in an inn called the Teradaya in Fushimi, near Kyoto, when they thought they heard footsteps and the rattle of bō. At that point, a maid raced upstairs and warned them that men with spears were coming to get them. The comrades pulled on their hakama trousers, seized their swords, and crouched down in a corner of the room to meet the attack. Twenty or so samurai were ascending the stairs and moving into an adjoining room. As they entered the room where the two shishi were concealed, Sakamoto Ryōma brandished his revolver, at which the leaders withdrew, but others came against them and soon the fight grew fast and furious. One samurai leapt at Sakamoto out of the darkness and cut his left hand, but, making good use of the six shots in the pistol and their sharp swords, the two managed to drive them temporarily out of the room. Sakamoto tried to reload his pistol, but the wound on his hand made it difficult, and all the while the enemy were to be heard outside. As he fumbled in the dark, Sakamoto dropped the bullet chamber and could not find it. His companion was all for rushing into the midst of the enemy in good old samurai style, but Sakamoto suggested they look for a way out. Fortunately, the rear of the building was unguarded, so the two companions slipped down a ladder into the rear courtyard.

As the courtyard was enclosed, there was no direct way out except through one of the buildings that surrounded it. All the shutters of the house next to them were locked, so the only way of escape was literally to bash their way through the entire house. This they proceeded to do with gusto. After smashing through the outer wooden shutters, they found themselves in a bedroom, occupied by several rather startled inhabitants. Believing that the shortest distance between two points was a straight line, the two shishi drew their swords and headed for the open street, cutting through each shoji (sliding screen) as they came to it. The house proved to be rather large, so by the time they had made it out into the street, Sakamoto and his comrade had cut and kicked their way through several rooms, leaving a series of irregular holes behind them.[19]

The Last Days of the Shogun
Sakamoto Ryōma survived the Teradaya raid, and the alliance between Satsuma and Chōshū against the Tokugawa shogunate, brokered by him and sealed in 1866, proved to be a vital turning point in the continuing

Takasugi Shinsaku from Chōshū created Japan's first modern militia, which he called the Kiheitai (the extraordinary corps). It drew its recruits from outside the samurai class, a remarkable development for such a traditional samurai *han*. Even so, he was content to be photographed in full samurai costume.

struggle. It heralded the end of the age of the shoguns, and, on a much smaller scale, also that of their servants, the Shinsengumi. The former event happened on November 8, 1867, when the fifteenth and last Tokugawa shogun announced his abdication and the restoration of rule to the emperor. A previous chapter has covered the momentous events of the Meiji Restoration as the shogun was pursued to Edo. Here we will examine this pivotal moment in Japanese history at a micro level, with the final years of the shishi and the swordsmen of the Shinsengumi who had been appointed to exterminate them.

Not surprisingly, the members of the Shinsengumi received the news of the shogun's abdication with a mixture of fear, outrage, and a feeling of betrayal. Sakamoto Ryōma was more of a marked man than ever, and when he arrived in Kyoto on November 30, 1867, to work out the plans for the new government, he knew that his life was in danger. By now the Shinsengumi had been joined

The death of Sakamoto Ryōma.

with the two Shinsengumi men who were guarding him.[21]

The work that Sakamoto Ryōma had done during his short life was soon to make the Shinsengumi redundant. Once the shogun had resigned, there was no need for the post of Protector of Kyoto, nor was there any desire on the part of the newly dominant Satsuma and Chōshū faction to retain the services of the hated Shinsengumi. There were also scores to settle, and during the turbulent days that followed, Kondō Isami was ambushed and shot with a bullet through his shoulder. It was a bad wound, and it kept him away from the defeat of the Tokugawa army at Toba-Fushimi in January 1868. In his place, his longstanding comrade Hijikata Toshizō led the Shinsengumi against the artillery fire of the Satsuma forces. It was the first time these expert swordsmen had been subjected to cannon fire, and they responded with a brave but futile charge with drawn swords, during which thirty Shinsengumi members were killed. The survivors were evacuated via Osaka, where they picked up their convalescing commander, Kondō Isami, and traveled by ship to Edo. Their fighting spirit was remarkably undiminished, although Hijikata Toshizō was forced to acknowledge that "Swords and spears will no longer be of use in battle. They are simply no match for guns." But with a pragmatism that echoed the adoption of modern weapons by their enemies, he ordered a consignment of state-of-the-art breechloading rifles for Japan's most famous swordfighters.[22]

For Kondō and Hijikata, Edo now became a dream world where their beloved shogun still reigned. They accepted honors and high ranks from him, even though the titles were now meaningless, and planned a counterattack against the advancing imperial forces. They greatly mistrusted the new leader of the Tokugawa army, Katsu Kaishū, who they believed had sold out to the imperialists, and they felt that they had to deceive their own side in order to make their plans work, or at the very least to get them approved. They informed Kaishū that they would journey to Kōfu Castle and meet the advancing imperial army, with whom they would negotiate a peaceful settlement. What they actually intended was to take over the strategic fortress and set themselves up as neo-daimyō—a measure of how unrealistic any of their schemes were. Katsu Kaishū granted them weapons and promised reinforcements for their dangerous "peace mission," but the extra men never materialized. This delayed their departure, and their journey to Kōfu was further hindered by the fact that the route to Kōfu lay through Kondō's hometown, where he and his men were treated like conquering heroes. This allowed time for the imperial army to capture Kōfu, and when this was revealed, numerous members of

by another similar organization: the Mimawarigumi, which had an identical role but was composed of the younger sons of senior Tokugawa retainers.

Ryōma had made his headquarters in an upper room of the Omiya, the shop of a soy sauce merchant on Kawaramachi (Kawara Street), in Kyoto. It had exits that permitted a rapid escape. On the evening of December 10, he was there with Nakaoka Shintarō, a fellow samurai from the Tosa han, and this time there was no friendly maid to warn them of the approach of assassins. Neither of the pair had a chance to unsheathe his sword. Ryōma was killed almost instantly, but Shintarō survived just long enough to tell his colleague Tanaka Kōken what had happened, when he arrived shortly afterwards.[20]

Sakamoto Ryōma's colleagues didn't wait for proof that his murder was the work of the Shinsengumi. They were thirsting for revenge and, on the slenderest of circumstantial evidence, carried out a night raid of their own against Miura Kyūtarō of Kii Province, who they believed had instigated the assassination. They cut him down along

Sakamoto Ryōma, posing for a photograph and dressed like the samurai swordsman that he was. Ryōma was one of the great influences on the Meiji Restoration.

This exhibit in the Sakamato Ryōma History Museum—a wax diorama of the assassination of Ryōma—points the finger of suspicion directly at the Shinsengumi, because the intruders are all dressed in the Shinsengumi uniform of blue jacket with black and white sleeves.

the Shinsengumi, who had only recently joined the famous corps in their enthusiasm, deserted Kondō. While Hijikata hurried back to Edo to obtain reinforcements, Kondō, with 121 men, faced an imperial army of 1,200 from behind makeshift fortifications at Katsunuma. After two hours of fighting, the Shinsengumi scattered.

When Katsu Kaishū heard of the deception, he was furious. An imperial army was now advancing on Edo, so Katsu Kaishū placed a genuine peace mission in the hands of someone he could trust: the veteran sensei Yamaoka Tesshū, whose subsequent meeting with Saigō Takamori saved the city from destruction. But Kondō Isami still would not be muzzled, although his pride forbade him to go to Aizu, where the Tokugawa remnant was rallying, because there he would have been treated merely as an equal. Instead, he recruited more men to the Shinsengumi banner, and set up his own training headquarters in the village of Nagareyama, in Shimōsa Province, from which

he intended to lead a rejuvenated army of his own to Aizu. In Nagareyama, the imperial troops finally caught up with him. He was completely unprepared, and his new recruits threw down their weapons and fled, leaving the imperialists free for the unexpected honor of capturing the hated Kondō Isami alive. Kondō had, however, adopted an alias, and denied that he was the man that the imperial army was seeking. But when he was being taken off for questioning, a former Shisengumi man identified him, and Kondō finally realized that he faced death by an executioner's sword rather than his own. Worse, he was put on trial, found guilty, and sentenced to death.

After Kondō's arrest, most of the Shinsengumi men headed for the enclave of Aizu, while Hijikata Toshizō faced an imperial attack at Utsunomiya Castle. It was a melodramatic scenario that Kondō would greatly have preferred to his own incarceration. During the course of the fighting, Hijikata cut down one of his own men who attempted to

Nagaoka Shintarō, a loyalist activist from Tosa, who was killed alongside Sakamoto Ryōma.

flee, and then took a bullet in his shoulder. He was carried from the battlefield as a wounded hero. The following day, April 25, 1868, his former commander, Kondō Isami, suffered an ignominious escort to the scaffold, where his head was struck from his body.

Hijikata Toshizō, who had been present at the formation of the Shinsengumi, was destined to die in its final combat. His wound prevented him from assisting in the futile defense of Aizu-Wakamatsu, and when the castle fell, he fled to Sendai. But when Sendai pledged allegiance to the Meiji government, Hijikata, who now commanded the entire pro-Tokugawa army of 2,300 men, including his Shinsengumi, was driven off the edge of Honshū to the remote northern island of Hokkaidō, which was then called Ezo. Their destination was Japan's most modern castle—the pentagonal bastion of Goryōkaku, near Hakodate, built in imitation of Vauban's fortress at Lille, at a time when the Tokugawa government had expected to use it to resist foreign invasion. The fortress was officially in the hands of the new Meiji government, but Hijikata's army easily defeated them,

and in December 1868 they set up a Tokugawa "government in exile" on Hokkaidō, which they called the Ezo Republic.

The nemesis of the Ezo Republic, along with that of the last of the Shinsengumi, came in the shape of a formidable ironclad battleship called *Stonewall Jackson,* which the bakufu had ordered from America. It had lain at anchor off Yokohama until the foreign powers were satisfied that the new Meiji regime was the appropriate customer. The stage was then set for the most bizarre display of the art of the samurai swordsman in the whole of Japanese history, as Hijikata Toshizō prepared to capture a battleship.

The plan was that three warships belonging to the Republic of Ezo would surround the *Stonewall Jackson,* and Hijikata Toshizō would lead a boarding party on to the battleship. Their swords would make short shrift of the crew before they had a chance to defend themselves. The prize would then be taken to Hakodate. But things went very wrong. First, only one of the three warships, the *Kaiten,* made it out to the enemy fleet, because the other two suffered mechanical failures. Unfortunately, the *Kaiten* was a paddle ship, so could not get alongside the *Stonewall Jackson* and had to attack it bow-first. The first attempt failed, and this gave ample warning of their intentions to the enemy crew, who were able to bring firearms to bear on the swordsmen. As the *Kaiten*'s bow was ten feet higher than the deck of the *Stonewall Jackson,* boarding was almost impossible, although a large number of determined samurai, including many from the Shinsengumi, managed to get on board. They were mown down by gunfire, and as the *Kaiten* withdrew, the *Stonewall Jackson* sailed on at the head of the imperial navy, ready to land troops on Hokkaidō. The last stand of the Shinsengumi took place at Hakodate, where Hijikata Toshizō led sword charges against the besiegers' camp. With the city surrounded on all sides, Hijikata left the Goryōkaku fortress after composing a farewell poem, and was shot dead while on horseback as he led his troops into battle like a samurai of old.

The Divine Wind

From the above, it may be thought that the fall of Goryōkaku in 1869 marked the end of any swordsman-like opposition to the conscript armies of modern Japan. But this was not the case. Both the spirit and the technique that had sustained the last leader of the Shinsengumi to his last stand in the snow were echoed by another stand at the opposite end of Japan. It would therefore be wrong to conclude this chapter with anyone other than the reactionaries of the Meiji period, whose rebellions scarred the face of Meiji Japan, but whose use of bugei, often in preference to Western weaponry, makes their anachronistic efforts memorable.

The triumph of the modern methods of the Meiji government led to the abolition of the samurai class. The fine details of the reforms included symbolic gestures, such as the abolition of the samurai's pigtail, but one of the main reforms that spurred the reactionary groups to action was the government's ban on the wearing of swords by anyone but the armed forces. This was doubly insulting to the samurai class, because the new army had been formed by conscription from among all classes. The probable reaction to such a ban was anticipated by Lord Redesdale in his *Tales of Old Japan*:

> The statesman who shall enact a law forbidding the carrying of this deadly weapon will indeed have deserved well of his country; but it will be a difficult task to undertake, and a dangerous one. I would not give much for that man's life. The hand of every swashbuckler in the country would be against him.[23]

The sentiments of Lord Redesdale's lavish prose were in fact reflected by a petition presented by a Kyūshū samurai to the government in protest against the act. His comments make the reaction to a ban on swords sound somewhat like the opposition to gun control in the U.S.A., but on a much more spiritual level. The bearing of swords, like guns, is seen as a civil right and a valuable safeguard for law and order. The novelist Yukio Mishima quotes it in his novel *Homba* (Runaway Horses), and its reference to ancient times provides an interesting link with the early swords and sword bearers of Japan:

> In my view the bearing of swords is a custom that characterised our land even in the ancient era of the gods and Emperor Jimmu. It is closely bound up with the origins of our country, it enhances the dignity of the imperial throne, solemnizes the rites of our gods, banishes the spirits of evil, and puts down disorders. The sword, therefore, not only maintains the tranquillity of the nation but also guards the safety of the individual citizen. Indeed the one thing essential to this martial nation that reveres the gods, the one thing that can never be set aside even for one moment, is the sword. How then, could those upon whom is laid the burden of fashioning and executing a national policy that honours the gods and strengthens our land be so forgetful of the sword?

This sentiment was widely echoed, and one of the most dramatic reactions was a rebellion that occurred in the town of Kumamoto, where two hundred former samurai, enraged at what they saw as the government's abandonment of Japanese traditions for Western decadence, formed a league

Hijikata Toshizō, the last of the Shinsengumi, who was killed defending the last bastion of pro-Tokugawa resistance, in 1869.

which they called the *kami kaze*, thus identifying themselves with the tempest that sank the Mongol fleet in the thirteenth century. They had very extreme views, and bizarre ways of expressing them. For instance, they regarded all Western innovations, such as telegraph wires, as defilements of their sacred lands, and felt obliged to walk under wires with their heads covered by white paper fans. If they so much as glimpsed someone wearing Western clothes they would purify themselves by scattering salt.

In an attempt to act unsullied by the decadent Western technology, they refused to carry guns or other Western weapons, and launched themselves in an attack on the imperial garrison of Kumamoto using only swords. In the words of a Western commentator, their army of 170 men "dressed in beetle-headed helmets and old armor made of steel and paper laced with silk, and armed with spears and swords," carried out a night raid on the castle. More than three hundred imperial troops were massacred in their beds by samurai swords. The insurgents then retired to the hills, and finding that there was no likelihood of a general uprising to support them,

eighty-four of their number committed seppuku. The rest fought the imperial troops who had pursued them, and either surrendered or were killed. Mishima tries to explain their actions in *Homba*:

What the men of the League had been willing to risk by renouncing their use of firearms had clarified their intent. Divine aid was to be theirs, and their very purpose was to challenge the Western arms hateful to the gods, by swords alone. Western civilisation would as time went by search out weapons still more terrible and would direct them at Japan. . . . To rise to the combat bearing only the sword, to be willing to risk even more crushing defeat, in this way could the fervent aspirations of each man of the League take expression. Here was the essence of the gallant Yamato spirit.

The Satsuma Rebellion

The fighters of the better-known Satsuma Rebellion, which took place in the same general area of Japan in 1877, did not scorn Western style weapons. They still claimed the Yamato spirit, and saw themselves as vastly superior to the "conscripted peasants" of the newly formed imperial army in training, motivation, and above all in the sincerity of their cause. But the most extraordinary feature of the Satsuma Rebellion was that it was led by a senior and respected government figure who had been one of the architects of the Meiji Restoration.[24]

Frustrated by the Western-style reformers who did not appear to be leading Japan in the directions he sought, Saigō Takamori withdrew from the government in October 1873 and retired to his native Satsuma, in Kagoshima Province. There he busied himself setting up a series of organizations that bore the somewhat euphemistic title of "Private Schools." The curriculum of these institutions, of which 120 were established in the province, revealed that they were effectively military academies to train a Satsuma-led private army. Candidates seeking admission to these schools were required to agree to an oath similar to that of the Shinsengumi, that they would be faithful unto death, and then seal it with their own blood. Not surprisingly, the Meiji government in Tokyo became alarmed by these developments. Also, as the Satsuma clan had been instrumental in establishing the Meiji regime in the first place, a large quantity of arms and ammunition was located in Kagoshima. This had, of course, been officially imperial property since 1871, but with the growth of the Private Schools, the Tokyo authorities decided to transfer the entire contents of the Kagoshima arsenal to Osaka, where they could more easily keep an eye on it. In a secret night operation on January 30, 1877, a ship was sent to collect the equipment. Their arrival was discovered, and the ship's crew found themselves attacked by more than a thousand Satsuma warriors. The government officials fled empty-handed, and the Satsuma samurai seized the imperial arsenal for their own.

Saigō Takamori had been absent from Kagoshima on a hunting trip when the incident happened, but returned immediately to find the province in turmoil and rumors circulating about a government conspiracy to have him assassinated. Fears were also expressed of direct military intervention from Tokyo, so on February 13, 1877, the Satsuma soldiers from the Private Schools were organized into tactical units. Satsuma now had its own army in reality. A European correspondent wrote:

Saigō's men were but partly armed with rifles. Most of them were equipped with the keen double handed swords of feudal times and with daggers and spears. It seemed to be their opinion that patrician samurai could rush into close quarters with the common people and easily rout them—granting even that they were armed with rifles and bayonets. And it was reported that the astute Saigō ordered his soldiers not to kill the poor plebes in the government ranks, but rather to slash them well about the legs so as to disable them and render it necessary for each man thus wounded to be borne off the field by two able-bodied comrades—thus depriving the opposing ranks of three soldiers instead of one.

This passage is undoubtedly a dramatic exaggeration. Saigō Takamori was not such an extreme conservative as to believe that samurai swords and bravery were all that a modern army needed. The sword was indeed the universal weapon, but in addition they carried Snider and Enfield rifles, some carbines and pistols, and enough ammunition for about a hundred rounds per man. The training in the Private Schools had also included artillery and engineering techniques from the West.

In order to make any military progress, Saigō Takamori was faced with having to overcome the imperial garrison at Kumamoto. He expected either that the garrison would let him pass unhindered, or that overcoming them would be an easy matter. He knew the garrison included many survivors of the bizarre suicide raid by the fanatical samurai of the Divine Wind the year before, so Saigō's first move against Kumamoto was heralded by the rather quaint action of firing "arrow letters" into the castle, calling upon the defenders to surrender. The exhortations produced no response, and in the early hours of February 22, the advance guard of the Satsuma army began their assault on Kumamoto Castle from the southeast. As the hours went by, the attack spread around the outer walls, and small-arms fire could be heard

coming from all directions. For the next two days, furious attacks were carried out on the castle ramparts. The Satsuma samurai, their ancestral swords in hand, clambered up the walls like suicide squads, to be shot down by the rifle fire from the conscript army. Many were the hand-to-hand combats that happened on the black walls of Kumamoto as fanaticism met determination, and an old loyalty was pitted against a new version of samurai honor. But the men of Meiji held firm, and no foothold was gained by February 24, at which point Saigō regrouped and withdrew two thousand out of his original attacking force of five thousand, to move north to face the imperial reinforcements that he knew would be on their way.

The siege then developed into a war of attrition, with casualties mounting on both sides of Kumamoto's walls. Saigō was now forced to fight on three fronts, against the castle, against the imperial troops in the south, and soon against a huge reinforcement that moved down from the north. To add to the infantry attacks along the walls, Saigō established artillery positions on the hills around the castle, from which a bombardment began, while from within the garrison brave attempts were made to contact units outside.

By mid-April, the pressure from the imperial army was beginning to tell, but Saigō's excellent generalship prevented them from relieving the castle. Meanwhile, the advance from the south continued like the sweep from the hand of a clock. The orders were to stand firm as soon as they had secured positions on the north bank of the Midori River. Kumamoto might not have been relieved for some time, had it not been for a certain Lieutenant Colonel Yamakawa, whose subsequent conduct reminded the rest of the imperial army that the spirit of the samurai was not quite dead among the imperial troops. Instead of halting, he continued his advance, and at about 4:00 P.M. he broke through and appeared in front of the gate to relieve the castle on his own.

The relief of Kumamoto Castle was the turning point in the Satsuma Rebellion. The imperial troops now had little to fear from Saigō's army, and between April and September of 1877, the course of the action dwindled to a series of pursuits and dispersals across southern Kyōshū. The government troops concentrated their efforts on taking Kagoshima, which Saigō had been forced to leave poorly defended. Even though many of Saigō's men were defeated at other engagements, he, together with a now pitifully small number of followers, managed to break through the government cordon and enter Kagoshima. Together with only a few hundred men, Saigō took up a position on Shiroyama, the site of the former castle of the mighty Shimazu daimyō at the center of the city. Thirty thousand government troops slowly closed in on him. By all accounts, Saigō Takamori had already made up his mind either to be killed in battle or to die at his own

hand. The night before the final assault he behaved like the samurai of old, listening to the music of the Satsuma lute, performing an ancient sword dance, and composing poetry:

> If I were a drop of dew
> I could take shelter on a leaf tip
> But, being a man
> I have no place in this whole world

He then exchanged cups of sake with his chief officers, and prepared for the attack by the government forces that began at four o'clock the following morning. Saigō and his followers moved down the hill under intense enemy fire. Soon he was hit in the groin by a bullet and could no longer walk. His follower Beppu Shinsuke lifted him up and carried him down the mountain until they came to a place that Saigō regarded as suitable for seppuku. It was the gate of a former mansion of the Shimazu. Saigō bowed in the direction of the imperial palace and then cut himself open. Beppu Shinsuke acted as his second, and, as soon as Saigō's head was safely disposed of, he charged down the hill and was mown down by gunfire.

With the passing of Saigō Takamori, the final act of organized military resistance to the reforms of the Meiji government came to its conclusion. It was also the final war of the samurai swordsmen. Japan's last samurai army had been pitted against a force of conscripted farmers, and had failed. The human cost of the lesson was enormous. More than sixty thousand imperial troops fought in the Satsuma Rebellion and suffered seven thousand deaths and nine thousand wounded. Of the total rebel strength of thirty thousand, only a handful survived. The symbolic effect of the defeat was every bit as dramatic. The Western correspondent quoted above had watched the imperial force leave Tokyo, and had written:

Someone said that the *heimin*, or common people, comprising a large part of the imperial forces, would never be able to face the samurai of Satsuma—that one samurai would put five heimin to flight, and as the troops marched through Tokyo on their way south they were the receipt of pitying comments that they were but so much meat for Saigō's swords.

That such comments were proved so wrong was the epitaph for the samurai class. The belief that only samurai could fight had been finally and dramatically laid to rest around the walls of Kumamoto Castle, and the death of Saigō at Shiroyama was but the confirmation of it. Like Prince Yamato, this final example of the lone warrior died a lonely death in the true spirit of the samurai swordsman.

NOTES

Chapter 1

1 Ryusaku Tsunoda et al., *Sources of Japanese Tradition*, vol. 1 (New York: Columbia University Press, 1964), 25.
2 Tsunoda et al., *Sources*, 30.
3 Ivan Morris, *The Nobility of Failure: Tragic Heroes in the History of Japan* (London: Holt, Rinehart and Winston, 1975), 4.
4 Morris, *Nobility*, 5.
5 Morris, *Nobility*, 6.
6 A. L. Sadler, "*Heike Monogatari.*" *Transactions of the Asiatic Society of Japan* 46 (1918), 49 (1921).
7 Karl F. Friday, *Hired Swords: The Rise of Private Warrior Power in Early Japan* (Palo Alto, California: Stanford University Press, 1992), 47.
8 Karl F. Friday, *Samurai, Warfare and the State in Early Medieval Japan* (New York: Routledge, 2004), 36.
9 Wayne W. Farris, *Heavenly Warriors: The Evolution of Japan's Military, 500–1300* (Cambridge, Massachusetts: Harvard University East Asia Center, 1992).
10 William R. Wilson, "The Way of the Bow and Arrow. The Japanese Warrior in *Konjaku Monogatari*," *Monumenta Nipponica* 28 (1973): 177–233.
11 Paul Varley, *Warriors of Japan As Portrayed in the War Tales* (Honolulu: University of Hawaii Press, 1994).
12 Judith Rabinovitch, *Shōmonki: The Story of Masakado's Rebellion* (Tokyo, 1986).
13 Wilson, "The Way of the Bow and Arrow."
14 William R. Wilson, *Hōgen Monogatari: Tale of the Disorder in Hōgen* (Tokyo, 1971) is much better than the earlier translation by Edward Kellogg "Selective Translation of *Hōgen Monogatari*," *Transactions of the Asiatic Society of Japan* 45 (1917).
15 Friday, *Samurai, Warfare and the State*, 15.
16 Ian Bottomley and Jock Hopson, *Arms and Armour of the Samurai* (London, 1988).
17 Wilson, "The Way of the Bow and Arrow," 198.
18 Sadler, *Heike Monogatari* (1921): 236.
19 Wilson, *Hōgen Monogatari*, 37.
20 Wilson, *Hōgen Monogatari*, 39.
21 Wilson, *Hōgen Monogatari*, 106.
22 Friday, *Samurai, Warfare and the State*, 146–149.
23 Friday, *Samurai, Warfare and the State*, 146.
24 Sadler, *Heike Monogatari* (1921): 29.
25 Wilson, *Hōgen Monogatari*, 27.
26 Wilson, "The Way of the Bow and Arrow," 208.
27 Minoru Shinoda, *The Founding of the Kamakura Shogunate 1180–1185, with Selected Translations from the Azuma Kagami* (New York, 1960), 209–210.
28 Friday, *Samurai, Warfare and the State*, 78–80.
29 Friday, *Samurai, Warfare and the State*, 81.
30 Sadler, *Heike Monogatari* (1921): 237.
31 Sadler, *Heike Monogatari* (1921): 237.
32 Sadler, *Heike Monogatari* (1921): 238.
33 Wilson, "The Way of the Bow and Arrow," 187–188.
34 Sadler, *Heike Monogatari* (1921): 143.
35 Sadler, *Heike Monogatari* (1921): 35.
36 Sadler, *Heike Monogatari* (1921): 92.
37 Shinoda, *The Founding of the Kamakura Shogunate 1180–1185*, 169–170.
38 Shinoda, *The Founding of the Kamakura Shogunate 1180–1185*, 162.
39 Sadler, *Heike Monogatari* (1921): 194
40 *Ishiyamadera engi emaki*, Ishiyamadera, 1996, 12.
41 Sadler, *Heike Monogatari* (1918): 195.
42 Sadler, *Heike Monogatari* (1921): 34.
43 William H. McCullough, "*Shōkyūki*: An Account of the *Shōkyū* War of 1221," *Monumenta Nipponica*:186–221.
44 Sadler, *Heike Monogatari* (1921): 154.
45 Sadler, *Heike Monogatari* (1921): 151–152.
46 Sadler, *Heike Monogatari* (1921): 153.
47 McCullough, "*Shōkyūki*," 197–198.

Chapter 2

1 Benjamin H. Hazard, "The Formative Years of the Wakō, 1223–63," *Monumenta Nipponica* 22 (1967): 260–277; Benjamin H. Hazard, "Japanese Marauding in Medieval Korea: The Wakō Impact on Late Koryō (PhD diss., Berkeley), 1967).

2 William A. Henthorn, *Korea, the Mongol Invasions* (Leiden: E. J. Brill, 1963).

3 Hazard, "The Formative Years of the Wakō, 1223–63," 260.

4 Hazard, "The Formative Years of the Wakō, 1223–63," 262.

5 Benjamin J. Hazard, "Wakō," *Encyclopaedia of Japan* 8:220–221.

6 Joshua A. Fogel, ed., *Sagacious Monks and Bloodthirsty Warriors: Chinese Views of Japan in the Ming-Qing Period* (Norwalk, Connecticut: EastBridge, 2002), 21.

7 Fogel, *Sagacious Monks and Bloodthirsty Warriors*, 22.

8 Fogel *Sagacious Monks and Bloodthirsty Warriors*, 23.

9 Marius B. Jansen, *Warrior Rule in Japan* (Cambridge: Cambridge University Press,1995), 54.

10 S. Komatsu, *Henyō Tsushima-Iki Sakimoro Shi* (Tsushima, 2000), 93.

11 Nakaba Yamada, *Ghenkō: The Mongol Invasion of Japan* (London, 1916), 111. This work, written in English by an enthusiastic and very nationalistic Japanese scholar, is something of a period piece.

12 Karl F. Friday, *Samurai, Warfare and the State in Early Medieval Japan* (New York: Routledge, 2004), 147.

13 Yamada, *Ghenkō*, 114.

14 Large sections are reproduced in Bradley Smith, *Japan: A History of Art* (London, 1972), pages 106–121.

15 These have been extensively studied by Thomas Conlan in his fascinating book *In Little Need of Divine Intervention: Takezaki Suenaga's Scrolls of the Mongol Invasions of Japan* (Cornell University, 2001).

16 Smith, *Japan: A History of Art*, 108–109.

17 Kyotsu Hori, "The Mongol Invasions and the Kamakura Bakufu" (PhD diss., Columbia University, 1967), 121.

18 Joseph Needham, *Science and Civilisation in China, vol. 5, part 7: The Gunpowder Epic* (Cambridge, 1986), 178.

19 Needham, *Science and Civilisation in China*, 176.

20 Torao Mozai, "The Lost Fleet of Kublai Khan," *National Geographic* (November 1982), 635–649. This article includes excellent reproductions of the paintings by Issho Yada that are displayed in the Mongol Invasion Memorial Museum in Hakata.

21 Nagasaki-ken Takashima-chō Kyōiku Iinkai, *Takashima kaitei iseki VII* (Takashima, 2002); James P. Delgado, "Relics of the Kamikaze," *Archaeology* 56, no. 1 (2003): 26–42.

22 Hori, *The Mongol Invasions and the Kamakura Bakufu*, 139.

23 Jansen, *Warrior Rule in Japan*, 56.

24 Yamada, *Ghenkō*, 141. This incident appears in a bas-relief on the side of the memorial statue of Nichiren, in Hakata.

25 Fogel, *Sagacious Monks and Bloodthirsty Warriors*, 24.

26 Fogel, *Sagacious Monks and Bloodthirsty Warriors*, 33.

27 Fogel, *Sagacious Monks and Bloodthirsty Warriors*, 29.

28 Fogel, *Sagacious Monks and Bloodthirsty Warriors*, 29.

29 Fogel, *Sagacious Monks and Bloodthirsty Warriors*, 24–25.

30 Fogel, *Sagacious Monks and Bloodthirsty Warriors*, 27.

31 Fogel, *Sagacious Monks and Bloodthirsty Warriors*, 28.

32 Thomas Nelson, "Slavery in Medieval Japan" *Monumenta Nipponica* 59: 470.

33 Taneo Tanaka, "Japan's Relations with Overseas Countries," in John Whitney Hall and Toyoda Takeshi, eds., *Japan in the Muromachi Age* (Berkeley, 1958), 159–178.

34 Fogel, *Sagacious Monks and Bloodthirsty Warriors*, 28.

35 For a map of the raid, see S. Komatsu's *Henyō Tsushima-Iki Sakimoro Shi* (Tsushima, 2000), page 150.

36 Benjamin J. Hazard, "Oei Invasion" *Encyclopaedia of Japan* 5:66.

37 Tanaka, "Japan's Relations with Overseas Countries," 171.

38 Thomas D. Conlan, *State of War: The Violent Order in Fourteenth-Century Japan* (Ann Arbor, Michigan: Center for Japanese Studies, University of Michigan, 2003), 60.

39 Friday, *Samurai, Warfare and the State in Early Medieval Japan*, 152.

40 Friday, *Samurai, Warfare and the State in Early Medieval Japan*, 153.

41 Helen Craig McCullough, trans., *The Taiheiki: a Chronicle of Medieval Japan* (New York, 1959), 214.

42 Smith, *Japan: A History of Art*, 121.

43 Conlan, *State of War*, 21.

44 Conlan, *State of War*, 23

45 Conlan, *State of War*, 59.

46 Andrew Goble, "War and Injury: The Emergence of Wound Medicine in Medieval Japan," *Monumenta Nipponica* 60 (2005): 297–338.

47 Conlan, *State of War*, 70.

48 Yoshihiko Sasama, *Buke Senjin Sahō Shūsei* (Tokyo, 1968), 153.

49 Conlan, *State of War*, 71.

Chapter 3

1 Roald M. Knutsen, *Japanese Polearms* (London, 1963), 162.

2 For a full account, see Stephen Turnbull's *Osaka 1615: The Last Samurai Battle* (Oxford: Osprey Publishing, 2006).

3 Thomas D. Conlan, *State of War: The Violent Order in Fourteenth-Century Japan* (Ann Arbor, Michigan: Center for Japanese Studies, University of Michigan, 2003), 60.

4 John M. Rogers, "Arts of War in Times of Peace: Swordsmanship in *Honchō Bugei Shōden* Chapter 6." *Monumenta Nipponica* 46 (1991): 198.

5 Orinosuke Momochi, *Kōsei Iran-ki*, vol. 6 (Iga-Ueno, 1897), 2.

6 Miyamoto Musashi. *The Book of Five Rings: Gorinshō*, trans. Victor Harris (London, 1974), 47–48.

7 W. M. Hawley, ed., *Heihō*

Okugishō: The Secret of High Strategy: Yamamoto Kansuke (Los Angeles, 1994), 5.

8 Hawley, ed., *Heihō Okugishō*, 106.

9 F. Honda et al., *Kobudō no hon* (Tokyo, 2002), 40–41.

10 S. Kobe, "Yamanaka Shikanosuke to Tarakai Okaminosuke Katsumori," in *Sengoku no Gunyū, Raibaru Gekitotsu Nohon shi*, vol. 3 (Tokyo, 1979), 123.

11 Published by the Zoku Gunsho Ruijū Kanseikai, *Okochi Hidemoto: Chōsenki in Zoku Gunshō Ruijū* (Tokyo, 1933), pages 281–282.

12 Related in John M. Rogers's "Arts of War in Times of Peace: Swordsmanship in *Honchō Bugei Shōden* Chapter 5," *Monumenta Nipponica* 45 (1990), pages 443–444.

Chapter 4

1 *Sengoku Kengō Den*, Rekishi Gunzō Series, vol. 68 (Tokyo, 2003).

2 For a well-illustrated guide to sword making, see Kunihira Kawachi's *Nihontō no Miryoku* (Tokyo, 2003).

3 G. Cameron Hurst, *Armed Martial Arts of Japan: Swordsmanship and Archery* (New Haven, Connecticut: Yale University Press, 1998), 37.

4 G. Cameron Hurst, *Armed Martial Arts of Japan*, 43.

5 Caryl Callahan, "Tales of Samurai Honor: Saikaku's *Buke Giri Monogatari*," *Monumenta Nipponica* 34 (1979): 12.

6 T. Harada, "Shintō-ryū 'hitotsu no tachi' no gokui," in *Kengō to Otokodate, Raibaru Gekitotsu Nihon shi*, vol. 7 (Tokyo, 1979), 36–45.

7 Hurst, *Armed Martial Arts of Japan*, 48.

8 John M. Rogers, "Arts of War in Times of Peace: Swordsmanship in *Honchō Bugei Shōden* Chapter 6," *Monumenta Nipponica* 45 (1991): 429–430.

9 Rogers, "Arts of War in Times of Peace" (1991): 442.

10 T. Harada, "Saitō Denkibō to Sakurai Kasuminosuke," in *Kengō to Otokodate, Raibaru Gekitotsu Nihon shi*, vol. 7 (Tokyo, 1979), 39.

11 S. Kunihika, "Miyamoto Musashi no Issei," in *Kengō to Otokodate, Raibaru Gekitotsu Nihon shi*, vol. 7 (Tokyo, 1979), 26–31.

12 See the excellent biography *The Lone Samurai: The Life of Miyamoto Musashi* by William Scott Wilson (Tokyo: Kodansha International, 2004).

13 Miyamoto Musashi. *The Book of Five Rings: Gorinshō*, trans. Victor Harris (London, 1974).

Chapter 5

1 G. Cameron Hurst, *Armed Martial Arts of Japan: Swordsmanship and Archery* (New Haven, Connecticut: Yale University Press, 1998), 45.

2 F. Honda et al., *Kobudō no hon* (Tokyo, 2002), 36–37.

3 Hurst, *Armed Martial Arts of Japan*, 49.

4 Honda et al., *Kobudō no hon*, 40–41.

5 Honda et al., *Kobudō no hon*, 44–45.

6 John M. Rogers, "Arts of War in Times of Peace: Swordsmanship in *Honchō Bugei Shōden* Chapter 5," *Monumenta Nipponica* 45 (1990): 435–437.

7 Y. Takeda, "Ichigeki Hitsu Satsu no Jigen-ryū Tanjō," in *Kengō to Otokodate, Raibaru Gekitotsu Nihon shi*, vol. 7 (Tokyo, 1979): 51–53.

8 Fukushima, Shoichi. "Bushido in Tokugawa Japan: A Reassessment of the Warrior Ethos" (PhD diss., Berkeley), 1984), 196.

9 Fukushima, *Bushido in Tokugawa Japan*, 197.

10 Honda et al., *Kobudō no hon*, 57.

11 Y. Takeda, "Hibana o chirasu Itō Ittōsai no kōtei futari," in *Kengō to Otokodate, Raibaru Gekitotsu Nihon shi*, vol. 7 (Tokyo, 1979): 46–49.

12 Y. Takeda, "Moroka Ippa no Aideshi, Hashiue no Kettō," in *Kengō to Otokodate, Raibaru Gekitotsu Nihon shi*, vol. 7 (Tokyo, 1979): 54–55.

13 K. Nagaoka, "Karasugawa Kahan no Kettō," in *Kengō to Otokodate, Raibaru Gekitotsu Nihon shi*, vol. 7 (Tokyo, 1979): 56–58.

Chapter 6

1 Jirōkichi Yamada, *Nihon Kendō-shi* (Tokyo, 1960), 57.

2 Kōsaka Danjō, *Koyō Gunkan*, in *Sengoku Shiryō Shosō*, series 1, vols. 3–5 (Tokyo, 1965).

3 A fascinating and highly mathematical study of the economic decline of the samurai is provided by Kozo Yamamura in *A Study of Samurai Income and Entrepreneurship: Qualitative Analyses of Economic and Social Aspects of the Samurai in Tokugawa and Meiji Japan* (Cambridge, Massachusetts: Harvard University Press, 1974).

4 Shoichi Fukushima, "Bushido in Tokugawa Japan: A Reassessment of the Warrior Ethos" (PhD diss., Berkeley), 1984), 96–97.

5 Kunihika, S, "Machi yakko to Hatamoto yakko no Gekitotsu," in *Kengō to Otokodate, Raibaru Gekitotsu Nihon shi*, vol. 7 (Tokyo, 1979): 108–110. Chōbe'e's story is also memorably recounted in English in *Tales of Old Japan*, by A. B. Mitford, Lord Redesdale (Rutland, Vermont: Charles E. Tuttle Co., 1966), pages 90–124. (First published London: Macmillan, 1871.)

6 S. Hagiwara, "Yagi Bushi ni mo utawareta Chūji no Isaburō koroshi," in *Kengō to Otokodate, Raibaru Gekitotsu Nihon shi*, vol. 7 (Tokyo, 1979: 114–117.

7 S. Inagaki, "Yōjimbō no hanashi," in *Kengō to Otokodate, Raibaru Gekitotsu Nihon shi*, vol. 7 (Tokyo, 1979): 125.

8 S. Inagaki, "Dai Tonegawa Hara no Kenka," in *Kengō to Otokodate, Raibaru Gekitotsu Nihon shi*, vol. 7 (Tokyo,

1979): 122–124. See illustrations on pages 90–91 of the same volume.

9 K. Nagaoka, "Otoko no naka no otoko, Kōjinyama ni chirasu," in *Kengō to Otokodate, Raibaru Gekitotsu Nihon shi*, vol. 7 (Tokyo, 1979): 130–131.

10 A. Kōzaki, "Machi Hikeshi to Daimyō Hikeshi no Komyō Arasoi," in *Kengō to Otokodate, Raibaru Gekitotsu Nihon shi*, vol. 7 (Tokyo, 1979): 119–121.

Chapter 7

1 H. L. Joly, *Legend in Japanese Art* (London, 1908), 330–331.

2 J. Dautremer, "The Vendetta or Legal Revenge in Japan," *Transactions of the Asiatic Society of Japan* 13 (1885): 86.

3 Dautremer, "The Vendetta," 84.

4 A. L. Sadler, *The Maker of Modern Japan: The Life of Tokugawa Ieyasu* (London: Ams Pr Inc., 1937), 387–398.

5 Dautremer, "The Vendetta," 86–87

6 Dautremer, "The Vendetta," 82–89.

7 A. B. Mitford, Lord Redesdale, *Tales of Old Japan* (Rutland, Vermont: Charles E. Tuttle Co., 1966), 70–87. First published London: Macmillan, 1871.

8 Y. Takeda, "Araki Mata'emon san jū roku nin kiri no kyojitsu," in *O-ie sōdō to katakiuchi, Raibaru Gekitotsu Nihon shi*, vol. 6 (Tokyo, 1979): 52–57.

9 A. Kōzaki, "Nijū hachinen o tsuiyashite honkai o togeru," in *O-ie sōdō to katakiuchi, Raibaru Gekitotsu Nihon shi*, vol. 6 (Tokyo, 1979): 58–60.

10 The story was first told in English in Mitford's *Tales of Old Japan*, pages 15–41. It is also covered very well in Catharina Blomberg's *The Heart of the Warrior: Origins and Religious Background of the Samurai System in Feudal Japan* (Folkestone, Kent: Japan Library/Curzon Press, 1994). The two-hundredth anniversary of the incident has spawned many articles and features. Two

very good ones in English are Henry D. Smith II's "The Capacity of Chūshingura," in *Monumenta Nipponica* 58 (2003), pages 1–37, and Bitō Masahide's "The Akō Incident 1701–1703," in *Monumenta Nipponica* 58 (2003), pages 149–169. See also James McMullen's "Confucian Perspectives on the Akō Revenge," in *Monumenta Nipponica* 58 (2003), pages 293–315.

11 Mitford, *Tales of Old Japan*, 39.

12 Mitford, *Tales of Old Japan*, 39.

13 William S. Wilson, trans., *Hagakure: The Book of the Samurai Yamamoto Tsunetomo* (Tokyo: Kodansha International,1979), 81.

14 Dautremer, "The Vendetta," 88–89.

Chapter 8

1 Inazu Nitobe, *Bushidō: The Soul of Japan* (London, 1905), 140.

2 Nitobe, *Bushidō*, 141.

3 Nitobe, *Bushidō*, 141.

4 Nitobe, *Bushidō*, 142.

5 H. L. Joly, *Legend in Japanese Art* (London, 1908), 139–140.

6 *Gempei Kassen Jimbutsuden* (Tokyo, 2005), 124–125.

7 H. Paul Varley, *Warriors of Japan as Portrayed in the War Tales* (Honolulu: University of Hawaii Press, 1994), 104.

8 A. L. Sadler, "Heike Monogatari," *Transactions of the Asiatic Society of Japan* 46 (1918) and 49 (1921): 121.

9 Sadler, "Heike Monogatari," 123.

10 Varley, *Warriors of Japan as Portrayed in the War Tales*, 104.

11 Varley, *Warriors of Japan as Portrayed in the War Tales*, 235; Joly, *Legend in Japanese Art*, 374.

12 Joyce Ackroyd, "Women in Feudal Japan," *Transactions of the Japan Society of London* (1957): 31–68.

13 Michael P. Birt, "Warring States: A Study of the Go-Hōjō

Daimyō and Domain 1491–1591" (PhD diss., Princeton University, 1983), 242.

14 *Sengoku Kyūshū Gunki*, Rekishi Gunzō Series, vol. 12 (Tokyo, 1989), 20–23.

15 Tsuneyoshi Matsuno, *Wives of the Samurai* (New York: Vantage Press, 1989), 51–54.

16 Matsuno, *Wives of the Samurai*, 54–57.

17 From a pamphlet at the reconstructed site of Sakasai.

18 Ackroyd, "'Women in Feudal Japan," 50.

19 Kuwada Tadachika, ed., *Shinchōkōki* (Tokyo, 1966), 177.

20 Yoshihiko Sasama, *Buke Senjin Sahō Shūsei* (Tokyo, 1968) 529.

21 Ivan Morris, *The Nobility of Failure: Tragic Heroes in the History of Japan* (London: Holt, Rinehart and Winston, 1975), 171.

22 Stephen Turnbull, *Japanese Fortified Temples and Monasteries* (Oxford: Osprey Publishing, 2005), 47–48.

23 K. Nagaoka, "Appare! Kōjo no kaikyō," in *O-ie sōdō to katakiuchi, Raibaru Gekitotsu Nihon shi*, vol. 6 (Tokyo, 1979): 66–69.

24 Diana E. Wright, "Female Combatants and Japan's Meiji Restoration: The Case of Aizu," *War in History* 8 (2001): 396–417.

25 Stephen Turnbull, *Samurai: The World of the Warrior* (Oxford: Osprey Publishing, 2003), 167–189.

26 Shiba Gorō, *Remembering Aizu:The Testament of Shiba Gorō* (Honolulu: University of Hawaii Press, 1999).

27 Wright, "Female Combatants and Japan's Meiji Restoration," 402.

28 Illustrated by a print in Bradley Smith's *Japan: A History in Art* (London, 1972), pages 268–269.

29 Wright, "Female Combatants and Japan's Meiji Restoration," 404, 413.

30 Wright, "Female Combatants and Japan's Meiji Restoration," 408–410.

31 Wright, "Female Combatants and Japan's Meiji Restoration," 413.

Chapter 9

1 C. R. Boxer, "Notes on Early European Military Influence in Japan (1543–1853)," *Transactions of the Asiatic Society of Japan* 8, 2nd series (1931): 68–93.

2 Antony Wild, *The East India Company: Trade and Conquest from 1600* (London, 1999), 33.

3 A. L. Sadler, *The Maker of Modern Japan: The Life of Tokugawa Ieyasu* (London: Ams Pr Inc., 1937), 387–398.

4 Shoichi Fukushima, "Bushido in Tokugawa Japan: A Reassessment of the Warrior Ethos" (PhD diss., Berkeley, 1984), 80.

5 Karl F. Friday, *Legacies of the Sword: The Kashima Shinryū and Samurai Martial Culture* (Honolulu: University of Hawaii Press, 1997), 161.

6 Friday, *Legacies of the Sword,* 8, 163.

7 The best antidote for anyone who feels he is taking the martial arts too seriously is to read the hilarious spoof by "Beholder," entitled *Fudebakudo: The Way of the Exploding Pen* (Fetcham, 2003). My favorite item must be *chabado,* the tea ceremony for horses!

8 My translation from Boxer's note in French, in C. R. Boxer's "Notes on Early European Military Influence in Japan (1543–1853)," page 87.

9 *Bakumatsu Kenshinden,* Rekishi Gunzō Series, vol. 56 (Tokyo, 1998).

10 A. Kōzaki, "Shimada Tora no suke to Inoue Gensai," in *Kengō to Otokodate, Raibaru Gekitotsu Nihon shi,* vol. 7 (Tokyo, 1979): 73.

11 A. Kōzaki, "Chiba Shōsaku to Takayanagi Matashichirō," in *Kengō to Otokodate, Raibaru Gekitotsu Nihon shi,* vol. 7 (Tokyo, 1979): 74–76.

12 A. Kōzaki, "Kensō Jitsuryoku Dai-ichininsha no Gozen Shiai," in *Kengō to Otokodate, Raibaru Gekitotsu Nihon shi,* vol. 7 (Tokyo, 1979): 78–83.

13 A. Kōzaki, "Onitetsu no musō kaiden," in *Kengō to Otokodate, Raibaru Gekitotsu Nihon shi,* vol. 7 (Tokyo, 1979): 81–83.

Chapter 10

1 Related in detail by Anne Walthall in "Off with Their Heads! The Hirata Disciples and the Ashikaga Shoguns," *Monumenta Nipponica* 50 (1995), pages 137–170.

2 Walthall, "Off with Their Heads!" 155, 158.

3 Marius B. Jansen, *Sakamoto Ryōma and the Meiji Restoration* (Palo Alto, California: Stanford University Press, 1971), 81–85.

4 Inagaki, S, "Bunkyū no Ansatsusha," in *Gekidō no Bakumatsu Ishin, Raibaru Gekitotsu Nihon shi,* vol. 5 (Tokyo, 1979), 42.

5 *Bakumatsu Ishin Taisensō* (Tokyo, 2004), 12; Inagaki, S. "Bunkyū no Ansatsusha," 42.

6 *Bakumatsu Ishin Taisensō,* 14.

7 For an illustration of the display of his and other victims, see Walthall's "Off with Their Heads!" page 153.

8 Romulus Hillsborough, *Shinsengumi: The Shogun's Last Samurai Corps* (Rutland, Vermont: Tuttle Publishing 2005), 14–16.

9 Marius B. Jansen, *Sakamoto Ryōma and the Meiji Restoration* (Palo Alto, California: Stanford University Press, 1971), 138.

10 See, for example, *Ketsu makoto: Shinsengumi,* Rekishi Gunzō Series, vol. 31 (Tokyo, 1992); *Aizu han to Shinsengumi* (Tokyo, 2003); N. Hagio, *Shinsengumi Shiseki Kikō* (Tokyo, 2003). The first work in English to deal with them is Hillsborough's excellent and highly detailed *Shinsengumi.*

11 For beautifully reproduced photographs of Kondō and Hijikata, see *Samurai: Koshashinchō* (Tokyo, 2003), pages 113 and 125.

12 Hillsborough, *Shinsengumi.*

13 Hagio, *Shinsengumi Shiseki Kikō,* 54–55; Hillsborough, *Shinsengumi,* 57–58.

14 The rope still hangs in the same place! Hagio, *Shinsengumi Shiseki Kikō,* 57.

15 Hillsborough, *Shinsengumi,* 78; Hagio, *Shinsengumi Shiseki Kikō,* 56.

16 Hillsborough, *Shinsengumi,* 81.

17 *Takasugi Shinsaku,* Rekishi Gunzō Series, vol. 46 (Tokyo, 1996).

18 Hillsborough, *Shinsengumi,* 110.

19 For Sakamoto's own account of the attempt on his life, see Jansen, *Sakamoto Ryōma and the Meiji Restoration,* 228–230. The scene is nicely reconstructed in *Sakamoto Ryōma,* Rekishi Gunzō Series, vol. 23 (Tokyo, 1991), 22–23.

20 Jansen, *Sakamoto Ryōma and the Meiji Restoration,* 343–344.

21 Hillsborough, *Shinsengumi,* 134.

22 Hillsborough, *Shinsengumi,* 143.

23 A. B. Mitford, Lord Redesdale, *Tales of Old Japan* (Rutland, Vermont: Charles E. Tuttle Co., 1966), 70–87. First published London: Macmillan, 1871, 70.

24 Augustus Mounsey, *The Satsuma Rebellion* (London, 1879); James H. Buck, "The Satsuma Rebellion of 1877: From Kagishima through the Siege of Kumamoto Castle," *Monumenta Nipponica* 28 (1973): 427–446.

GLOSSARY

Agemaki: The ornamental bow on the back of armor

Aikidō: A modern martial art derived from grappling techniques

Ashigaru: Foot soldier

Atemi: Techniques involving striking

Baku han: Mutual support between the shogun and the daimyō

Bakufu: The shogunate

Bokutō: Wooden practice sword

Budō: Martial arts

Bugei: Martial arts or techniques

Bushidō: The way of the warrior

Daimyō: Japanese warlord

Dan: Teaching grade in the martial arts

Dō: Body armor

Dōjō: Martial arts practice hall

Dōjō yaburi: Contests between schools, or external challenges for gain

Emishi: Ancient Japanese natives

Gokenin: Houseman or retainer

Gunkimono: The war tales

Han: A daimyō's fief

Hatamoto: A daimyō's closest retainers

Heishi: Ancient conscript soldiers

Hitotsu tachi: The "one stroke" style of the Shintō-ryū

Ie: Family or household

Jitte: A defensive weapon fitted with a sword-blade catcher

Kabuto: Helmet

Kamayari: A cross-bladed spear

Kami: Deity of the Shintō religion

Kanji: Chinese characters used in writing the Japanese language

Kata: Set forms of swordplay

Kendō: The modern martial art of swordsmanship

Kengō: Master swordsman

Ken-jutsu: Sword techniques

Kesa: A scarf-like garment worn by a priest

Kishōmon: A promise not to reveal secrets

Koku: A measure of wealth expressed in rice

Kote: Sleeve armor

Kyūba no michi: The way of horse and bow

Kyūdō: Japanese archery

Machi bugyō: Magistrate

Machi yakko: Townsman gang

Maku: Field curtains on a battlefield

Menkyō kaiden: Secrets of the art

Mimawarigumi: Tokugawa security unit drawn from retainers

Mutō: The "no sword" technique of the Yagyū

Nagaeyari: Long-shafted spears

Naginata: A glaive, a polearm with a curved blade

Ninja: Secret spies and assassins

Nin-jutsu: The art of stealth and invisibility

Otokodate: Townsmen "samurai"

Rōnin: A samurai without a master to serve

Ryū: School of swordsmanship (combination form)

Ryūha: School of swordsmanship

Sake: Rice wine

Samurai: A member of the military class

Sensei: Teacher

Shikoro: Neck guard

Shinai: Lightweight practice sword

Shinsengumi: The shogun's protectors in Kyoto

Shishi: Imperial loyalist

Shōgun: The military dictator of Japan

Shōji: Internal dividing screens in a Japanese house

Shugo: Military governor of a province

Sode: Shoulder plates

Sōhei: Warrior monk

Suburi: Sword practice by repetitive movements

Tampo yari: Practice spear

Tengu: Forest goblin

Tennō: The emperor of Japan

Tsumeru: Pulling a blow

Uji: Clan or lineage

Yabusame: Horseback archery

Yamabushi: A mountain ascetic

Yari: Spear

Yari-jutsu: Spear techniques

Yoroi: Armor

Yoroi-gumi: Armored grappling techniques

BIBLIOGRAPHY

Ackroyd, Joyce. "Women in Feudal Japan." *Transactions of the Japan Society of London* (1957), 31–68.

Aizu han to Shinsengumi. Tokyo, 2003.

Allen, Louis. "Death and Honour in Japan." *The Listener* 24 (June 1976).

———. *Burma: The Longest War*. London, 1984.

Bakumatsu Ishin Taisensō. Tokyo, 2004.

Various authors. *Bakumatsu Kenshinden* (Rekishi Gunzō Series, vol. 56), Tokyo, 1998.

Beholder. *Fudebakudo: The Way of the Exploding Pen*. Fetcham, 2003.

Birt, Michael P. "Warring States: A Study of the Go-Hōjō Daimyō and Domain 1491–1591." PhD diss., Princeton University, 1983.

Bitō, Masahidee. "The Akō Incident (1701–1703)." *Monumenta Nipponica* 58 (2003), 149–169.

Blomberg, Catharina. *The Heart of the Warrior: Origins and Religious Background of the Samurai System in Feudal Japan*. Folkestone, Kent: Japan Library (Curzon Press), 1994.

Bottomley, Ian and Jock Hopson. *Arms and Armour of the Samurai*. London, 1988.

Boxer, C. R. "Notes on Early European Military Influence in Japan (1543–1853)." *Transactions of the Asiatic Society of Japan* 8, 2nd ser. (1931), 68–93.

Brownlee, John. "The Shōkyō War and the Political Rise of the Warriors." *Monumenta Nipponica* 24 (1969), 59–77.

Buck, James H. "The Satsuma Rebellion of 1877: From Kagishima through the Siege of Kumamoto Castle." *Monumenta Nipponica* 28 (1973), 427–446.

Butler, Kenneth. "The *Heike Monogatari* and the Japanese Warrior Ethic." *Harvard Journal of Asian Studies* 29 (1969), 93–108.

Callahan, Caryl. "Tales of Samurai Honor: Saikaku's *Buke Giri Monogatari*." *Monumenta Nipponica* 34 (1979), 1–20.

Conlan, Thomas D. *In Little Need of Divine Intervention: Takezaki Suenaga's Scrolls of the Mongol Invasions of Japan*. Cornell University, 2001.

———. *State of War: The Violent Order in Fourteenth-Century Japan*. Ann Arbor, Michigan: Center for Japanese Studies, University of Michigan, 2003.

Daidōji, Yuzan. *Budō Shōshinshō*. Tokyo, 1941.

Dautremer, J. "The Vendetta or Legal Revenge in Japan." *Transactions of the Asiatic Society of Japan* 13 (1885), 82–89.

Delgado, James P. "Relics of the Kamikaze." *Archaeology* 56, no. 1 (2003), 26–42.

Farris, Wayne W. *Heavenly Warriors: The Evolution of Japan's Military, 500–1300*. Cambridge, Massachusetts: Harvard University East Asia Center, 1992.

Fogel, Joshua A., ed. *Sagacious Monks and Bloodthirsty Warriors: Chinese Views of Japan in the Ming-Qing Period*. Norwalk, Connecticut: EastBridge, 2002.

Friday, Karl F. *Hired Swords: The Rise of Private Warrior Power in Early Japan*. Palo Alto, California: Stanford University Press, 1992.

———. *Legacies of the Sword: The Kashima Shinryū and Samurai Martial Culture*. Honolulu: University of Hawaii Press, 1997.

———. *Samurai, Warfare and the State in Early Medieval Japan*. New York: Routledge, 2004.

Fukushima, Shoichi. "Bushido in Tokugawa Japan: A Reassessment of the Warrior Ethos." PhD diss., UC Berkeley, 1984.

Gempei Kassen Jimbutsuden. Tokyo, 2005.

Goble, Andrew E. "War and Injury: The Emergence of Wound Medicine in Medieval Japan." *Monumenta Nipponica* 60 (2005), 297–338.

Hagio, N. *Shinsengumi Shiseki Kikō*. Tokyo, 2003.

Hagiwara, S. "Yagi Bushi ni mo utawareta Chūji no Isaburō koroshi," in *Kengō to Otokodate (Raibaru Gekitotsu Nihon shi*, vol. 7), Tokyo, 1979, 114–117.

Harada, T. "Shintō-ryū 'hitotsu no tachi' no gokui," in *Kengō to Otokodate (Raibaru Gekitotsu Nihon shi*, vol. 7), Tokyo, 1979, 36–45.

———. "Saitō Denkibō to Sakurai Kasuminosuke," in *Kengō to Otokodate (Raibaru Gekitotsu Nihon shi*, vol. 7), Tokyo, 1979, 39.

Hawley, Willis. *Introduction to Japanese Swords*. Los Angeles, 1973.

Hawley, Willis, ed. *Heihō Okugishō: The Secret of High Strategy: Yamamoto Kansuke*. Los Angeles, 1994.

Hazard, Benjamin H. "The Formative Years of the Wakō, 1223–63." *Monumenta Nipponica* 22 (1967), 260–277.

———. "Japanese Marauding in Medieval Korea: The Wakō Impact on Late Koryō." PhD diss., Berkeley, 1967.

———. "Wakō." *Encyclopaedia of Japan* 8 (1982), 220–221.

Hearn, Lafcadio. *Japan: An Interpretation*. Rutland, Vermont: Charles E. Tuttle Co., 1955.

Henthorn, William A. *Korea, the Mongol Invasions*. Leiden, 1963.

Hillsborough, Romulus. *Shinsengumi: The Shogun's Last Samurai Corps*. Rutland, Vermont: Tuttle Publishing, 2005.

Honda, F., et al. *Kobudō no hon*. Tokyo, 2002.

Hori, Kyotsu. "The Mongol Invasions and the Kamakura Bakufu." PhD diss., Columbia University, 1967.

Hurst, G. Cameron. *Armed Martial Arts of Japan: Swordsmanship and Archery*. New Haven, Connecticut: Yale University Press, 1998.

Imamura, Yoshio. *Nihon Budō Zenshū*. Tokyo, 1962.

Inagaki, S. "Bunkyū no Ansatsusha," in *Gekidō no Bakumatsu Ishin* (*Raibaru Gekitotsu Nihon shi*, vol. 5), Tokyo, 1979, 42.

———. "Dai Tonegawa Hara no Kenka," in *Kengō to Otokodate* (*Raibaru Gekitotsu Nihon shi*, vol. 7), Tokyo, 1979, 122–124.

———. "Yōjimbō no hanashi," in *Kengō to Otokodate* (*Raibaru Gekitotsu Nihon shi*, vol. 7), Tokyo, 1979, 125.

Ise, Sadatake. *Gunyōki*. Edo, 1843.

Ishiyamadera engi emaki. Ishiyamadera, 1996.

Jansen, Marius B. *Sakamoto Ryōma and the Meiji Restoration*. Palo Alto, California: Stanford University Press, 1971.

———. *Warrior Rule in Japan*. Cambridge: Cambridge University Press, 1995.

Joly, H. L. *Legend in Japanese Art*. London, 1908.

Kammer, Reinhard. *The Way of the Sword: The Tengu Geijutsu-ron of Chōzan Shissai*. London, 1978.

Kawachi, Kunihira. *Nihontō no Miryoku*. Tokyo, 2003.

Kellogg, Edward. "Selective Translation of *Hōgen Monogatari*." *Transactions of the Asiatic Society of Japan* 45 (1917).

Ketsu makoto: Shinsengumi (Rekishi Gunzō Series, vol. 31), Tokyo, 1992.

Knutsen, Roald M. *Japanese Polearms*. London: Holland Press, 1963.

Kobe. "Yamanaka Shikanosuke to Tarakai Okaminosukc Katsumori," in *Sengoku no Gunyū* (*Raibaru Gekitotsu Nihon shi*, vol. 3), Tokyo, 1979, 123.

Kofujita, Toshisada. *Ittōsai Sensei Kenposhō*, in Hiroto Saigusa and Akira Miyagawa, *Nihon Tetsugaki Shisō Zenshū* 15, Tokyo, 1957.

Komatsu, S. *Henyō Tsushima-Iki Sakimoro Shi*. Tsushima, 2000.

Kōsaka, Danjō. *Kōyō Gunkan*, in *Sengoku Shiryō Soshō*, series 1, Tokyo, 1965.

Kōzaki, A. "Nijū hachinen o tsuiyashite honkai o togeru," in *O-ie sōdō to katakiuchi* (*Raibaru Gekito tsu Nihon shi*, vol. 6), Tokyo, 1979, 58–60.

———. "Shimada Tora no suke to Inoue Gensai," in *Kengō to Otokodate* (*Raibaru Gekitotsu Nihon shi*, vol. 7), Tokyo, 1979, 73.

———. "Chiba Shūsaku to Takayanagi Matashichirō," in *Kengō to Otokodate* (*Raibaru Gekitotsu Nihon shi*, vol. 7), Tokyo, 1979, 74–76.

———. "Kensō Jitsuryoku Dai-ichininsha no Gozen Shiai" in *Kengō to Otokodate* (*Raibaru Gekitotsu Nihon shi*, Vol. 7) Tokyo, 1979 pp. 78–83.

———. "Machi Hikeshi to Daimyō Hikeshi no Komyō Arasoi," in *Kengō to Otokodate* (*Raibaru Gekitotsu Nihon shi*, vol. 7), Tokyo, 1979, 119–121.

Kunihika, S. "Miyamoto Musashi no Issei," in *Kengō to Otokodate* (*Raibaru Gekitotsu Nihon shi*, vol. 7), Tokyo, 1979, 26–31.

———. "Machi yakko to Hatamoto yakko no Gekitotsu," in *Kengō to Otokodate* (*Raibaru Gekitotsu Nihon shi*, vol. 7), Tokyo, 1979, 108–110.

Kuwada Tadachika ed. *Shinchōkōki*. Tokyo, 1966.

Lindsay, K. and J. Kano. "Jiu-jutsu." *Transactions of the Asiatic Society of Japan* 16 (1889).

Matsuno, Tsuneyoshi. *Wives of the Samurai*. New York: Vantage Press, 1989.

McCullough, Helen Craig, trans. *The Taiheiki: A Chronicle of Medieval Japan*. New York, 1959.

McCullough, William. "Shōkyūki—An Account of the Shōkyū War of 1221." *Monumenta Nipponica*, 186–221.

———. "The Azuma-kagami account of the Shōkyū War." *Monumenta Nipponica* 23, 102–155.

McMullen, James. "Confucian Perspectives on the Akō Revenge." *Monumenta Nipponica* 58 (2003), 293–315.

Miyamoto Musashi. *The Book of Five Rings: Gorinshō*, trans. Victor Harris. London, 1974.

Mitford, A. B., Lord Redesdale. *Tales of Old Japan*. Rutland, Vermont: Charles E. Tuttle Co., 1966. First published London: Macmillan, 1871.

Momochi, Orinosuke. *Kōsei Iran-ki*, vol. 6. Iga-Ueno, 1897.

Morris, Ivan. *The Nobility of Failure: Tragic Heroes in the*

History of Japan. London, 1975.

Mounsey, Augustus. *The Satsuma Rebellion.* London, 1879.

Mozai, Torao. "The Lost Fleet of Kublai Khan." *National Geographic,* November 1982, 635–649.

Nagaoka, K. "Appare! Kōjo no kaikyō," in *O-ie sōdō to katakiuchi (Raibaru Gekitotsu Nihon shi,* vol. 6), Tokyo, 1979.

———. "Karasugawa Kahan no Kettō," in *Kengō to Otokodate (Raibaru Gekitotsu Nihon shi,* vol. 7), Tokyo, 1979, 56–58.

———. "Otoko no naka no otoko, Kōjinyama ni chirasu," in *Kengō to Otokodate (Raibaru Gekitotsu Nihon shi,* vol. 7), Tokyo, 1979, 130–131.

Nagasaki-ken Takashima-chō Kyōiku Iinkai. Takashima kaitei iseki VII. Takashima, 2002.

Needham, Joseph. *Science and Civilisation in China, vol. 5, part 7: The Gunpowder Epic.* Cambridge, 1986.

Nelson, Thomas. "Slavery in Medieval Japan." *Monumenta Nipponica* 59 (2005), 463–491.

Nitobe, Inazu. *Bushidō: The Soul of Japan.* London, 1905.

Okubo, Tadataka. *Mikawa Monogatari.* Tokyo, 1974.

Ono, Yasumaro, et al. *Kojiki,* in *Nihon Koten Zenshū 1.* Tokyo, 1962.

Rabinovitch, Judith. *Shōmonki: The Story of Masakado's Rebellion.* Tokyo, 1986.

Rogers, John M. "Arts of War in Times of Peace: Swordsmanship in *Honchō Bugei Shōden* Chapter 5." *Monumenta Nipponica* 45 (1990), 413–447.

———. "Arts of War in Times of Peace: Swordsmanship in *Honchō Bugei Shōden* Chapter 6." *Monumenta Nipponica* 46 (1991), 173–202.

Sadler, A. L. *"Heike Monogatari." Transactions of the Asiatic Society of Japan* 46 (1918) and 49 (1921).

———. *The Maker of Modern Japan: The Life of Tokugawa Ieyasu.* London: Ams Pr Inc., 1937.

Saigusa, Hiroto, and Akira Miyagawa. *Nihon Tetsugaki Shisō Zenshū,* vol. 15. Tokyo, 1957.

Sakamoto Ryōma (Rekishi Gunzō Series, vol. 23), Tokyo, 1991.

Sasama, Yoshihiko. *Buke Senjin Sahō Shūsei.* Tokyo, 1968.

Satō, Kan'ichi. *Nihon no tōken.* Tokyo, 1963.

Sengoku Kengōden (Rekishi Gunzō Series, vol. 68),Tokyo, 2003.

Sengoku Kantō Sangokushi (Rekishi Gunzō Series, vol. 2), Tokyo, 1987.

Sengoku Kyūshū Gunki (Rekishi Gunzō Series, vol. 12), Tokyo, 1989.

Shiba, Gorō. *Remembering Aizu: The Testament of Shiba Gorō.* Honolulu: University of Hawaii Press, 1999.

Shinoda, Minoru. *The Founding of the Kamakura Shogunate 1180–1185, with Selected Translations from the Azuma Kagami.* New York, 1960.

Smith, Bradley. *Japan: A History in Art.* London, 1972, 121.

Smith, Henry D. II. "The Capacity of Chūshingura." *Monumenta Nipponica* 58 (2003), 1–37.

Takasugi Shinsaku (Rekishi Gunzō Series, vol. 46),Tokyo, 1996.

Takeda, Y. "Araki Mata'emon san jū roku nin kiri no kyo jitsu," in *O-ie sōdō to katakiuchi (Raibaru Gekitotsu Nihon shi,* vol. 6), Tokyo, 1979, 52–57.

———. "Hibana o chirasu Itō Ittōsai no kōtei futari," in *Kengō to Otokodate (Raibaru Gekitotsu Nihon shi,* vol. 7), Tokyo, 1979, 46–49.

———. "Ichigeki Hitsu Satsu no Jigen-ryū Tanjō," in *Kengō to Otokodate (Raibaru Gekitotsu Nihon shi,* vol. 7), Tokyo, 1979, 51–53.

———. "Moroka Ippa no Aideshi, Hashiue no Kettō," in *Kengō to Otokodate (Raibaru Gekitotsu Nihon shi,* vol. 7), Tokyo, 1979, 54–55.

Takuan, Sōhō. *Fūdōchi shinmyōroku,* in Hiroto Saigusa and Akira Miyagawa, *Nihon Tetsugaki Shisō Zenshū,* vol. 15, Tokyo, 1957.

Tanaka, Takeo. "Japan's Relations with Overseas Countries," in Hall and Toyoda, eds., *Japan in the Muromachi Age,* Berkeley, 1958.

Tanizaki, Junichiro. *Some Prefer Nettles: The Secret History of the Lord of Musashi.* London, 1985.

Toneri, Shinno, et al. *Nihon Shoki,* in *Shintei Zōho Kokushi Taikei,* vol. 1, Tokyo, 1951.

Tsukahara, Bokuden. "Bokuden Ikun-shō," in Yoshio Imamura, *Nihon Budō Zenshū,* Tokyo, 1962.

Tsunoda, Ryusaku, et al. *Sources of Japanese Tradition,* vol 1. New York, 1964.

Turnbull, Stephen. *The Lone Samurai and the Martial Arts.* London: Arms and Armour, 1990.

———. *The Samurai Sourcebook.* London: Arms and Armour, 1998.

———. *Japanese Fortified Temples and Monasteries.* Oxford: Osprey Publishing, 2005.

———. *Osaka 1615: The Last Battle of the Samurai.* Oxford: Osprey Publishing, 2006.

Varley, Paul. *Warriors of Japan as Portrayed in the War Tales.* Honolulu: University of Hawaii Press, 1994.

Walthall, Anne. "Off with Their Heads! The Hirata Disciples and the Ashikaga Shoguns." *Monumenta Nipponica* 50 (1995), 137–170.

Watatani, Kiyoshi. *Nihon kengō hyakusen.* Tokyo, 1971.

———. *Bugei ryūha hyakusen.* Tokyo, 1972.

Wild, Antony. *The East India Company: Trade and*

Conquest from 1600. London, 1999.

Wilson, William R. *Hōgen Monogatari: Tale of the Disorder in Hōgen.* Tokyo, 1971.

———. "The Way of the Bow and Arrow. The Japanese Warrior in Konjaku Monogatari." *Monumenta Nipponica* 28 (1973), 177–233.

Wilson, William S., trans. *Hagakure: The Book of the Samurai,* by Yamamoto Tsunetomo. Tokyo: Kodansha International, 1979.

Wilson, William S. *The Lone Samurai: The Life of Miyamoto Musashi.* Tokyo: Kodansha International, 2004.

Wright, Diana E. "Female Combatants and Japan's Meiji Restoration: The Case of Aizu." *War in History* 8 (2001), 396–417.

Yamada, Nakaba. *Ghenkō, the Mongol Invasion of Japan.* London, 1916.

Yamada, Jirōkichi. *Nihon Kendō-shi.* Tokyo, 1960.

Yamamura, Kozo. *A Study of Samurai Income and Entrepreneurship: Qualitative Analyses of Economic and Social Aspects of the Samurai in Tokugawa and Meiji Japan.* Cambridge, Massachusetts: Harvard University Press, 1974.

Yuasa, Jōzan. *Jūzan Kidan.* Tokyo, 1965.

Zoku Gunsho Ruijū Kanseikai. Okochi Hidemoto: Chōsenki, in *Zoku Gunshō Ruijū,* Tokyo: Zoku Gunsho Ruijū Kanseikai, 1933.

INDEX